P9-EEP-919

DATE DUE

MAR 30 2010			

the comics

the comics
SINCE 1945

BRIAN WALKER

ABRAMS, NEW YORK

Thanks

To Mort, for his inspirational dedication to the art of cartooning

To Jay, for recommending me

To Eric, for his guidance and support

To Abby, Sarah, and David for their patience

Editors: Nicole Columbus, Richard Slovak
Designer: Carole Goodman / Blue Anchor Design
Production Manager: Alyn Evans

Library of Congress Cataloging-in-Publication Data

Walker, Brian.
 The comics : since 1945 / Brian Walker.
 p. cm.
Includes bibliographical references and index.
 ISBN 13: 978-0-8109-9260-3 (pbk.)
 ISBN 10: 0-8109-9260-4 (pbk.) / 0-8109-3481-7 (hardcover)
1. Comic books, strips, etc.—United States—History and criticism.
I. Title.
 PN6725 .W25 2002
 741.5'0973'09045—dc21

 2002008375

HNA ■■■■■
harry n. abrams, inc.
a subsidiary of La Martinière Groupe

115 West 18th Street
New York, NY 10011
www.hnabooks.com

contents

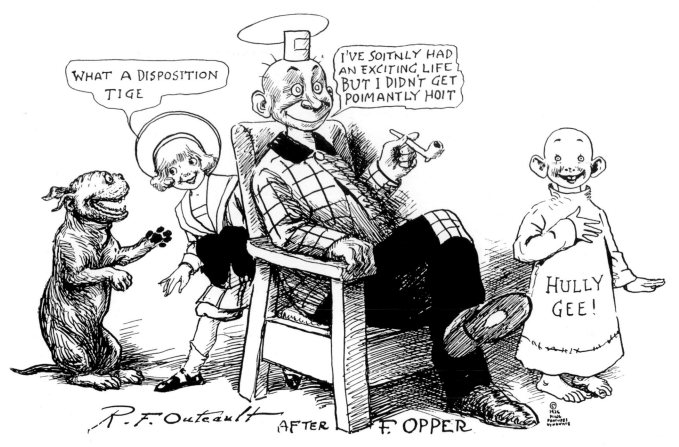

SUNDAY FUNNIES STARS—Buster Brown and Tige, Happy Hooligan, and The Yellow Kid. Illustration by R. F. Outcault from Circulation magazine, 1926

introduction

"**THE SUNDAY FUNNIES**" is a term that evokes nostalgic images. Family members arguing over who gets the comics first. Children on their hands and knees gazing at the colorful pages scattered across the living room floor. Father snoozing in his easy chair, the newspaper open in his lap.

It is hard to imagine a world without Little Orphan Annie, Popeye, Snoopy, and Garfield. Yet the comics as we know them today are a relatively recent invention. The roots of the art form can be traced to prehistoric cave paintings, Egyptian hieroglyphics, and Renaissance tapestries. The immediate antecedents of modern comics are the satirical prints, broadsheets, and illustrated magazines published in Europe during the eighteenth and nineteenth centuries. European artists pioneered the use of caricature, speech balloons, and sequential panels before graphic satire became popular in the colonies. It is in America, however, that the Sunday funnies were born.

American newspaper comics evolved during the latter half of the nineteenth century when powerful forces of social and technological change combined to revolutionize mass entertainment. All of the elements that gave birth to this new art form—the mechanization of printing and distribution, the concentration of population in urban centers, the acceptance of new forms of graphic expression—had been gaining momentum for decades. Critical mass was achieved in 1896, when the phenomenal popularity of Richard F. Outcault's Yellow Kid proved that a comic character could sell newspapers as effectively as blaring headlines and sensational gossip. The Yellow Kid is remembered today as a symbol of the fierce journalistic competition of that era and an icon of a new national institution, the Sunday funnies.

The birth of the comics was the direct result of three major developments in American newspaper publishing: Sunday editions, color printing, and national syndication. *The Katzenjammer Kids, Happy Hooligan, Buster Brown,* and the many other creations that followed in the wake of *The Yellow Kid*'s success appeared in color every Sunday and were distributed to newspapers throughout the country.

On March 20, 1825, the *New York Courier* published one of the first Sunday newspaper editions in America. James G. Edwards, the owner of the *Courier*, was immediately attacked by religious groups for violating "blue laws." "The Sunday paper, in its issue, its sale, and its reading," wrote one clergyman, "is antagonistic to the spirit of the Lord's day, and tends to subvert the institution." In spite of this opposition, Sunday newspapers gradually began to proliferate. In 1870 fewer than

fifty papers put out Sunday editions, but by 1890 the number had risen to over 250.

The first syndicate was started by Ansel Kellogg in Wisconsin in the 1860s. At that time, small-town newspapers had modest resources and limited access to quality writers and national news. Country editors could save on production costs by buying preprinted pages from early syndicates such as Kellogg's. These sheets had generic columns and illustrations, known as "evergreen" features, printed on one side of the page. The other side was left blank, where client papers could print their own local news and advertising. This arrangement was particularly successful during the Civil War, when there was an acute shortage of newspaper workers.

In 1883 Joseph Pulitzer purchased the *New York World* from Jay Gould, and within months, as the result of Pulitzer's innovative changes, the circulation of the *World* rose from 22,000 to 100,000. Pulitzer outdid the competition by publishing a *Sunday World* that was bigger and better than anything on the street. It offered an entertaining mix of features for women, children, and sports fans, as well as humorous illustrations. In 1889 Pulitzer added cartoons to the *Sunday World*, and in 1893, when he obtained a color press, he launched one of the first Sunday color comics sections.

Richard F. Outcault, a freelance cartoonist who contributed regularly to *Truth* magazine as well as to the *New York World*, often depicted scenes of slum life in his drawings. On February 17, 1895, a small black-and-white cartoon by Outcault, featuring a bald-headed street urchin in a nightshirt, appeared in the

World. A few months later, on May 5, the character that was to become the Yellow Kid made his first appearance in color, although his nightshirt was blue, not yellow. Outcault's kid was a slow developer. It took another six months before he donned his trademark yellow shift (November 24, 1895). In spite of this low profile, the Kid managed to attract the attention of newspaper readers. One of his admirers would change his destiny dramatically.

William Randolph Hearst took the town by storm in the fall of 1895, rejuvenating the *New York Journal* and stealing Joseph Pulitzer's thunder as well as his staff. Hearst dropped the price of his paper from two cents to a penny in December 1895, and in four months the circulation of the *Journal* soared from 20,000 to 150,000. In January 1896 Hearst dined with Morrill Goddard, editor of Pulitzer's *Sunday World*, at the Hoffman House in New York City and offered him a salary of $350 a week to edit his new *Sunday Journal*. When Goddard balked, Hearst presented him with $35,000 in cash as a guarantee. In the following months, Hearst lured away many more of Pulitzer's best people with lucrative salary offers, including S. S. Carvalho, the *World*'s vice-president and publisher, and its three top artists, Archie Gunn, Walt McDougall, and Richard F. Outcault. On October 18, 1896, Hearst launched his own Sunday color comic supplement, the *American Humorist*, with the Yellow Kid by Richard F. Outcault as the star attraction.

Pulitzer countered Hearst by dropping his price to a penny on February 10, 1896. When Outcault started working

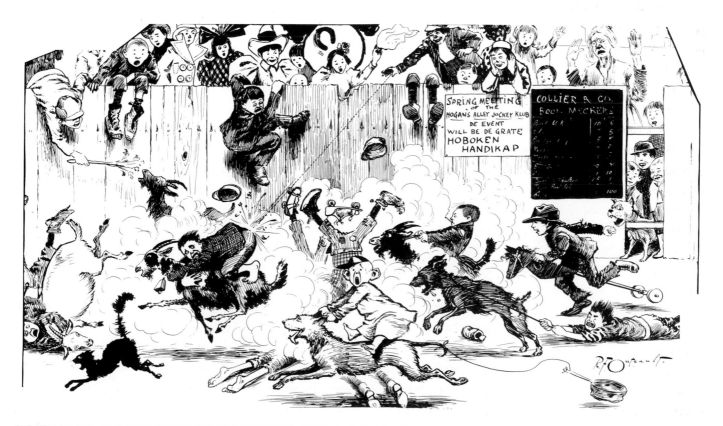

THE YELLOW KID—"THE RACING SEASON OPENS IN HOGAN'S ALLEY," by R. F. Outcault. New York World, May 24, 1896. Courtesy of Richard Marschall

SPANNING THE GENERATIONS—FAMILY CIRCUS Sunday page by Bil Keane. © 6/1/80 King Features Syndicate, Inc.

for the *Journal* in October 1896, Pulitzer turned the *Hogan's Alley* feature over to George Luks. For the next year, the competing Yellow Kids ran simultaneously in both New York papers. Posters were plastered all over town, as each paper claimed to have the genuine article.

At the peak of his popularity in 1896 and 1897, the Yellow Kid's toothy grin showed up on hundreds of products, including buttons, crackers, cigars, and fans. The *Hogan's Alley* gang appeared on stage at Weber and Fields's Broadway Music Hall in 1896, numerous songs were published in sheet-music form, including "The Dugan Kid Who Lives in Hogan's Alley," and a *Yellow Kid* magazine was launched in 1897.

All of the characteristics now associated with comics—a continuing cast of characters, text in speech balloons, sequential panels, regular publication, color on Sundays—had been experimented with before the Yellow Kid made his

first appearance. It was the commercial success of Outcault's creation, during the pivotal year of 1896, that was the crucial factor in establishing the new art form.

On January 5, 1896, the Yellow Kid took center stage in Outcault's Sunday comic for the first time. His bright yellow nightshirt attracted the attention of thousands of newspaper readers, who kept coming back, week after week, to see what this strange character would do next.

In the following months, more milestones were passed. On April 12, 1896, the Kid began talking directly to his audience, via crude writing on his nightshirt. On September 6 the supporting cast of *Hogan's Alley* was formally introduced, in an advertisement drawn by Outcault for a Broadway stage adaptation. On September 7 Outcault applied for a copyright to protect "The Yellow Dugan Kid" from infringement and to insure further profits from the Kid's merchandising success.

WERE THE COMICS INVENTED YET WHEN YOU WERE A GIRL, GRANDMA?

INDEED THEY WERE, JEFFY.

BIL KEANE

The episode on October 25 marked two firsts: the Kid spoke with the aid of a speech balloon, and Outcault utilized sequential comic strip panels. On November 14 the first of the "Yellow Kid Diaries" began appearing semiregularly in the daily edition of the *New York Journal*.

Richard Felton Outcault, the father of the funnies, had in one short year defined the form and content of the American newspaper comic feature. More significant, he proved that the art form had great commercial potential and the ability to build newspaper circulation. All of the developments that have taken place in the funnies business since 1896 rest upon Outcault's original foundation.

Soon after the debut of the Yellow Kid, large metropolitan papers in other cities, including the *San Francisco Examiner* and the *Philadelphia Inquirer*, began publishing their own Sunday comic sections. In New York City the competition between newspapers continued to rage. The *New York Herald*, some-

what less sensational than the *World* and the *Journal* but equally intrigued by the potential of the new medium, tried out sixty new comic features between 1899 and 1905. William Randolph Hearst sold and shipped the entire *New York Journal American Humorist* Sunday section to other cities across the country. As a result, the Yellow Kid became a national celebrity and his creator reaped huge profits from the hundreds of Yellow Kid licensed products.

Humorous drawings had appeared in daily newspapers since the mid-nineteenth century, but it was not until more than a decade after the success of the Yellow Kid that daily comic strips became a fixture in American newspapers.

In 1903 Clare Briggs created a comic strip, *A. Piker Clerk*, which ran on the daily sports page of the *Chicago American*. The star of the feature, a chinless racetrack gambler, placed bets, and readers had to wait until the next episode to learn the results. Briggs's promising formula failed to win the allegiance

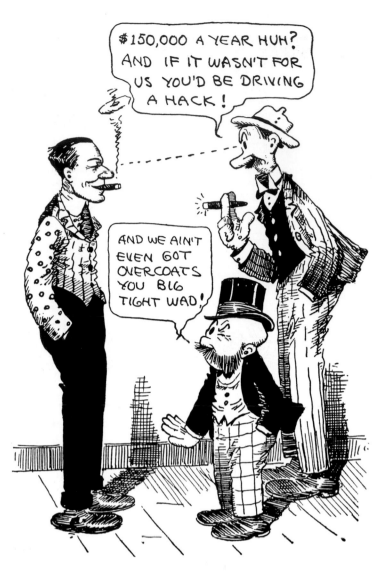

COMIC KING—Bud Fisher discusses his annual earnings with his two stars, Mutt and Jeff. Self-caricature by Bud Fisher from The American Magazine, c. 1916

of readers, and William Randolph Hearst, who owned the *American*, canceled *A. Piker Clerk* after a few short months because he thought it was "vulgar."

Four years later Bud Fisher tried an almost identical formula in the *San Francisco Chronicle*, and the result, *A. Mutt*, went on to become the first successful daily comic strip. *Mutt and Jeff*, as Fisher's creation was later renamed, ran for seventy-five years and made Fisher the first millionaire cartoonist in the funnies business.

Daily comic strips appeared, in the early years, scattered throughout newspapers on editorial, sports, or classified pages. Gradually, small groupings of strips began to appear. One of the first daily comic-strip pages debuted in the *New York Evening Journal* on January 31, 1912.

National syndication of comic features began almost immediately after the commercial potential of the art form was realized. Hearst distributed a package of features to client newspapers as early as 1895, and Pulitzer followed his competitor's lead in 1897. Metropolitan papers in Philadelphia, Chicago, Boston, and St. Louis set up their

own syndicate operations within the next decade. There were also a number of independent distributors, such as the George Matthew Adams Syndicate and the McNaught Syndicate, which began selling comics in the first decade of the new century.

The Newspaper Feature Syndicate was incorporated in 1913. According to its founder Moses Koenigsberg, it was the "first independent syndicate organized to supply a complete budget of features to seven-day-a-week publications." At that time, the number of daily newspapers in America had reached a peak of 2,262, with a combined circulation of 28 million. These papers were serviced by about forty syndicates. Newspaper Feature Syndicate, an arm of the Hearst empire, was the largest of these distributors. It supplied its client newspapers with the papier-mâché matrices from which their comic features could be reproduced. Because the majority of papers could not afford the machinery to print their own color comics sections, N.F.S. could also arrange to have them preprinted at one of nine separate manufacturing stations, saving their clients one-third of labor and material costs. Today most of the nation's Sunday funnies are still prepared at a few large printing plants, such as American Color Graphics and Western Color.

On November 16, 1915, Koenigsberg launched King Features Syndicate. Named after its founder, it has been among the leading comics distributors ever since. The competition also continued to thrive. By 1935, 130 syndicates were offering over 1,600 features to almost 14,000 daily and Sunday newspapers throughout the world.

Syndication provided significant opportunities to cartoonists. In the early years cartoonists worked in their newspaper's art departments and were paid fixed salaries for drawing weekly comic features as well as sports, editorial, and filler cartoons. With the advent of syndication, artists were liberated from the regimentation of newspaper staff positions. Their creations were seen by a much larger audience and they received a cut (usually 50 percent) of the weekly fees paid by subscribing newspapers. The most successful ones, such as Bud Fisher and Sydney Smith, became wealthy and famous.

There was also a downside to the relationship. Syndicates spent a considerable amount of money developing, promoting, and marketing their features. To protect their investments, syndicates insisted on total control of their properties. Cartoonists were forced to sign "work-for-hire" contracts, relinquishing ownership of their creations. This situation has changed within the last two decades and now many cartoonists own the copyrights to their features and control the merchandising of their characters.

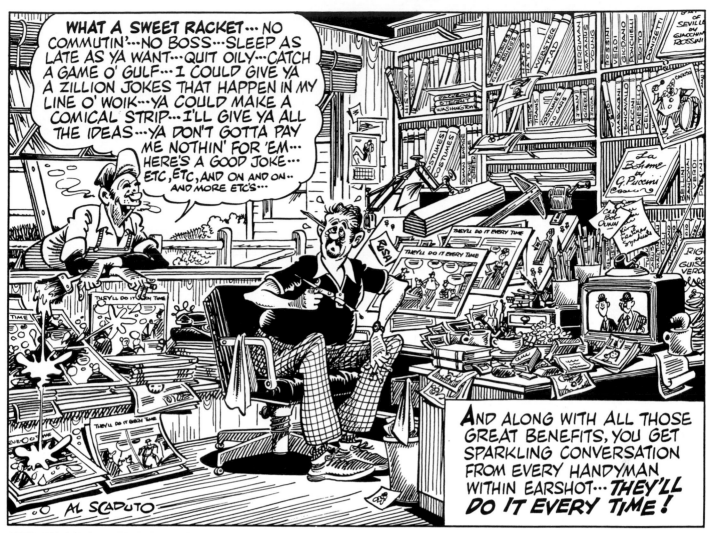

HOW HARD COULD IT BE?—*THEY'LL DO IT EVERY TIME* daily panel by Al Scaduto, c. 1970. © King Features Syndicate, Inc.

Syndicates are rarely given credit for their part in helping to establish the comics medium. By handling the distribution and financial headaches, syndicates enabled cartoonists to concentrate exclusively on what they did best: create. The goal of the syndicates was to offer the widest variety of features for their clients to choose from. As a result, they provided work for thousands of artists and writers over the years. There are, of course, many stories of unsavory syndicate dealings, but in general, it has always been in the best interests of the syndicates to preserve the delicate relationship with their most valuable resources, the cartoonists. Without their talents they have nothing to sell.

Two decades after the first appearance of the Yellow Kid in the *New York World*, the funnies business was a national institution. Comics appeared, both daily and on Sundays, in virtually every newspaper in the United States. Syndicates distributed the top comic features to over a thousand clients, and the most sought-after creators were well-known celebrities. Comic characters starred in stage adaptations and animated films, their praises were sung in hit songs, their adventures were collected in books and magazines, and their popular images were used to sell a wide variety of products, ranging from toys and dolls to cigars and whisky.

Since that time, the comics business has operated on the same basic principles. Syndicates are "content providers" to American newspapers. Cartoonists create content that the syndicates sell. Syndicates split the profits with the cartoonists. The process starts with the cartoonist, who develops an original concept for a new feature. The creator then submits a sampling of daily strips and Sunday pages to the comics editors of the syndicates.

The largest syndicates, King Features, United Media, Universal Press, Tribune Media Services, and Creators, each receive over 5,000 submissions annually and release approximately a dozen new features combined a year. If the comics editor sees promise in a submission, he or she might solicit the opinions of other syndicate executives and salespeople. If the consensus is positive, the comics editor will offer a contract to the cartoonist. A development period of six months to a year often follows, so that the cartoonist can work out the kinks in the original concept and hit the ground running when the strip begins.

Hopefully, by the date of the launch, a few dozen papers, preferably large metropolitan dailies, have agreed to carry the

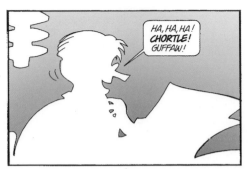
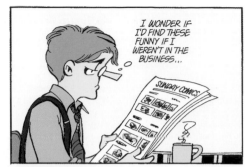
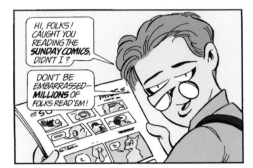
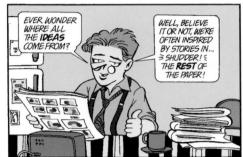
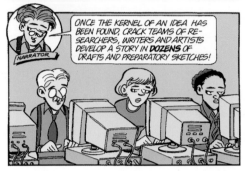

WHERE IDEAS COME FROM—DOONESBURY Sunday page by Garry Trudeau. © 9/4/94 by G. B. Trudeau. Used by permission of Universal Press Syndicate. All rights reserved

feature. Salespeople work hard during these first months to build up momentum and convince other editors to sign on as well. The goal is to have more than 100 papers after the first year. Only about 40 percent of new features make it past their second year.

Newspaper editors have difficult choices to make. A feature often has to be eliminated to make room for a new one. Readership polls and telephone surveys are used to determine the most-liked and least-liked strips in a paper, but the results are rarely definitive. Editors will occasionally "test drop" a feature and wait to see if any readers protest. In the end, the decision about which comics to add and subtract is based on an editor's professional instincts.

While the feature is being marketed, the cartoonist is busy meeting deadlines. Every week or so, a batch of new material is sent to the syndicate. Dailies are typically completed six weeks before publication date and Sunday pages are done eight weeks ahead, although schedules vary from artist to artist. The basic steps involved in creating each daily installment are writing, editing, penciling, inking, and lettering. The majority of cartoonists do all of these chores themselves when they are first getting started. As a feature begins to generate additional income, the creator might choose to hire

assistants to perform one or more of these tasks. Most cartoonists have some form of help. Charles Schulz, who wrote, drew, lettered, and inked every *Peanuts* strip for almost fifty years, was an exception.

For many years the majority of cartoonists produced their camera-ready artwork with similar tools and materials. They would first draw their strips and panels in pencil on heavy-ply, plate-finish bristol board, at least twice the size it would appear in the newspaper, and then ink and letter over the pencil lines with a flexible nib pen or brush and India ink. Shading was sometimes added by applying a patterned adhesive overlay, commonly known as "Ben Day," over the desired areas. In more recent times, artists have employed a wider variety of supplies and methods, including vellum, chemically treated paper, graphite pencils, felt-tip pens, magic markers, and fountain pens, as well as digital drawing pads, software programs, and computer fonts.

Daily strips and Sunday pages are almost always done in black and white. The artist will often provide the syndicate with a color guide for the Sunday page, although since the mid-1990s, most of the coloring has been done by computer.

The production department at the syndicate photographs or scans the artwork and puts together weekly proof sheets,

which are sent or transmitted to subscribing papers. Artwork for the Sunday pages takes a little longer to prepare, because the color needs to be added.

Some syndicates will pay a cartoonist a guaranteed minimum salary until there is enough additional income to divide. The split is usually fifty-fifty after the production costs are deducted. A cartoonist can hope to earn a modest living in the first year of syndication, although many keep their day jobs until the feature takes off.

Beyond that, the sky is the limit. The top strips in the business appear in over 2,000 newspapers (daily and Sunday clients are counted separately) and earn their creators million-dollar incomes. If a strip becomes a merchandising success, even greater profits are possible. The average cartoonist can hope to earn a six-figure salary for a strip that runs in a few hundred newspapers.

Of course, the process is never uniform or predictable. In the funnies business, exceptions are the rule. Each story is different.

There have been cartoonists who sell a strip on their first submission, and others who never succeed after developing dozens of ideas. A comics editor at one syndicate may pass on a submission that becomes a huge hit for another syndicate. Some cartoonists are rejected after going through the development period, whereas others go straight to the launch phase. A sales kit may be little more than a few pages of black-and-white samples, or it can be an elaborate, full-color masterpiece of graphic design. There have been strips that had over 500 clients at their launch date. Others were unable to sign up a single paper. New features may skyrocket and then drop off precipitously. Many grow gradually. A strip with a handful of large-circulation papers can earn more than a feature with over a hundred small-town subscribers. A cartoonist with a good lawyer might negotiate a huge guarantee, a more favorable split, and greater control of all merchandising. A cartoonist with no legal representation can get screwed.

The daily working methods of syndicated cartoonists also vary. Some manage to get months ahead of their deadlines and can afford to pay assistants to do most of the work. Others are habitually behind schedule, sending in batches of a few strips at a time, their incomes depleted with late charges from the syndicates.

All cartoonists utilize the same basic building blocks. A cartoon is a picture that tells a story, or conveys an idea. A newspaper comic is a cartoon that appears in a newspaper. Speech balloons, sequential panels, a regular cast of characters, and a recurring title are only common characteristics, not the defining elements of the newspaper comic.

The two types of newspaper comic features are **strips** and **panels**. Daily comic strips can consist of either multiple panels or a single panel but are almost always horizontal in shape. Newspaper panels can be vertical, square, or circular in shape and usually consist of a single panel but also come in multipanel layouts.

Most syndicated comics appear in both **daily** and **Sunday** formats. Daily comics have traditionally been printed in black and white, but many newspapers are now featuring color comics seven days a week. Sunday pages are almost always printed in color and come in a variety of layouts: quarter-page, third-page, half-page, and full-page tabloid. Most cartoonists are required to construct their pages so that the panels can be rearranged to conform to all of these layouts. Others only use a rectangular configuration that cannot be reformatted.

Within these somewhat restricted boundaries of form, cartoonists explore a limitless world of content. In terms of writing there are two basic approaches. A **gag-a-day** strip delivers a complete joke or observation in each installment. A **continuity** strip has plotlines that can run for days or weeks. Many gag-a-day strips feature running themes and many continuity strips have punch lines—some cartoonists combine the two methods into what is called "narrative humor."

Drawing styles run the gamut from stick figures to anatomically correct illustrations, but three general descriptive terms are familiar to most cartoonists. The **big-foot** method, in which the characters have oversized feet, noses, and heads, is typical of most humor strips. The **five-finger** approach, found

FIVE FINGER MEETS BIG FOOT—SAM'S STRIP daily strip by Mort Walker and Jerry Dumas. © 5/9/62 King Features Syndicate, Inc.

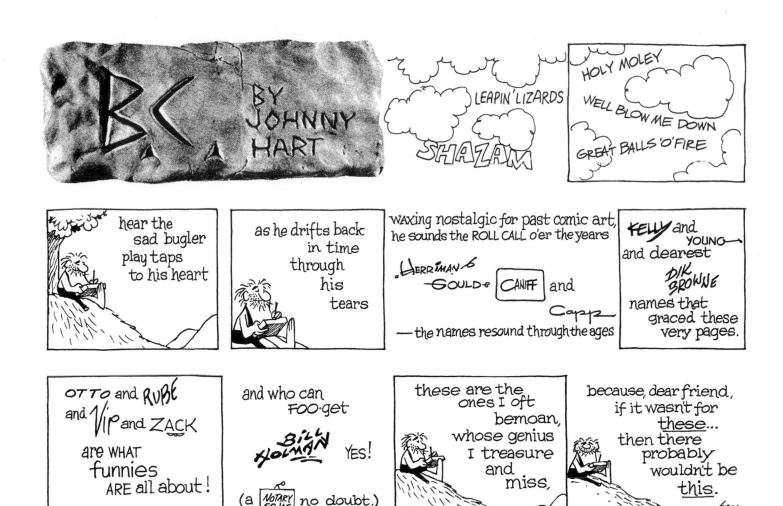

A TRIBUTE TO PAST MASTERS—B.C. Sunday page by Johnny Hart. © 5/29/94 Creators Syndicate, Inc.

commonly in adventure and soap-opera strips, is a name for a realistic style of illustrating characters. The **semi-straight** school bridges the gap between big-foot and five-finger. Semi-straight characters can have large heads, with realistic bodies, and big feet, as in *Li'l Abner*, or a blend of characteristics, typified by *For Better or For Worse*. Many comics do not fit neatly into any of these traditional categories.

In terms of genres, newspaper comics cover the scope of human experience. Adventure, aviation, fantasy, science fiction, military, western, detective, sports, romance, soap opera, humor, screwball, pantomime, animals, pets, kids, teens, families, and babies are among the many popular themes and subjects for comics, but this list is hardly all-inclusive. Cartoonists have a talent for dreaming up ideas that are outside established genres. *Zippy the Pinhead* is a good example of a contemporary creation that defies categorization.

Every newspaper cartoonist working today is restricted by the rigid formats and demanding deadlines of the funnies business. They are also challenged by the infinite thematic possibilities of the art form. Fred Lasswell, who produced *Barney Google and Snuffy Smith* for 55 years, claimed, "The thing that drives you crazy in this business is that you should acquire two skills—both contradictory. One is having an excellent memory so you can remember what you did in the past and not do the same thing today. The other is an ability to forget, so you can clear your head and think of something fresh."

Each syndicated cartoonist has complete control over a small patch of newsprint real estate. Some respond to the limitless possibilities of "filling in the boxes" with imagination and innovative solutions. Others experience "white paper fever" and are eventually worn down by the relentless deadlines of daily comics production. The sheer volume of output (365 installments a year) is staggering. The ways in which cartoonists have met this challenge have produced a fascinating spectrum of creative expression.

Although current events are reflected on the comics pages, social trends do not necessarily dictate the subject matter of comics features. Strips based on passing fads or changing lifestyles are usually short-lived. In the postwar era, technological advances such as television and computers and social changes brought about by the baby-boom generation have had a major influence on the comics business. Trends within the industry have had an even greater impact on cartoonists. The decline of story strips and the increasing dominance of humor features in the last fifty years have led to both terminated careers and new opportunities. The shrinking size that

comics are printed in newspapers has posed an ongoing threat to creativity. Other issues—censorship, ownership, and merchandising—have presented additional challenges to creators.

Cultural elitists relegate comics to the status of "low art." Cartoon art should not be judged by the same criteria as fine art. Comics are a unique visual and narrative art form, and both elements should be considered when evaluating the work of an individual cartoonist. Comic creations are also products of the culture within which they are produced. All of these factors must be taken into account when developing an appreciation for cartoon art.

The achievements of the great pioneers and early masters of American newspaper comics have been well documented in previously published histories. The majority of these accounts trace the evolution of comics from the heady days of innovation at the turn of the century, through the widespread popularization of the funnies during the 1910s and 1920s, to the proliferation of adventure strips in the 1930s. The patriotic participation of characters in World War II is often depicted as the pinnacle of the glorious golden age of newspaper comics. The postwar period is then summed up in a few brief closing chapters.

Many comics historians believe that the funnies business has been in decline during the postwar era. In *America's Great Comic-Strip Artists* (1989), Richard Marschall stated: "There have been many new comic strips but few trends since the 1950s, a situation that falls somewhere between sad and frightening. Commerce, once such a benign partner, today smothers the newspaper comic strip in America. Licensing and merchandising considerations now often precede the creation of a strip, rather than the reverse. Printing quality has declined, and coloring is not as brilliant as it once was. Formats have shrunk, and Sunday comics are now crowded several to a page instead of each filling a whole sheet. New features seem imitative; the gag-a-day mode has degenerated into stale punch lines; and newspapers themselves no longer promote—or evidently, appreciate—comic strips as they once did."

In *The Comic Strip Century* (1995), Bill Blackbeard concluded that "by the late 1960s, the newspaper comic strip had largely self-destructed as a measurably competent narrative art form."

By writing off the last half-century of comic-strip history, some scholars overlook the contributions of great talents like Walt Kelly, Charles Schulz, Garry Trudeau, and Bill Watterson. They ignore the popularization of American comics around the world and the successful adaptation of comic creations to new media, such as television and computers.

The argument that comics have changed for the better has rarely been made. Yet today more minorities are represented on the funnies pages than ever before. Women cartoonists have established a voice, and old taboos have tumbled. Cartoons are read by far more people than in the "golden age" of the 1930s and 1940s.

Doomsayers underestimate the art form's ability to reinvent itself. "I've read articles that were about to put us all out of business," said Milt Caniff in 1984. "And the next year some new thing like *Hagar the Horrible* comes along and knocks all of the pins down." The same could be said in more recent years for *Mutts* and *Zits*.

The comics industry has changed dramatically during the past fifty years. Radio, television, and the internet have challenged newspapers for dominance. Cartoonists have been forced to adapt to shifting perceptions and economic realities.

A fuller appreciation of American newspaper comics can be gained by examining how this unique communicative medium has evolved from 1895 to the present. Documenting the second half of this story should provide a better understanding of the connections between recent creations and strips from the past. Throughout its more than 100-year history, the art form has, time and again, proved its popular appeal and commercial adaptability. From the newspaper wars at the end of the nineteenth century to the cutting-edge competition on the information superhighway at the beginning of the twenty-first century, comics have continued to thrive.

The funnies have endured primarily because comic characters have a universal, timeless appeal. Their daily appearances make them familiar to millions. Their triumphs make them heroic. Their struggles make them seem human. Cartoonists create friends for their readers. Pogo, Charlie Brown, Calvin and Hobbes, and Dilbert are part of a great cultural legacy that is being further enriched every day. The final panel has yet to be drawn.

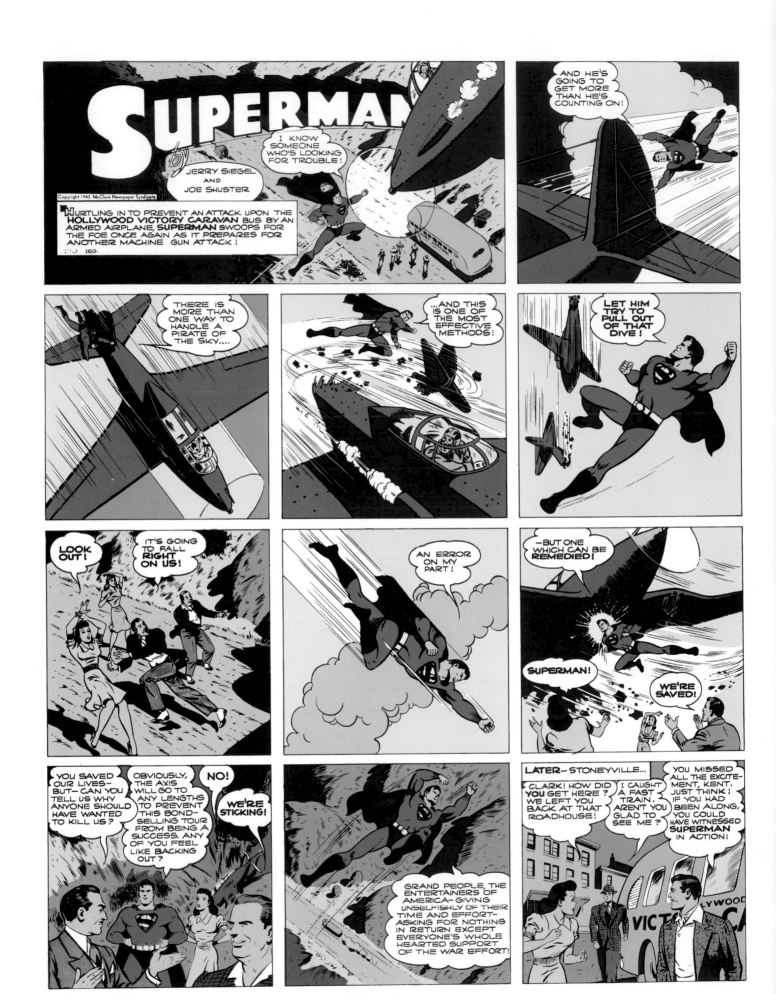

WAR EFFORT—Superman rescues a Hollywood bond-selling tour from an Axis saboteur in this Sunday page by Wayne Boring.

Superman © January 1943. Superman™ and © DC Comics. All rights reserved. Used with permission

the postwar years

LOWIZIE *from* BARNEY GOOGLE AND SNUFFY SMITH *by* Fred Lasswell. © King Features Syndicate, Inc.

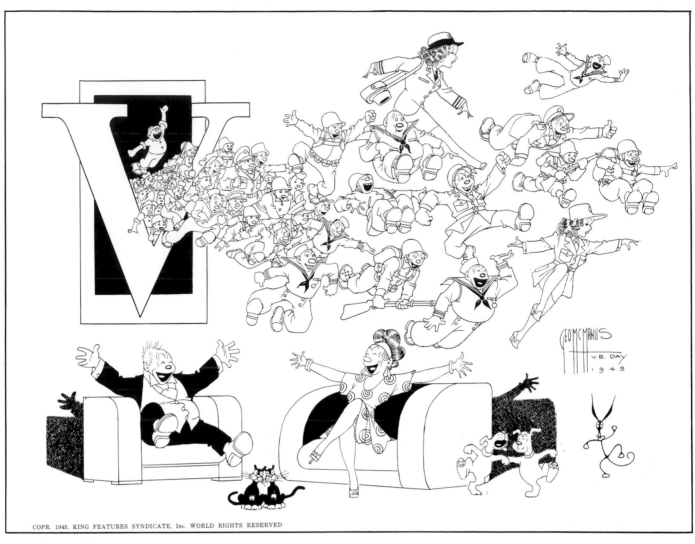

VICTORY—BRINGING UP FATHER by George McManus. © 1945 King Features Syndicate, Inc. Courtesy Howard Lowery Gallery

O N A SUNNY AFTERNOON IN LATE JUNE 1945, THE *QUEEN MARY*, CARRYING 14,500 BATTLE-WEARY VETERANS, WAS WELCOMED INTO NEW YORK HARBOR WITH A CHORUS OF TUGBOAT WHISTLES. THE ALLIES HAD DECLARED VICTORY IN EUROPE ON MAY 8, 1945, AND THE JAPANESE SURRENDERED FOUR MONTHS LATER, AFTER ATOMIC BOMBS DEVASTATED HIROSHIMA AND NAGASAKI. ALTHOUGH 7 MILLION SOLDIERS REMAINED OVERSEAS, THE TROOPS WERE FINALLY COMING HOME.

The stars of America's funnies pages were also returning. They had served their country valiantly. "My people, the comic-strip characters, are in this war up to their inked-in eyebrows," wrote *Terry and the Pirates* creator Milton Caniff in 1943.

Snuffy Smith was one of the first to enlist, over a year before the Japanese attack on Pearl Harbor. He convinced Army recruiters to overlook his advanced age, flat feet, and toothlessness and was inducted on November 13, 1940. Snuffy's buddy, Barney Google, joined the Navy in September 1941. By the time America officially entered the war, many comic characters were doing their part, both in active duty and on the home front.

Skeezix said goodbye to the gang at *Gasoline Alley* and, after basic training, was shipped off to North Africa. Buz Sawyer was marooned on an island in the South Pacific.

Mickey Mouse went on a bombing mission over Germany. Little Orphan Annie organized the Junior Commandos to collect scrap metal for the war effort, and Dick Tracy helped sell government bonds.

"It's impossible to compute how many millions of dollars worth of War Bonds and Stamps have been sold through the constant plugging of the cartoonists in their daily releases," reported *Editor and Publisher* in 1942. "The cartoonists are up near the top among the various agencies now doing similar work throughout the country, if only for the fact that so many millions of persons read the comics daily and are influenced by them."

Not all cartoonists put their characters in uniform. On July 4, 1942, Al Capp explained to his readers why he had decided not to have his hillbilly star enlist. "Perhaps Li'l Abner and his friends, living through these terrible days in a peaceful,

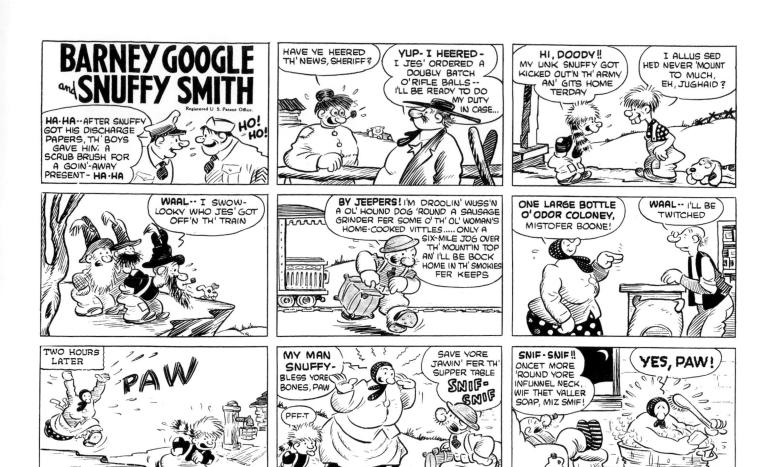

COMING HOME—BARNEY GOOGLE AND SNUFFY SMITH Sunday page by Joe Musial. © 10/28/45 King Features Syndicate, Inc.

happy, free world, will do their part—by thus reminding us that this is what we are fighting for—to have that world again." Capp supported the war effort by doing special cartoons for the military, the Red Cross, and the Treasury Department, but his strip remained an oasis from the grim realities of the global conflict.

Front-line cartoon dispatches were provided by a handful of G.I. cartoonists. Sgt. George Baker (*The Sad Sack*), Lt. Dave Breger (*Private Breger*), Sgt. Dick Wingert (*Hubert*), and Sgt. Bill Mauldin (*Up Front*) chronicled the gritty aspects of training and combat in the pages of *Stars and Stripes*, *Yank*, and *Leatherneck*. When the fighting was over, Sad Sack, Hubert, and Mr. Breger became civilian stars of nationally syndicated features but never managed to recapture the popularity they had during the war.

Established comic characters adapted more successfully to life in peacetime. On October 28, 1945, Snuffy Smith's bride Loweezy doused herself in "odor coloney" to welcome him back to Hootin' Holler after almost five years of military service. Snuffy was reunited with his sidekick, Barney Google, the following February. When Skeezix returned home he proudly held his newborn son Chipper for the first time. The boy had been born nine months after Skeezix married his sweetheart Nina while on leave in 1944. After being discharged from the Navy, Buz Sawyer visited his family in Texas, traveled to New York, and was accused of murdering

his former girlfriend. After clearing himself of the charges, Buz was hired as a globe-trotting troubleshooter for an international airline.

Cartoonists also made adjustments. Alex Raymond, who served as a combat artist during the war, returned home in 1945 to find that his replacement on *Flash Gordon*, Austin Briggs, had been signed to a long-term contract with King Features. Raymond soon overcame his disappointment and helped King develop a detective strip to compete with *Dick Tracy*. *Rip Kirby* debuted on March 4, 1946, and starred a sophisticated private eye, who, like his creator, was a distinguished Marine veteran.

Discharged G.I.s faced rising unemployment and a shortage of available housing. Ten days after V-J Day, 1.8 million workers were unemployed; six months later 2.7 million were out of work. Although the U.S. economy was heading toward an unprecedented period of prosperity, the immediate postwar years were difficult for many veterans.

The economic future of the newspaper business was threatened by the escalating cost of newsprint in the late 1940s. The war cut off the supply of paper from overseas, which led to rationing in 1943. When the price controls ended in 1946, the cost of newsprint rose $35 a ton, and by 1948 it was at $100 a ton, double the prewar price. Newspapers experimented with ways to cut back on paper consumption. One solution was to reduce the size they printed the comics. Between 1937

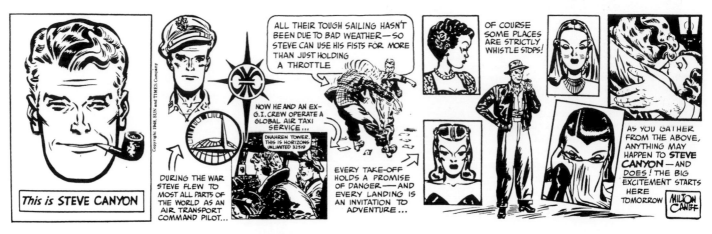

A STAR IS BORN—STEVE CANYON *introductory strip by Milton Caniff.* © 1948 Milton Caniff Estate

and 1952, the average size of a daily comic strip shrank from $11\frac{1}{2}$ to $7\frac{1}{4}$ inches in width.

In 1942 George McManus, creator of *Bringing Up Father*, complained about the effect this development was having on his work. "The space is so small today that I can show only the heads of the characters—or else must draw the complete figure very small—if I wish to have any room for the balloons at the top. While more and more space is being devoted to comics, the strips themselves are gradually being cut down in size." The shrinking of the comics would continue to restrict creativity in subsequent decades.

Newspaper circulation reached an all-time peak during the postwar period. In New York nine major papers boasted total daily sales of more than 6 million and the six papers that printed Sunday editions sold a total of 10.1 million copies per week. At the head of the pack was the *New York Daily News*, which distributed 2.4 million daily morning editions and 4.7 million papers wrapped in the funnies every Sunday.

Although an anticipated postwar sales boom never materialized, business was also good for the newspaper syndicates. In 1946 more than 125 new features were launched and fewer than 40 were dropped. Unsolicited submissions from returning G.I.s, anxious to break into the field, more than doubled at the fifteen major syndicates. King Features reported that with the return of its lucrative foreign markets, its sales were 75 percent above its 1938 total, the previous record year.

The most significant new comic strip of the postwar era was Milton Caniff's *Steve Canyon*. In 1944 Caniff was earning $70,000 a year producing *Terry and the Pirates* but was frustrated because he did not own the copyright to his creation. When publisher Marshall Field offered Caniff full ownership and a five-year contract worth $525,000 to develop a new adventure strip, he accepted the offer.

Caniff was not the first cartoonist to switch syndicates. As recently as 1943, Roy Crane had been lured away from the Newspaper Enterprise Association, which had distributed *Wash Tubbs* since 1924, to produce *Buz Sawyer* for King Features.

Caniff wanted the same opportunity to control his destiny.

In January 1945 columnist Walter Winchell broke the story that Caniff was jumping ship. *Time* magazine claimed the defection was equivalent to "Henry Ford quitting his motor company and setting up shop in competition across the street." Marshall Field, who signed a distribution agreement with King Features, sold the new strip to 125 subscribers before Caniff had drawn a line.

In the meantime, Caniff was still under contract with the Chicago Tribune New York News Syndicate to continue *Terry and the Pirates* until the end of 1946. Not content to coast through his final two years, Caniff did some of the finest work of his career during this period.

By November 1946 Caniff had designed a character he described as "a modern-day Davy Crockett." "Steve Canyon's been around," Caniff continued. "I couldn't have Terry smoke, or even fall in love really without knowing

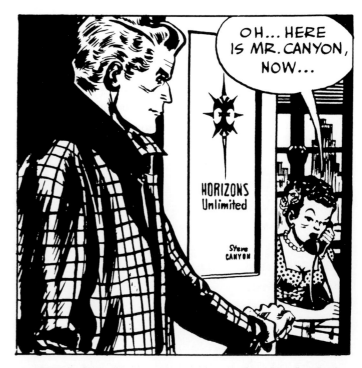

IN PROFILE—*Steve Canyon's dramatic entrance. Panel from first Sunday page.* © 1/19/47 Milton Caniff Estate

A NATIONAL CRAZE—Shmoo illustration by Al Capp from Life magazine, 1948

everything that led up to it. But this guy might have been in love a dozen times."

A war veteran, Steve Canyon ran an independent air-taxi service called "Horizons Unlimited." "He'll have lots of gals—one at every port," Caniff claimed. "With a big C-54 airplane they can move around very fast. Naturally one of the problems will be to keep him single."

Steve Canyon debuted on Monday, January 13, 1947, after a nationwide promotional blitz. It became the first comic strip introduced on television when NBC brought Caniff into the studio for a preview. Suspense built up throughout the opening week because Caniff had decided not to reveal his hero's handsome, square-jawed profile until halfway through the first Sunday page on January 19.

"It was very deliberate, of course," remembered Caniff years later. "Coming out like that after all the publicity and all the noise about it, I had to have something. It worked."

The other big newsmaker of the postwar era was Al Capp. Between 1946 and 1952, Li'l Abner's creator went on an unprecedented binge of artistic productivity and public notoriety. Capp's smiling mug appeared on the covers of both *Newsweek* (1947) and *Time* (1950), and his exploits were covered regularly in the national media.

In June 1946 Abner journeyed to Lower Slobbovia to meet Lena the Hyena, a girl so ugly Capp claimed he was

unable to draw her face. After asking his readers for help, he received 500,000 grisly portraits. The winning entry, by Basil Wolverton, was revealed in the October 28, 1946, issue of *Life* magazine.

The following year, after launching a $14 million lawsuit against his syndicate for underpayment of royalties, Capp created a thinly veiled satire of the dispute. In the *Li'l Abner* story, Rockwell P. Squeezeblood of the Squeezeblood Comic Strip Syndicate cheated two naive cartoonists out of the proceeds to their comic-strip creation, *Jack Jawbreaker.* "And the nicest part of it all is it's perfectly legal," boasted Squeezeblood.

In 1948 the National Cartoonists Society began investigating a long-running feud between Ham Fisher and Al Capp. Fisher had repeatedly accused his former assistant of stealing the hillbilly characters, Big Leviticus and his clan, from *Joe Palooka* and using them as the inspiration for *Li'l Abner.* The N.C.S. board of governors eventually told Fisher and Capp to settle their differences privately. This ugly dispute would erupt again in the 1950s.

At the end of August 1948, Capp introduced one of his most inspired creations. Shmoos were cute, ham-shaped creatures who could produce all of mankind's basic needs without any cost to the owner. They laid neatly packaged and bottled eggs and milk labeled "Grade A." When broiled, they tasted like steak. When fried, they resembled chicken. They multiplied at a rapid rate. They were the perfect solution to the shortages of the postwar economy. They were too good to be true.

Ignoring a warning that Shmoos pose the "greatest threat to humanity th' world has ever known," Abner let them loose in Dogpatch, and before long they were overrunning the countryside. "The U.S. Becomes Shmoo-Struck" announced a headline in *Life* magazine as Shmoo merchandise proliferated as rapidly as the Shmoos in *Li'l Abner.* There were Shmoo-shaped dolls, deodorizers, key chains, soap, and banks. By mid-1949, Capp Enterprises claimed that close to 100 different items were being produced by about seventy-five manufacturers creating an estimated $25 million in income. The Shmoo business was particularly lucrative for Al Capp, who had settled his dispute with United Feature Syndicate by setting up Capp Enterprises as his own licensing company.

Nogoodniks (bad Shmoos), Money Ha-Has (who laid money instead of eggs), Bald Iggles (whose gaze made everyone tell the truth), and Kigmies (who loved to be kicked) followed in the wake of the Shmoos. So did a colorful parade of Capp crazies, including J. Roaringham Fatback, One-Fault Jones, Evil Eye Fleegle, and Burping Buffalo.

Li'l Abner continued to be one of the most talked-about pop-culture institutions in America until Capp's surprising decision to have Abner marry Daisy Mae in 1952. In an era of increasing Cold War paranoia, Capp felt the mood

of the nation had changed and was no longer receptive to his brand of social satire. "I was astounded to find it had become unpopular to laugh at any fellow Americans," he wrote in *Life* magazine. "I realized that a new kind of humorist had taken over, the humorist who kidded nothing but himself."

Capp took a long look at his characters. "I became reacquainted with Li'l Abner as a human being, with Daisy Mae as an agonizingly frustrated girl. I began to wonder myself what it would be like if they were ever married. The more I thought about it, the more complicated and disastrous and, therefore, irresistible the idea became."

It would be the most second-guessed decision in comics history. Capp's hillbilly hero had resisted his sweetheart's marriage proposals for years. Many readers felt that Abner lost some of his masculine appeal after he sacrificed his independence. *Li'l Abner* continued to be one of the top features in the business, reaching a circulation peak of 900 newspapers in the 1960s, but Capp's most daring and creatively productive period was behind him.

On April 25, 1944, George Herriman died quietly in his sleep. A week of unfinished *Krazy Kat* strips remained on his drawing board. Many of the art form's pioneers had passed away before the war, including Richard F. Outcault (*The Yellow Kid*), Frederick Opper (*Happy Hooligan*), Winsor McCay (*Little Nemo in Slumberland*), and E. C. Segar (*Popeye*). A hardy group of early innovators—Rudolph Dirks (*The*

Captain and the Kids), George McManus (*Bringing Up Father*), Cliff Sterrett (*Polly and Her Pals*), and Jimmy Swinnerton (*Little Jimmy*)—continued to produce their features well into the postwar years.

Many of the comic masters who began their careers in the 1920s and 1930s were the top cartoonists in the business in the late 1940s. In addition to Caniff, Raymond, Crane, and Capp, Harold Gray (*Little Orphan Annie*), Chester Gould (*Dick Tracy*), Hal Foster (*Prince Valiant*), and Ernie Bushmiller (*Nancy*) produced some of their best work during this period.

The most successful comic strip in postwar America was Chic Young's *Blondie*. The *Saturday Evening Post* reported in 1948 that *Blondie* appeared in a total of 1,136 daily and Sunday papers in the United States and abroad, earning its creator an annual salary of $300,000. Young had developed a strict set of rules for his comic strip. Most of the action in *Blondie* was limited to the Bumstead home and Dagwood's office. Dialogue was kept to a minimum. Certain taboos were followed, including avoidance of physical infirmities, politics, religion, liquor, and other subject matter that might offend or confuse readers.

"I think everybody is a little tired," observed Young in the *Post* article. He had discovered that *Blondie* readers experienced vicarious pleasure from observing Dagwood coping with his fatigue by eating, sleeping, or soaking in the bathtub. They saw their own lives reflected in the struggles of this common man. Strong reader identification with popular

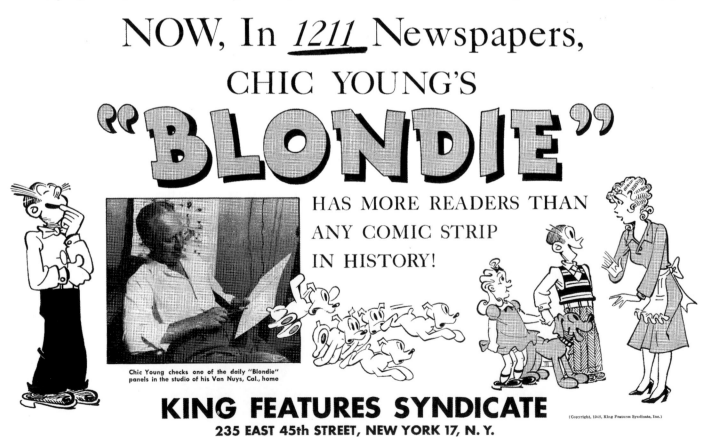

BEST SELLER—BLONDIE sales advertisement. © 1948 King Features Syndicate, Inc. Courtesy of Richard Marschall

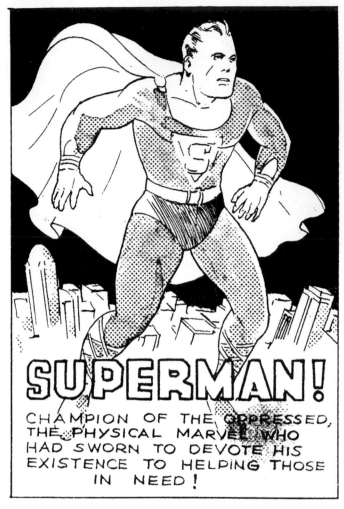

AMERICAN HERO—SUPERMAN by Jerry Siegel and Joe Shuster. c. 1930s.
Panel from the first daily strip submission. © Superman™ and © DC Comics. All rights
reserved. Used with permission

characters was the bedrock upon which all modern humor
strips would be built.

In 1934 two teenagers from Cleveland, writer Jerry Siegel
and artist Joe Shuster, began submitting an idea for a comic
strip about a costumed superhero to all of the major newspaper
syndicates. It was turned down by everyone. United Feature
Syndicate called it "a rather immature piece of work" in a
rejection letter. In 1937 Max Gaines of the McClure Syndicate
showed the rejected strips to comic-book publisher Harry
Donenfeld, who asked Siegel and Shuster to develop the strip
idea into a thirteen-page comic-book story. *Superman* debuted
in *Action Comics* no. 1, dated June 1938, and within a year
Donenfeld's DC Comics was publishing 900,000 copies of its
new hit comic book. The McClure Syndicate capitalized on
this success by releasing a *Superman* daily comic strip on January
16, 1939, and two years later *Superman* was appearing in 300
daily and 90 Sunday newspapers. The first incarnation of the
Superman strip survived for twenty-seven years until it was
canceled due to lagging sales in 1966. McClure also adapted
another DC property, *Batman and Robin*, to the comic-strip
format in 1943, but that version lasted only until 1946.

The comic-book industry flourished during the war years
with the most popular titles selling over a million copies each
month. Newspapers and syndicates were becoming increasingly
worried that competition from the new medium would
adversely affect the sales of the Sunday funnies. Will Eisner,
who ran an independent "shop" that produced art and stories
for comic-book publishers, came up with a unique solution.
In 1940 Eisner created a weekly, sixteen-page comic-book
insert that was distributed to newspapers by the Register
and Tribune Syndicate. The star of Eisner's creation was
The Spirit, a masked detective, believed to be dead, who
stalked the rain-drenched alleyways of Central City. A daily
comic-strip version of *The Spirit* had a brief run, from 1941
to 1944, but his newspaper comic-book adventures lasted
until 1952.

During the 1940s comic-book publishers faced increasing
pressure from civic groups that objected to the violent and
unwholesome content of certain titles. The newspaper syndicates
were careful to distance themselves from this controversy. A
representative from King Features, in a 1948 article in *Editor and
Publisher*, described the strict taboos the syndicate applied to its
comic features: "No blood, no torture, no horror, no controver-
sial subjects such as religion, politics, and race. Above all, is the
important matter of good taste. The comics must be clean."

The term "teenager" appeared in *Popular Science* magazine
in 1941. Music, movies, clothing, and advertising were marketed
to this emerging demographic group as teenage culture, from
jalopies to jukeboxes, spread through middle-class America. In
1941 Bob Montana created a red-haired, freckle-faced teenager
named Archie Andrews, who made his debut in *Pep Comics*
no. 22. After the war, Archie, Jughead, Betty, and Veronica
starred in their own newspaper comic strip, which was pro-
duced by Montana from 1946 to 1975. *Penny*, *Bobby Sox*, and
Teena were among the numerous teen-oriented comic features
that got their start during the decade.

After the war, aviation remained the most popular profes-
sion in the comics. Terry Lee, Steve Canyon, Johnny Hazard,
and Buz Sawyer were among the flyboys who dominated the
adventure-strip genre. Other occupations also began to emerge
as inspiration for continuity features. Rip Kirby and Kerry
Drake were private investigators. Brenda Starr and Steve
Roper were newspaper reporters. Ozark Ike was a baseball
player. Rex Morgan became the most famous medical doctor
on the funnies pages.

The "soap-opera strip," patterned after the popular radio
serials of the 1930s and 1940s, developed into a clearly defined
genre when Apple Mary, who was created by Martha Orr in
1934, was transformed into Mary Worth by writer Allen
Saunders and artist Ken Ernst in 1942. Mary abandoned her
Depression-era, street-corner, social-worker persona and became
a modern-day therapist who used grandmotherly wisdom to

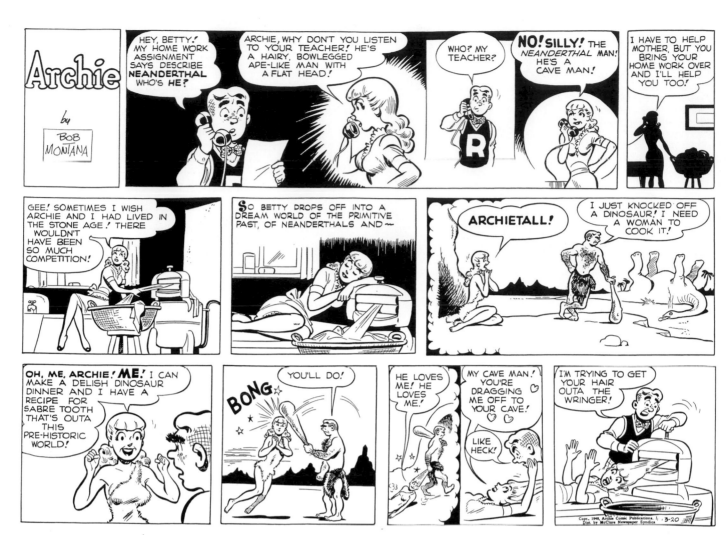

TEEN TOON—ARCHIE Sunday page by Bob Montana. © 3/20/49 Creators Syndicate, Inc. Courtesy of International Museum of Cartoon Art

solve the romantic problems of the rich and famous. During the postwar period she expanded her horizons and counseled combat veterans and newlywed couples. In the next decade, the soap-opera genre would continue to become increasingly sophisticated.

One of the most admired comic strips of the era was Crockett Johnson's *Barnaby*, which debuted in the liberal New York tabloid, *PM*, on April 20, 1942. Although his strip appeared in only fifty-two papers at its peak and lasted less than ten years, it was collected in book form and praised by writers, artists, and intellectuals. In the 1950s Johnson created a similar character, Harold, who drew an imaginary world with a purple crayon and starred in a series of seven classic children's stories.

Barnaby was a bright young boy who conversed freely with his bumbling fairy godfather, Mr. O'Malley. Barnaby's parents doubted the existence of this mysterious friend, who was invisible to everyone except Barnaby, his talking dog Gorgon, and the reader.

Johnson drew in a flat, economical style with a fixed perspective. The dialogue was set in type, to accommodate the extended conversations between Barnaby and O'Malley. Weary of daily deadlines, Johnson turned the production over to Ted Ferro and Jack Morley in 1946 but continued to be creatively involved until the strip ended on February 2, 1952.

In the final episode, O'Malley wished his friend a happy sixth birthday and then flew off into the starry heavens. Comic-strip continuities rarely had this type of closure.

Walt Kelly's Pogo, "a possum by trade," first appeared in *Animal Comics* in 1942 and, beginning in 1946, starred in his own comic book with his trusty sidekick Albert the Alligator. In June 1948 Kelly was hired as art director for the *New York Star*, a reincarnation of *PM*. In addition to drawing political cartoons, Kelly created a *Pogo* comic strip, which debuted in the *Star* on October 4, 1948. After the *Star* folded in 1949, *Pogo* was distributed by The Hall Syndicate.

By 1951 *Pogo* had evolved into a graphic tour de force that combined satire, caricature, slapstick, and whimsy. After only two years of syndication, the strip appeared in 100 newspapers and earned its creator an annual salary of $50,000. Kelly won the Reuben Award as the "outstanding cartoonist of the year" in 1951.

The accolades, particularly from the intelligentsia, were also piling up. Kelly never thought of himself as an intellectual. "If the high-brows find satire in my stuff, that's fine," he said in 1952. "The best I can say for myself is that I'm a high-brow low-brow. Kids and bartenders get as much bang out of *Pogo* as college professors."

Trained as an animation artist at the Walt Disney Studio,

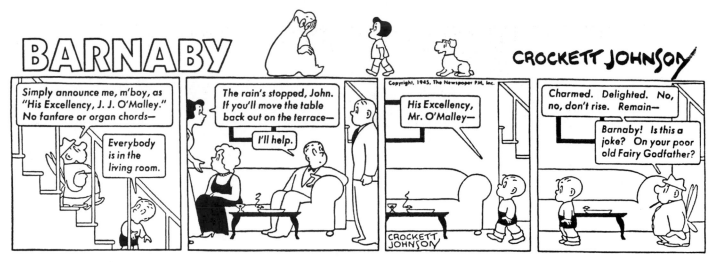

BARNABY

CROCKETT JOHNSON

Panel 1: Simply announce me, m'boy, as "His Excellency, J. J. O'Malley." No fanfare or organ chords— / Everybody is in the living room.

Panel 2: The rain's stopped, John. If you'll move the table back out on the terrace— / I'll help.

Copyright, 1945, The Newspaper PM, Inc.

Panel 3: His Excellency, Mr. O'Malley—

Panel 4: Charmed. Delighted. No, no, don't rise. Remain— / Barnaby! Is this a joke? On your poor old Fairy Godfather?

SMART STRIP—BARNABY daily strip by Crockett Johnson. © 1945 The Newspaper PM, Inc.

Kelly filled *Pogo*'s Okefenokee Swamp with masterfully rendered flora and fauna. The colorful cast, which included Churchy LaFemme, Howland Owl, Porky Pine, Mam'selle Hepzibah, Beauregard, Pogo, and Albert, spoke in a unique blend of patois, puns, and prattle. Deacon Muskrat pontificated in Old English script and P. T. Bridgeport's balloons displayed circus-poster lettering. *Pogo* was brimming with inspired lunacy.

In 1952 Pogo ran for president against Dwight Eisenhower and Adlai Stevenson, and "I Go Pogo" rallies were held on college campuses across the country. Kelly gained national notoriety for his political satire and devastating caricatures of such public figures as Sen. Joseph McCarthy (Simple J. Malarky), Richard Nixon (Sam the Spider), and George Wallace (Prince Pompadoodle). He was also adept at social comment ("We have met the enemy and he is us") and cosmic musings ("God is not dead, He is merely unemployed").

Pogo strips were reprinted in thirty-two books, published by Simon & Schuster between 1951 and 1976, which sold an estimated 3 to 4 million copies. At its peak, *Pogo* ran in more than 600 newspapers. A modest amount of licensed adaptations were also produced, including a record album, *Songs of the Pogo* (1956), on which Kelly sang, and an animated cartoon, *The Pogo Birthday Special* (1969), directed by Chuck Jones.

Walt Kelly passed away in 1973 at the relatively tender age of sixty, but his legacy and influence live on. In 1989 Bill Watterson, the creator of *Calvin and Hobbes*, stated, "Although *Pogo* ended years before I ever had a drawing published, Kelly gave me a standard to apply to myself and cartooning as a whole."

Cartoonists are independent by nature, and sporadic attempts at forming a professional organization before the war met with failure. In 1927 Walt McDougall, Winsor McCay, Rube Goldberg, Clare Briggs, Harry Hershfield, and a host of other New York celebrities were among the guests at the first gathering of the Cartoonists of America. It was also the last. Another attempt to establish a cartoonist club in the early 1930s survived less than a year.

During World War II many of the top artists were called upon to travel around the country and entertain the troops. On one of these tours, a group that included Ernie Bushmiller, Gus Edson, Russell Patterson, Otto Soglow, and Rube Goldberg discussed the idea of forming a permanent organization after the war was over.

Goldberg was talked into taking a leadership role, and on February 20, 1946, he sent out a letter on behalf of the founders: "We got the idea it might be a very natural thing to have a cartoonists' club or society. Your name has been selected to join a group to sit down at dinner to make some

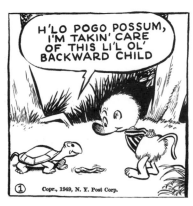
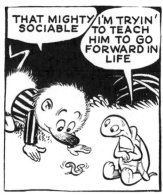
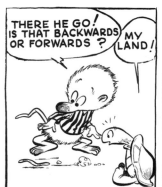

Panel 1: H'LO POGO POSSUM, I'M TAKIN' CARE OF THIS LI'L OL' BACKWARD CHILD / *Copr., 1949, N. Y. Post Corp.*

Panel 2: THAT MIGHTY SOCIABLE / I'M TRYIN' TO TEACH HIM TO GO FORWARD IN LIFE

Panel 3: THERE HE GO! IS THAT BACKWARDS OR FORWARDS? / MY LAND!

Panel 4: WAIT—WAIT! WHICH WAY IS YOU POINTIN'? / IT HARD TO FIGURE THE ANGLES ON A WORM CHILD

NEWSPAPER DEBUT—The first POGO strip by Walt Kelly. © 1949 Used by permission of Okefenokee Glee & Perloo, Inc. Courtesy of Craig Yoe

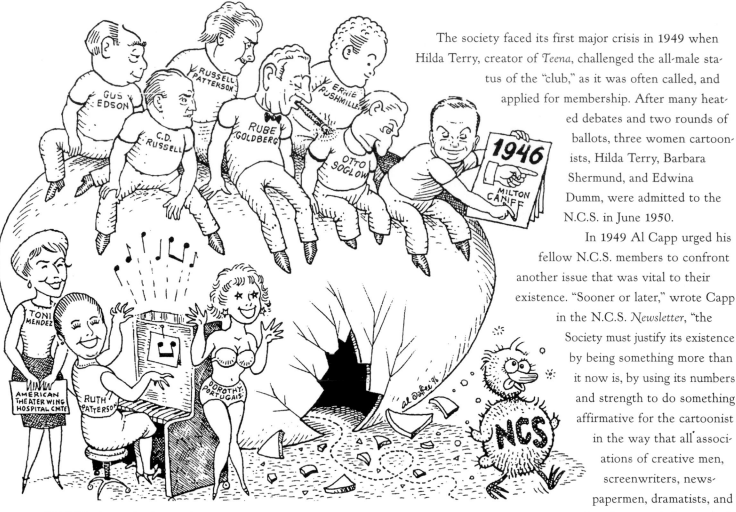

THE CLUB—Illustration for the 50th anniversary of the National Cartoonist Society, by Al Jaffee, 1996

The society faced its first major crisis in 1949 when Hilda Terry, creator of *Teena*, challenged the all-male status of the "club," as it was often called, and applied for membership. After many heated debates and two rounds of ballots, three women cartoonists, Hilda Terry, Barbara Shermund, and Edwina Dumm, were admitted to the N.C.S. in June 1950.

In 1949 Al Capp urged his fellow N.C.S. members to confront another issue that was vital to their existence. "Sooner or later," wrote Capp in the N.C.S. *Newsletter*, "the Society must justify its existence by being something more than it now is, by using its numbers and strength to do something affirmative for the cartoonist in the way that all associations of creative men, screenwriters, newspapermen, dramatists, and authors have made better and sounder the relationship between the artist and his business management."

Capp was proposing that the N.C.S. become a trade union and use its influence to challenge the archaic "work-for-hire" contracts the syndicates forced on eager cartoonists. Under the existing system, a newspaper syndicate owned the copyright to a cartoonist's feature. The creator could be fired at any time and replaced by another artist who would continue the strip, with the original characters, under the supervision of the syndicate.

The N.C.S. established a committee to investigate the feasibility of Capp's proposal. It eventually decided that the society could not realistically become a trade union because it did not have the clout to shut down the comics business by going on strike. Defeated, Capp curtailed his activities in the N.C.S.

Milton Caniff struck a blow for creative freedom when he secured the ownership of *Steve Canyon*. Al Capp and Walt Kelly also negotiated the copyrights to their features. But the majority of cartoonists had virtually no legal claim to what they created. This issue would continue to pose a challenge to cartoonists in the coming years.

plans—select a name, determine the dues, elect officers, and other such nonsense."

The inaugural meeting of the Cartoonists Society (the "National" was added later) was on Friday, March 1, 1946, in the Bayberry Room on East 52nd Street in Manhattan. The twenty-six cartoonists in attendance elected Goldberg president, Russell Patterson vice president, C. D. Russell secretary, and Milt Caniff treasurer.

When the N.C.S. gathered to celebrate its first anniversary in March 1947, it had 112 members. A few months later, the society presented its first award for "outstanding cartoonist of the year" to Milt Caniff. The trophy, a silver cigarette box engraved with the cast of *Barney Google and Snuffy Smith*, was named "The Billy DeBeck Memorial Award" after that strip's creator. Caniff had just quit smoking. The "Barney," as it came to be known, was replaced by the "Reuben," named after the society's first president, in 1953.

As the N.C.S. continued to grow, it became more than just a social organization. In 1948 members participated in the U.S. Treasury Bond Drive, a traveling exhibition of cartoon art, and a tour of veterans' hospitals. Milt Caniff served as president from 1948 to 1950 and was instrumental in guiding the N.C.S. during its formative years.

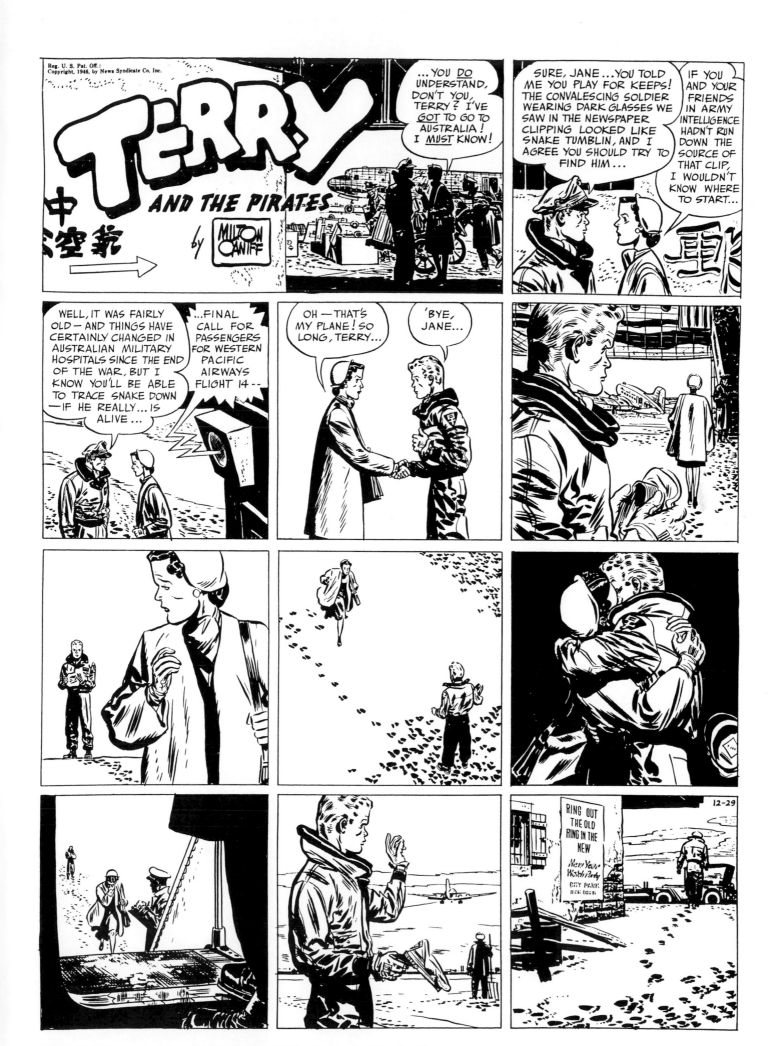

RING OUT THE OLD—*The last TERRY AND THE PIRATES Sunday page by Milton Caniff.* © 12/29/46 Tribune Media Services, Inc. All rights reserved. Reprinted with permission.
Courtesy of the Milton Caniff Collection, The Ohio State University Cartoon Research Library

milton caniff

THE "REMBRANDT of the comic strip," Milton Caniff created two masterpieces of graphic adventure, *Terry and the Pirates* in 1934 and *Steve Canyon* in 1947. Caniff's richly woven plots, memorable characters, distinctive dialogue, and exotic settings earned him the reputation as one of the greatest storytellers ever to work in the comics medium. His artistry influenced a generation of illustrators and revolutionized the adventure-strip genre. A founder of the National Cartoonists Society, Caniff was recognized as the "outstanding cartoonist of the year" in 1946 and 1971.

In the mid-1930s, Caniff shared a studio in Manhattan with Noel Sickles, a boyhood friend from Ohio. The young cartoonists collaborated closely on their two features, *Terry and the Pirates* and *Scorchy Smith*. Sickles began

STEVE CANYON by Milton Caniff, c. 1947

experimenting with a new technique, in which he rendered shadows and shapes with broad areas of black applied with a brush. Caniff borrowed Sickles's innovation and made it his own. He discovered he could maintain the realism in his adventure strip by indicating forms with impressionistic brush strokes, rather than inking in details with a pen. The method also saved time. An avid film buff, Caniff emulated the work of the movie directors he admired. He became a master at atmospheric lighting effects and dramatic perspective, using close-ups, long shots, and continuous tracking sequences.

When Caniff launched *Steve Canyon* in 1947, he was one of the most imitated artists in the comics business. He was also under tremendous pressure to do something different with his new feature, while not disappointing the fans who had been following *Terry and the Pirates* for twelve years. During the formative years of *Steve Canyon*, Caniff applied his creative talents to developing strong characters, fast-paced story lines, and realistically rendered scenes.

Dangerous and alluring women, such as the Dragon Lady, Burma, and April Kane, had been essential to the chemistry of *Terry and the Pirates*. Caniff continued to blend romance and adventure in *Steve Canyon*. Feeta-Feeta, Copper Calhoon, Delta, and Madame Lynx were among the seductive temptresses he introduced between 1947 and 1950.

When the Korean War escalated in 1951, Steve Canyon reenlisted in the Air Force and eventually rose to the rank of full colonel. The plots of Caniff's feature increasingly dealt with military intrigue, as Canyon was assigned to undercover operations around the world.

In 1953 Caniff hired Richard Rockwell, the nephew of Norman Rockwell, to pencil *Steve Canyon*. Penciling is regarded by most cartoonists as the crucial step in the production process and is therefore the last responsibility a creator is willing to relinquish to an assistant. Caniff felt that he could maintain his signature style more effectively by doing the final inking. Rockwell worked as Caniff's assistant until the strip ended in 1988.

The circulation of *Steve Canyon* reached a peak of 600 papers in the late 1950s but began declining in the 1960s and 1970s, a victim of size reduction and anti-military sentiment during the Vietnam War. Milton Caniff worked right up until his death in 1988, remaining a significant force in the cartoon business for more than half a century.

SELF-CARICATURE by Milton Caniff

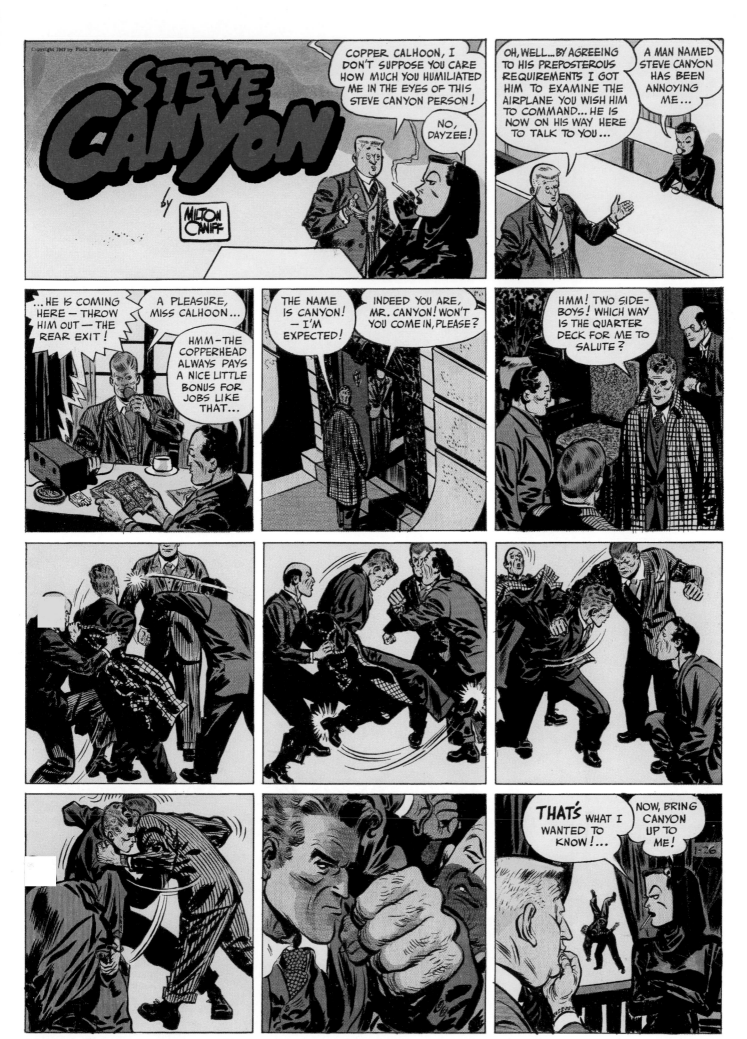

STEVE CANYON Sunday page by Milton Caniff. © 1/26/47

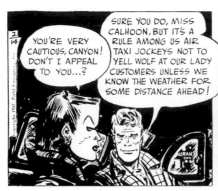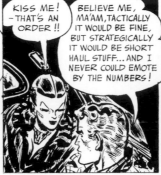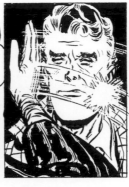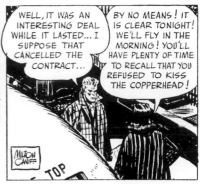

STEVE CANYON daily-strip sequence by Milton Caniff © 2/14–2/18/47

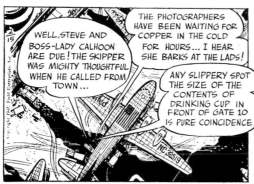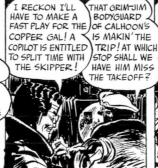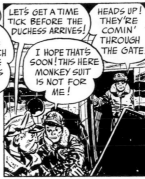

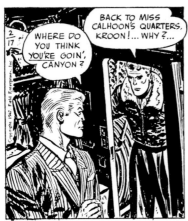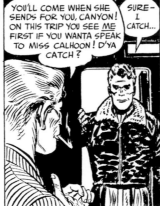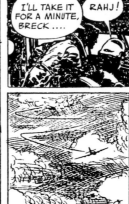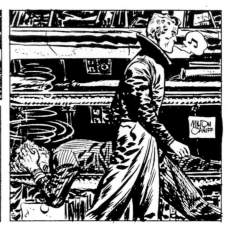

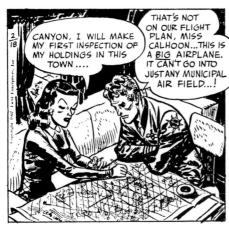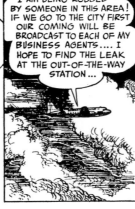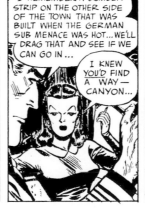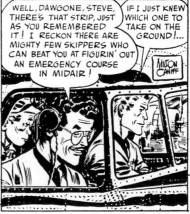

HIGH PRAISE Sylvan Byck, the comics editor of King Features Syndicate, wrote the following note to Caniff about the sequence above: "Frank Engli [Caniff's assistant at the time] just brought in the latest set of dailies. When I finished reading them, I felt that I had to write and tell you how wonderful they are. If this is not the best week of comic strips you have ever drawn, it certainly is a mighty strong challenger for the title." (Courtesy of R. C. Harvey)

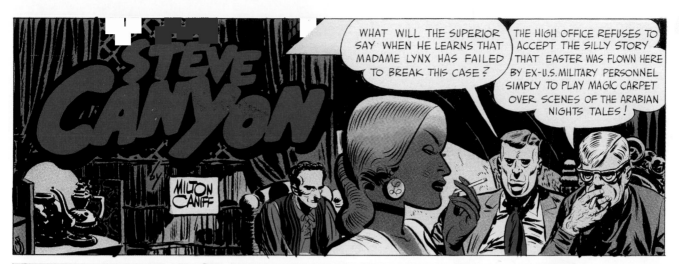

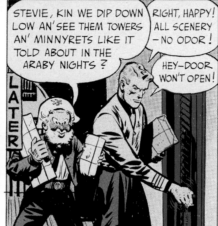

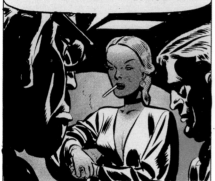

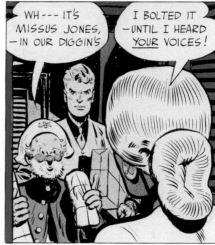

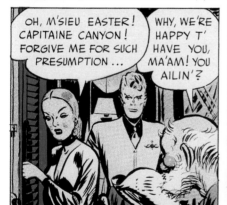

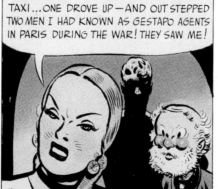

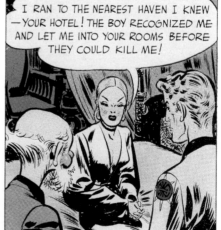

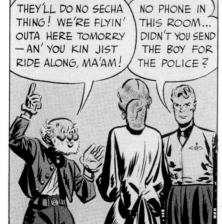

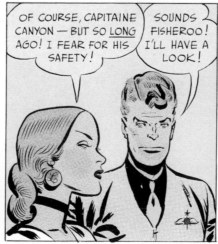

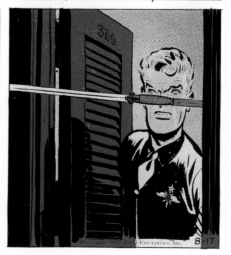

STEVE CANYON *Sunday page by Milton Caniff* © 8/17/47

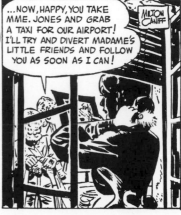

STEVE CANYON daily-strip sequence by Milton Caniff © 8/18–8/21/47

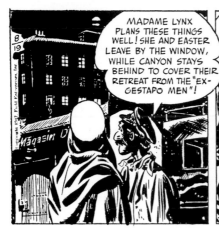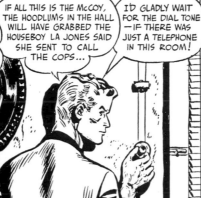

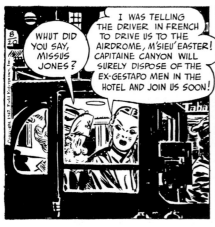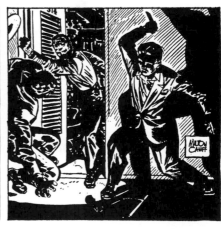

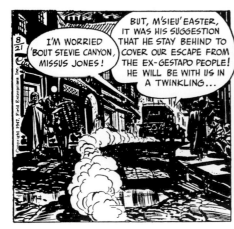

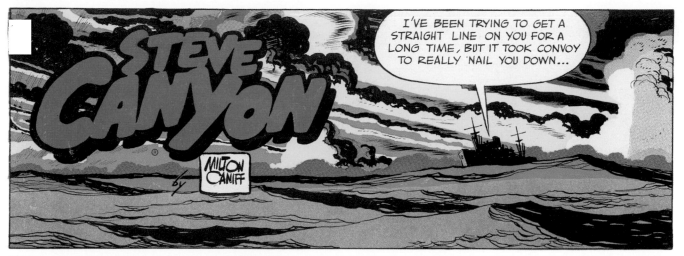

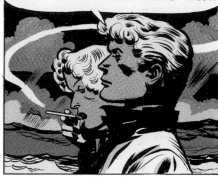

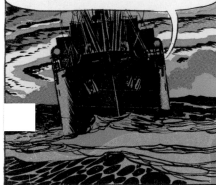

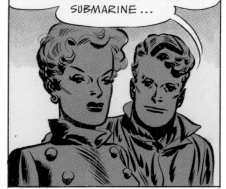

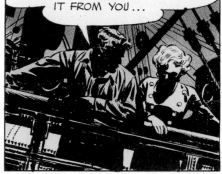

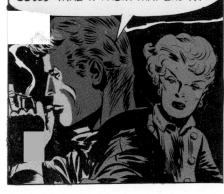

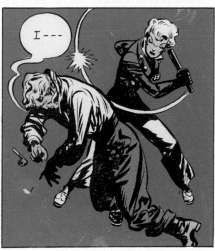

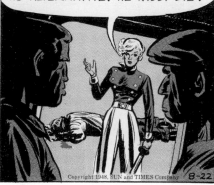

STEVE CANYON Sunday page by Milton Caniff. © 8/22/48

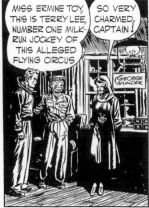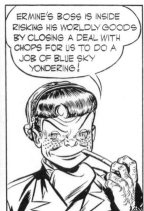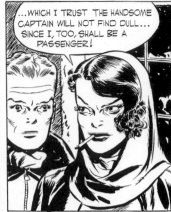

TERRY AND THE PIRATES daily strip by George Wunder. © 12/31/46 Tribune Media Services, Inc. All rights reserved. Reprinted with permission. Courtesy of William Crouch

THE CANIFF SCHOOL

The graphic techniques that Milton Caniff perfected in *Terry and the Pirates* and *Steve Canyon* influenced many of the story-strip artists of the post-war era. George Wunder was chosen as Caniff's successor on *Terry and the Pirates* (his second daily strip, from December 31, 1946, is shown above) and continued the feature until he retired in 1973. In the early years Wunder emulated Caniff's style closely, but he eventually developed a more distinctive look. Frank Robbins, who took over *Scorchy Smith* in 1939 and created his own adventure strip, *Johnny Hazard*, in 1944 (below), was a talented contemporary of Caniff's. Ray Bailey, who worked as Caniff's assistant on *Terry and the Pirates* in the early 1940s, launched another aviation adventure strip, *Bruce Gentry*, in 1945 (bottom).

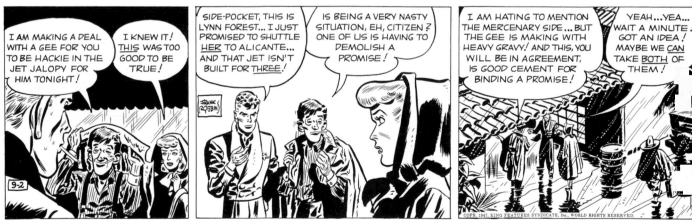

JOHNNY HAZARD daily strip by Frank Robbins. © 9/2/47 King Features Syndicate, Inc. Courtesy of International Museum of Cartoon Art

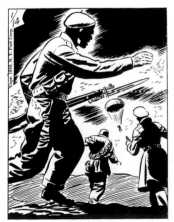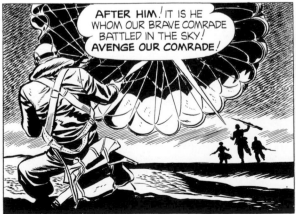

BRUCE GENTRY daily strip by Ray Bailey. © 1/14/48 New York Post Corp. Courtesy of International Museum of Cartoon Art

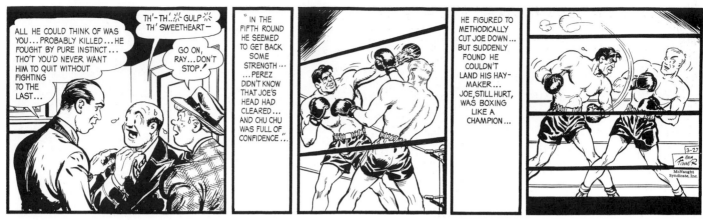

JOE PALOOKA daily strip by Ham Fisher, c. 1940s. © McNaught Syndicate, Inc. Courtesy of International Museum of Cartoon Art

SPORTS

One of the most popular comics of the 1940s was Ham Fisher's *Joe Palooka*, which appeared in more than 1,000 newspapers at its peak. Fisher created the naive prize-fighter in 1930 but employed numerous art assistants, including Phil Boyle, Al Capp, and Mo Leff, to illustrate the strip until his tragic suicide in 1955. Another sports-oriented feature of the era was Ray Gotto's *Ozark Ike*, which debuted in 1945 and dealt primarily with baseball stories, but switched to football and basketball continuities during the off-season.

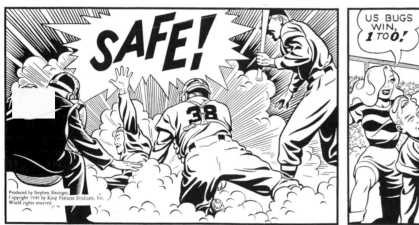
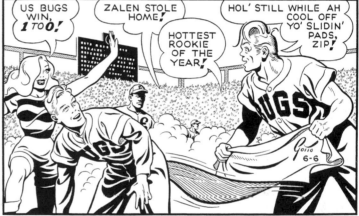

OZARK IKE daily strip by Ray Gotto. © 6/6/49 King Features Syndicate, Inc. Courtesy of International Museum of Cartoon Art

SOUTH OF THE BORDER

Gus Arriola's *Gordo* debuted thirteen days before Pearl Harbor, was put on hold in 1942 when Arriola joined the Air Force, resumed daily distribution in 1946, and continued until 1985. R. C. Harvey, Arriola's biographer, wrote that "Gordo evolved into a cultural ambassador who represented life in Mexico to an American audience." In 1948 Arriola was deluged with thousands of letters when he offered his readers the secret recipe to Gordo's favorite dish, beans and cheese (referred to in the strip below).

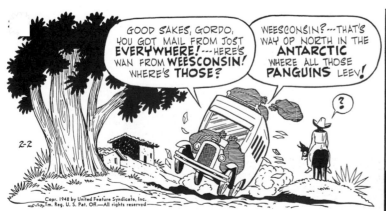
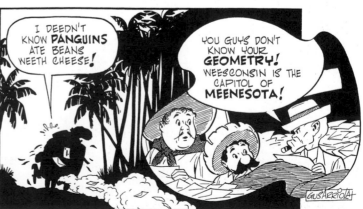

GORDO daily strip by Gus Arriola. © 2/2/48 by United Feature Syndicate, Inc. Courtesy of International Museum of Cartoon Art

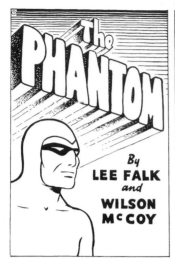
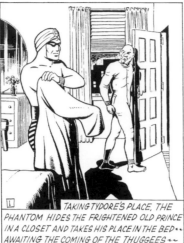
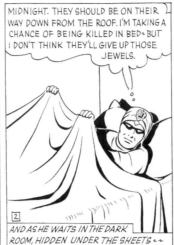
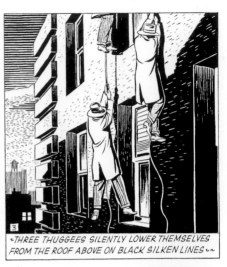

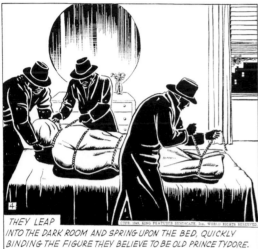
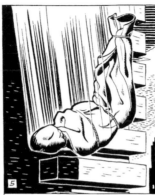

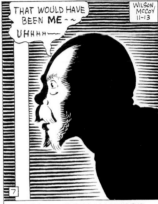

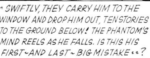

THE PHANTOM Sunday page by Lee Falk and Wilson McCoy. © 11/13/49 King Features Syndicate, Inc. Courtesy of International Museum of Cartoon Art

WORDSMITH Lee Falk created two long-running adventure strips in the 1930s and continued to write both features until he passed away in 1999. *Mandrake the Magician*, the mysterious crime-fighting illusionist, first appeared in 1934 and was illustrated by Phil Davis for thirty years, until Fred Fredericks took over in 1964. *The Phantom*, which starred one of the first costumed heroes, debuted in 1936 and was drawn in the 1940s by Wilson McCoy.

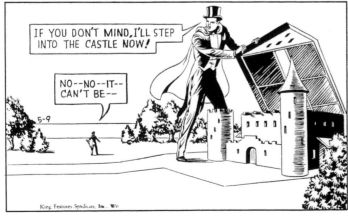

MANDRAKE THE MAGICIAN daily strip by Lee Falk and Phil Davis. © 5/9/1940s King Features Syndicate, Inc. Courtesy of International Museum of Cartoon Art

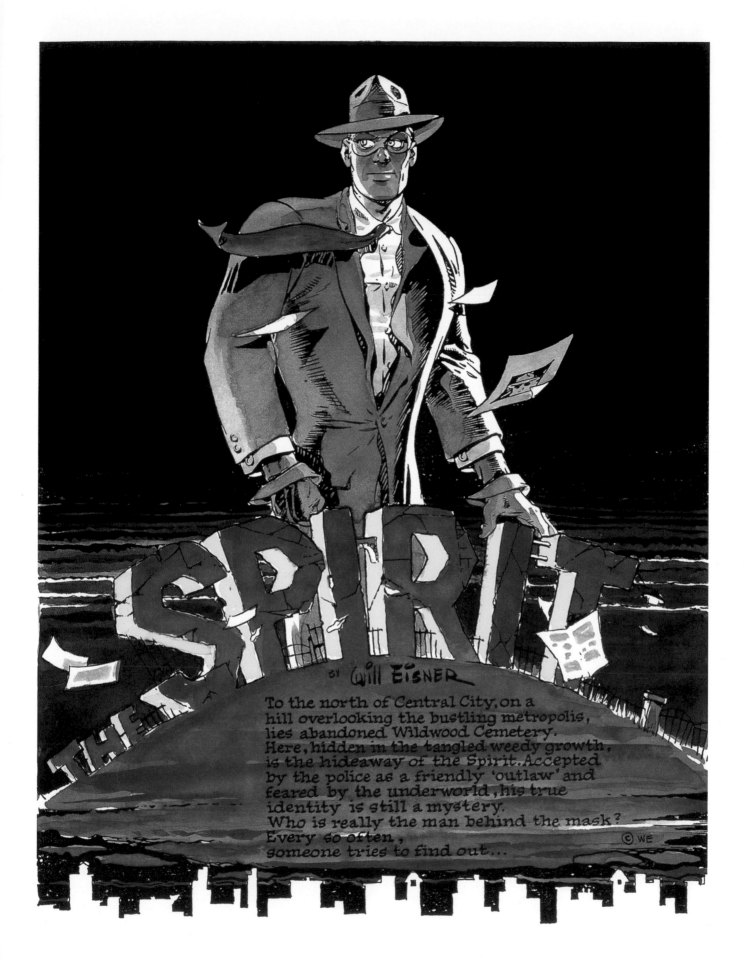

The text within the image reads:

THE SPIRIT
BY WILL EISNER

To the north of Central City, on a
hill overlooking the bustling metropolis,
lies abandoned Wildwood Cemetery.
Here, hidden in the tangled weedy growth,
is the hideaway of the Spirit. Accepted
by the police as a friendly 'outlaw' and
feared by the underworld, his true
identity is still a mystery.
Who is really the man behind the mask?
Every so often,
someone tries to find out...

© WE

THE SPIRIT splash page by Will Eisner. © 10/19/49 by Will Eisner. Courtesy of International Museum of Cartoon Art

WILL EISNER The Spirit, who starred in a sixteen-page newspaper comic-book insert beginning in 1940, was a gumshoe/flatfoot in the Sam Spade tradition. This dramatic splash page from 1949 recounts the background story of Eisner's masked crime fighter (a.k.a. Denny Colt).

DICK TRACY daily strip by Chester Gould. © 12/25/48

CHESTER GOULD

Dick Tracy, Chester Gould's classic plainclothes detective, started his battle against crime in 1931. Gould retired on Christmas Day, 1977, after forty-six years, two months, and twenty-one days of single-minded devotion to his creation. The postwar era was a significant transition period in Gould's artistic development. He introduced a lineup of unforgettable villains, showcased bold, black-and-white graphics in double-sized panels, and unraveled gripping stories filled with violence and pathos. In the 1950s Gould was forced to shrink the size of his art, and, graphically, the strip would never be the same as it was in the peak years of 1943 to 1950.

Shown on the next page are examples from two memorable sequences of Gould's postwar period. In the top two strips, from 1949, Dick Tracy and Tess are on their honeymoon and, after being stranded in a snowstorm, cross paths with Wormy Marron, a classic Gould villain (Wormy's demise is shown at the bottom of this page). In the bottom two strips, from 1950, Tracy valiantly tries to rescue his trusty sidekick, Junior, from his burning home.

 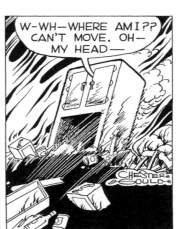

DICK TRACY daily strip by Chester Gould. © 1/27/47

 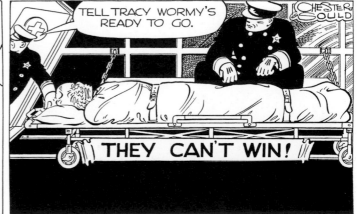

DICK TRACY daily strip by Chester Gould. © 3/25/50

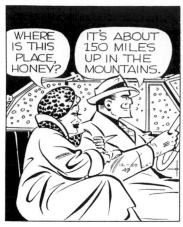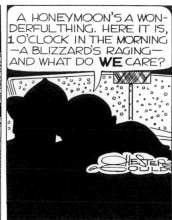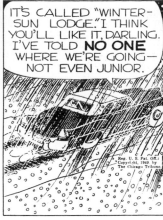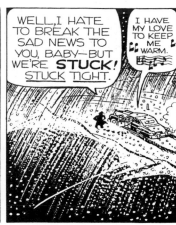

DICK TRACY daily strip by Chester Gould. © 12/29/49

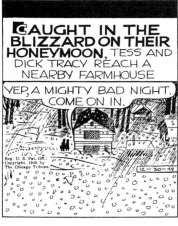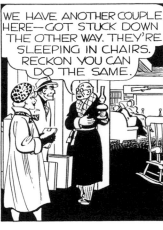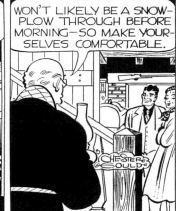

DICK TRACY daily strip by Chester Gould. © 12/30/49

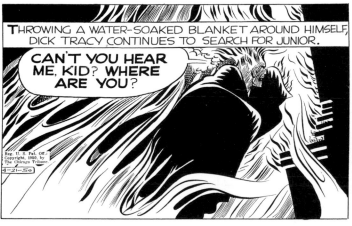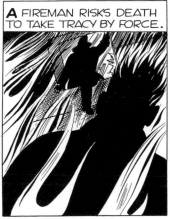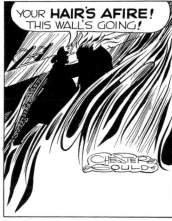

DICK TRACY daily strip by Chester Gould. © 4/21/50

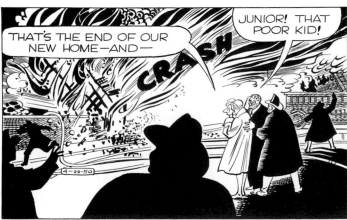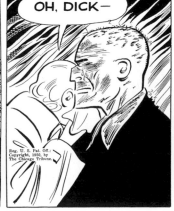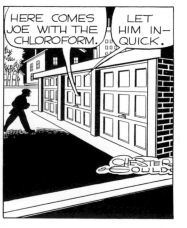

DICK TRACY daily strip by Chester Gould. © 4/22/50

CHAKA, POINTING TO THE SNAKE SYMBOL ABOUT TARZAN'S THROAT, SCREAMED THE DREAD CURSE OF THE DAGOMBAS AND COMMANDED THE SUPERSTITIOUS NATIVES TO ATTACK HIM.

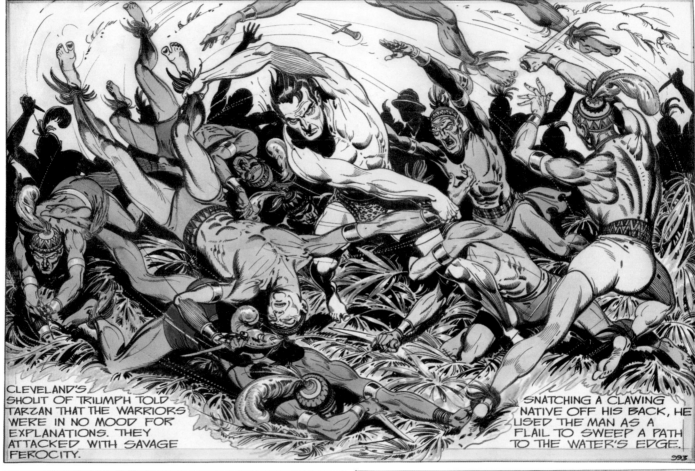

CLEVELAND'S SHOUT OF TRIUMPH TOLD TARZAN THAT THE WARRIORS WERE IN NO MOOD FOR EXPLANATIONS. THEY ATTACKED WITH SAVAGE FEROCITY.

SNATCHING A CLAWING NATIVE OFF HIS BACK, HE USED THE MAN AS A FLAIL TO SWEEP A PATH TO THE WATER'S EDGE.

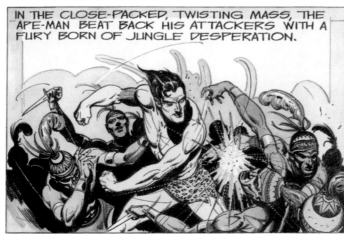

IN THE CLOSE-PACKED, TWISTING MASS, THE APE-MAN BEAT BACK HIS ATTACKERS WITH A FURY BORN OF JUNGLE DESPERATION.

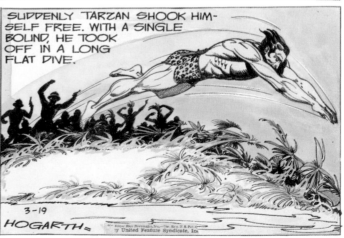

SUDDENLY TARZAN SHOOK HIMSELF FREE. WITH A SINGLE BOUND, HE TOOK OFF IN A LONG FLAT DIVE.

3-19

HOGARTH

BURNE HOGARTH This hand-colored Sunday page by Burne Hogarth is reportedly the last episode Tarzan's creator, Edgar Rice Burroughs, read before he passed away on March 19, 1950.

TARZAN Sunday page by Burne Hogarth. © 3/19/50 United Feature Syndicate, Inc. Courtesy of Ricardo Martinez

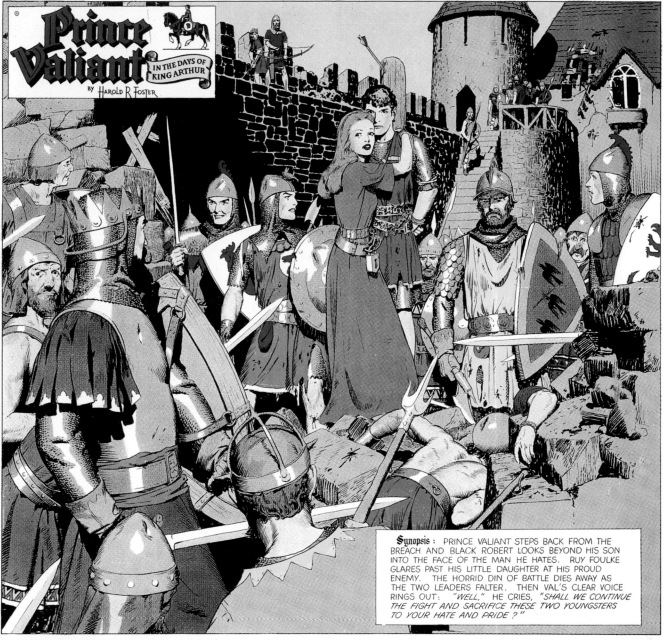

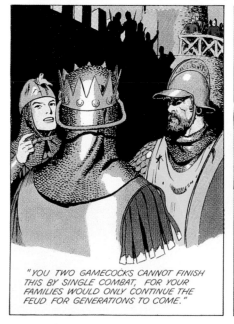

"YOU TWO GAMECOCKS CANNOT FINISH THIS BY SINGLE COMBAT, FOR YOUR FAMILIES WOULD ONLY CONTINUE THE FEUD FOR GENERATIONS TO COME."

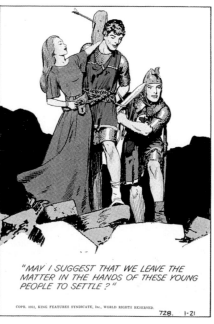

"MAY I SUGGEST THAT WE LEAVE THE MATTER IN THE HANDS OF THESE YOUNG PEOPLE TO SETTLE?"

COPR. 1951, KING FEATURES SYNDICATE, Inc., WORLD RIGHTS RESERVED. 728. 1-21

MANY A VERSE WAS WRITTEN AND MANY A SONG SUNG TO THE YOUNG, MAID WHO CHAINED HERSELF TO THE STAKE WITH HER LOVER.

THERE WERE ALSO SOME HUNDREDS OF WIDOWS AND ORPHANS WHO FAILED TO SEE ANYTHING ROMANTIC IN THE EVENT. BUT THEN, THEY HAD NO APPRECIATION OF POETRY!

NEXT WEEK– **Unwanted Peace**

HAL FOSTER A spectacular page from 1951 in which Prince Valiant intercedes in a dramatic face-off. Foster created the epic illustrated Sunday-only feature in 1937 and continued working on it until he officially retired in 1979.

PRINCE VALIANT Sunday page by Hal Foster. © 1/21/51 King Features
Syndicate, Inc. Courtesy of International Museum of Cartoon Art

ROY CRANE A pioneer of the adventure-strip genre, Roy Crane created *Wash Tubbs* in 1924, which he abandoned to launch *Buz Sawyer* in 1943. In the late 1940s Buz Sawyer married his longtime sweetheart, Christy Jameson, and the two set off on a series of globe-trotting adventures to Europe, Africa, and Latin America. Exotic scenery and dramatic composition, masterfully rendered with the duo-shade technique, were typical of *Buz Sawyer* during this period. These sequences were illustrated by Crane's assistant, Hank Schlensker, and scripted by Ed Granberry.

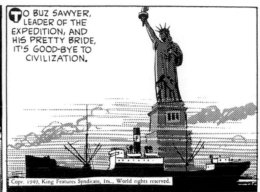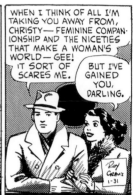

BUZ SAWYER daily strip by Roy Crane. © 1/31/49

All Buz Sawyer strips © King Features Syndicate, Inc.

BUZ SAWYER daily strip by Roy Crane. © 4/13/49

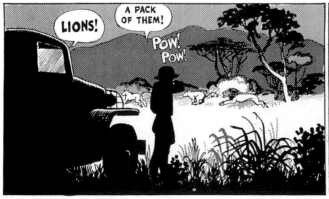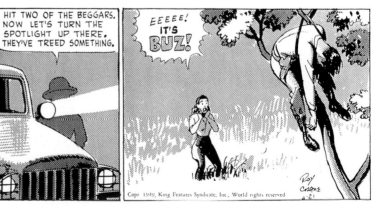

BUZ SAWYER daily strip by Roy Crane. © 4/21/49

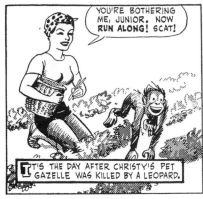
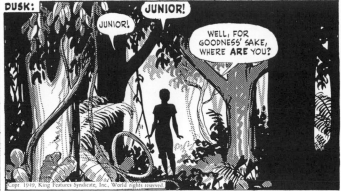
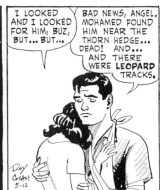

BUZ SAWYER daily strip by Roy Crane. © 5/12/49

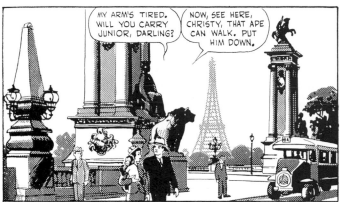
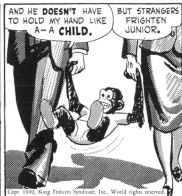
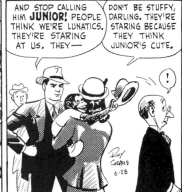

BUZ SAWYER daily strip by Roy Crane. © 6/28/49

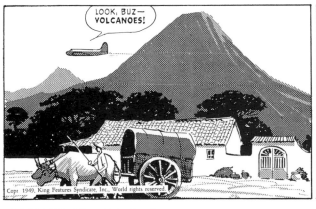

BUZ SAWYER daily strip by Roy Crane. © 9/23/49

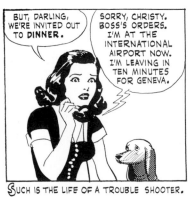
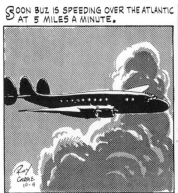
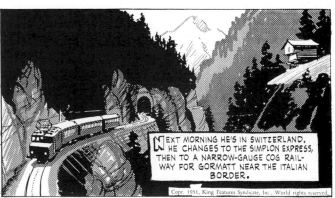

BUZ SAWYER daily strip by Roy Crane. © 10/4/51

LITTLE ORPHAN ANNIE *illustration by Harold Gray.* © 10/20/46. Courtesy of Richard Marschall

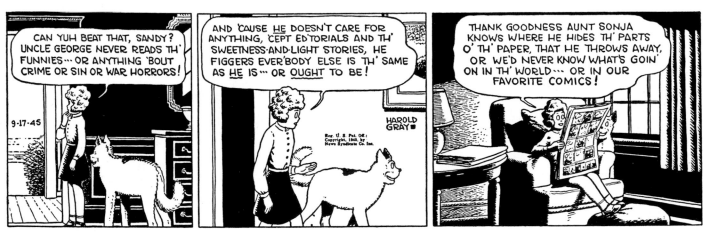

LITTLE ORPHAN ANNIE *daily strip by Harold Gray.* © 9/17/45

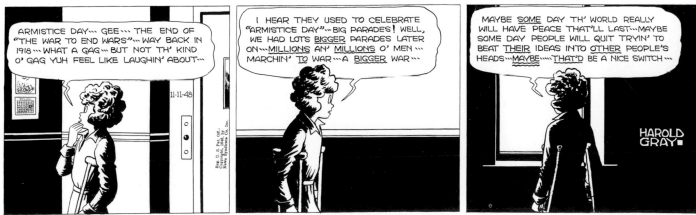

LITTLE ORPHAN ANNIE *daily strip by Harold Gray.* © 11/11/48. Courtesy of The Harold Gray Collection, Boston University

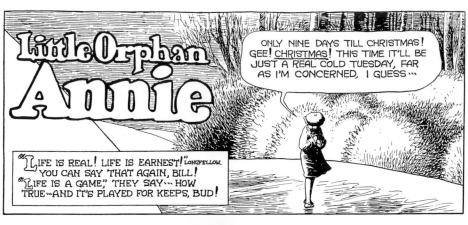
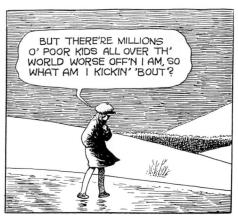
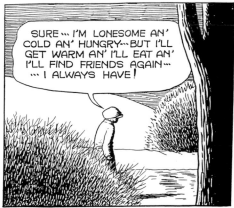
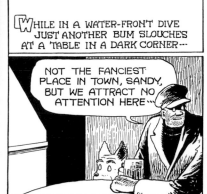
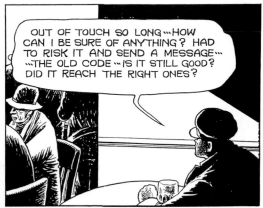

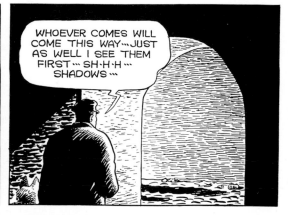
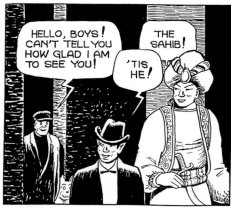
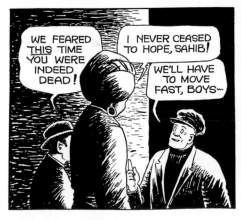
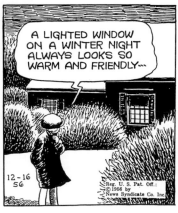
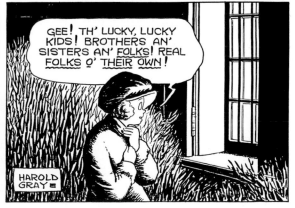

HAROLD GRAY *Little Orphan Annie* had been a fixture on the funnies pages for more than two decades when World War II ended in 1945. Throughout the Cold War era, the strip provided Gray with a platform to express his conservative views on politics, economics, and social injustice. Gray was also adept at sentimental digressions, as this seasonal Sunday page from 1956 demonstrates. Gray continued to produce his uniquely personal comic-strip fable until he died in 1968.

LITTLE ORPHAN ANNIE Sunday page by Harold Gray. © 12/16/56. *Courtesy of The Harold Gray Collection, Boston University*

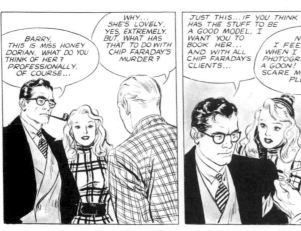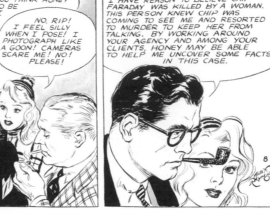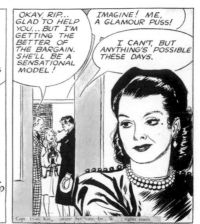

RIP KIRBY daily strip #8 by Alex Raymond. © 1946. Courtesy of Jack Gilbert
All Rip Kirby strips © King Features Syndicate, Inc.

ALEX RAYMOND

The illustrator of three classic adventure strips, *Secret Agent X-9*, *Flash Gordon*, and *Jungle Jim*, all of which made their debut in 1934, Alex Raymond distinguished himself in the postwar era as the creator of the cerebral detective feature *Rip Kirby*. From the beginning (the eighth episode from 1946 is shown above), the style of Raymond's new strip was influenced by the latest trends in magazine illustration. Glamorous women, realistically rendered settings, and understated action sequences complemented the scripts, which were written by Fred Dickenson. A decade after *Rip Kirby* was launched, Raymond was killed in an auto accident. His last signed strip, dated September 29, 1956, appears at the bottom of the next page.

SELF-CARICATURE by Alex Raymond

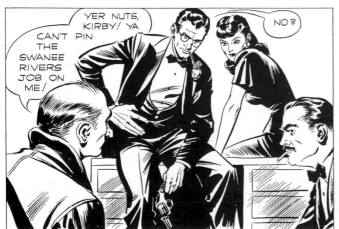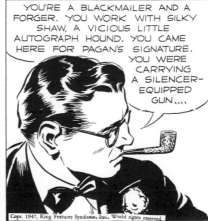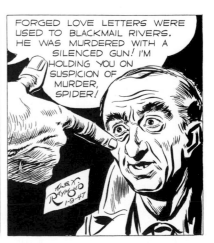

RIP KIRBY daily strip by Alex Raymond. (Note the self-caricature of Raymond in the right-hand corner of the first panel.) © 1/9/47. Courtesy of International Museum of Cartoon Art

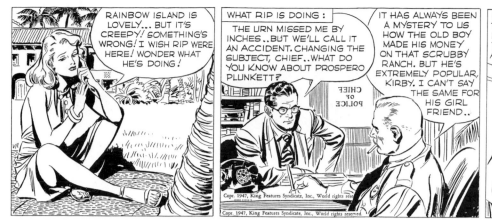

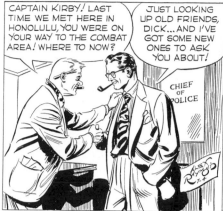

RIP KIRBY daily strip by Alex Raymond. © 7/4/47. *Courtesy of International Museum of Cartoon Art*

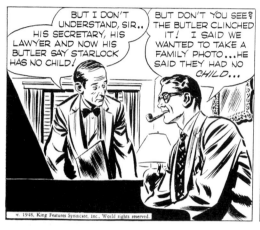

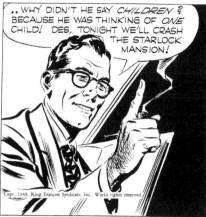

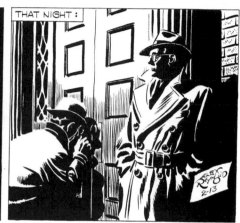

RIP KIRBY daily strip by Alex Raymond. © 2/13/48. *Courtesy of Art Wood Collection*

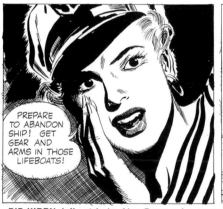

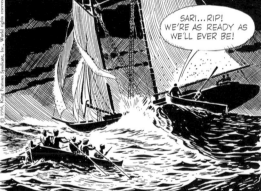

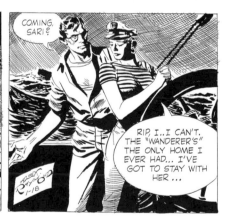

RIP KIRBY daily strip by Alex Raymond. © 1/18/56. *Courtesy of International Museum of Cartoon Art*

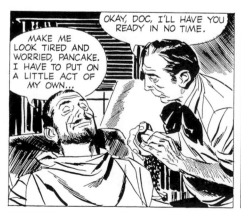

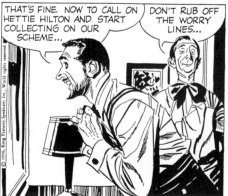

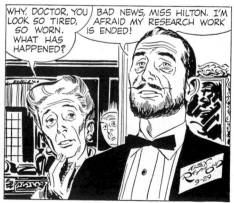

RIP KIRBY daily strip by Alex Raymond. © 9/29/56. *Courtesy of King Features Syndicate, Inc.*

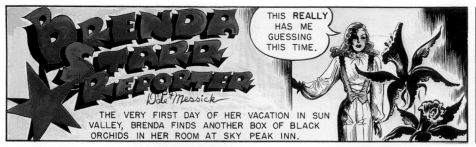

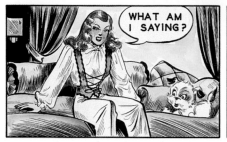
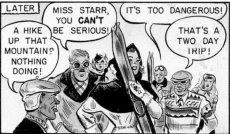
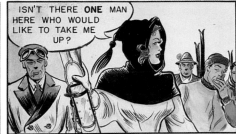
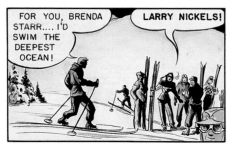
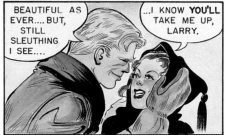

BRENDA STARR *Sunday page by Dale Messick.* © 12/30/45 Tribune Media Services, Inc. All rights reserved. Reprinted with permission. Courtesy of the Frye Art Museum, Seattle.

Photo credit: Susan Dirk/Under the Light

ROMANCE

Dale Messick, one of the first female cartoonists to succeed in the male-dominated story-strip genre, introduced the redheaded newspaper reporter Brenda Starr in 1940. For many years the romantic intrigue in Messick's strip revolved around the mysterious Basil St. John and his magical black orchids until Brenda and Basil were finally married in 1976. *Abbie an' Slats* (below), which was created by Al Capp in 1937 and written by his brother, Elliot Caplin, beginning in 1946, featured a blend of romance, adventure, and homespun humor. The long-running strip was ably illustrated by Raeburn Van Buren until 1971.

ABBIE AN' SLATS *daily strip by Raeburn Van Buren.* © 8/31/49 United Feature Syndicate, Inc. Courtesy of International Museum of Cartoon Art

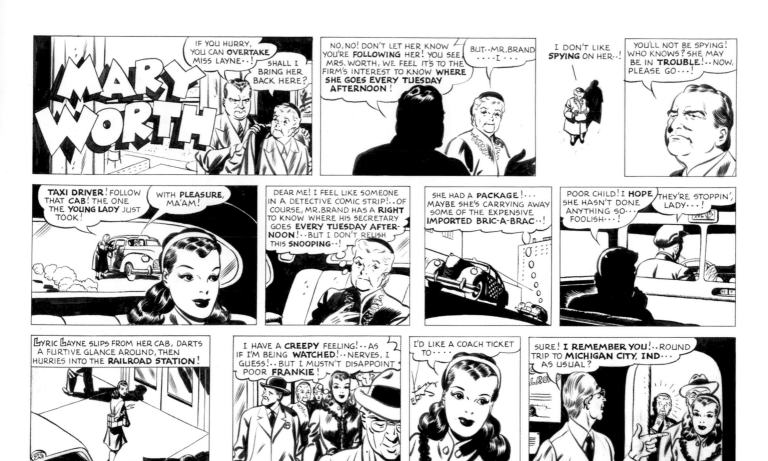

MARY WORTH Sunday page by Allen Saunders and Ken Ernst. © 3/25/45 King Features Syndicate, Inc. Courtesy of the Frye Art Museum, Seattle. Photo credit: Susan Dirk/Under the Light

SOAP OPERA

In 1939, when Allen Saunders took over the writing chores on Martha Orr's 1934 creation, *Apple Mary*, he decided to give the strip a contemporary makeover, as Mary became a counselor to the rich and famous. Ken Ernst came on board as the artist in 1942 and provided the perfect match to Saunders's sophisticated story lines. The strip was renamed *Mary Worth* in 1944 and established the definitive format for the emerging soap-opera genre. In 1948 Dr. Nicholas Dallis teamed up with artists Marvin Bradley and Frank Edginton to create *Rex Morgan M.D.* (below). The handsome, dark-haired medical doctor has been solving his patients' problems for more than half a century.

REX MORGAN M.D. daily strip by Dr. Nicholas Dallis, Marvin Bradley, and Frank Edginton. © 7/13/48 King Features Syndicate, Inc. Courtesy of International Museum of Cartoon Art

al capp

DOGPATCH U.S.A., Sadie Hawkins Day, Kickapoo Joy Juice, Shmoos, and Kigmies are among the lasting inspirations Al Capp contributed to American folklore. *Li'l Abner*, which debuted in 1934, was a direct reflection of Capp's colorful personality and provided him with a vehicle to lampoon the shortcomings of the human race. Social comment was only one of his tools, as he used suspense, slapstick, and characterization to establish *Li'l Abner* as one of the most consistently hilarious and wildly unpredictable strips in comics history.

Alfred Gerald Caplin was born in New Haven, Connecticut, in 1909 and lost his left leg when he was run over by a trolley car at the age of nine. This handicap was a source of ambition as well as insecurity for Capp throughout the rest of his life. "I wonder if it wasn't because of the wooden leg slowing me down, that I had patience to study art," he once said.

Capp first became interested in rural America during a trip he made to Tennessee when he was a teenager. In 1933, while working as the "ghost artist" on Ham Fisher's *Joe Palooka*, Capp introduced a hillbilly boxer named "Big Leviticus." Fisher later accused his former assistant of stealing the idea from him, but in truth, Capp had adapted his own creation when he came up with the idea for *Li'l Abner*.

In 1937 the first Sadie Hawkins Day took place in Dogpatch. The event, in which the unattached females chased the eligible bachelors, became an annual tradition at many college campuses across the country.

As Capp's style matured, he increasingly used a variety of visual techniques to maximize the strip's impact on the comics pages. Heavy black borders, bold lettering, and stylized speech balloons, as well as grotesque caricatures, exaggerated dialect, and voluptuous females, all served to grab the attention of newspaper readers.

SELF-CARICATURE by Al Capp

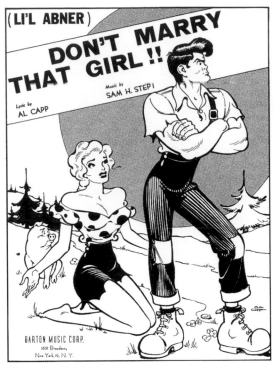

SHEET MUSIC 1946. *Courtesy of Kitchen Sink Press*

Capp hired his first assistant, Mo Leff, in 1935. Over the course of the next forty-two years, Capp employed many artists to help illustrate *Li'l Abner*, including Andy Amato, Harvey Curtis, Walter Johnson, Frank Frazetta, Lee Elias, Bob Lubbers, and Stan Drake. Although he remained creatively involved in the production of the strip, Capp kept up a busy schedule of extracurricular activities, pursuing stints as a columnist, lecturer, and television personality.

During the 1940s and 1950s, Capp ventured beyond Dogpatch and the adventures of the Yokum family, exploring a wide range of themes as his humor became more sardonic. Fearless Fosdick, a takeoff on Chester Gould's *Dick Tracy*, starred in a number of extended episodes. Creatures such as Shmoos, Kigmies, and the Bald Iggle exposed the selfishness and hypocrisy of human nature. Lower Slobbovia, a snowbound backwater populated with ignorant peasants, was an obvious Cold War dig at the Soviet Union. Capp's below-the-belt satire earned him the moniker of the "outhouse Voltaire" from one critic.

In the 1960s Capp began attacking liberals and college protesters with the same vehemence that he had directed toward conservatives in the previous decades. "My politics didn't change," he claimed. "I had always been for those who were despised, disgraced, and denounced by other people."

When *Li'l Abner* ended in 1977, the circulation of the strip had dropped from a peak of 900 papers to 300. Capp died two years later.

LI'L ABNER daily strip by Al Capp (the residents of Dogpatch). © 9/19/47. Courtesy of Howard Lowery Gallery

LI'L ABNER daily strip by Al Capp (Fearless Fosdick was a recurring spoof of Dick Tracy). © 3/18/48. Courtesy of Bruce Hamilton

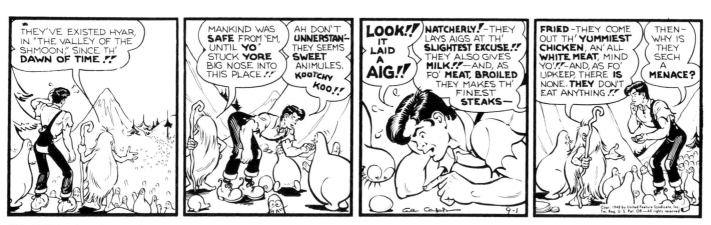

LI'L ABNER daily strip by Al Capp (the legend of the Shmoo). © 9/1/48. Courtesy of Howard Lowery Gallery

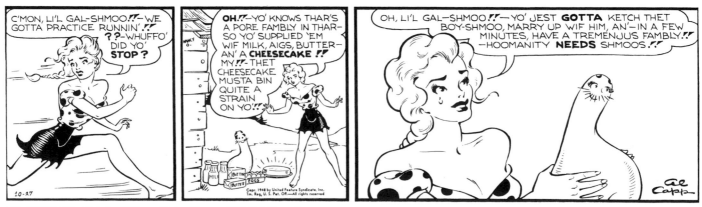

LI'L ABNER daily strip by Al Capp (Daisy Mae and Li'l Gal Shmoo). © 10/27/48. Courtesy of Russ Cochran

 

LI'L ABNER
by
AL CAPP

AW!! TURN ON TH' **FIGHTS!!**

NAW—LET'S KEEP WATCHIN' **"THIS IS YOUR WIFE"**. TH' WAY IT'S GOIN', IT MIGHT END UP IN A MUCH BETTER FIGHT!!

—AND, NOW, WE'LL GO ON WITH THE **BOOK OF YOUR WIFE'S LIFE!!**— IT'S 1903—AND HERE'S YOUR **WEDDING PICTURE!!**—

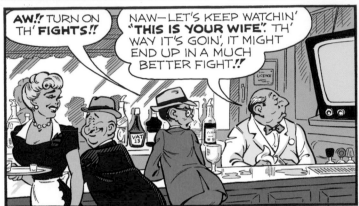

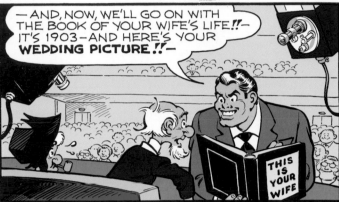

Tm. Reg. U. S. Pat. Off.—All rights reserved Copr. 1954 by United Feature Syndicate, Inc.

CHUCKLE!! — THASS PANSY, UNDER TH' TURNIP SACK. SHE WERE TH' WINNER O' TH' "MISS TURNIP" CONTEST—AN' **AH** WERE TH' GRAND PRIZE!!

IT WAS ONLY WHEN THEY TOOK TH' SACK OFF, THET AH REELIZED **WHO** AH'D MARRIED!!

HMMM— SAY, PANSY!!

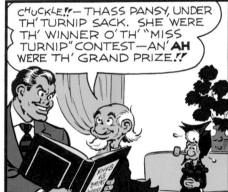

AH BIN MEANIN' T'AX YO', FO' 50 Y'ARS—HOW **DID** YO' WIN THET CONTEST?

ER—*B*LUSH!!— SAME WAY **ANY** GAL WINS A BOOTY CONTEST!!

OH, NO!!—NOT **QUITE** THE SAME WAY, MRS. YOKUM!!—HERE'S A PICTURE TAKEN OF **THAT** CONTEST!!—

YO' DONE **ROONT** TH' **BOOTY** O' ALL T' OTHER CONTESTANTS!!—SO **THASS** HOW YO' GOT ME!!

THIS **STOOPID** PROGRAM DONE GONE FAR ENUFF!!

WIVES OF AMERICA!!— AH STOPPED THIS PROGRAM FO' YORE GOOD!!— TH' GREATEST ATTRACK-SHUN US WIVES GOT IS **MYSTERY!!**

—AN' TH' **BIGGEST** MYSTERY T'MOST MEN IS HOW WE EVER GOT 'EM T'MARRY US!!— SO—*CHUCKLE*!!— LET'S NOT GIVE AWAY NO **TRADE SECRETS**, HUH?

RIGHT!!

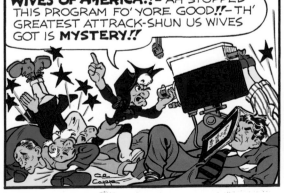

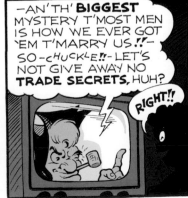

LI'L ABNER Sunday page by Al Capp (takeoff on the popular TV show "This is Your Life"). © 3/21/54. Courtesy of Denis Kitchen

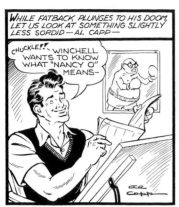

LI'L ABNER daily strip by Al Capp (Capp self-caricature). © 7/20/49. Courtesy of Matt Masterson

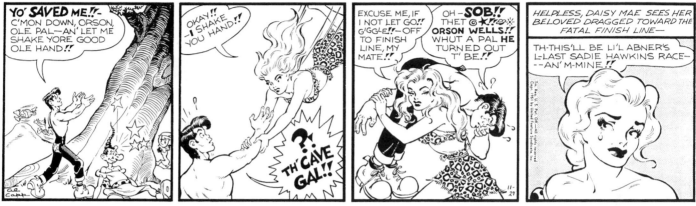

LI'L ABNER daily strip by Al Capp (Cave Gal wins Sadie Hawkins race). © 11/27/51. Courtesy of William Crouch

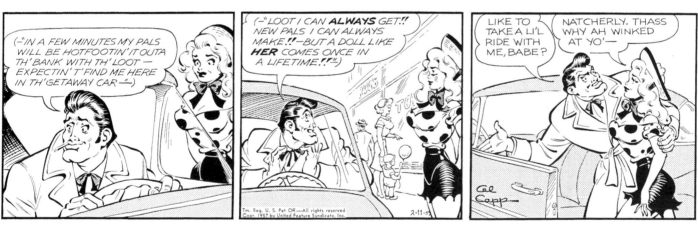

LI'L ABNER daily strip by Al Capp (ghosted by Frank Frazetta). © 2/11/57. Courtesy of International Museum of Cartoon Art

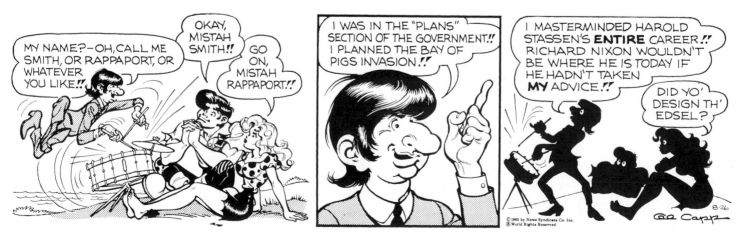

LI'L ABNER daily strip by Al Capp (caricature of Beatle Ringo Starr). © 8/26/65. Courtesy of International Museum of Cartoon Art

LI'L ABNER Sunday page by Al Capp (poking fun at Peanuts and Charles Schulz). © 10/20/68. Courtesy of International Museum of Cartoon Art

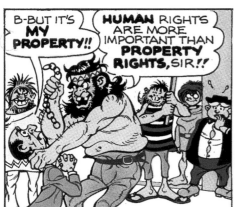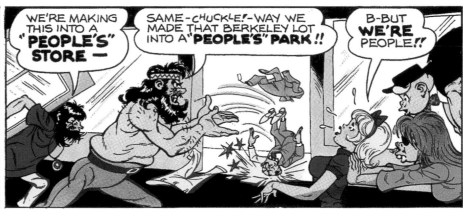

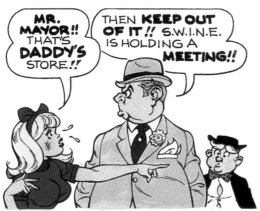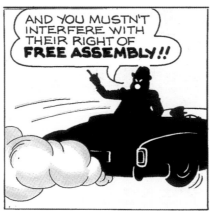

LI'L ABNER Sunday page by Al Capp (attacking student protesters). © 9/21/69. Courtesy of International Museum of Cartoon Art

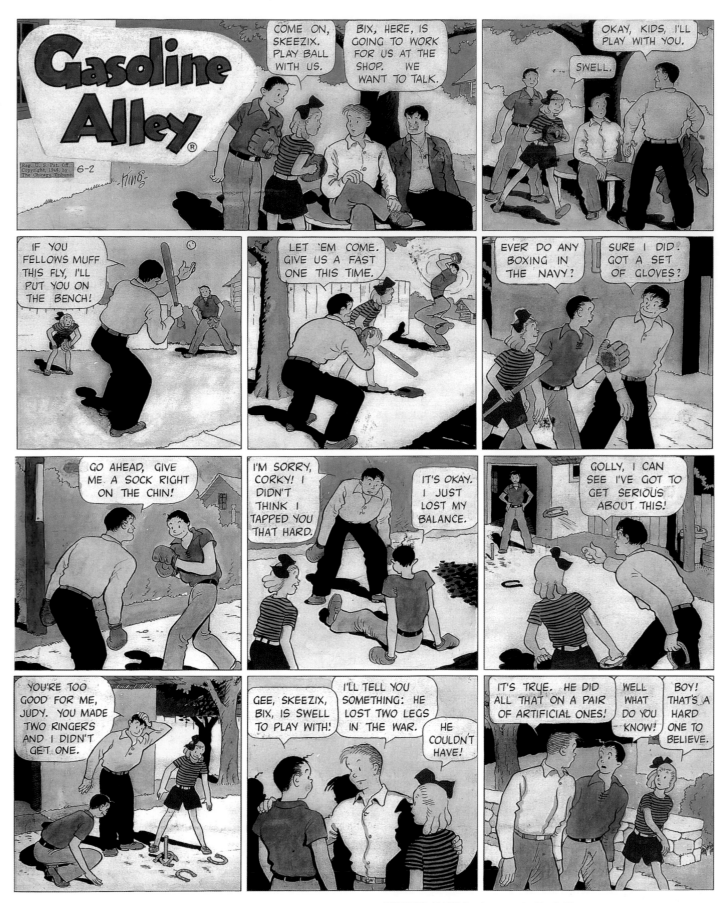

FRANK KING *Gasoline Alley*, which began as a daily feature in 1919, is unique in that it is one of the only strips in which the characters age at a natural rate. In 1921 a baby, later named Skeezix, was left on Walt Wallet's doorstep. In this hand-colored Sunday page by Frank King

from 1946, Skeezix, now a husband and a father, introduces Bix, a WWII Navy combat veteran, to his younger brother and sister, Corky and Judy.

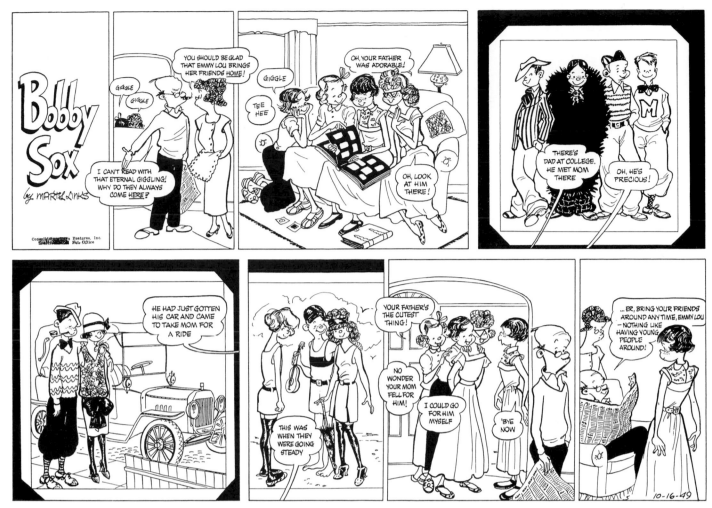

BOBBY SOX Sunday page by Marty Links. © 10/16/49 United Feature Syndicate, Inc. Courtesy of International Museum of Cartoon Art

HAPPY DAYS Comics starring teenagers proliferated in the 1940s. Marty Links had just graduated from high school when her panel, *Bobby Sox*, was first published in the *San Francisco Chronicle*. It was nationally syndicated beginning in 1944 and was renamed *Emmy Lou* in the 1950s. America's most well-known pen-and-ink post-pubescents, Archie, Jughead, Betty, and Veronica, made their newspaper debut in 1946, five years after their initial appearance in a comic book. *Archie*'s creator, Bob Montana, continued the strip until 1975.

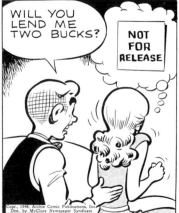

ARCHIE daily strip by Bob Montana. © 8/16/48 Creators Syndicate Courtesy of International Museum of Cartoon Art

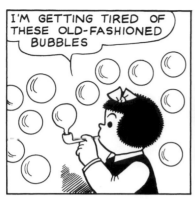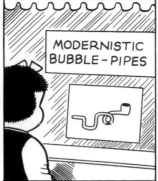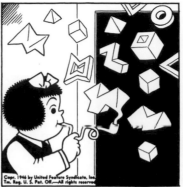

NANCY daily strip by Ernie Bushmiller. © 5/17/46

ERNIE BUSHMILLER Nancy made her first appearance in Ernie Bushmiller's *Fritzi Ritz* in 1933. Fritzi's fuzzy-haired niece gradually usurped the starring role from her aunt, and in 1938 the name of the strip was officially changed. By the 1940s *Nancy* was among the top syndicated features, appearing in more than 450 newspapers. The years between 1944 and 1959 are considered to be the peak period of Bushmiller's long-running creation, as he refined his gag-a-day formula and introduced classic themes that would be endlessly recycled. The selection of *Nancy* strips shown here displays Bushmiller's graphic inventiveness and surreal sense of humor.

SELF-CARICATURE by Ernie Bushmiller

NANCY daily strip by Ernie Bushmiller. © 8/29/47

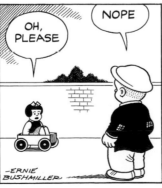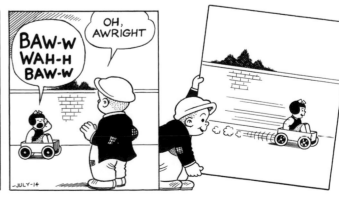

NANCY daily strip by Ernie Bushmiller. © 7/14/47

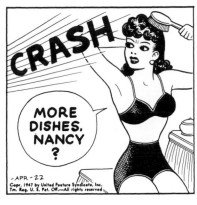
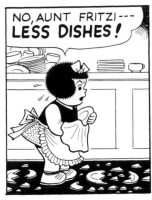

NANCY daily strip by Ernie Bushmiller. © 4/22/47

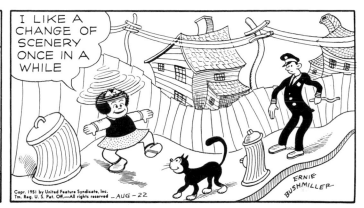

NANCY daily strip by Ernie Bushmiller. © 8/22/51

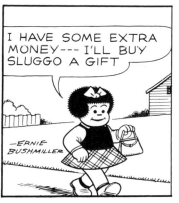
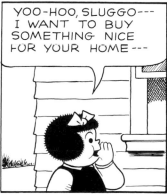
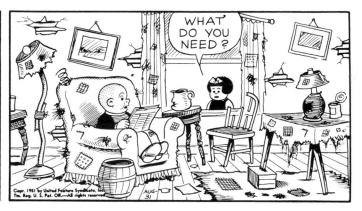

NANCY daily strip by Ernie Bushmiller. © 8/31/51

NANCY daily strip by Ernie Bushmiller. © 8/24/66

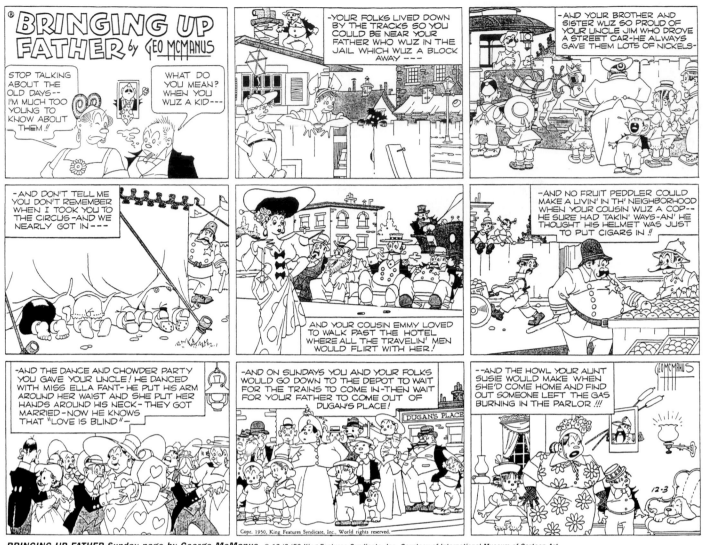

BRINGING UP FATHER Sunday page by George McManus. © 12/3/50 King Features Syndicate, Inc. Courtesy of International Museum of Cartoon Art

GEORGE MCMANUS *Bringing Up Father* began in 1913, and George McManus's bickering costars, Maggie and Jiggs, were still popular with newspaper readers more than three decades later. By that time most of the artwork was being produced by McManus's talented assistant, Zeke Zekley, who drew himself in the strip below. The Sunday page above represents a semiannual tradition in which Maggie and Jiggs would reminisce nostalgically about the good old days, growing up in the Irish neighborhood.

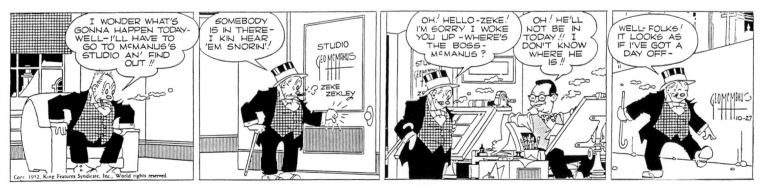

BRINGING UP FATHER daily strip by George McManus (Zeke Zekley in third panel). © 10/27/52 King Features Syndicate, Inc. Courtesy of Bill Janocha

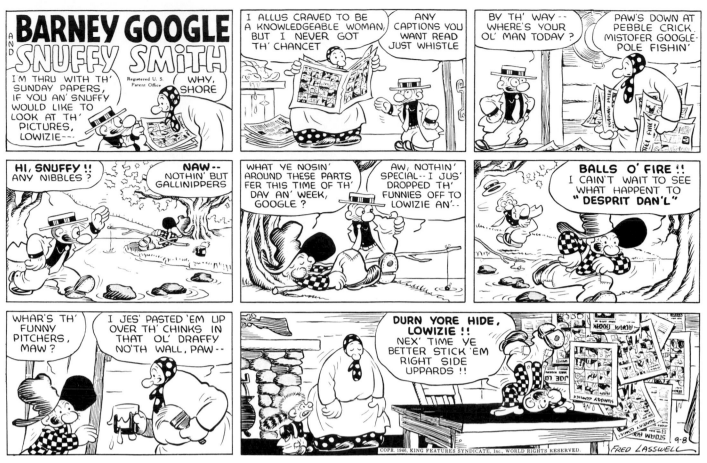

BARNEY GOOGLE AND SNUFFY SMITH Sunday page by Fred Lasswell. © 9/8/46 King Features Syndicate, Inc.

FRED LASSWELL

In 1934 Billy DeBeck hired Fred Lasswell to assist him on *Barney Google and Snuffy Smith*, and after DeBeck died in 1942 Lasswell stepped in to continue the fading feature. In Lasswell's hands, Snuffy and his hillbilly clan took over the strip as the humor became more folksy and the circulation rose from 206 subscribers in 1946 to nearly 900 clients in 1989.

SMOKEY STOVER Sunday page by Bill Holman. © 2/18/51 Tribune Media Services, Inc. All rights reserved. Reprinted with permission. Courtesy of International Museum of Cartoon Art

BILL HOLMAN

A tour de force of screwball comedy, Bill Holman's *Smokey Stover* ran from 1935 to 1973. A Sunday-only feature for most of this time, Holman's creation starred a goofy fireman and was cluttered with cryptic references, such as "1506 Nix Nix," "Notary Sojac," and "Foo," and clever visual puns hanging in the backgrounds.

POGO painting for Newsweek *magazine by Walt Kelly.* © 1955. Courtesy of Carolyn Kelly

All Pogo artwork used by permission © Okefenokee Glee & Perloo, Inc.

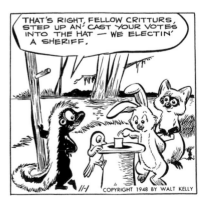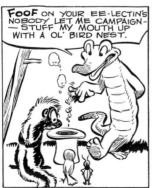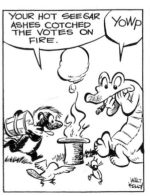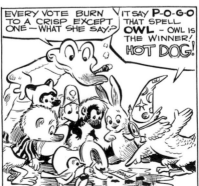

Early POGO daily strip from the New York Star by Walt Kelly. © 11/1/48. Courtesy of Garry Trudeau

walt kelly

ONE OF THE MOST versatile talents ever to work in the comics medium, Walt Kelly mastered all of the art form's tools and techniques. He was adept at flights of fantasy as well as biting political satire. He loved clever wordplay and penned lines of nonsense and thought-provoking philosophy. Intellectuals praised *Pogo* for its literary content, and children delighted in the strip's visual slapstick and enchanting whimsy. With his facile brush, Kelly conjured up a world filled with talking animals and evocative scenery.

After graduating from high school in 1930, Kelly gained experience working as a reporter and cartoonist for his hometown newspaper in Bridgeport, Connecticut. In 1935 he traveled west to seek his fortune in the animation business. For the next five years, he honed his talents at the Walt Disney Studio and was credited as a storyboard artist and animator on *Pinocchio*, *Fantasia*, and *Dumbo*. The Disney influence was evident in the style of his later comics creations.

When he returned east Kelly worked on a number of comic-book titles for Western Printing, including *Fairy Tale Parade*, *Raggedy Ann and Andy*, *Our Gang*, *Santa Claus Funnies*, and *Walt Disney Comics and Stories*. Pogo made his first appearance in *Animal Comics* no. 1, which was published by Dell in 1942.

As Pogo evolved from a comic-book sidekick to the star of a nationally syndicated comic strip, he became increasingly subordinate to Kelly's expanding cast of colorful creatures. More than 150 characters, each with a distinct name and personality, eventually populated Pogo's Okefenokee Swamp. The many species represented included an alligator (Albert), an owl (Howland), a skunk (Mam'selle Hepzibah), a porcupine (Porky Pine), and a hound (Beauregard). There were bats, frogs, mice, ducks, rabbits, bears, birds and bugs, a jazz-playing pig (Solid Mac Hogany), and a boxing kangaroo (Basher).

In the early 1950s Kelly began introducing a new element into the fantasy world of *Pogo*—political satire. "I finally came to understand that if I were looking for comic material, I would never have to look long," he explained. "The news of the day would be enough. Perhaps the complexion of the strip changed a little in that direction after 1951. After all, it is pretty hard to walk past an unguarded gold mine and remain empty-handed."

To help combat the "growing peril" that threatened the swamp in 1953, Simple J. Malarky, a bobcat who was a dead ringer for Senator Joseph McCarthy, was called in to weed out the subversives. Although McCarthy never publicly complained about the portrayal, a number of newspapers dropped selected strips they considered objectionable.

POGO promotional piece for the Minneapolis Tribune by Walt Kelly. © 1969. Courtesy of Art Wood Collection

Throughout the 1950s and 1960s Kelly continued to feature political satire. In 1962 when he depicted Soviet leader Khrushchev as a pig and Cuban dictator Castro as a goat, "inquiries" were made by the Russian embassy, forcing the cancellation of *Pogo* in a Japanese paper. During the 1960s the political humor in *Pogo* became more strident as Kelly's liberal leanings came to the surface. Overt commentary and unflattering caricatures of Richard Nixon, Lyndon Johnson, and Spiro Agnew alternated with surreal fantasy, as in the extended "Prehysterical *Pogo* (in Pandemonia)" sequence, which ran from July 1966 to April 1967. Eventually Kelly began offering replacement strips when he felt the political comment might be offensive to editors and readers. These innocuous episodes came to be known as his "bunny rabbit strips."

Walt Kelly died on October 18, 1973. Years earlier he challenged his readers with the following words of wisdom: "There is no need to sally forth, for it remains true that those things which make us human are, curiously enough, always close at hand. Resolve, then, that on this very ground, with small flags waving and tinny blasts on tiny trumpets, we may meet the enemy . . . and not only may he be ours, he may be us."

SELF-CARICATURE by Walt Kelly. © 1969

Unpublished illustration of Simple J. Malarky (Sen. Joseph McCarthy) from "King of Hearts" by Walt Kelly. © c. 1953. Courtesy of the Pogo Collection, The Ohio State University Cartoon Research Library

POGO daily strip by Walt Kelly (featuring Simple J. Malarky). © 9/23/54. Courtesy of Garry Trudeau

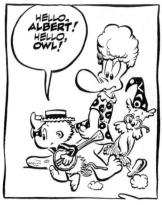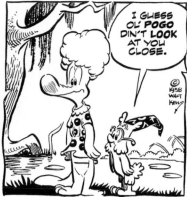

POGO *daily strip by Walt Kelly (Little Orphan Annie takeoff).* © 5/6/58. Courtesy of Scott Daley

POGO *daily strip by Walt Kelly (caricatures of Khrushchev and Castro).* © 6/22/62. Courtesy of Bruce Hamilton

POGO *daily strip by Walt Kelly (caricature of Barry Goldwater).* © 10/6/64. Courtesy of Garry Trudeau

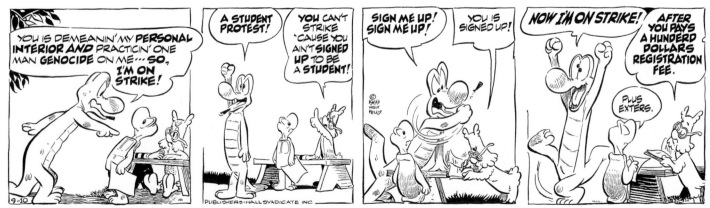

POGO *daily strip by Walt Kelly (comment on student protest movement).* © 9/10/69. Courtesy of Scott Daley

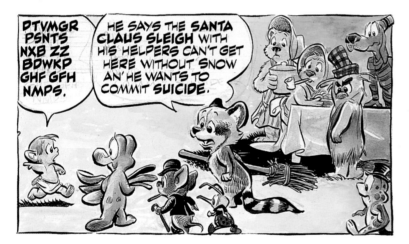

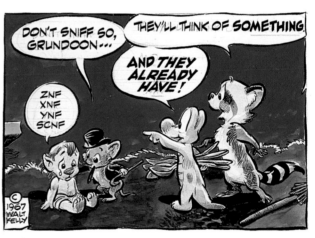

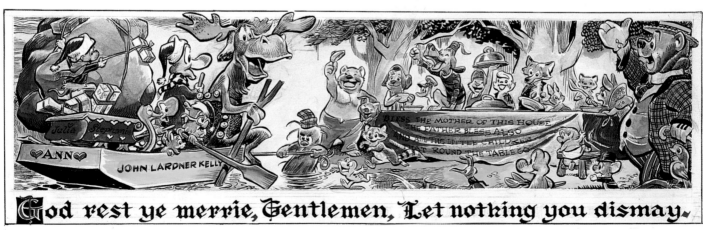

POGO hand-colored Christmas Sunday page by Walt Kelly. © 12/24/67. Courtesy of Bruce Hamilton.

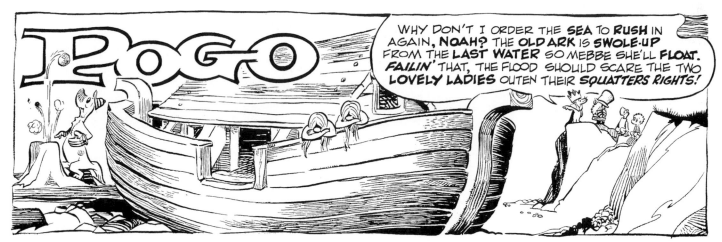

POGO Sunday page by Walt Kelly (from the extended "prehysterical" sequence, a graphic homage to pen-and-ink artist T. S. Sullivant, one of Kelly's major influences). © 1/22/67. Courtesy of International Museum of Cartoon Art

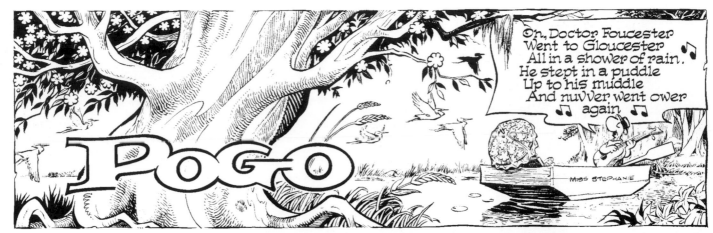
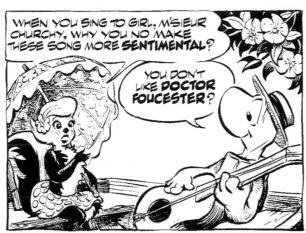
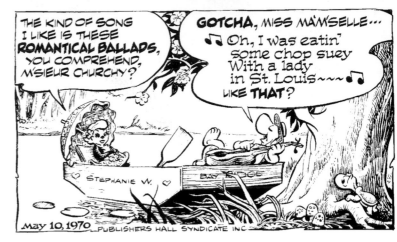

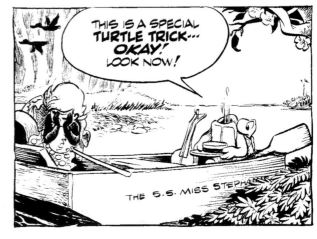

POGO *Sunday page by Walt Kelly (a romantic encounter between Churchy LaFemme and Mam'selle Hepzibah).* © 5/10/70. Courtesy of Mark Evanier

God Rest You Merry, Gentlemen ~~~~ Let Nothing You Dismay ~~

POGO illustration from Ten Ever-Lovin' Blue-Eyed Years with Pogo *by Walt Kelly.* © 1959. Courtesy of Scott Daley

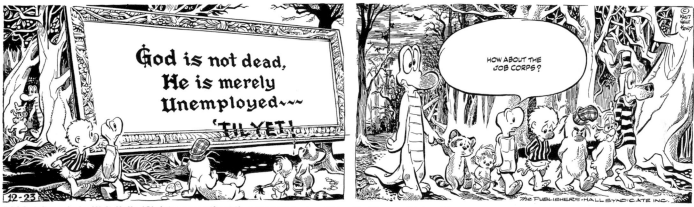

POGO daily strip by Walt Kelly (Christmas sentiment). © 12/23/67. Courtesy of International Museum of Cartoon Art

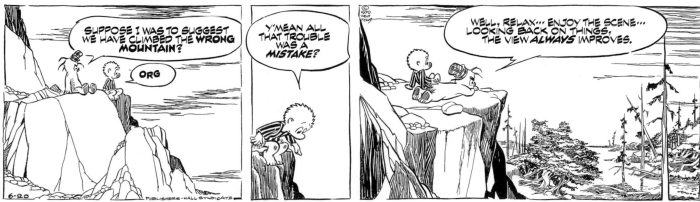

POGO daily strip by Walt Kelly (ecology statement). © 6/20/70. Courtesy of International Museum of Cartoon Art

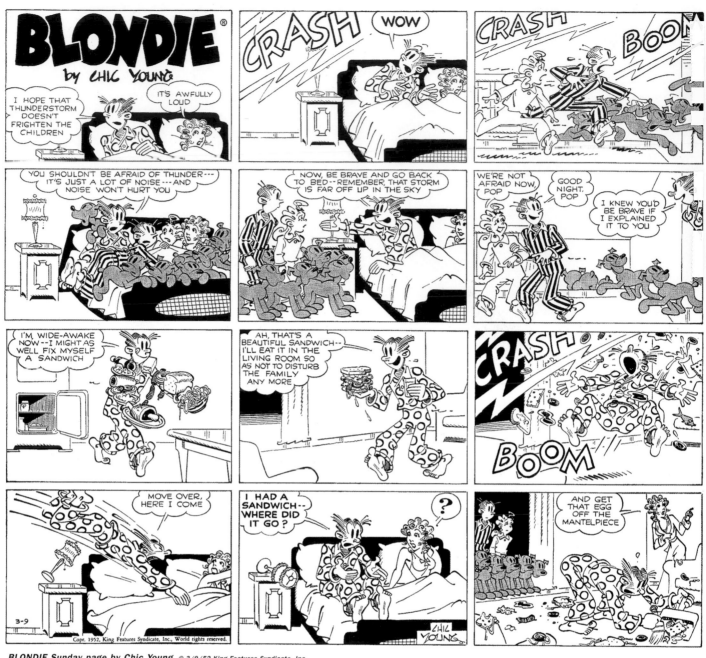

BLONDIE Sunday page by Chic Young. © 3/9/52 King Features Syndicate, Inc.

CHIC YOUNG At the end of the 1940s *Blondie* was the top strip in America and would remain so for many years to come. In 1950 Chic Young's longtime assistant, Jim Raymond (the brother of Alex Raymond), took over the sole artistic duties on the feature. The Sunday page above shows Dagwood Bumstead fixing his famous sandwich, and the daily strip below has an uncharacteristically gruesome ending.

BLONDIE daily strip by Chic Young. © 7/4/45 King Features Syndicate, Inc. Courtesy of Bruce Hamilton.

the
fifties

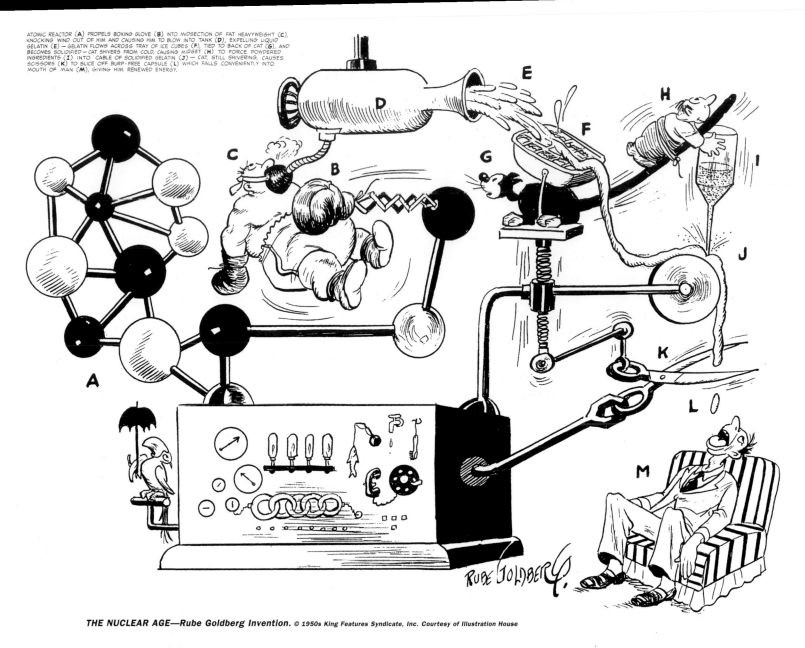

ATOMIC REACTOR (**A**) PROPELS BOXING GLOVE (**B**) INTO MIDSECTION OF FAT HEAVYWEIGHT (**C**), KNOCKING WIND OUT OF HIM AND CAUSING HIM TO BLOW INTO TANK (**D**), EXPELLING LIQUID GELATIN (**E**) — GELATIN FLOWS ACROSS TRAY OF ICE CUBES (**F**), TIED TO BACK OF CAT (**G**), AND BECOMES SOLIDIFIED — CAT SHIVERS FROM COLD, CAUSING MIDGET (**H**) TO FORCE POWDERED INGREDIENTS (**I**) INTO CABLE OF SOLIDIFIED GELATIN (**J**) — CAT, STILL SHIVERING, CAUSES SCISSORS (**K**) TO SLICE OFF BURP-FREE CAPSULE (**L**) WHICH FALLS CONVENIENTLY INTO MOUTH OF MAN (**M**), GIVING HIM RENEWED ENERGY.

THE NUCLEAR AGE—Rube Goldberg Invention. © 1950s King Features Syndicate, Inc. Courtesy of Illustration House

B Y 1950 THE POSTWAR HOUSING CRISIS HAD BEEN SOLVED. IN THAT YEAR ALONE, 1.4 MILLION NEW HOMES WERE BUILT. AFFORDABLE SUBURBAN DEVELOPMENTS MADE THE AMERICAN DREAM OF MARRIAGE, HOME OWNERSHIP, AND PARENTHOOD POSSIBLE FOR THE VETERANS OF WORLD WAR II. BUILDERS AND DEVELOPERS STRUGGLED TO KEEP UP WITH THE DEMAND AS THE FLIGHT TO THE SUBURBS GREW AND THE BIRTH RATE SOARED. BETWEEN 1950 AND 1959, 30 MILLION BABIES WERE BORN.

The baby boom did not lead to a sudden proliferation of comics starring kids. Humorous features for "children of all ages" had been a staple of the medium since *The Yellow Kid* and *The Katzenjammer Kids* started the tradition in the 1890s. The only change was now Charlie Brown and Dennis the Menace competed for space with Henry and Nancy on the funnies pages.

Television would have a greater influence on the comics business than any other development of the decade. In 1950 TV sets were owned by only 3.1 million homes. Within five years the number jumped to 32 million. By 1959 the average family spent six hours a day, seven days a week, in front of the "boob tube."

Newspaper publishers were nervous. "The newspaper-TV battle is not merely a fight for the advertiser's dollar, as was the radio-newspaper fight," *Editor and Publisher* magazine warned in 1951. "This is a contest for the readers' time in which no holds are barred."

Artists were asked not to promote the new medium in their strips. One publisher in New Jersey actually billed United Feature Syndicate for advertising space when Al Capp "plugged" the Milton Berle show in *Li'l Abner*.

In spite of these objections, comics based on popular television shows were soon being offered. *Hopalong Cassidy* and *Howdy Doody* strips debuted in 1950, and *Dragnet* and *I Love Lucy* followed in 1952.

"Having a strip based on another medium is like getting a foot in the door," admitted comic-strip agent Toni Mendez in 1950. "It means immediate recognition for that particular strip. But once in, the strip will have to live on its own merits."

Most of the TV spin-off strips lasted only a few years. The syndicates were more successful with original ideas that provided an alternative to broadcast entertainment. Two distinct new genres of comic strips—soap opera and gag-a-day—began to emerge in the 1950s, at least partly in response to the growing popularity of television.

The success of *Mary Worth* in the 1940s convinced editors that they could lure women readers away from radio soap operas with romance and intrigue. A wave of "soap-opera strips," led by *The Heart of Juliet Jones* and *On Stage*, followed in the 1950s.

The difference between romance and adventure strips was debated among comics creators as the genres overlapped. Allen Saunders, writer of both *Mary Worth* and *Steve Roper*, pointed out that romance strips were built around emotional conflict whereas adventure strips emphasized physical confrontation. Editors believed that women readers preferred affairs of the heart, while the guys went for the guns. King Features made distinctions between "comic strips" (*Blondie*), "adventure strips" (*Rip Kirby*), and "romance and adventure strips" (*The Heart of Juliet Jones*) in its promotional material.

The illustrators of the new story strips were influenced by the work of two veterans of adventure comics, Milton Caniff (*Terry and the Pirates* and *Steve Canyon*) and Alex Raymond (*Flash Gordon* and *Rip Kirby*). They blended the cinematic composition of Caniff with the elegant line work of Raymond to create a modern hybrid.

Many of the story-strip illustrators were recruited from the ranks of comic-book artists after that industry fell on hard times in the 1950s. Jack Kirby, Wally Wood, and Lou Fine were among the comic-book legends who crossed over into the field of syndicated strips during the decade.

Other newcomers came from the ranks of commercial illustrators. One advertising art agency, Johnstone and Cushing, produced a crop of talented draftsmen that included Stan Drake (*Juliet Jones*), Leonard Starr (*On Stage*), Alex Kotzky (*Apartment 3-G*), and Neal Adams (*Ben Casey*).

Thematically, the new story strips featured a mix of violence and sex toned down for family newspaper readership. As the work of these creators became more polished, and western and science-fiction subgenres emerged, the term "soap opera" became outmoded. Cartoonists began using terms like "straight," "serious," or "illustrative" to

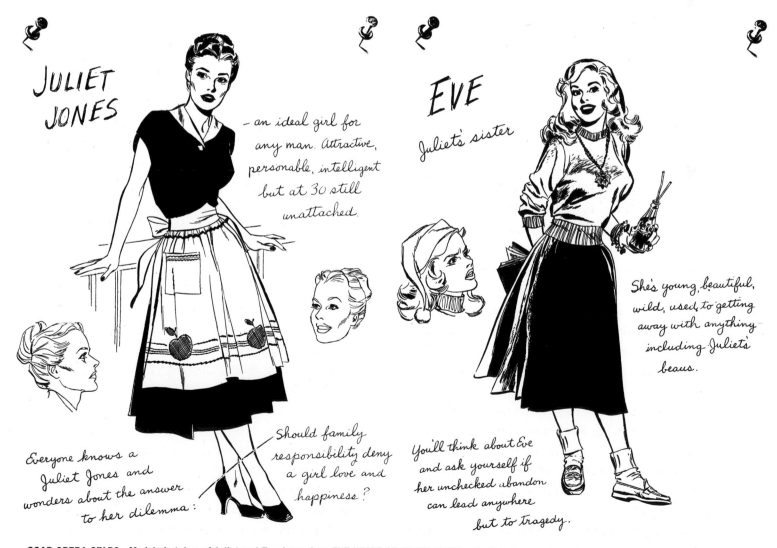

JULIET JONES

— an ideal girl for any man. Attractive, personable, intelligent but at 30 still unattached.

Everyone knows a Juliet Jones and wonders about the answer to her dilemma:

Should family responsibility deny a girl love and happiness?

EVE

Juliet's sister

She's young, beautiful, wild, used to getting away with anything including Juliet's beaus.

You'll think about Eve and ask yourself if her unchecked abandon can lead anywhere but to tragedy.

SOAP OPERA STARS—Model sketches of Juliet and Eve Jones from THE HEART OF JULIET JONES sales brochure. © 1953 King Features Syndicate, Inc. Courtesy of Gill Fox

describe the modern trend in realistic rendering and story-telling.

There was nothing new about the gag-a-day formula. Chic Young had built *Blondie* into a circulation blockbuster with daily laughs. But a major shift was taking place. Humor strips were gradually replacing story strips as the dominant genre.

In 1950 *Time* magazine named as the top five newspaper comics *Little Orphan Annie*, *Dick Tracy*, *Joe Palooka*, *Li'l Abner*, and *Blondie*. Only *Blondie* was a gag-a-day strip.

A readership study by Boston University in 1962 listed as the top fifteen features *Blondie*, *Dick Tracy*, *Little Orphan Annie*, *Peanuts*, *Rex Morgan M.D.*, *Dennis the Menace*, *Li'l Abner*, *Mary Worth*, *Nancy*, *Snuffy Smith*, *Beetle Bailey*, *Brenda Starr*, *Bringing Up Father*, *Steve Canyon*, and *Prince Valiant*. Humor and story strips were now split almost evenly in popularity.

Editors became increasingly convinced that newspaper readers no longer had the patience to follow plotlines that took weeks to develop when they could watch a complete episode on television in thirty minutes or an hour. Humor strips, they claimed, delivered a quick punch line and captured the shorter attention span of television viewers more effectively than continuity strips.

Story-strip artists objected to this assumption. "The best gag strip in the world in terms of just plain acceptance is *Blondie* and you can miss it any day," reasoned Milt Caniff. "But assuming you're hooked, you can't miss *Rex Morgan* because every day there's always a push forward of the story. If you miss it, you're penalized; you lack some significant bit of information about the story."

The argument fell on deaf ears. Newspaper editors continued to choose new humor strips over story strips, and the polls tended to reinforce the wisdom of their logic. As a result, the syndicates launched fewer and fewer continuity strips.

Between September 1950 and March 1951, a trio of comic features debuted that were to have a major influence on this shift in readership. All three started inauspiciously but eventually eclipsed *Steve Canyon*, *Li'l Abner*, and *Pogo* in popularity.

The creators of these features took similar paths to success. Mort Walker (*Beetle Bailey*), Charles Schulz (*Peanuts*), and Hank Ketcham (*Dennis the Menace*) grew up during the Depression, inspired by the fame and fortune of their cartoonist heroes. They all served in the military during World War II and started their professional careers selling single-panel "gag cartoons" to major magazines, such as the *Saturday Evening Post* and *Collier's*. Their comic creations would eventually pass the 1,000-paper plateau in circulation and endure for over fifty years.

Beetle Bailey was launched in twelve newspapers on September 4, 1950, and after six months had signed up only

FRAT BOY—This panel from an unpublished college-era strip is the only time Beetle Bailey ever exposed his eyes. © 1950 King Features Syndicate, Inc.

twenty-five clients. King Features considered dropping the college-themed strip after the first year's contract was over. The Korean War was heating up at the time, so Walker decided to have Beetle enlist in the army. He quickly picked up 100 papers. He redesigned the cast and a Sunday page was added in 1952.

After the Korean War was over, the army brass wanted to tighten up discipline and felt that *Beetle Bailey* encouraged disrespect for officers. The strip was banned in the Tokyo *Stars and Stripes*, and sympathetic publicity rocketed Beetle's circulation another 100 papers. When Walker won the National Cartoonists Society's Reuben Award as the "outstanding cartoonist of the year" in 1953, *Beetle Bailey* had become a certified success with a growing list of clients.

During that same year, Walker was concerned that the military theme of his strip would soon become irrelevant. He created a sister and brother-in-law, Lois and Hi Flagston, for Beetle and sent him home on a visit. After two weeks, readers demanded Beetle's return to the army. Walker enjoyed writing family gags, so he started a second comic strip and found the perfect partner in advertising artist Dik Browne.

Hi and Lois, which debuted on October 18, 1954, grew slowly and then took off around 1960 when the youngest of the Flagston children, Trixie, became the first "thinking baby" in the comics. Dik Browne won the Reuben Award as the "outstanding cartoonist of the year" in 1962, and in less than a decade, *Hi and Lois* had accumulated 400 subscribers.

From 1954 to 1968, the circulation of *Beetle Bailey* grew from 200 newspapers to 1,100, and many new characters were added to the cast. The lineup at that time included:

LOVABLE LOSER—Panel from the first PEANUTS daily strip. © 10/2/50
United Feature Syndicate, Inc.

Beetle, Sarge, Gen. Halftrack, Zero, Killer, Cookie, Capt. Scabbard, Lt. Fuzz, Major Greenbrass, Chaplain Staneglass, Rocky, Cosmo, Julius, Otto, Plato, Pvt. Blips, Martha, Dr. Bonkus, Bunny, Ozone, and Pop. (Lt. Flap, Miss Buxley, Sgt. Lugg, and Cpl. Yo came later.) A series of fifty animated television cartoons, produced by Paramount Studios, debuted in 1963 and led to a wave of licensed products, including books, toys, and dolls.

"As I zoomed past the 500-paper mark," Walker remembered, "I began to feel a tremendous responsibility to my readers, almost a stage fright. If I've done this good today I've got to do at least as good tomorrow, or better, if I can. If you're not moving forward in this business, you are moving backward." *Beetle Bailey* became the second feature in comics history, after *Blondie*, to appear in more than 1,000 newspapers when it passed that milestone in 1965.

Peanuts was initially marketed as a space-saving feature before its debut in seven newspapers on October 2, 1950. It was vertically shorter than other strips and could be reconfigured in square, vertical, and horizontal formats due to its four equal-sized panels, although most papers ran it horizontally. Charles Schulz's simple but expressive graphics stood out on the comics page, and his strip didn't suffer as much as other features when editors further reduced the size they printed the comics.

Thematically, *Peanuts* began as a conventional gag strip with stereotypical characters and stock juvenile situations. But Schulz was heading in a new direction. The *Peanuts* kids developed adultlike personalities, and the humor gradually became more introspective. In an age when television was drawing millions into its seductive universe, a comic strip that delivered wit and wisdom in daily doses and appealed to adults as well as kids was just what the newspapers needed.

During the 1960s, beginning with a series of television commercials for the Ford Motor Company, Schulz showed how comics could be adapted successfully to other media. In 1962 *Happiness Is a Warm Puppy* became a best-selling book, *A Charlie Brown Christmas Special* was the first prime-time animated television special in 1965, and *You're A Good Man Charlie Brown*, which opened off-Broadway in 1967, went on to become the most frequently produced musical in the history of American theater.

The *Peanuts* merchandising program became a licensing juggernaut in the 1970s as Snoopy rose to international superstar status. There were Snoopy telephones and toothbrushes, Cartier gold charms and designer dolls. Snoopy ran for president in 1972. The beagle took Japan by storm in the 1980s and appeared at major sporting events on the side of the MetLife blimp.

Schulz's creation was the perfect marriage of simple graphics, sophisticated humor, and commercial adaptability. *Peanuts* not only answered the challenges of size reduction and competition from television, it revolutionized the medium of newspaper comic strips. The next generation of creators, including Lynn Johnston (*For Better or For Worse*), Cathy Guisewite (*Cathy*), and Patrick McDonnell (*Mutts*), would all acknowledge the debt they owed to Schulz's innovations.

Hank Ketcham was inspired by his own four-year-old son, Dennis Lloyd Ketcham, when he created his famous panel. "One October afternoon in 1950," remembered Ketcham, " I was at work in my tiny studio, finishing a drawing for the *Saturday Evening Post*, when I was startled by a sudden outburst from the bedroom area of our new home in Carmel. 'Your son is a MENACE!' exclaimed my wife. 'Dennis . . . a menace?' I mused. 'Let's see, there's Tillie the Toiler and Felix

THE BABY BOOM—DENNIS THE MENACE promotional drawing from Editor and Publisher. © 1951 King Features Syndicate, Inc.

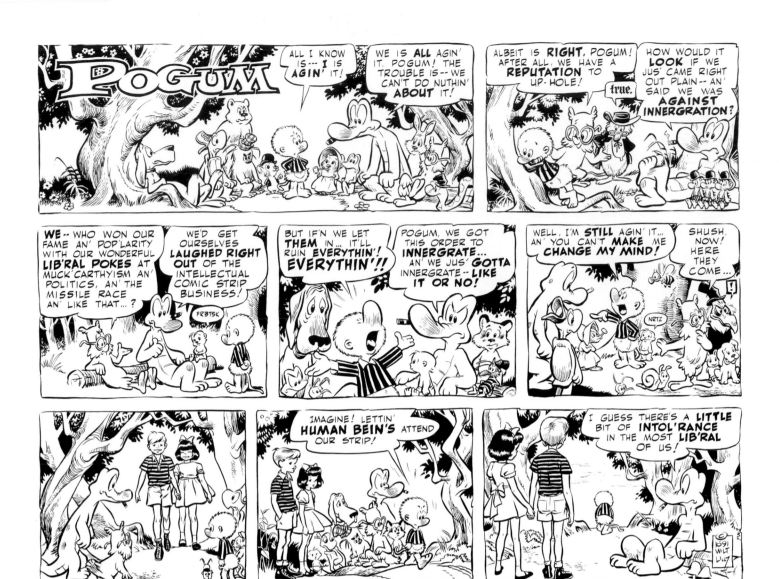

MAD SATIRE—"Pogum" (POGO spoof) by Wally Wood. © 1961 E. C. Publications, Inc. All rights reserved. Used with permission. Courtesy of David Applegate

the Cat. Why couldn't there be—DENNIS THE MENACE?! Wow! Why not!'"

Dennis the Menace was released on March 12, 1951, in sixteen newspapers. Editors responded more favorably to Hank Ketcham's creation than they had to *Beetle Bailey* and *Peanuts*, and sales surged at a respectable pace. By the end of the first year, *Dennis* was appearing in 100 of the largest U.S. newspapers. In 1952 the syndicate launched a Sunday page, and Pines Publications came out with the first *Dennis the Menace* comic book.

In 1959 a live-action TV series, starring Jay North, debuted on CBS, and by the mid-1960s *Dennis* was at the top of many newspaper-readership polls. He also had his own line of successful comic books and trade paperback collections. Merchandise included Dennis dolls, hand puppets, children's clothes, and toys.

Ketcham earned respect among his peers for his single-minded devotion to the craft of cartooning. He approached each composition as a mini-masterpiece. "I seem to have trapped myself over the years into creating such realistic situations that I must resort to elaborate designs that penetrate

space and give the illusion of depth," Ketcham explained. "It's like peering through a window in the page. I try to draw so convincingly that the reader won't notice."

Ketcham's unique artistic perspective enabled readers to briefly recapture the innocence of childhood and imagine a life of white-picket fences, green grass, and golden sunsets. Although it reflected an idealized depiction of the Baby Boom era, *Dennis the Menace* endured because Ketcham's vision was timeless.

The 1950s, which is often dismissed as a placid period of conformity and consumerism, was in fact a time when rock and roll, Beat poetry, and abstract painting altered the cultural climate. A new brand of satiric humor also came into vogue. Lenny Bruce revolutionized the world of stand-up comedy with his controversial monologues. Sid Caesar and his troupe introduced an innovative style of live improvisation on *Your Show of Shows*. Billy Wilder's *Some Like It Hot* blended the sex appeal of Marilyn Monroe with the comedic talents of Tony Curtis and Jack Lemmon. Mike Nichols, Elaine May, Mort Sahl, and Shelly Berman were among the leading exponents of the new humor.

Cartoonists were also pushing the limits of creativity and convention. United Productions of America, which was founded by a group of Disney Studio dropouts, experimented with a fresh approach to cartoon animation. The design of U.P.A. films, such as *Gerald McBoing Boing*, written by Ted Geisel (Dr. Seuss), and *A Unicorn in the Garden*, based on the drawings of James Thurber, was influenced by the latest trends in modern art and magazine illustration.

MAD magazine, which was launched in 1952, pioneered a brand of humor that was aimed directly at the youth of America. Harvey Kurtzman, Jack Davis, Wally Wood, Bill Elder, and the rest of the "Gang of Idiots" at *MAD* turned out an endless stream of takeoffs on contemporary comic strips (*Gopo Gossum*), television programs (*Howdy Dooit!*), and movies (*Hah! Noon*). Many of the underground cartoonists of the 1960s were influenced by this irreverent publication while growing up in the 1950s.

The new humor was described by critics as "sick." Jules Feiffer, who had worked as an assistant to Will Eisner on *The Spirit* from 1946 to 1951, began drawing a multi-image cartoon for the *Village Voice* in 1956 that he sardonically titled *Sick, Sick, Sick*. Feiffer's sketchy style and probing dialogue earned him a following among New York intellectuals and influenced many cartoonists who were to follow. The weekly feature was renamed *Feiffer* and began national syndication in 1959.

The New York Herald Tribune Syndicate, which had failed to strike gold with a string of detective strips in the late 1940s and early 1950s (*Bodyguard*, *The Saint*, and *Sherlock Holmes*), saw the potential in the sophisticated humor being pioneered by Feiffer. Mell Lazarus's *Miss Peach*, which debuted in 1957, was touted by the syndicate as "different in that it has a four-column format, with almost every strip a single wide-screen panel." In *Miss Peach* the words took precedence over the art as the students of the Kelly School filled their speech balloons with thoughtful discussions about life, love, and other weighty matters. The drawing was appropriately childlike in its simplicity.

Johnny Hart presented his caveman creation, *B.C.*, to five other syndicates before he sold it to the Herald Tribune in 1958. The most successful of the new humor strips, *B.C.* combined a minimalist drawing style with dry wit, slapstick, puns, sound effects, and anachronisms to create a mood that was both modern and traditional. Hart started a second successful feature, *The Wizard of Id*, in 1964 and won the Reuben as the "outstanding cartoonist of the year" in 1968.

At the end of the decade, the Herald Tribune announced two other promising features. "Readers' heads today are too full of fact," stated a syndicate representative in 1958. "*Poor*

PUBLISHERS-HALL SYNDICATE
30 EAST 42nd STREET, NEW YORK, N.Y.

SOCIAL COMMENT—FEIFFER newspaper promotion by Jules Feiffer. © 1959 Jules Feiffer. Used by permission of Universal Press Syndicate. All rights reserved

Arnold's Almanac is designed to empty those heads and bring on a state of bliss. Each panel is a topnotch joke, but they are in sequence on one subject, giving the cumulative impact of 10 to 15 laughs in a row." *Poor Arnold* was Arnold Roth, a former writer, editor, and cartoonist for *Trump* and *Humbug*, two short-lived magazines launched by Harvey Kurtzman, the genius behind *MAD*.

The second creation was from another cartoonist with a *MAD* connection. Al Jaffee's *Tall Tales* was unusual in that it was exactly what it said it was: one column wide by 7½ inches tall. Similar to the famous *Fold-In* page Jaffee would later

develop for MAD, *Tall Tales* attracted attention with clever visual compositions.

Apparently, newspapers readers weren't ready for these innovations. *Poor Arnold's Almanac* ended in 1960 and *Tall Tales* was gone by 1966.

The new humor strips made subtle observations about philosophy, politics, and religion but always maintained an air of playful unpretentiousness. When a cartoonist got up on his soapbox and expressed strong opinions, the editors howled in protest.

A 1950 column in the *Denver Post* set off a heated debate between newspaper editors and Al Capp, a frequent violator

KEEP IT CLEAN—LITTLE ORPHAN ANNIE promotional drawing from **Editor and Publisher.** © *1950s Tribune Media Services, Inc. All rights reserved. Reprinted with permission*

of the unwritten "no comment" law in comics. The column writer expressed the widely held belief that politics belonged on the editorial page and whenever a cartoonist started preaching, the entertainment value of his feature went down.

"A cartoonist is a commentator," responded Capp. "Every line he draws, every word he writes IS a comment on the world he knows. When a newspaper editor asks a cartoonist to stop commenting, they ask him—in effect—to stop being a cartoonist."

James Pope, managing editor of the *Louisville (Ky.) Courier-Journal*, had his own ideas about the role a cartoonist was supposed to play. "They should think about human nature, about social foibles, about romance and adventure and laughter," wrote Pope. "I'm hanged if I see why any of them want to bother with the contentious artificial area of political and economic ideas, or any controversial issues whatever."

Harold Gray was another favorite target for critics in the Cold War era. After drawing a *Little Orphan Annie* sequence in which Daddy Warbucks thwarted a gang of Chinese Reds, Gray was accused of being both a right-wing warmonger and a Communist sympathizer. Another series on juvenile delinquency, which depicted violence, drug use, and anti-labor sentiment, set off a firestorm of protest and thirty newspapers canceled the strip.

Gray remained undaunted in defense of his beliefs. In response to a reader's complaint about his editorializing, he wrote: "I shall continue to pound on the idea that the old time way was the best for us—individual freedom, honest hard work, and a chance for any man with the proper drive and decency to gain and hold wealth and power."

In addition to Capp and Gray, Walt Kelly, Milt Caniff, and Chester Gould also spoke out for freedom of expression on the comics page. These influential creators were not as courageous when the comic-book industry came under attack in the 1950s.

A movement had been mounting to censor violence in comic books during the postwar years as concerned parents organized protests to put pressure on the publishers. In 1954 the psychologist Frederick Wertham charged, in his controversial book *Seduction of the Innocent*, that comic-book reading led directly to juvenile delinquency. A Senate committee was formed, which included Senators Kefauver (D-Tenn.), Hennings (D-Mo.), and Hendrickson (R-N.J.), to investigate the connection. A month after the McCarthy hearings got under way in Washington, D.C., Kefauver's committee questioned Wertham, William Gaines (the publisher of EC comic books), Walt Kelly, and Milt Caniff in a courthouse in lower Manhattan.

Kelly, the newly elected president of the National Cartoonists Society, defensively claimed that he had tried to help clean up the industry in the mid-1940s, when he was producing funny animal comic books. Caniff pointed out that newspaper strips were subjected to strict censorship rules by newspaper and syndicate editors as well as the good judgment of the artists. Both cartoonists implied that there was an important distinction to be made between the standards that governed the comic-strip business and the ethics of the comic-book industry.

Caniff and Kelly managed to take the spotlight off their branch of the profession, but William Gaines was not so fortunate. After the hearings were over, negative publicity and the threat of boycotts forced Gaines to shut down his entire line of horror comics. The comic-book publishers adopted a form of self-censorship, called the Comics Code Authority, which sent the industry into a creative and economic tailspin from which it took more than a decade to recover.

The National Cartoonists Society faced another crisis in 1955 when the feud between Al Capp and Ham Fisher escalated. Fisher continued to assert that Capp's lead character bore a striking resemblance to Big Leviticus, a supporting player in *Joe Palooka*. He argued that the theft was irrefutable because Capp had been working as his assistant the year before he created *Li'l Abner* in 1934. As Capp eclipsed Fisher in popularity during the late 1940s, the accusations became more vicious.

In April 1950 Capp wrote a piece for the *Atlantic Monthly* entitled "I Remember Monster," a thinly disguised account of his unpleasant experiences working as Fisher's assistant. In desperate retaliation, Fisher sent a batch of drawings to a New York state committee investigating comics, "proving" that Capp was sneaking pornography into the panels of *Li'l Abner*. Fisher denied having anything to do with the alleged forgeries, but in 1954 he staged the same stunt when Capp applied for a TV license from the Federal Communications Commission.

Capp was forced to withdraw his F.C.C. application and angrily demanded that the National Cartoonists Society Ethics Committee take action against Fisher. In 1955 Fisher was suspended from the N.C.S. for unprofessional conduct. Capp had won the feud. Rejected, depressed, and lonely, Fisher took an overdose of pills. Morris Weiss, a freelance comic-book artist and one of the last people Fisher considered a friend, found the disgraced cartoonist's body in his Madison Avenue studio on December 27, 1955.

Another tragic death occurred less than a year later. On September 6, 1956, Alex Raymond was killed when the

INSTEAD OF A SELF PORTRAIT I HAD PALOOKA DRAW ME! HAM FISHER.

EGO TRIP—Self-caricature of Ham Fisher from Comics and Their Creators by Martin Sheridan. © 1942 McNaught Syndicate

Corvette he was driving skidded on a rain-soaked road in Westport, Connecticut, and smashed into a tree. Stan Drake, illustrator of *The Heart of Juliet Jones*, was thrown clear of the overturned sports car but suffered a broken shoulder and other injuries. Raymond was a past president of the National Cartoonists Society and had won the award as the "outstanding cartoonist of the year" in 1949. John Prentice, who had been working as a magazine and comic-book illustrator, was selected to take over the production of Raymond's *Rip Kirby*, which appeared in 500 daily newspapers at the time.

Jack Cole, a veteran comic-book and magazine cartoonist, also suffered an untimely demise in the 1950s. Cole created the elastic superhero Plastic Man in 1941 but always yearned to return to his first love, gag cartooning. After *Playboy* was launched in 1953, Cole began submitting color cartoons to the new men's magazine and soon became a regular contributor. In 1958 he realized another dream when he sold a comic strip, *Betsy and Me*, about two doting parents and their genius son, to the Chicago Sun-Times Syndicate. After its launch, the strip was doing well and picking up papers. Three months later, Cole bought a .22 rifle, drove the family station wagon a few miles from his home, and shot himself. The next day, *Playboy* publisher Hugh Hefner and Cole's wife received letters from the cartoonist, but his motive remained a mystery. In a 1999

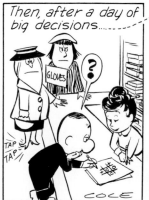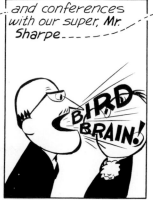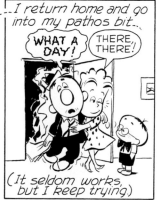

A CRY FOR HELP?—BETSY AND ME daily strip by Jack Cole. © 1958 Field Enterprises, Inc. Courtesy of Bill Janocha

COMICS PATRON—William Randolph Hearst, "The Wizard of Ooze," by William Rogers, 1906. *Harper's Weekly*

New Yorker article about Cole, the cartoonist and comics historian Art Spiegelman observed that *Betsy and Me* "reads like a suicide note delivered in daily installments. As he climbed the ladder of success, up from the primal mulch of the comic books, he finally arrived at air that was too thin to breathe: Jack Cole, a comics genius, died of growing up."

The comics industry lost its founding patron when William Randolph Hearst succumbed to a heart condition on August 14, 1951, at the age of eighty-eight. The Chief left behind

sixteen daily and thirteen Sunday newspapers, eight monthly magazines, a sprawling real-estate empire, and a vast collection of art and antiques. The value of his estate was estimated at $200 million.

Hearst had remained personally involved in every detail of his publishing empire until his death, including the supervision of the comics. All new features had to be approved by The Chief before his syndicate, King Features, could sign them up. When Hearst saw a comic strip he liked that was not owned by King, he directed his people to hire the artist away from the current employer with a better offer. Many cartoonists, including Richard F. Outcault, Winsor McCay, and Roy Crane, came under Hearst's control in this way.

Ward Greene, who was the editor and general manager of King Features at the time of Hearst's death, made regular trips from the syndicate offices in New York to his boss's home in California. Hearst would pore over two bound volumes, containing all 300 of the syndicate's features, and make comments and suggestions. He frequently suggested plotlines for comic strips and objected to sequences that he disliked.

More than a half-century before his death, Hearst set the stage for the birth of the comics medium. On October 17, 1896, the day preceding the Yellow Kid's debut in Hearst's Sunday edition of the *New York Journal*, a full-page advertisement guaranteed "Eight pages of iridescent polychromous effulgence that makes the rainbow look like a lead pipe." Hearst didn't invent the comics, but his promotional bravado was what sold them to the American public.

A Hearst editor once said that his boss's goal was to make every reader exclaim "Gee whiz!" upon opening the newspaper. That phrase might have been a fitting epitaph for the greatest showman in the history of journalism.

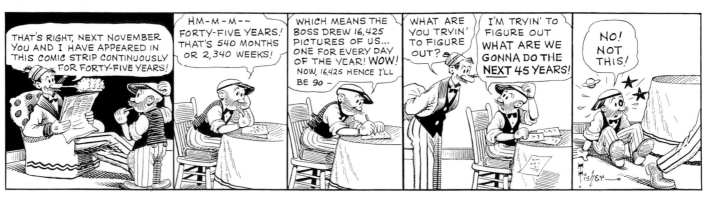

THE OLDEST STRIP—MUTT AND JEFF's 45th anniversary. © 1952 McNaught Syndicate. Courtesy of International Museum of Cartoon Art

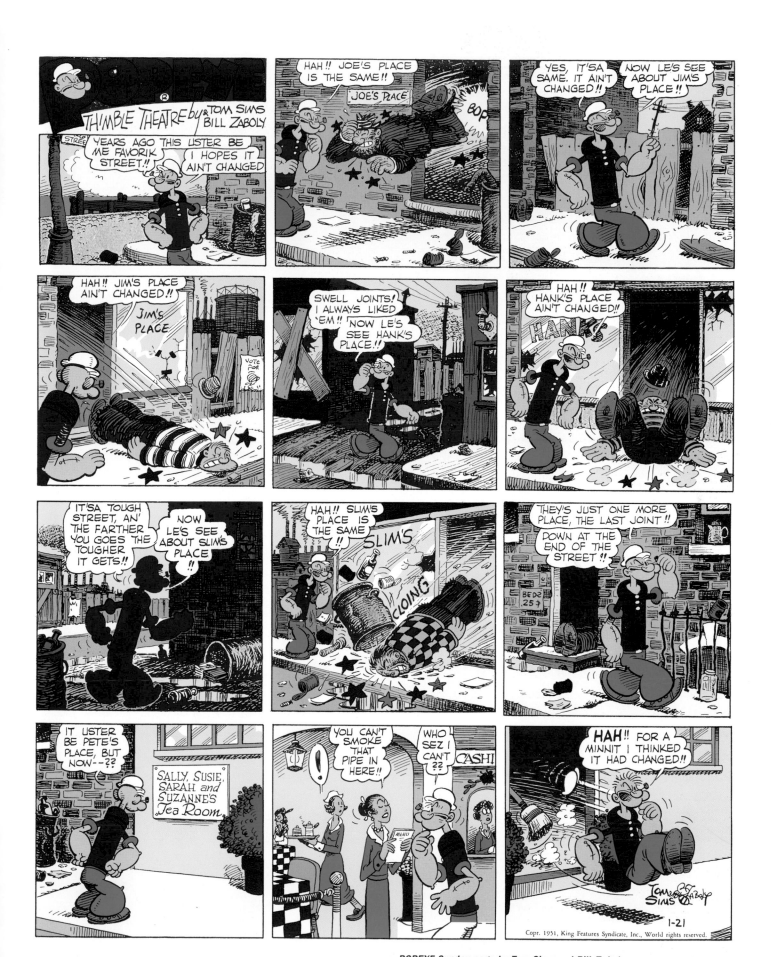

POPEYE Sunday page by Tom Sims and Bill Zaboly. © 1/21/51 King Features
Syndicate, Inc. Courtesy of International Museum of Cartoon Art

SIMS & ZABOLY Elzie Segar, the creator of *Popeye*,
died in 1938, and after a short stint by King Features "bullpen"
artist Doc Winner, Bill Zaboly (illustrator) and Tom Sims
(writer) continued the classic comic strip. This outstanding

Popeye Sunday page from 1951 is drawn in the classic 1930s
"big-foot" style that Robert Crumb would revive in the 1960s.

BIG BEN BOLT *daily strip by John Cullen Murphy.* © 5/22/56

JOHN CULLEN MURPHY

The first major story-strip debut of the decade was *Big Ben Bolt*, which began on February 20, 1950. This literate and stylish boxing feature was written by Elliot Caplin and illustrated by John Cullen Murphy. An accomplished artist who had painted covers for *Liberty*, *Sport*, *Holiday*, *Collier's*, and *Look* magazines, Murphy rendered the action scenes in *Big Ben Bolt* with drama and authenticity. The feature ended in 1978, eight years after Murphy started collaborating with Hal Foster on *Prince Valiant*.

BIG BEN BOLT *daily strip by John Cullen Murphy.* © 5/31/56

BIG BEN BOLT *daily strip by John Cullen Murphy.* © 6/25/56

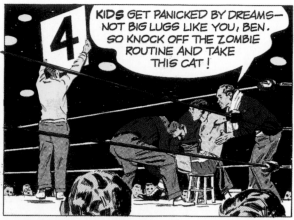

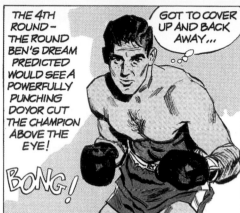

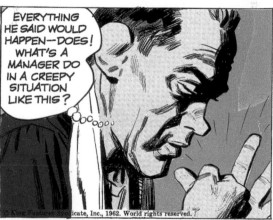

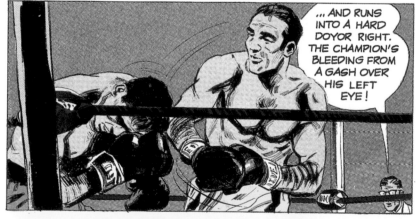

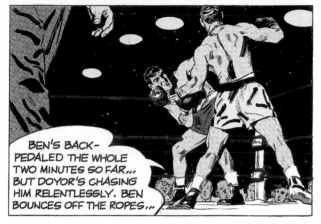

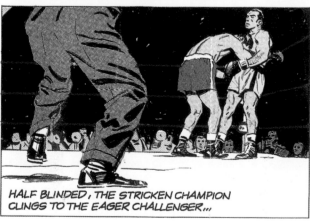

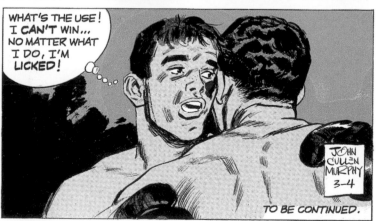

BIG BEN BOLT Sunday page by John Cullen Murphy. © 3/4/62. Courtesy of John Cullen Murphy

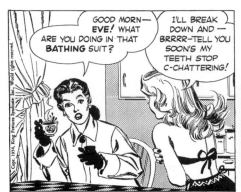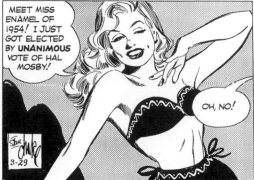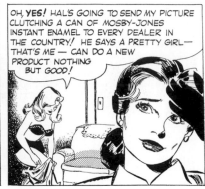

THE HEART OF JULIET JONES daily strip by Stan Drake. © 3/29/54

STAN DRAKE In 1953 Elliot Caplin teamed up with another top illustrator, Stan Drake, to create the sexy soap-opera strip *The Heart of Juliet Jones.* Caplin's story lines revolved around the romantic exploits of two sisters. Juliet, the brunette, was older and more sensible than Eve, an impulsive and trouble-prone blonde. Drake, a veteran of the Johnstone and Cushing advertising art agency, brought a slick, commercial approach to the feature and pioneered the use of photorealistic backgrounds. On October 13, 1970 (in the Sunday-page episode on the next page), Juliet finally tied the knot with Owen Cantrell, but the attorney was later murdered, renewing the contrasting love interests between the Jones siblings.

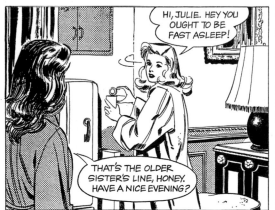

THE HEART OF JULIET JONES daily strip by Stan Drake. © 2/22/57. Courtesy of International Museum of Cartoon Art

THE HEART OF JULIET JONES daily strip by Stan Drake. © 9/6/66

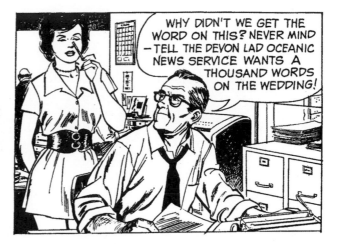

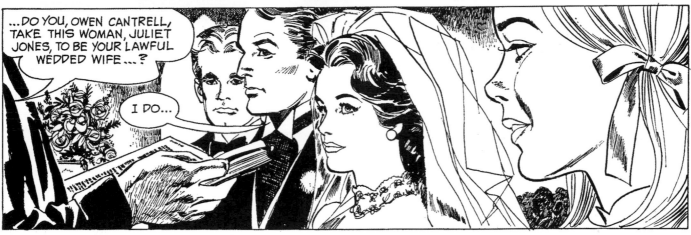

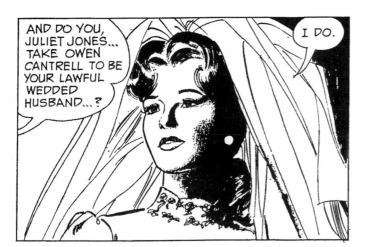

THE HEART OF JULIET JONES Sunday page by Stan Drake. © 10/18/70

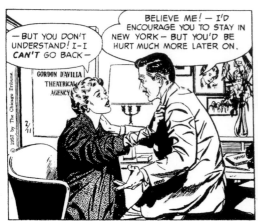
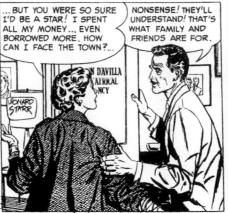
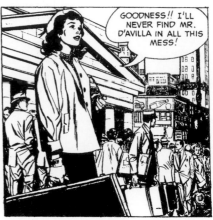

ON STAGE *daily-strip sequence by Leonard Starr. © 2/11–2/13/57*

LEONARD STARR Mary Perkins, the raven-haired heroine of Leonard Starr's stylish story strip, *On Stage*, was a small-town girl who came to New York City to seek fame and fortune in the Broadway theater. Mary's arrival is shown in the strips on this page from February 1957, the first week of the feature. Over the years dishonest agents, unappreciative directors, and back-stabbing actors never dimmed her optimism, and in 1959 she married her longtime suitor, photographer Pete Fletcher. Starr was one of the most respected illustrators and writers of his generation, and he was recognized as the "outstanding cartoonist of the year" in 1965. *On Stage* ended in 1979, when Starr was hired to launch the revived *Annie* comic strip.

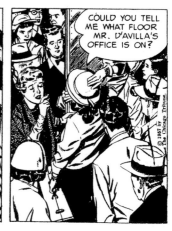

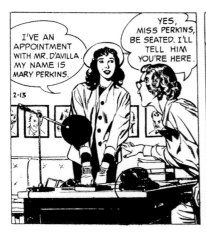
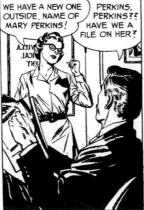
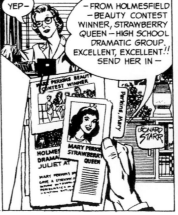

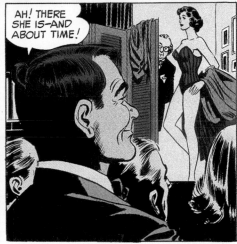

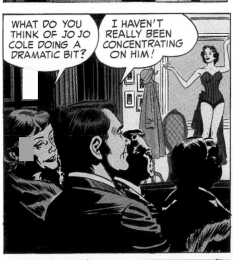
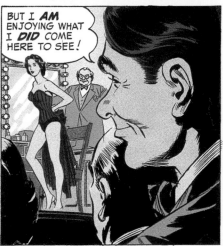
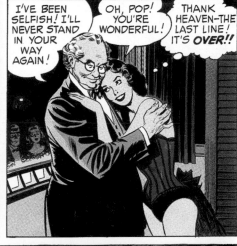

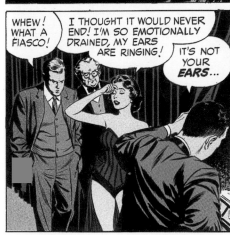
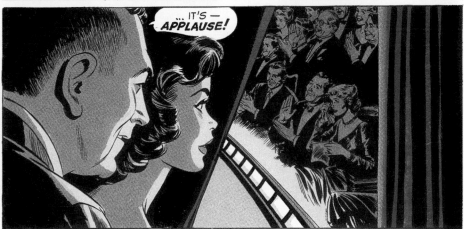

ON STAGE Sunday page by Leonard Starr. © 2/16/58

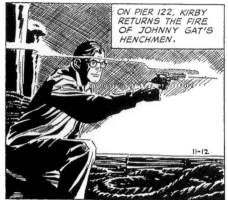 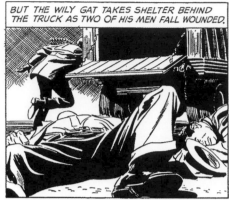 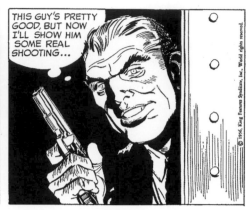

RIP KIRBY daily-strip sequence by John Prentice. © 11/12–11/14/56. King Features Syndicate, Inc.

JOHN PRENTICE

When Alex Raymond was killed in an automobile accident in 1956, John Prentice was selected by King Features Syndicate to take his place. The *Rip Kirby* strips shown here, unsigned by Prentice, are from the first story he illustrated. Prentice was the ideal choice because he had been an admirer of Raymond for many years. The transition was so seamless that many newspaper editors could not tell where Raymond's work ended and where Prentice's began. *Rip Kirby* by Prentice was recognized as Best Story Strip of the Year three times by the National Cartoonists Society and continued until Prentice's death in 1999.

 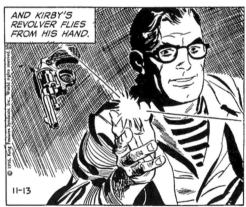

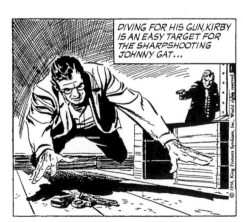 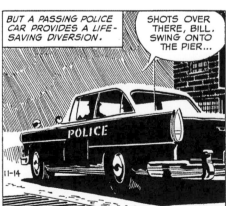 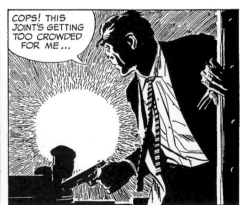

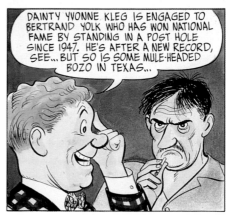

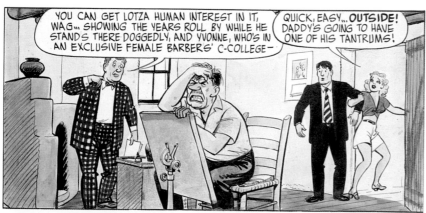

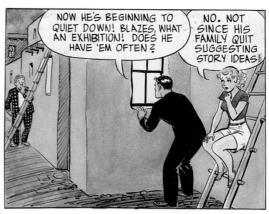

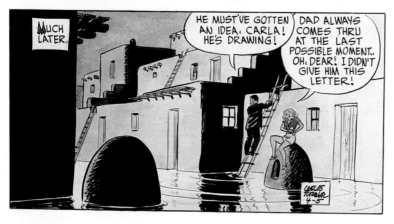

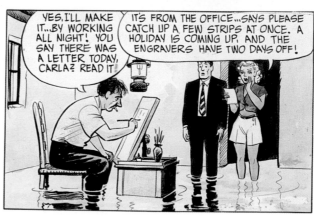

*CAPTAIN EASY hand-colored Sunday page by Leslie Turner. © 4/5/1950s by
NEA Service, Inc. Courtesy of International Museum of Cartoon Art*

LESLIE TURNER Historian Ron Goulart has described
Leslie Turner as "the best strip successor in the long history
of comics." Turner took over the humorous adventure feature
Wash Tubbs/Captain Easy from Roy Crane in 1943 and
continued it until 1970. Turner was responsible only for the
daily strips until 1952, when he took over the Sunday page
as well. This unusual autobiographical episode reveals the
pressure Turner must have been under trying to keep up
with his endless deadlines.

WESTERNS Among the many cowboy comic strips that were popular in the postwar era were *Red Ryder* (1938–64) by Fred Harmon, *Casey Ruggles* (1949–55) by Warren Tufts, *The Cisco Kid* (1951–68) by José-Luis Salinas, and *Rick O'Shay* (1958–81) by Stan Lynde.

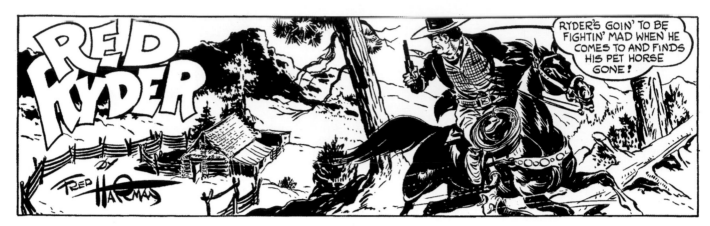

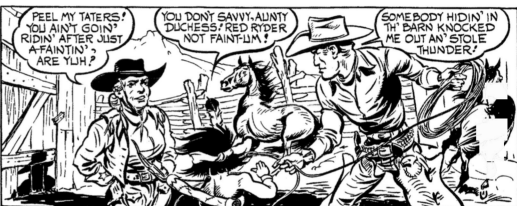

RED RYDER Sunday page by Fred Harmon. © 12/4/1950s NEA Service, Inc. Courtesy of International Museum of Cartoon Art

CASEY RUGGLES Sunday page by Warren Tufts. © 12/2/51 United Feature Syndicate, Inc.

THE CISCO KID daily strip by José-Luis Salinas. © 11/3/1950s King Features Syndicate, Inc. Courtesy of Jack Gilbert

RICK O'SHAY daily strip by Stan Lynde. © 9/18/58 Tribune Media Services, Inc. All rights reserved. Reprinted with permission. Courtesy of David Applegate

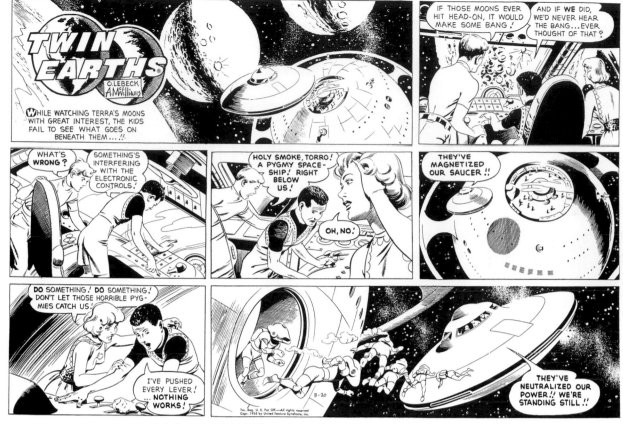

TWIN EARTHS Sunday page by O. LeBeck and A. McWilliams. © 3/20/55 United Feature Syndicate, Inc. Courtesy of International Museum of Cartoon Art

SCIENCE FICTION

The space race helped launch a number of new strips, including *Twin Earths* (1952–63) by Oskar LeBeck and Alden McWilliams and *Sky Masters* (1958–60) by Jack Kirby and Wally Wood. An updated version of the *Flash Gordon* daily strip, which began as a Sunday page in 1934, was released by King Features in 1952, with Dan Barry as the artist.

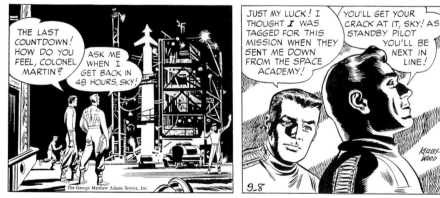

SKY MASTERS daily strip by Jack Kirby and Wally Wood. © 9/8/58 by The George Matthew Adams Service, Inc. Courtesy of TRH Gallery/Tom Horvitz

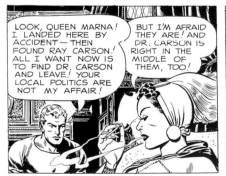

FLASH GORDON daily strip by Dan Barry. © 4/16/62 King Features Syndicate, Inc. Courtesy of TRH Gallery/Tom Horvitz

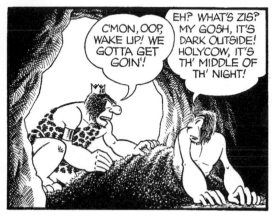
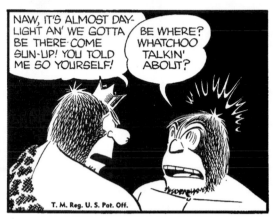

ALLEY OOP Sunday page by V. T. Hamlin. © 4/25/54 NEA Service, Inc.

V. T. HAMLIN *Alley Oop*, V. T. Hamlin's classic caveman comic, debuted in 1933 and was still going strong in the 1950s. Originally set in the Mesozoic era, Hamlin introduced time travel to the plotlines in 1939, enabling his hero to range freely through a variety of periods and locations.

This Sunday page from 1954 demonstrates how Hamlin, a student of paleontology, rendered dinosaurs and scenery somewhat realistically, while Alley Oop and King Guzzle were drawn to look like prehistoric Popeyes.

LITTLE ANNIE ROONEY daily strip by Darrell McClure. © 10/7/50 King Features Syndicate, Inc. Courtesy of International Museum of Cartoon Art

KIDS AND DOGS

In the tradition of Little Orphan Annie and Sandy, comic-strip juveniles inevitably had canine companions. Shown here are Little Annie Rooney and Zero by Darrell McClure, Rusty Riley and Flip by Frank Godwin, and Cap Stubbs and Tippie by Edwina Dumm. In the *Dondi* Sunday episode by Gus Edson and Irwin Hasen on the next page, the recently adopted war orphan brings home a sick dog, who gives birth to puppies in the basement of his foster home.

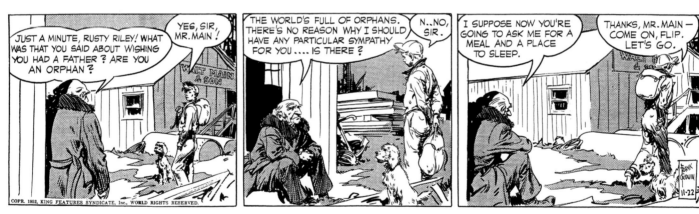

RUSTY RILEY daily strip by Frank Godwin. © 11/22/52 King Features Syndicate, Inc. Courtesy of International Museum of Cartoon Art

CAP STUBBS AND TIPPIE daily strip by Edwina Dumm, n.d. © by The George Matthew Adams Service, Inc. Courtesy of International Museum of Cartoon Art

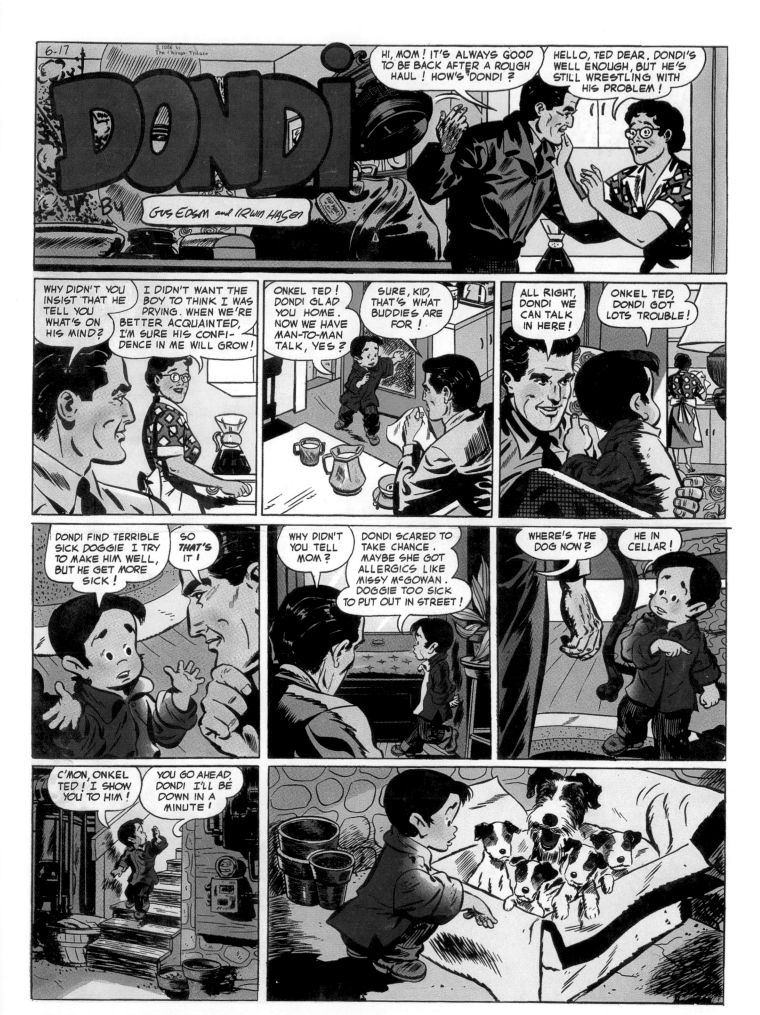

DONDI Sunday page by Gus Edson and Irwin Hasen. © 6/17/56 Tribune Media Services, Inc. All rights reserved. Used by permission. Courtesy of Richard Marschall.

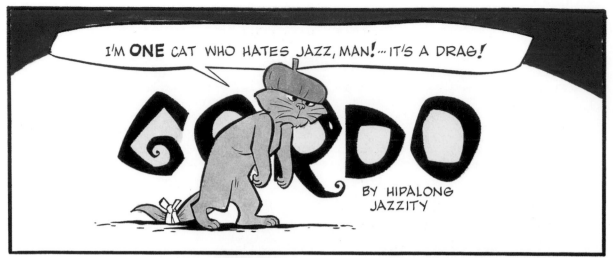

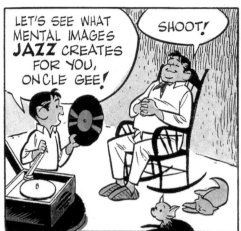

MODERN ART—In this abstract *GORDO* Sunday page from 1959, Gus Arriola provides a visual music appreciation lesson for his readers.
GORDO hand-colored Sunday page by **Gus Arriola**. © 1959 United Feature Syndicate, Inc. Courtesy of R. C. Harvey

mort walker

A COMPULSIVELY creative cartoonist, Mort Walker has conceived and supervised the production of nine syndicated comic strips since 1950, including *Beetle Bailey*, *Hi and Lois*, *Boner's Ark*, and *Sam and Silo*. He founded the Museum of Cartoon Art and served as president of the National Cartoonists Society and vice-president of the Newspaper Comics Council.

"If there is such a thing as being born into a profession, it happened to me," claimed Walker in the introduction to his autobiography. "From my first breath, all I ever wanted to be was a cartoonist." He drew cartoons for his school newspaper, *The Scarritt Scout*, when he was ten. He sold his first cartoon to *Child Life* magazine at the age of eleven. His earliest comic strip, *The Limejuicers*, ran in the *Kansas City Journal* when he was thirteen. He submitted his first idea to a national syndicate at the age of fifteen. By the time he graduated from high school, his work was polished and professional.

Walker held down a full-time job as a greeting-card designer for Hallmark while he attended Kansas City Junior College. In 1942 he was drafted into the army and served in Italy during the war. He kept an illustrated diary, and some of the G.I.s he met along the way later became inspirations for *Beetle Bailey* characters. When he returned home, he attended journalism school at the University of Missouri and was editor of the campus humor magazine, the *Showme*.

After graduation Walker was working as a magazine cartoonist in New York when John Bailey, the cartoon editor of the *Saturday Evening Post*, encouraged him to do some cartoons based on his college experiences. One character, a goof-off with a hat over his eyes named "Spider," emerged from these efforts. After selling a few college cartoons to the *Post*, Walker decided to submit a comic strip to King Features Syndicate starring Spider and his fraternity brothers. When King bought the strip, Mort changed Spider's first name to "Beetle" (another King strip, *Big Ben Bolt*, had a character named Spider) and added "Bailey" in honor of John Bailey.

Beetle Bailey debuted inauspiciously in twelve newspapers on September 4, 1950. The strip got a boost in circulation when Beetle enlisted in 1951, and again in 1954 when it was censored by the army brass for encouraging disrespect for officers. It continued to gain momentum, and by the mid-1960s only *Blondie* had more newspaper clients.

Beetle Bailey wasn't just about the army. The military pecking order of Camp Swampy represented all organizations in which incompetent bosses imposed pointless rules on those below them. Beetle was the classic low man on the totem pole who resisted authority. He became a hero to millions of readers.

Walker enjoyed working with other cartoonists, and his staff expanded as he continued to come up with ideas for new features. Eventually the studio became known as "King Features East," and the classic big-foot house style was dubbed "the Connecticut school." In 1975 Walker wrote *Backstage at the Strips*, a behind-the-scenes look at the workings of his laugh factory. He followed that in 1980 with *The Lexicon of Comicana*, a compendium of visual devices used by cartoonists, such as "plewds" (sweat drops), "hites" (speed lines), and "briffits" (dust clouds).

Over the years *Beetle Bailey* has been criticized for political incorrectness and challenged by newcomers to the comics field. Walker's creation endured and was still among the most popular features in the business when its fiftieth anniversary was celebrated in 2000.

"Someone said a diamond is just a piece of coal that stuck with the job," Walker mused. "To me the strip is a diamond. I never knew where that first step would take me and there were many rocky times, but a certain amount of fame and fortune were my reward for keeping at it."

It is ironic that Beetle Bailey, the laziest character in the history of comics, was created by Mort Walker, one of the hardest-working and most prolific cartoonists of all time.

SELF-CARICATURE by Mort Walker

BEETLE BAILEY daily strip by Mort Walker. © 10/22/63

BEETLE BAILEY daily strip by Mort Walker. © 5/5/65

BEETLE BAILEY daily strip by Mort Walker. © 3/29/67

BEETLE BAILEY daily strip by Mort Walker. © 1/6/70

BEETLE BAILEY hand-colored Sunday page by Mort Walker. © 1/1/60

BEETLE BAILEY daily strip by Mort Walker. © 5/22/70

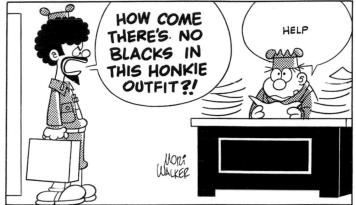

BEETLE BAILEY daily strip by Mort Walker (first appearance of Lt. Flap). © 10/5/70

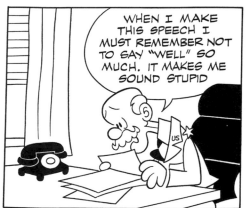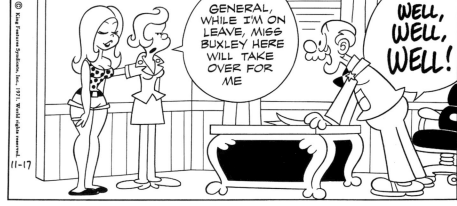

BEETLE BAILEY daily strip by Mort Walker (first appearance of Miss Buxley). © 11/17/71

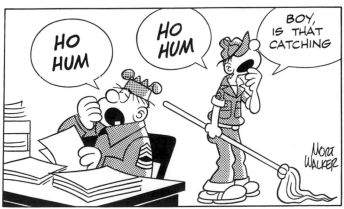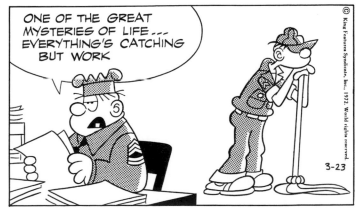

BEETLE BAILEY daily strip by Mort Walker. © 3/23/72

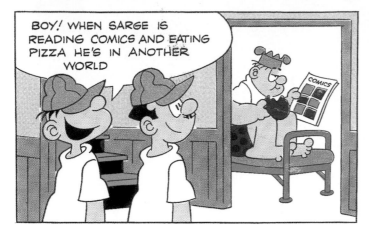

BOY! WHEN SARGE IS READING COMICS AND EATING PIZZA HE'S IN ANOTHER WORLD

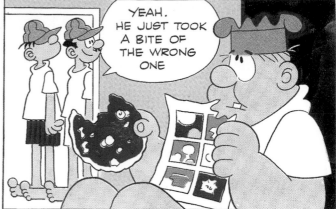

YEAH. HE JUST TOOK A BITE OF THE WRONG ONE

THE COMIC STRIP ADVENTURES OF **Li'l Orphan Orvie**

I'M TIRED OF WANDERING AROUND.. HOMELESS.. UNLOVED... BUT WHERE CAN I GO?

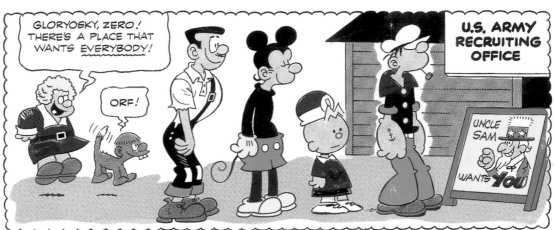

GLORYOSKY, ZERO! THERE'S A PLACE THAT WANTS EVERYBODY!

ORF!

U.S. ARMY RECRUITING OFFICE

UNCLE SAM WANTS **YOU**

GANGWAY!!

AFTER ALL THESE YEARS I'VE FOUND A REAL HOME! THE U.S. ARMY!!

BEAT IT, KID! GET LOST!

BUT (SOB) THE SIGN SAID UNCLE SAM NEEDS ME

GENERAL HALFBAT

GRRR

Y'OUTA YOUR SKULL?! WHY WOULD WE NEED A 45-YEAR-OLD, 260-POUND GIRL WITH EYE PROBLEMS?!

ZOT

HOME SWEET HOME

GEE! AM I GLAD I'M NOT IN THE COMICS

10-23

PIZZA

© King Features Syndicate, Inc., 1966. World rights reserved.

BEETLE BAILEY Sunday page by Mort Walker. © 10/23/66

HI and LOIS

HI AND LOIS daily strip by Mort Walker and Dik Browne. © 12/19/1960s

WALKER AND BROWNE The co-creators of *Hi and Lois* were the odd couple of cartooning. Mort Walker was as neat and orderly as Dik Browne was messy and disorganized. The two were friends and partners for thirty-five years. The Flagston family consisted of Hi, a decent, hardworking father, Lois, a pretty baby-boom mother, Chip, a mildly rebellious teenager, twins Dot (precocious) and Ditto (a cookie thief), and Trixie, the sunbeam kid. The cast was rounded out by Thirsty and Irma, the childless next-door neighbors, Abercrombie and Fitch, the garbagemen, Mr. Foofram, Hi's boss, and Dawg, the family pet. A reader once wrote to Walker and Browne about a favorite strip that struck a familiar chord. "You must have been looking through my window, because the same thing happened to me," she speculated. This family-friendly coziness was the secret to the success of *Hi and Lois.*

HI AND LOIS daily strip by Mort Walker and Dik Browne. © 5/16/62

HI AND LOIS daily strip by Mort Walker and Dik Browne. © 6/20/62

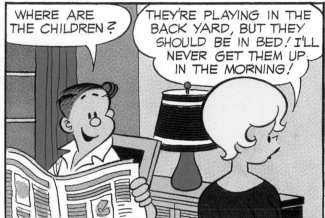

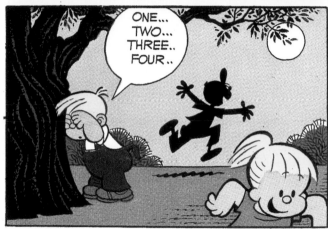

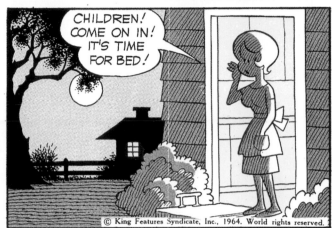

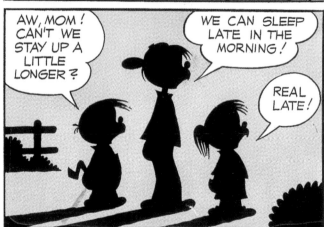

HI AND LOIS Sunday page by Mort Walker and Dik Browne. © 9/6/64

HI AND LOIS daily strip by Mort Walker and Dik Browne. © 6/28/65

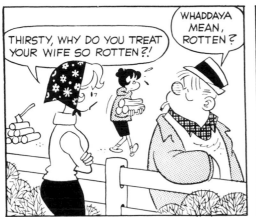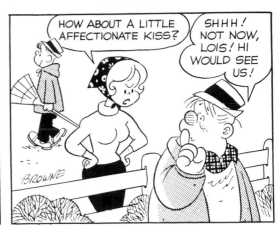

HI AND LOIS daily strip by Mort Walker and Dik Browne. © 12/10/65

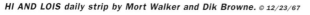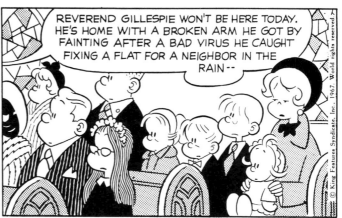

HI AND LOIS daily strip by Mort Walker and Dik Browne. © 12/23/67

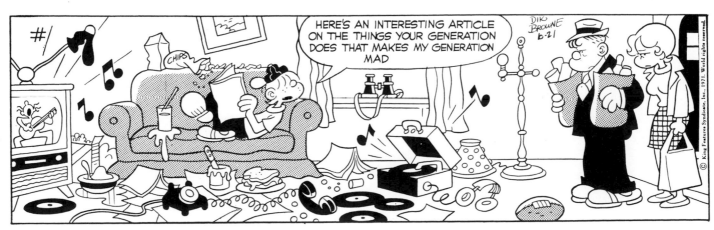

HI AND LOIS daily strip by Mort Walker and Dik Browne. © 6/21/71

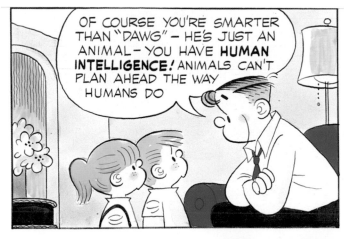

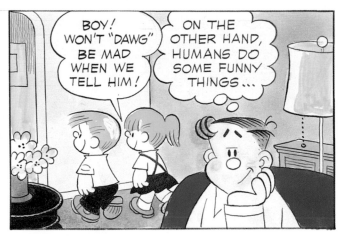

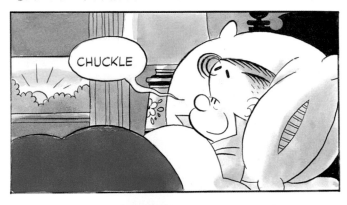

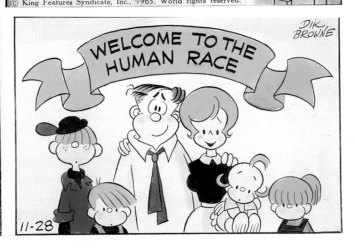

HI AND LOIS hand-colored Sunday page by Mort Walker and Dik Browne. © 11/28/65

charles schulz

SELF-CARICATURE by Charles Schulz

ON OCTOBER 2, 1950, an unassuming four-panel comic strip, with the curiously generic title *Peanuts*, debuted in seven newspapers. The strip's creator, Charles Monroe Schulz, kept his day job at the Art Instruction Schools in Minneapolis.

Peanuts grew slowly. In 1951 it was in thirty-five papers; a year later, forty-one; fifty-seven the next. A Sunday page was added in 1952, and by 1956 it finally passed the 100-paper mark in circulation.

During this time Schulz was refining his formula. The original cast—Charlie Brown, Shermy, Patty, and Snoopy—expanded to include Schroeder (1951), Violet (1951), Lucy and Linus (1952), and Pigpen (1954). As the decade progressed, Snoopy became more anthropomorphic. He began communicating with thought balloons in 1952 and started walking on two legs in 1956.

Each of the characters developed distinctive personalities and had a defined role in the ensemble. Charlie Brown, who started out as an obsessive perfectionist, became the quintessential loser. Lucy was the fussbudget, Linus the philosopher, Schroeder the artist, Pigpen the slob, and Snoopy the dreamer.

Schulz would place these pen-and-ink performers in different situations and let the sparks fly. Unlike the predictable pattern of most traditional gag strips, the humor in *Peanuts* was derived from the char-

PEANUTS daily strip by Charles Schulz. © 8/23/89

acters rather than the situations. "I introduced the slight incident," Schulz proudly explained. The dilemma of the day could be as insignificant as taking out the dog dish or kicking a football. It was how Schulz's kids responded to these minor events that produced the laughs.

Some of the slight incidents gradually evolved into running gags. The "twelve devices" that Schulz identified as crucial to the success of *Peanuts* were: 1. the kite-eating tree; 2. Schroeder's music; 3. Linus's security blanket; 4. Lucy's psychiatry booth; 5. Snoopy's doghouse; 6. Snoopy himself; 7. the Red Baron;

8. Woodstock; 9. the baseball games; 10. kicking the football; 11. the Great Pumpkin; 12. the little red-haired girl. These themes were repeated regularly, like the changing of the seasons, and gave readers a comforting sense of familiarity.

Adults rarely appeared in *Peanuts*. The children were left on their own to figure out the world they inhabited. The resulting conversations blended childlike innocence with grown-up concerns. In a very subtle way, Schulz was revealing the universality of human emotions. Readers of all ages saw their insecurities, frustrations, and fears reflected in the struggles of the *Peanuts* gang.

Graphically, Schulz was a master of minimalism. Charlie Brown could convey a wide range of emotions with the simple lines that floated within his large, round face. Schulz delighted in rendering Woodstock's scratchy dialogue or rain cascading down on the pitcher's mound. Backgrounds were indicated with a squiggle, lettering was customized to fit the mood of a situation, and comic sound effects were used effectively. Late in his career, Schulz's hand became unsteady. His lines, although shaky, were just as expressive as they had always been.

Schulz was the most influential cartoonist of his generation. "A comic strip like mine would never have existed if Charles Schulz hadn't paved the way," claimed Cathy Guisewite, creator of *Cathy*. "He broke new ground, doing a comic strip that dealt with real emotions, and characters people identified with."

Peanuts was an intimately autobiographical creation. "If you read the strip for just a few months, you will know me," said Schulz, "because everything that I am goes into the strip. That is me." Charles Schulz could be as philosophical as Linus, as insecure as Charlie Brown, or as crabby as Lucy. He was a shy and sensitive man who was easily wounded. He was also deeply religious and had an abiding faith in human resilience and eternal hope. His comic strip read like a daily letter to millions of his closest friends.

PEANUTS daily strip by Charles Schulz. © 9/27/56

All Peanuts strips by Charles Schulz © United Feature Syndicate, Inc.

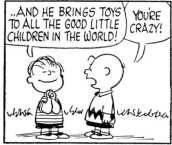
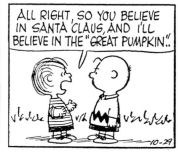
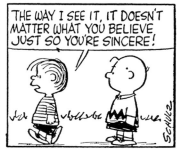

PEANUTS daily strip by Charles Schulz © 10/29/59

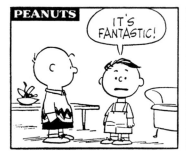

PEANUTS daily strip by Charles Schulz © 11/25/59

PEANUTS daily strip by Charles Schulz © 4/25/60

PEANUTS daily strip by Charles Schulz © 8/22/60

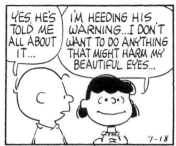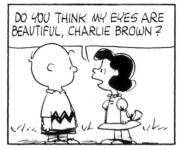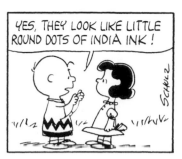

PEANUTS daily strip by Charles Schulz © 7/18/63

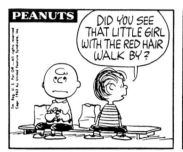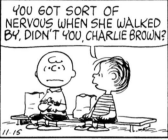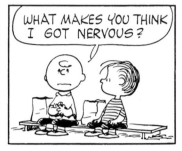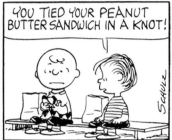

PEANUTS daily strip by Charles Schulz © 11/15/63

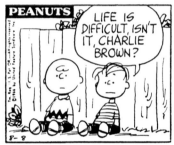

PEANUTS daily strip by Charles Schulz © 8/8/66

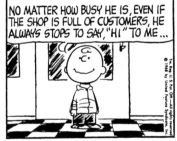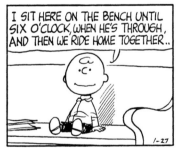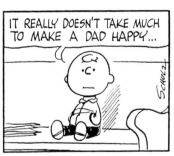

PEANUTS daily strip by Charles Schulz © 1/27/68

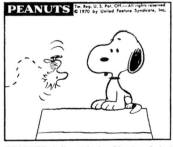

PEANUTS daily strip by Charles Schulz © 6/22/70

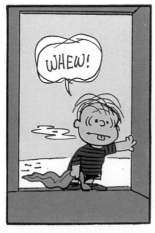
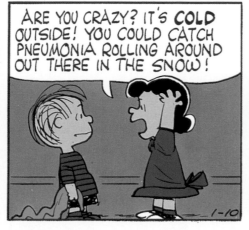
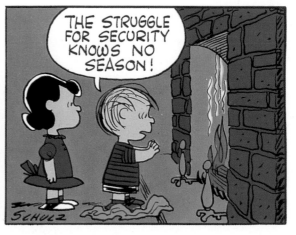

PEANUTS Sunday page by Charles Schulz © 1/10/60

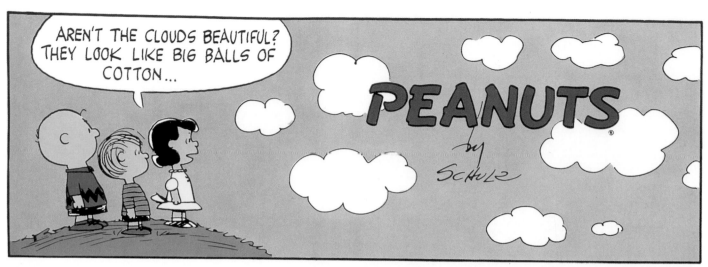

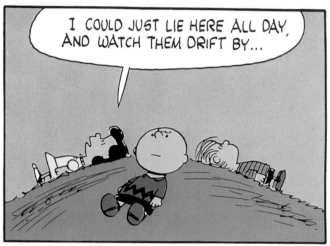

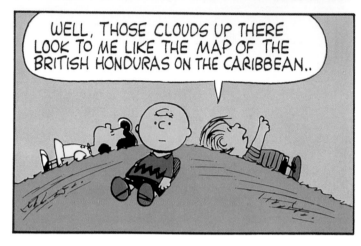

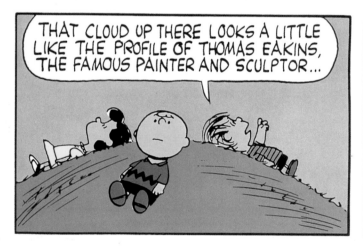

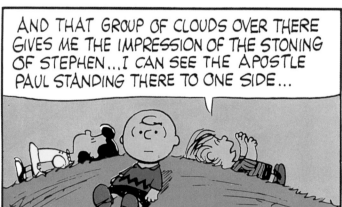

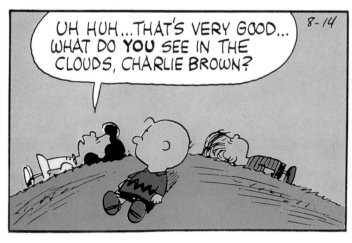

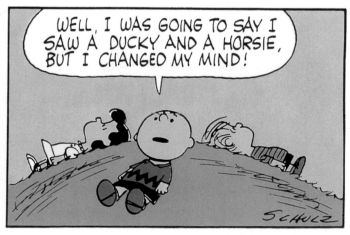

PEANUTS Sunday page by Charles Schulz © 8/14/60

 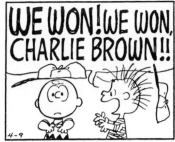 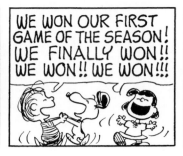

PEANUTS daily strip by Charles Schulz © 4/9/73

 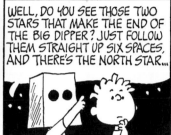 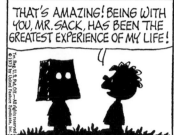 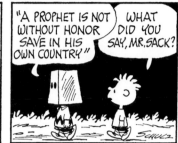

PEANUTS daily strip by Charles Schulz © 6/30/73

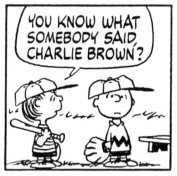

PEANUTS daily strip by Charles Schulz © 5/24/79

 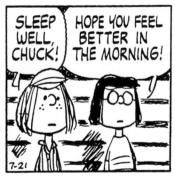 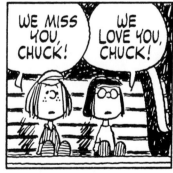 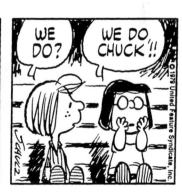

PEANUTS daily strip by Charles Schulz © 7/21/79

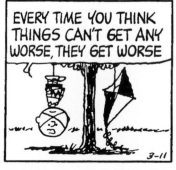

PEANUTS daily strip by Charles Schulz © 3/11/80

PEANUTS **Sunday page by Charles Schulz. © 12/24/67**

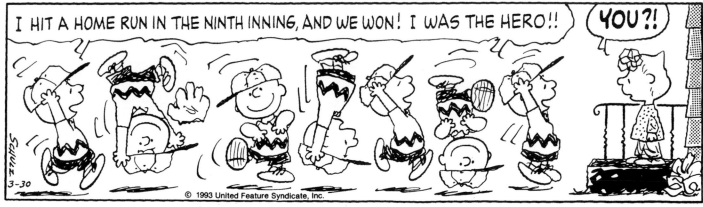

PEANUTS daily strip by Charles Schulz. © 3/30/93

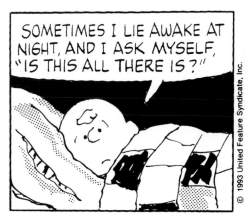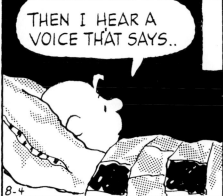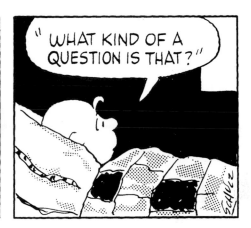

PEANUTS daily strip by Charles Schulz. © 8/4/93

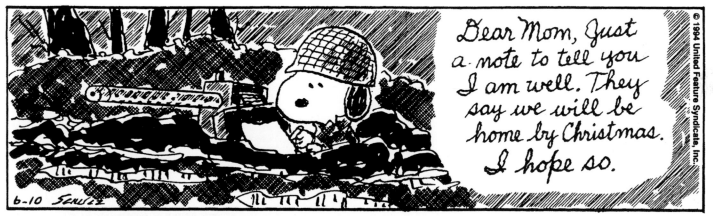

PEANUTS daily strip by Charles Schulz. © 6/10/94

PEANUTS daily strip by Charles Schulz. © 6/1/98

hank ketcham

DENNIS THE MENACE made his first appearance in sixteen newspapers on March 12, 1951. Fifty years and more than 18,000 daily installments later, Dennis was still a frisky "five-ana-half"-year-old bundle of fun.

When asked to explain Dennis's enduring appeal, his creator, Hank Ketcham, said with paternal pride, "He makes people smile and laugh when they read his words and see his actions, which expresses an innocence shared universally by five-year-olds. Some things fortunately never change."

Like Walt Kelly, Ketcham received his early art training at the Walt Disney Studio between 1939 and 1942. After serving in the navy during the war, he started selling gag cartoons to the major magazines in New York. In 1948 he moved to California, where he created his classic newspaper feature.

Putting his magazine experience to good use, Ketcham became a master of single-panel composition. "I'm like a director," he explained. "I set up the thing with the camera and spot the actors in a certain area. If I don't like it, I move the camera to the left or right or bring one of the people up close and balance it that way. When I have that figured out I go in and draw. I become the actor for every character. So it becomes an acting situation after you've done the staging."

Ketcham was a stickler for details. Objects such as bicycles, automobiles, and appliances had to be rendered accurately. His drawings never looked mechanical, however. Each composition was a perfect blend of graphic elements, creating the illusion of gazing through a window at a realistic setting. He was also a skilled draftsman. His lines were smooth and clean,

and he experimented endlessly with shading, silhouetting, and perspective.

SELF-CARICATURE by Hank Ketcham

Almost from the beginning, the central cast of *Dennis the Menace* was limited to Dennis, his parents Alice and Henry Mitchell, his dog Ruff, the next-door neighbors George and Martha Wilson, and friends Joey, Margaret, and Gina. They lived in a small Midwestern town with a main street, barbershop, soda fountain, schoolhouse, library, movie theater, restaurant, grocery store, and doctor's office. The houses were close together and had small backyards and white-picket fences.

Thematically, Ketcham adhered to a simple philosophy. "I make a point of staying away from the ugly side of life," he stated. "It's just my nature. I'd rather have upbeat things around me. Lord knows, there are enough things dragging you down."

Dennis tended to be insatiably curious rather than mischievous. When he did get in trouble, his parents made him sit in the corner in a rocking chair. At night Dennis would try to make amends with his bedtime prayers. Repeated situations like these reinforced Dennis's basically wholesome nature.

Ketcham employed many art assistants and gag writers over the years. In the early 1980s Ron Ferdinand took over the Sunday page, and in the mid-1990s Marcus Hamilton began producing the daily panel. Ketcham continued to closely supervise his creation until his death in 2001.

Dennis the Menace has had remarkable staying power. The King Features syndicated panel appears in over 1,000 newspapers around the world. Fifty million Dennis books have been sold since the first collection was published in 1952. The 1959–63 Jay North television series, as well as ninety-six animated programs and two live-action feature films, are being aired to a new generation of viewers. Dennis has transcended pen-and-ink to become an international cultural icon. Hank Ketcham raised him right.

(Nº 1. DRAWN OCT., 1950)

"GO AHEAD, DADDY — SQUIRT IT RIGHT IN HIS EYE!"

DENNIS NO. 1 drawn in October 1950, five months before the debut of the feature.

Dennis the Menace
by Hank Ketcham
The Perfect Day

"A BOY'S WILL IS THE WIND'S

WILL, AND THE THOUGHTS OF YOUTH ARE LONG,

LONG THOUGHTS." Henry Wadsworth Longfellow

DENNIS THE MENACE Sunday page by Hank Ketcham. © 6/7/81

"THIS IS MY MOTHER, TOMMY. ISN'T SHE PRETTY?"

DENNIS THE MENACE *daily panel by Hank Ketcham.* © 11/9/51

All Dennis the Menace artwork used by permission of Hank Ketcham Enterprises and © North America Syndicate.

"DENNIS!"

DENNIS THE MENACE *daily panel by Hank Ketcham.* © 2/18/53

IS THIS ALL?

Season's Greetings!
Hank Ketcham
12-25

DENNIS THE MENACE *daily panel by Hank Ketcham.* © 12/25/67

"YOU BETTER HURRY HOME, MARGARET! IT WOULD BE *TERRIBLE* IF YOU GOT STUCK HERE IN A BLIZZARD!"

DENNIS THE MENACE *daily panel by Hank Ketcham.* © 1/28/80

"I DON'T KNOW WHETHER TO BE A CARTOONIST WHEN I GROW UP, OR WORK FOR A LIVING."

DENNIS THE MENACE daily panel by Hank Ketcham. © 12/12/86

"YUP, FIVE YEARS OLD IS A VERY GOOD AGE FOR BOYS."

DENNIS THE MENACE daily panel by Hank Ketcham. © 11/24/86

"I DON'T LIKE THE WAY THIS YEAR'S STARTIN' OUT!"

DENNIS THE MENACE daily panel by Hank Ketcham. © 1/1/81

"FIRST, THE GOOD NEWS..."

DENNIS THE MENACE daily panel by Hank Ketcham. © 9/9/89

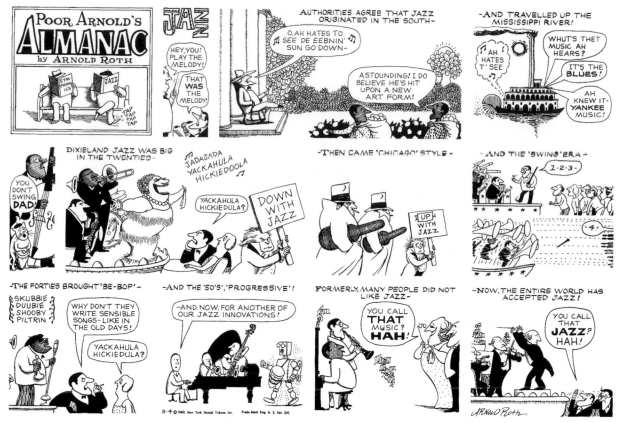

POOR ARNOLD'S ALMANAC Sunday page by Arnold Roth. © 9/4/60 New York Herald Tribune, Inc. Courtesy of Arnold Roth

THE NEW HUMOR A pair of innovative but short-lived humor features were introduced by the *New York Herald Tribune* in 1959. *Poor Arnold's Almanac* by Arnold Roth offered a clever visual digression on a different subject each Sunday, and *Tall Tales* by Al Jaffee was done daily in pantomime.

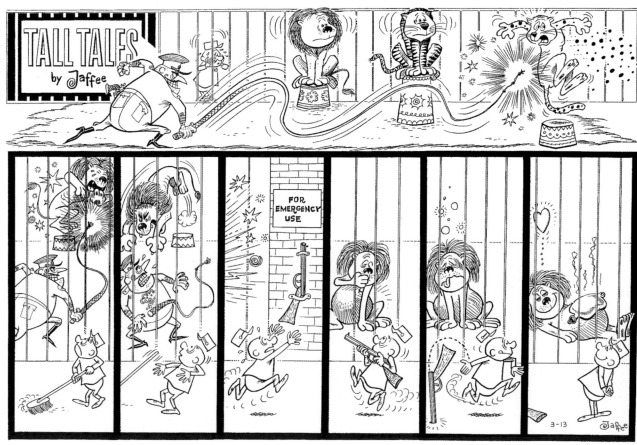

TALL TALES Sunday page by Al Jaffee. © 3/13/60 New York Herald Tribune, Inc. Courtesy of International Museum of Cartoon Art

the sixties

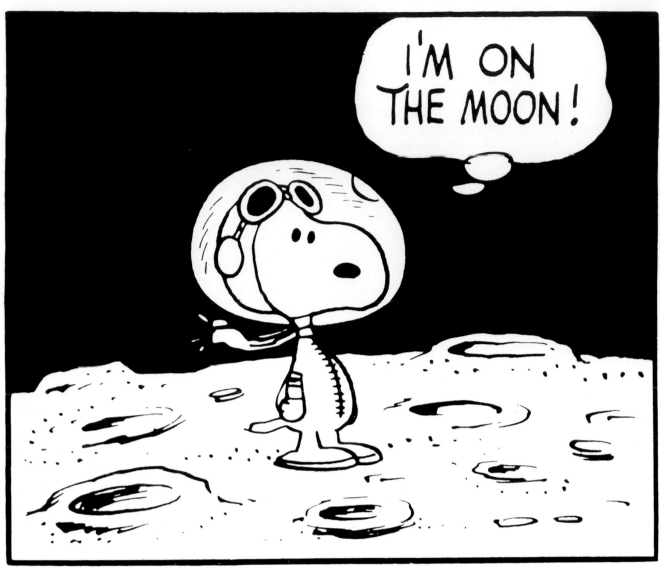

THE BEAGLE HAS LANDED—*"Snoopy on the Moon," panel from PEANUTS strip by Charles Schulz.* © 3/14/69 United Feature Syndicate, Inc.

THE MAJOR EVENTS AND SOCIAL CHANGES OF THE 1960S—THE KENNEDY ASSASSINATION, THE MOON LANDING, THE WAR IN VIETNAM, THE CIVIL RIGHTS MOVEMENT, THE CULTURAL REVOLUTION—WERE REFLECTED IN THE COMICS BUT DID NOT DIRECTLY INSPIRE ANY ENDURING CREATIONS. THE STARS OF THE FUNNIES PAGES WERE NOT ASTRO-NAUTS, HIPPIES, PROTESTERS, OR ROCK MUSICIANS. A LAZY ARMY PRIVATE, A FLYING BEAGLE, A MISCHIEVOUS TOWHEAD, AND AN ACERBIC CAVEMAN WERE AMONG THE MOST POPULAR PEN-AND-INK PERSONALITIES OF THE ERA.

It was a period of transition for the print media. During the decade at least 163 magazines ceased publication, including the 148-year-old *Saturday Evening Post*. The *Boston Traveler*, the *Houston Press*, the *Portland Reporter*, and the *Indianapolis Times* were among 160 daily newspapers that folded. The most dramatic failure was the 1967 demise of New York's *World Journal Tribune*. "*The Wijit*," which barely lasted for nine months, was the last chapter in a journalistic legacy that stretched back to the Park Row moguls of the nine-teenth century. Thirteen New York dailies could be found in the *W.J.T.*'s long ancestry of mergers, including Joseph Pulitzer's *World*, William Randolph Hearst's *Journal*, and James Gordon Bennett's *Herald*.

Newspaper strikes, rising production costs, and the loss of advertising revenue to television were all blamed for the crisis, but another force was also at work. During the decade, 176 new daily papers were launched. The large metropolitan newspapers were gradually being replaced by publishing ventures outside the cities. New York, the nation's largest urban market, lost more than half of its daily newspapers (from seven to three). At the same time the Gannett Company, which began publishing medium-size newspapers in New York, New Jersey, and Connecticut in the 1920s, expanded its holdings dramatically, from sixteen newspapers in 1957 to seventy-three dailies in 1977.

Summing up this trend, Stanford Smith, general manag-er of the American Newspaper Publishers Association, stated in 1963: "Where some newspapers have suspended, merged, or consolidated in some metropolitan cities since the end of World War II, new daily newspapers have been established

THE NEWSPAPER BUSINESS—"Growing with the Family," special FAMILY CIRCUS page by Bil Keane from **Editor** and **Publisher.** © 1964 The Register and Tribune Syndicate

in surrounding suburban communities so that the total number of newspapers has remained virtually constant while the total circulation has steadily increased."

This change had a major impact on the comics business. Syndicate salespeople had less leverage with editors in the growing number of cities that had only one newspaper. They could no longer threaten to take their strips "across town" when rate hikes were refused. At the same time, the number of cities with one or more daily newspapers also increased. This created new opportunities for the syndicates. Exclusive territories were being carved up into smaller portions, and the circulation figures for the top strips reached unprecedented highs. The immediate beneficiaries of this trend were the new humor strips. *Beetle Bailey*, *Peanuts*, *Dennis the Menace*, and *B.C.* were winning readership polls by the mid-1960s as their subscriber lists continued to grow.

The uneasy relationship between the comics business and television also began to change as syndicates discovered additional sources of revenue in the growing broadcast medium. In 1959 a successful live adaptation of Hank Ketcham's *Dennis the Menace*, starring Jay North, debuted on CBS. That same year the Ford Motor Company signed a licensing agreement with United Feature Syndicate for the advertising

rights to *Peanuts*. Charles Schulz's characters were animated in a series of television commercials for the Ford Falcon in the early 1960s. Newspaper editors argued that comic-strip characters, which had been promoted and popularized in their pages, should not be sold to the competition. Syndicates claimed that television and advertising increased the exposure of their features, which benefited both newspapers and creators. *A Charlie Brown Christmas*, which was originally broadcast on December 9, 1965, proved that comic-strip properties could be successfully adapted to television, without compromising the integrity of the newspaper feature.

The syndicates also turned television stars into comics characters. Yogi Bear, who made his first appearance on *The Huckleberry Hound Show* in 1958, received his own strip in 1961. *The Flintstones*, which debuted in 1960 as the first prime-time animated series, also became a newspaper feature in 1961. Although credited to Hanna Barbera Studios, both strips were drawn by animation artist Gene Hazelton. *Rocky and His Friends*, which premiered on ABC in 1959, was retitled *The Bullwinkle Show* in 1961 after its charismatic costar. A year later, a *Bullwinkle* comic strip, drawn by Al Kilgore, was released by the McClure Syndicate. "For some time now television has been cashing in on newspaper-built features,"

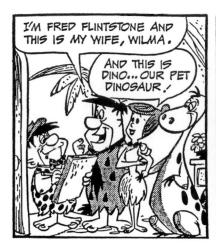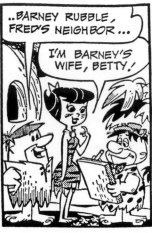

TV SPIN-OFF STRIP—THE FLINTSTONES daily strip by Hanna Barbera Productions. © 10/2/61 McNaught Syndicate

explained a syndicate spokesman. "*Bullwinkle* gives editors and publishers a turn-about opportunity to exploit a ready-made, enthusiastic audience."

Medical dramas were also popular on television in the early 1960s. Dr. Kildare, who was created by writer Max Brand in 1938, starred in a successful television series beginning in 1960. Ken Bald, a veteran comic-book artist, was selected to illustrate the *Dr. Kildare* comic strip, which was launched by King Features in 1962 and continued until 1983. Neal Adams, a twenty-four-year-old comic-book and advertising artist, took on the challenge of adapting *Ben Casey* to pen and ink later that same year. "The amazing thing about this young man," explained Ernest Lynn of the N.E.A. syndicate, "is the extraordinary likeness he bears to Vincent Edwards, the actor who plays Ben Casey on television." Adams was also a talented artist and, after the *Ben Casey* strip was discontinued in 1966, helped to revitalize such classic comic-book heroes as Batman, Green Lantern, and Green Arrow.

In 1962 William Steven, the editor of the *Houston Chronicle*, conducted an "unscientific and highly opinionated" poll of a dozen syndicate editors and salespeople. The twelve strips the voters regarded as "essential" to any comics page were (in alphabetical order): *Beetle Bailey*, *Blondie*, *Dennis the Menace*, *Dick Tracy*, *Family Circus*, *Grin & Bear It*, *Li'l Abner*,

Mary Worth, *Peanuts*, *Pogo*, *Rex Morgan*, and *Steve Canyon*. The old story-strip standbys seemed to be holding their ground against the new humor upstarts. But debuts of new romance and adventure strips were few and far between in the 1960s. The syndicates seemed convinced that the genre was dying, and editors claimed that readers no longer had the patience for continuity strips.

A few notable exceptions existed. *Apartment 3-G*, which debuted in 1961, revolved around the romantic adventures of three career girls. This stylish soap-opera strip was written by Nick Dallis, a former psychiatrist who also scripted *Rex Morgan* and *Judge Parker*, and illustrated by the veteran comic-book and commercial artist Alex Kotzky.

Al Williamson, a gifted draftsman who emulated the style of Alex Raymond, took over King Feature's *Secret Agent X-9* (renamed *Secret Agent Corrigan*) in 1967. In spite of the waning interest in adventure strips, Williamson maintained *Corrigan* as one of the best illustrated features in the business until he quit in 1980.

Other attempts at launching adventure strips in the 1960s suffered from bad timing. *Dan Flagg*, which debuted in 1963, starred a Marine Corps major and was illustrated by ex-Marine Don Sherwood, a former assistant to George Wunder on *Terry and the Pirates*. *Tales of the Green Beret*, which began two years later, was produced by Joe Kubert,

ILL-TIMED ADVENTURE—TALES OF THE GREEN BERET daily strip by Joe Kubert. © 4/4/66 Tribune Media Services, Inc. All rights reserved. Reprinted with permission

an accomplished comic-book artist, and Robin Moore, the author of the best-selling novel *The Green Berets*. With the Vietnam War escalating, the American public was not in the mood for military-themed adventure strips, and both features were short-lived.

A live-action *Batman* television series debuted on January 12, 1966. The campy comic-book spoof, starring Adam West as Batman, set off a wave of merchandising that included, not surprisingly, a new comic-strip adaptation. "The kids will love it for its deeds of derring-do, and adult newspaper readers are going to see the tongue-in-cheek camp and humor of it all," promised *Batman* creator Bob Kane. "To bring this across, I have developed a new art style that is pop, hard, clean, and flexible, and best suited to express both the action and humor contained in the script." *Batman & Robin* was produced by a competent string of DC comic-book artists, including Sheldon Moldoff, Carmine Infantino, Joe Giella, and Al Plastino, until it ended in 1974.

After the wave of political assassinations in the 1960s, editors became increasingly critical of violence on the funnies pages. On June 11, 1968, the *Greensboro* (N.C.) *Daily News* canceled *Dick Tracy* and *Little Orphan Annie* due to their "constant exploitation and advocacy of violence." Editor Charles Hauser added that "the June 7th *Tracy* strip summed it up in a panel that said 'Violence is golden when it's used to put down evil.'"

On September 26, 1968, the Newspaper Comics Council held a symposium on "Violence in the Comics." Dr. Joyce Brothers reported that, at a meeting of the American Psychiatric Association, doctors were asked if they thought fictional violence, as portrayed in comics, TV shows, and movies, promoted violent behavior. Thirty percent said yes; 24 percent said fictional violence actually helped to dissipate aggression. Dr. Brothers concluded that although the psychiatrists disagreed about the effects of graphic violence, there was a consensus that comic strips influenced the behavior of readers.

Milt Caniff, who also attended the conference, pointed out that violence existed in human society long before cartoons and that blaming the medium for the spread of aggressive behavior was illogical. "It's a schluffing off of responsibility on long-suffering comic artists," argued Caniff.

Adventure-strip creators struggled to keep their features relevant in the rapidly changing times. *Dick Tracy* entered the space age when Junior Tracy married Moon Maid in 1964. Terry and the Pirates fought the Viet Cong in Southeast Asia. Winnie Winkle joined the Peace Corps. Newspaper editors complained that the comics were becoming too serious. "Many comic-strip cartoonists are, with increasing frequency,

JUNIOR TRACY WEDS MOON MAID—Panel from DICK TRACY by Chester Gould. © 10/4/64 Tribune Media Services, Inc. All rights reserved

taking the pedestal to expound a wide range of cold war views without even a pretense of mockery or ridicule," complained newspaper reporter Dennis Blank in 1966. "Cartoonists can do a much better job of easing world tensions through humor."

Other journalists looked at this trend in a different way. On April 9, 1965, *Time* magazine featured a cover story on "Comment in the Comics." Bernard M. Auer wrote in his "Letter from the Publisher" that "the comics have gone through a slump as well as a renaissance" since Milton Caniff and Al Capp had appeared on the cover of *Time* in 1947 and 1950, respectively. After studying contemporary creations, Auer concluded that "more and more strips are offering political satire, psychology, and comments of varying subtlety on the rages and outrages of everyday life."

The majority of the *Time* piece, as well as the cover, was devoted to *Peanuts*, although other features, including *Li'l Abner*, *Pogo*, *B.C.*, *Miss Peach*, and *Beetle Bailey*, were cited as examples of increasing sophistication in modern humor strips.

Another group of cartoonists was taking social and political comment in new directions. Jules Feiffer started the movement with his weekly feature, which began national syndication in 1959. Feiffer attacked Nixon and Kennedy, segregationists and pseudoliberals with equal fervor. Editors had the option to reject his cartoon if they disagreed with the political sentiment or if they felt their readers might be offended. Feiffer argued that he was a satirist, not an editorial cartoonist. "The editorial cartoonist should look angry," he explained. "But the satirist is defeating himself when he reveals his true feelings."

BERRY'S WORLD

© 1969 by NEA, Inc.

"Oh, nothing—it's just that this is the first time I've ever seen you without your bell bottoms!"

SOCIAL COMMENT—BERRY'S WORLD by Jim Berry. © 1969 by NEA, Inc.

In 1963 N.E.A. released *Berry's World*, a single-panel cartoon that came out initially in triweekly installments. The creator, Jim Berry, was described as one of the "young moderns" of editorial cartooning who eschewed the labels and symbols of traditional political cartoons in favor of humorous social commentary. Newspaper editors were given the choice of running *Berry's World* on the editorial page or in any other part of the paper.

A handful of other syndicated features released in the 1960s also bridged the gap between humor strips and political cartoons. In Jerry Robinson's *Still Life*, inanimate objects made pithy observations about current events. Morrie Brickman's *the small society* was a single-panel strip that typically featured citizens and elected officials discussing the affairs of the day. Editors did not object to commentary in the comics as long as they knew beforehand what they were buying and were given the option to place the feature wherever they wanted in their newspapers. These creations blazed the path upon which Garry Trudeau's *Doonesbury* would soon follow.

The National Cartoonists Society held a roundtable discussion on "New Directions" in comics on April 20, 1964. One of the participants was Sylvan Byck, comics editor of King Features Syndicate. Byck stressed that successful features were built around strong characters. "Characterization is not new," he explained. "It started years ago in humor strips when cartoonists began to abandon the joke-book type of gag." Byck cited *Blondie* and *Beetle Bailey* as two outstanding comics that had well-developed characters.

Johnny Hart's two successful strips, *B.C.* and *The Wizard of Id*, added another element to the formula—situation comedy. Many new humor strips of the 1960s featured clearly defined characters who inhabited colorful locales, ranging from a desert island to an Indian reservation. As in *B.C.* and *The Wizard of Id*, none of these settings were historically accurate or realistic. They existed only in the imaginations of their creators and served as the stage upon which their pen-and-ink actors could perform.

The most surreal of the new humor strips was Mort Walker and Jerry Dumas's *Sam's Strip*, which debuted in 1961. Sam and his cartoonist assistant owned and operated the comic strip they inhabited. Famous cartoon characters, including The Yellow Kid, Jiggs, Dagwood, and Charlie Brown, would make walk-on appearances. Sam and his sidekick discussed the inner workings and hidden secrets of life within the panel borders. "Sam is in and of the world of drawing and comics and journalism," explained Dumas. "He exists in that abstract world where Krazy Kat still lives, though rarely seen today. It's a spiritual world of ideas, where Daumier and Happy Hooligan mix with Humpty Dumpty and Bing, Bang, Pow." The concept was too esoteric for most readers and *Sam's Strip*, which never appeared in more than sixty papers, was canceled in 1963.

Another offbeat creation was Howie Schneider's *Eek and Meek*, which made its first appearance on September 5, 1965. The two mouselike lead characters strolled through a minimally abstract world pondering the great mysteries of life. Schneider, who was often associated with the current intellectual movement in cartooning, saw his creation as an outlet for personal expression. In 1982 Eek and Meek miraculously transformed into human beings.

Two mid-decade offerings featured western locales. Tom K. Ryan's *Tumbleweeds* (1965) was set in the remote outpost of Grimy Gulch and starred a motley assortment of cowboys, Indians, lawmen, outlaws, and townspeople. When Gordon Bess's *Redeye* debuted in 1967, a King Features publicist claimed, "The gags and style of *Redeye* are on the 'wild' side. Although the characters are Indians and the setting is a reservation, the whole approach to humor is

as modern as mini-skirts. The strip is designed to appeal to those who are attracted to 'New Wave' comics, but it is not so far out it will miss the mark with the great mass of comic strip readers."

In 1968 Mort Walker's laugh factory produced another successful humor strip. *Boner's Ark* starred an inept sea captain who made the monumental mistake of bringing only one animal of each species on board his ark. Among the passengers were Arnie Aardvark, Priscilla Pig, Sandy Ostrich, Dum Dum the gorilla, Duke the penguin, and Rex the dinosaur. All of these creatures had distinctive personalities and interacted intimately on the aimlessly drifting vessel. *Boner's Ark* was continued by Frank Johnson until 2000.

Alf and Sandy, the lead players in Howie Post's 1968 creation, *The Dropouts*, were also stranded at sea. The "desert island gag" had always been a popular cliché for magazine cartoonists, and Post borrowed it as the setting for his new feature. After running out of fresh ideas in this limited locale, Post shipped *The Dropouts* to another island in 1969, which was inhabited by a colorful cast of misfits and outcasts.

Months before Beatlemania swept America, a British cartoon star invaded the nation's comics pages. Andy Capp, the diminutive Yorkshire limey with the oversized checkered cap, made his debut stateside on September 16, 1963. This popular anti-hero was created in 1957 by Reg Smythe

and appeared in twenty-eight countries before he was introduced to American newspaper readers. Although he never held down a job and spent his days sipping ale in a pub, Andy won the hearts of blue-collar readers around the world. In his early days, Andy was known to knock his poor wife Flossie to the ground and spend the night with a young barmaid, but Smythe eventually toned down the spousal abuse and adultery. "He's a horrible little man, really, and I'm always a little ashamed of the things he gets up to," Smythe admitted in a 1968 interview. "Oh I know he's a good giggle in the morning when the world gets up; but sometimes I worry about his behavior, the example he's setting."

Reg Smythe was not the only British cartoonist to cross the pond in the hopes of striking it rich in America. Harry Hanan relocated to New Jersey after his long-suffering nebbish, *Louie*, started appearing in American papers in 1947. Alex Graham's droll hound, *Fred Bassett*, made his U.S. debut in 1965. *Modesty Blaise*, a sophisticated spy thriller created by Peter O'Donnell and illustrated by Jim Holdaway, was imported from London in 1966.

Family-friendly comic strips continued to be the most popular genre during the 1960s. *Blondie* still had the largest list of subscribers, and *Peanuts*, *Dennis the Menace*, and *Hi and Lois* appeared regularly at the top of readership polls. One of the most successful new domestic features was Bil Keane's *Family Circus*, which debuted on February 29, 1960. Keane

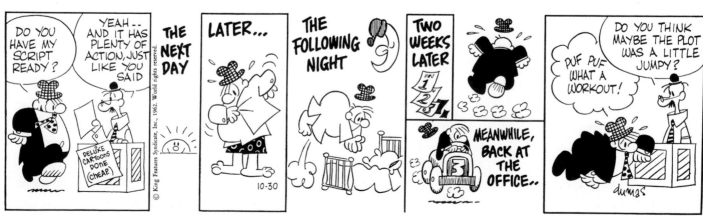

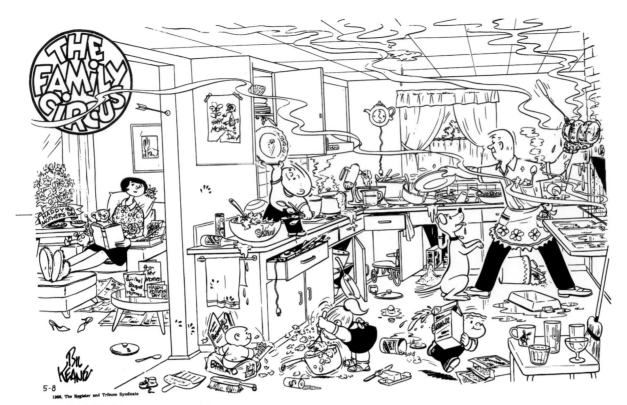

THE FAMILY CIRCUS Sunday page by Bil Keane. © 5/8/66

King Features Syndicate, Inc. Courtesy of Bil and Jeff Keane

sic comic kids like *Skippy* and *Reg'lar Fellers*. *Tiger* was drawn in a distinctive style, an elegant blend of flowing line and balanced composition, that earned Blake praise from his peers. It was voted Best Humor Comic Strip by the N.C.S. twice in the 1970s, again in 2000, and built a healthy list of 400 clients.

The feel-good domestic features were complemented on the comics pages by a group of new dysfunctional family comics. Art Sansom's *Born Loser*, which debuted in 1965, starred a bumbling breadwinner, Brutus T. Thornapple, who faced rejection and ridicule at home and at the office. King Features' answer to Andy Capp was Bob Weber's *Moose*, a lazy lowbrow who barely supported his family of five. The battle of the sexes was waged in daily installments by Leroy and Loretta Lockhorn, the childless couple in Bill Hoest's 1968 single-panel creation, *The Lockhorns*.

Among the other offerings in the gag-a-day genre in the 1960s were features that focused on individual family members. Lee Holley's *Ponytail* (1960) and Bernard Lansky's *Seventeen* (1956) were

had been producing *Channel Chuckles*, a TV-themed panel, for the Register and Tribune Syndicate since 1954. "The funniest things happen around the house," remarked Keane in an interview just before the launch of his new circular-shaped comic. "For the last year I have been loafing around our new desert home in Scottsdale, Arizona, just drawing what I see. And if my wife and our five little comic characters will forgive me, family life is just one cartoon after another."

The original cast of kids, Billy, Dolly, and Jeffy, was based on Keane's own children. *The Family Circus* was appearing in 125 newspapers in 1961, when readers were invited to guess the sex, birthdate, and name of a new arrival to the nation's comic pages. The baby boy, christened "Peter John," was called "PJ" by his siblings as soon as he came home from the hospital.

The public responded favorably to Keane's autobiographical feature. A poll taken in 1966 by the *Des Moines Register* revealed that *The Family Circus* was the favorite comic among all age groups, ahead of *Blondie*, *Peanuts*, and *Pogo*. Keane was voted Best Syndicated Panel creator by the National Cartoonists Society in 1967 as *The Family Circus* continued to grow in popularity.

Bud Blake's *Tiger* moved into the funnies neighborhood in 1965. The cast of the new strip—docile Tiger and his spotted dog Stripe, kid brother Punkinhead, dimwitted Hugo, brainy Julian, and precocious Suzy—was a throwback to clas-

A PIONEER—Self-caricature by Morrie Turner

INTEGRATION—PEANUTS daily strip (early appearance of Franklin) by Charles Schulz. © 11/12/69 United Feature Syndicate, Inc.

typical teenage fare. Jerry Marcus's *Trudy* (1963) was a hard-working housewife from the suburbs. Brad Anderson's *Marmaduke* (1954) was an ungainly house pet. *Amy*, a panel Jack Tippit inherited from Harry Mace in 1964, starred a female Dennis the Menace. In 1969 Ted Key's busybody maid, *Hazel*, made the transition from magazine and television stardom to the funnies pages.

Racial integration came late to the comics. Ethnic caricatures were a staple of the medium in its formative years but had fallen out of favor in the postwar period. It wasn't until the changes brought about by the civil rights movement in the 1960s that black cartoonists finally broke into the syndication business, and realistic black characters began appearing in major strips.

Immediately after the war, African Americans found work primarily in the black press. The *Chicago Defender*, the *Pittsburgh Courier*, and the *Baltimore Afro-American* were among the leading newspapers to publish comic strips by black cartoonists. One of the longest-running features was *Bungleton Green*, which debuted in 1920 and was continued by five different artists until 1968. Ollie Harrington (*Bootsie*) and Jackie Ormes (*Torchy Brown*) were also outstanding black cartoonists, who might have had a greater impact if they had been allowed to break into national syndication.

E. Simms Campbell was one of the first black artists to cross the color barrier. His cartoons of voluptuous white women in the pages of *Esquire* attracted the attention of King Features, which released the Sunday feature *Hoiman* in 1937 and the daily panel *Cuties* in 1943. *Cuties* lasted until Campbell's death in 1971. Very few readers were aware that Campbell was black, however.

Morrie Turner began submitting ideas to the syndicates in the 1950s, but it was not until 1965 that he finally sold a feature. *Wee Pals* was the first comic strip by a black artist to be syndicated to the mainstream press. It started in only five papers, but after the assassination of Martin Luther King, Jr., in 1968, Turner's list began to build. Other strips by black artists, starring black characters, soon followed. *Luther*, by Brumsic Brandon, Jr., debuted in 1968, and Ted Shearer's *Quincy* began in 1970.

All three creations starred children. "Black kids are much less threatening than black adults (to white editors and readers)," observed Brandon. "It's a shame that it's that way."

Creators of the leading humor features also experimented with adding black characters to their casts. Hank Ketcham made the fatal mistake of drawing his new *Dennis the Menace* character, Jackson, with racially stereotyped features. After protests erupted at a number of newspapers, Jackson went back into the ink bottle. Charles Schulz had better results with the inoffensive Franklin, who joined the *Peanuts* gang in 1969 but never became a major player in the strip. Lt. Flap, the first black character in *Beetle Bailey*, was initially controversial, but Mort Walker managed to diffuse criticism by making Flap a confident officer who was proud of his heritage.

A new adventure strip, *Dateline Danger*, was launched in 1968 with a black character in the leading role. Danny Raven was a news reporter and a former gridiron star who traveled the world in search of romance and adventure. Alden

SOUL BROTHER—Self-caricature by Ted Shearer

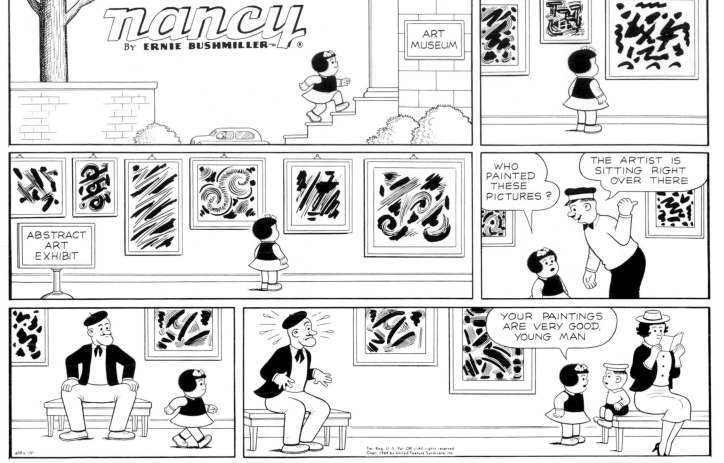

ABSTRACT ART—NANCY Sunday page by Ernie Bushmiller. © 4/19/64 United Feature Syndicate, Inc. *Courtesy of James T. Carlsson*

McWilliams, the illustrator of *Dateline Danger*, struggled at first with rendering black characters until he realized that "there is no such thing as a typical black face any more than there is a typical white one."

In 1969 Arthur Laro, the president of the Chicago Tribune New York News Syndicate, lamented that "for years America's 'invisible people'—the black people who make up ten percent of our newspaper readership—were unable to see themselves or to be seen in any but the most humble fictional roles." His solution to this inequity was a new comic strip, *Friday Foster*, which starred a black female fashion photographer.

By 1973 both *Dateline Danger* and *Friday Foster* were gone from the comics pages. Both strips, which were produced by white artists, had failed to attract a black audience. Although progress had been made toward integrating the comics, many barriers remained to be overcome.

Newspaper comic strips, like jazz, are an indigenous American art form. Yet they have often not been regarded highly in their country of origin. Americans appreciate the entertainment value of their popular arts but rarely take them seriously. The Europeans were the first to recognize both jazz and comics as forms of self-expression with a status equal to painting, sculpture, and classical music.

In 1967 the Decorative Arts Department of the Louvre in Paris featured an exhibition entitled *The Comic Strip and Narrative Figurative Art*. The main section of the display was devoted to American newspaper comics. In the 256-page book that accompanied the exhibition, a group of European scholars, the Société d'Etudes et de Recherches des Littératures Dessinées (Organization for the Study and Research of Pictorial Literatures), concluded that "the comic strip has created original works of which it can no longer be said that they are not art."

American cartoonists were unaccustomed to such high praise. "How did we ever make it to the Louvre?" marveled Milt Caniff. The National Cartoonists Society and the Newspaper Comics Council had held exhibitions at galleries and museums. They wondered if something more permanent could be established in the birthplace of the comics.

"It's wonderful to see that there's currently a renaissance of comics going on," remarked N.C.S. president Jerry Robinson in 1968. "We've had comics exhibitions all over the world and have many more planned. What we really do need, however, is a permanent home for both cartoonists and their work. Cartoons are housed in various museums all over the world and what we'd really like to get is a permanent National Museum for them." That dream would be realized in the next decade.

JACKYS DIARY Sunday page by Jack Mendelsohn. © 2/19/61 King Features Syndicate, Inc. Courtesy of International Museum of Cartoon Art

GRAPHIC MINIMALISM

The "new look" in sophisticated modern humor strips was pioneered by Jules Feiffer, Johnny Hart, Mell Lazarus, and Jack Mendelsohn in the late 1950s and early 1960s.

FEIFFER weekly page by Jules Feiffer © 1/12/64 Jules Feiffer. Used by permission of Universal Press Syndicate. All rights reserved. Courtesy of International Museum of Cartoon Art

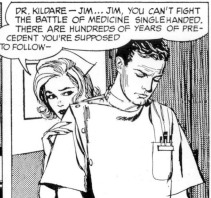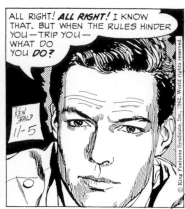

DR. KILDARE daily strip by Ken Bald. © 11/5/62 King Features Syndicate, Inc.

STORYTELLING

Among the relatively few new continuity features introduced during the 1960s were medical dramas and soap operas. *Dr. Kildare* (above) was based on the television program starring Richard Chamberlain that debuted in 1960. It was competently illustrated by Ken Bald and lasted for more than twenty years (1962–84). *Ben Casey*

(below), which was inspired by the TV show starring Vincent Edwards and was illustrated by Neal Adams, had a shorter run (1962–66). *Apartment 3-G* (bottom) revolved around the romantic adventures of three career girls and was written by Nicholas Dallis and illustrated by Alex Kotzky. It debuted in 1961 and is currently syndicated by King Features.

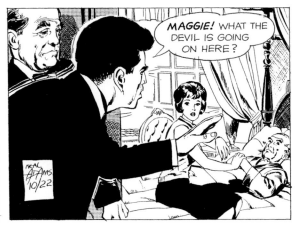

BEN CASEY daily strip by Neal Adams. © 10/22/64 NEA Inc. Courtesy of Jim Gauthier

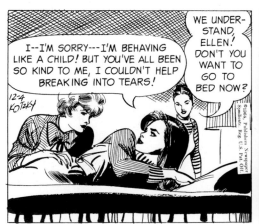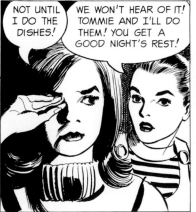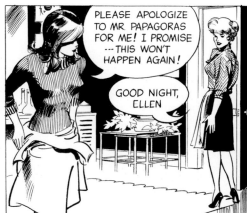

APARTMENT 3-G daily strip by Alex Kotzky. © 12/4/64 King Features Syndicate, Inc.

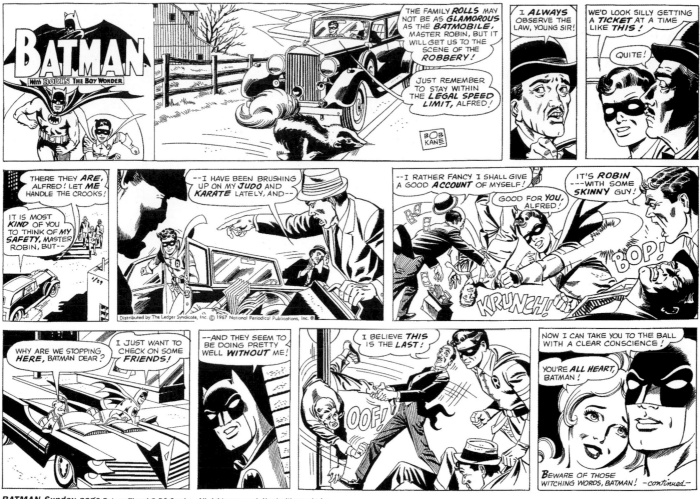

BATMAN Sunday page Batman™ and © DC Comics. All rights reserved. Used with permission.

THE THRILL IS GONE

Debuts of new adventure comics were even rarer in the 1960s. The *Batman* strip (above) was revived after the success of the television program starring Adam West and lasted for eight years (1966–74). Many of the adventure features that had been around since the 1930s got a new lease on life when they were taken over by younger artists. Sy Barry was hired to illustrate Lee Falk's long-running classic, *The Phantom* (below), in 1962 after Wilson McCoy passed away. The strip frequently focused on the relationship between the "ghost who walks" and Lady Diana, until their inevitable marriage in 1977.

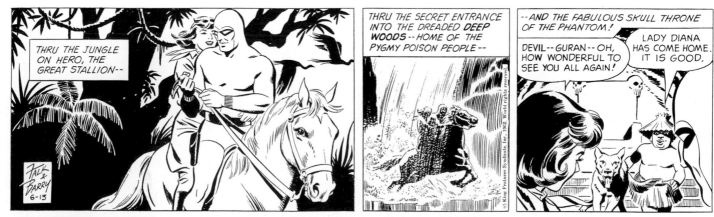

THE PHANTOM daily strip by Lee Falk and Sy Barry. © 6/13/62 King Features Syndicate, Inc. Courtesy of International Museum of Cartoon Art

"I don't ask that you agree with what I say, boys, but in a democracy you must defend to the death my right to deny having said it!"

GRIN AND BEAR IT daily panel by Lichty. © 8/19/64 Publishers Newspaper
Syndicate. Courtesy of Art Wood Collection

"WHAT ARE WE DOING ON THE MOON, WHEN WE HAVEN'T EVEN DEVELOPED AN INDUSTRIAL COMPLEX BIG ENOUGH TO ENDANGER OUR ENVIRONMENT?"

BERRY'S WORLD daily panel by Jim Berry. © 1970 NEA, Inc. Courtesy of
International Museum of Cartoon Art

SOCIAL COMMENT A number of artists explored
the boundaries between editorial cartoons and gag panels in
the 1960s. George Lichtenstein had been mining the fertile
fields of political satire in *Grin and Bear It* since 1932. "Lichty,"
who drew in a loose, free-flowing style, is best remembered
as the creator of the pompous Senator Snort (above). Jim
Berry, whose innovative panel *Berry's World* (above right)
debuted in 1963, used pencils and felt-tip pens to create a
spontaneous, contemporary look. Jerry Robinson employed
inanimate objects to voice his opinions in *Still Life* (right),
which began in 1963 and was followed by the self-syndicated
Life with Robinson in 1970. These features paved the way for
more direct political and social comment on the funnies pages.

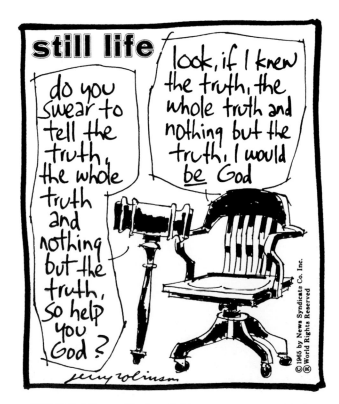

STILL LIFE daily panel by Jerry Robinson. © 1965 Tribune Media Services.
All rights reserved. Reprinted with permission

POPEYE daily strip by Bud Sagendorf. © 3/14/66 King Features Syndicate, Inc.

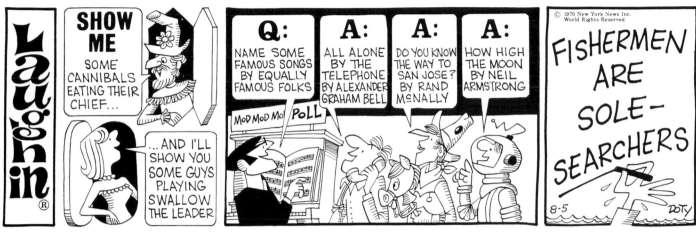

LAUGH-IN daily strip by Roy Doty. © 8/5/70 Tribune Media Services, Inc. All rights reserved. Reprinted with permission. Courtesy of International Museum of Cartoon Art

BIG-FOOT BOOM Humor strips of all types dominated the comics pages during the decade. Elzie Segar's former assistant, Bud Sagendorf, took over *Popeye* (top) in 1959 and continued to produce the daily and Sunday feature until 1986.

Roy Doty was hired to develop a comic strip (above) based on the *Laugh-In* television show in 1969. *Animal Crackers* (below) by Rog Bollen, which began in 1967, starred a cast of African game animals.

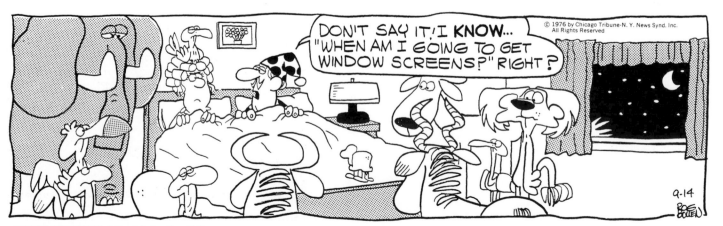

ANIMAL CRACKERS daily strip by Rog Bollen. © 9/14/76 Tribune Media Services, Inc. All rights reserved. Reprinted with permission. Courtesy of International Museum of Cartoon Art

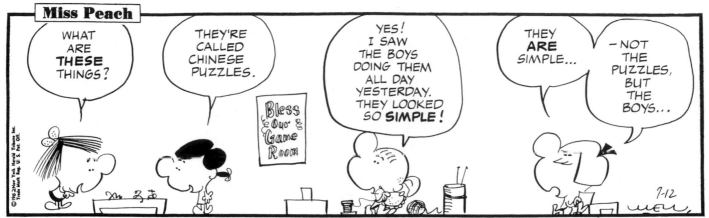

MISS PEACH daily strip by Mell Lazarus. © 7/12/62 Courtesy of International Museum of Cartoon Art

All Miss Peach strips © Creators Syndicate, Inc.

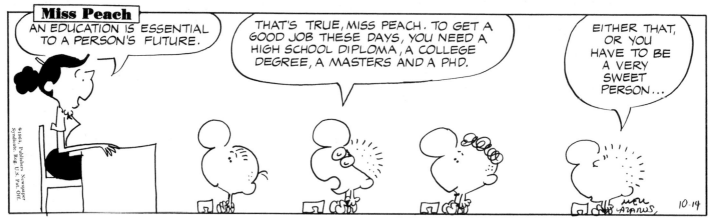

MISS PEACH daily strip by Mell Lazarus. © 10/14/64

MELL LAZARUS

Miss Peach, Mell Lazarus's 1957 creation, was initially inspired by the success of Charles Schulz's *Peanuts*. It combined simple graphics with sophisticated humor, pioneering a new "minimal" style that would influence a later generation of cartoonists. The star of Lazarus's single-panel daily strip was a well-meaning teacher who struggled to manage a classroom of big-headed, tiny tots. The students of the Kelly School, named after the creator of *Pogo*, included the brilliant Freddy, bossy Marcia, timid Ira, gullible Arthur, sickly Lester, and wily Francine. These kids mirrored the grown-up world by analyzing each other's problems, forming useless committees, and mimicking professional occupations. Lazarus created a second successful comic strip, *Momma*, in 1970 and was recognized by the National Cartoonists Society for his career achievements, winning the Reuben Award in 1981.

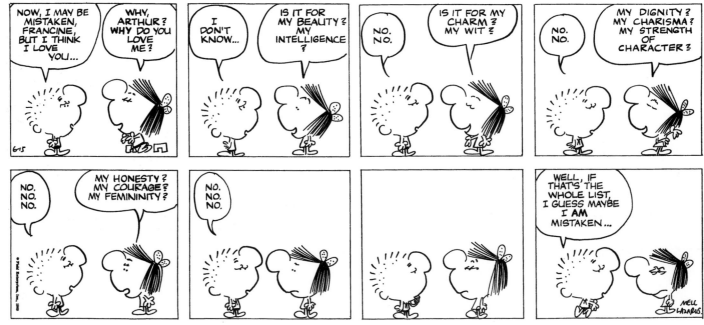

MISS PEACH Sunday page by Mell Lazarus. © 6/15/69 Courtesy of International Museum of Cartoon Art

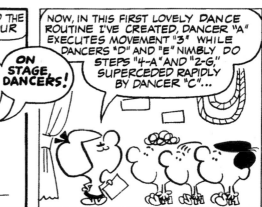
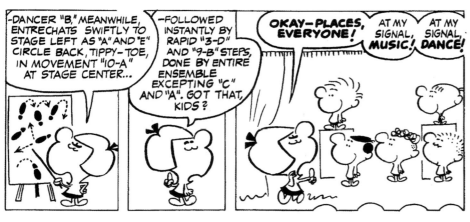
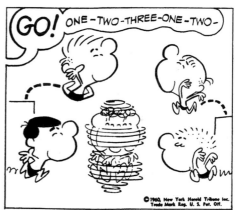
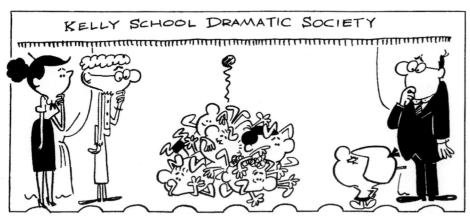

MISS PEACH Sunday page by Mell Lazarus. © 2/21/60 New York Herald Tribune Inc. Courtesy of Richard Marschall

johnny hart

SELF-CARICATURE by Johnny Hart

THE CREATOR of two classic humor strips, *B.C.* and *The Wizard of Id*, Johnny Hart is serious about being funny. "The comic field is an exciting one," he says. "It is made up principally of people who have refused to grow up and who offer their marvelous fantasies to those who wish they hadn't."

Born in Endicott, New York, in 1931, Hart was the oldest of three children. He began drawing cartoons as far back as he can remember. His formal education ended after he graduated from high school. At the age of nineteen, Hart met a young cartoonist from California who would become a major influence in his life. Brant Parker had worked at the Walt Disney Studio as an "in-betweener" and encouraged Hart to pursue a career in cartooning. Years later the two would collaborate on the *The Wizard of Id*.

After a tour in the Air Force, Hart began submitting cartoons to the national magazines. He made his first sale to the *Saturday Evening Post* for $65 in 1954. Realizing he couldn't support a family on such a meager income, he took a job in the art department at General Electric in Endicott. He also continued to sell cartoons to the *Saturday Evening Post, Collier's,* and *Redbook*.

"Caveman gags, for reasons which I still cannot explain, were an obsession in those days," remembered Hart, "although I must reluctantly confess, I have not sold a caveman gag to a magazine, to this date." Inspired by the success of Charles Schulz, he decided to create a comic strip. "Why don't you make it a caveman strip?" joked one of his coworkers. "You can't seem to sell them anywhere else."

Hart took on the challenge. After being rejected by five other syndicates, he finally sold his concept to the Herald Tribune. *B.C.* first appeared in thirty newspapers on February 17, 1958, just before Hart's twenty-seventh birthday. Six years later, on November 9, 1964, his second creation, *The Wizard of Id*, debuted.

B.C. was voted Best Humor Strip in 1967 and *The Wizard of Id* earned that distinction five times (1971, 1976, 1980, 1982, and 1983). Hart won the Reuben Award in 1968, and in 1973 *B.C. The First Thanksgiving* was chosen as the best animated film of the year by the National Cartoonists Society.

The central cast of *B.C.*, which was based on many of Hart's friends and family, included B.C. the innocent everyman, Curls the wise guy, Wiley the poet, Peter the genius, Thor the inventor, Clumsy Carp the ichthyologist, Grog the proto-caveman, and two females, Fat Broad and Cute Chick.

At first the humor in *B.C.* was essentially derived from the contrast between the prehistoric setting and the modern proclivities of its characters. Eventually Hart branched out into clever wordplay, slapstick, and cosmological musings.

The original lineup in *The Wizard of Id* consisted of the diminutive King, Bung the drunken court jester, Rodney the cowardly knight, Spook the prisoner, Gwen the fair maiden, the inept Wizard, and his nagging wife, Blanch.

Set in the medieval kingdom of Id, *Wizard* also relied on the interplay between its historical setting and contemporary references. Hart, along with his team of Jack Caprio, Dick Boland, and Dick Cavalli, supplied gags for both strips, while Parker was responsible for the artwork on *Wizard*.

Beginning in 1984 Hart had a gradual religious conversion and eventually began expressing his new-found Christian faith in *B.C.* Not wanting to be perceived as "a whacked-out religious-zealous fanatic," Hart maintained a playfully philosophical attitude about his beliefs. "Entertaining isn't always funny," he argues. "We entertain thoughts." Hart believes that humor is a form of salvation.

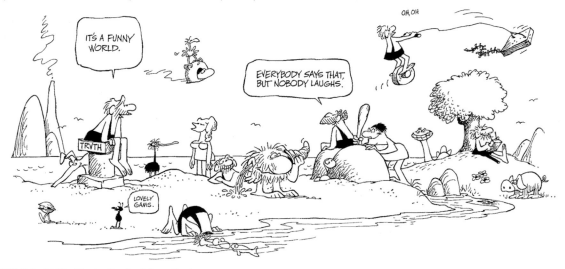

THE B.C. CAST—illustration by Johnny Hart

B.C. Sunday page by Johnny Hart. © 6/19/66

All B.C. and The Wizard of Id comic strips © Creators Syndicate, Inc. Courtesy of John Hart Studio

B.C. daily strip by Johnny Hart. © 10/12/66

B.C. daily strip by Johnny Hart. © 10/25/67

B.C. daily strip by Johnny Hart. © 2/6/70

B.C. daily strip by Johnny Hart. © 2/9/70

B.C. daily strip by Johnny Hart. © 1/19/72

B.C. daily strip by Johnny Hart. © 10/24/72

B.C. daily strip by Johnny Hart. © 7/30/79

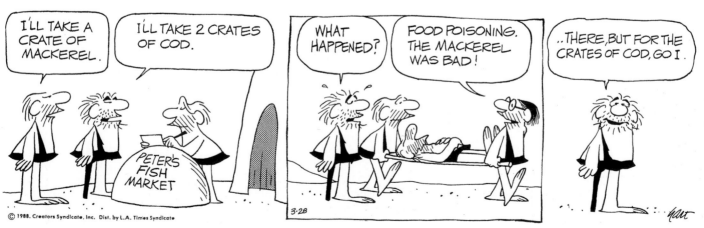

B.C. daily strip by Johnny Hart. © 3/28/88

B.C. Sunday page by Johnny Hart. © 7/29/90

THE WIZARD OF ID Sunday page by Brant Parker and Johnny Hart. © 11/2/75

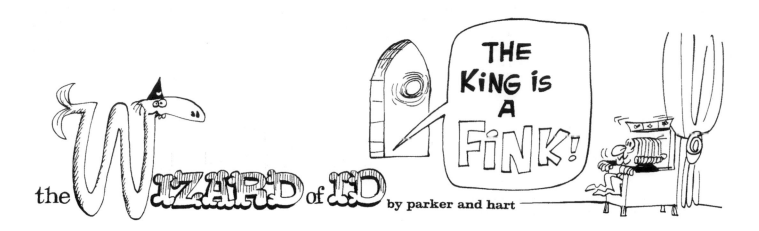

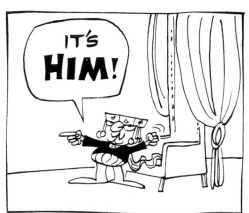
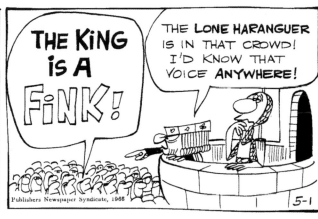

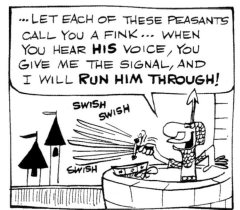
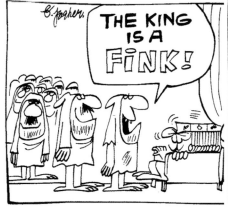
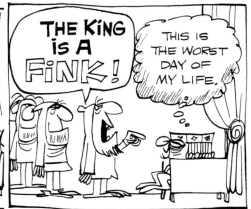

THE WIZARD OF ID Sunday page by Brant Parker and Johnny Hart. © 5/1/65

THE WIZARD OF ID daily strip by Brant Parker and Johnny Hart. © 5/3/65

THE WIZARD OF ID daily strip by Brant Parker and Johnny Hart. © 1/7/66

THE WIZARD OF ID daily strip by Brant Parker and Johnny Hart. © 6/10/66

THE WIZARD OF ID daily strip by Brant Parker and Johnny Hart. © 10/20/88

SAM'S STRIP daily strip by Mort Walker and Jerry Dumas. © 11/9/61

WALKER AND DUMAS

Sam's Strip was ahead of its time when it debuted in 1961. Mort Walker and Jerry Dumas's offbeat creation took the inside joke to a new level, playing with the basic elements of the cartoon form, experimenting with different art styles, and featuring guest appearances by famous characters from other strips. This type of self-referential humor, called "metacomics" by scholar Thomas Inge, had been explored previously by Al Capp, Ernie Bushmiller, and Walt Kelly and has been used on a more regular basis by such contemporary cartoonists as Garry Trudeau, Berke Breathed, and Bill Griffith. *Sam's Strip* had a brief life (twenty months), but it is considered a cult classic among comic-strip aficionados today.

SAM'S STRIP daily strip by Mort Walker and Jerry Dumas. © 3/2/62

SAM'S STRIP daily strip by Mort Walker and Jerry Dumas. © 10/3/62

SAM'S STRIP daily strip by Mort Walker and Jerry Dumas. © 5/3/62

SAM'S STRIP daily strip by Mort Walker and Jerry Dumas. © 10/31/61

SAM'S STRIP daily strip by Mort Walker and Jerry Dumas. © 8/16/62

SAM'S STRIP daily strip by Mort Walker and Jerry Dumas. © 9/5/62

EEK AND MEEK *daily strip by Howie Schneider.* © 10/11/71 NEA, Inc.

THE NEW WAVE Colorful characters, unusual settings, and a distinctive graphic style were the defining characteristics of the new humor strips that proliferated in the 1960s. Among the many outstanding features that debuted were *Eek and Meek* (1965) by Howie Schneider, about a pair of philosophizing rodents (above); *The Dropouts* (1968) by Howard Post, two shipwrecked castaways on a desert island who observed contemporary civilization from afar (below); *The Born Loser* (1965) by Art Sansom, otherwise known as Brutus P. Thornapple, the Rodney Dangerfield of the comics (bottom); and *Boner's Ark* (1968) by Addison (Mort Walker), helmed by a bungling sea captain who brought along only one animal of each species on his leaky vessel (next page).

THE DROPOUTS *daily strip by Howard Post.* © 3/14/74 United Feature Syndicate, Inc. Courtesy of International Museum of Cartoon Art

THE BORN LOSER *daily strip by Art Sansom.* © 4/30/73 NEA, Inc. Courtesy of International Museum of Cartoon Art

BONER'S ARK Sunday page by Addison. © 7/21/68 King Features Syndicate, Inc. Courtesy of Comicana, Inc

TUMBLEWEEDS *daily strip by T. K. Ryan.* © 7/16/66 North America Syndicate, Inc.

THE NEW WAVE (CONTINUED)

Western locales were also popular during the decade. Tom K. Ryan's *Tumbleweeds* (1965) featured an eccentric cast of cowboys, Indians, and townsfolk, a quirky big-foot style, and a dry sense of humor that was appropriate to the setting. *Redeye* (1967), which starred an equally inept tribe of Native Americans, was created by Gordon Bess, who lived in Utah and Idaho for most of his life. This firsthand knowledge brought a touch of authenticity to the strip. Morrie Brickman's *the small society* (1966) took place in a more contemporary milieu as generic civilians, businessmen, and politicians debated current events, often with the U.S. Capitol dome or an urban skyline in the background.

TUMBLEWEEDS *Sunday page by T. K. Ryan.* © 2/17/74 North America Syndicate, Inc. Courtesy of International Museum of Cartoon Art

TUMBLEWEEDS *daily strip by T. K. Ryan.* © 2/22/79 North America Syndicate, Inc.

REDEYE hand-colored Sunday page by Gordon Bess. © 10/12/1960s King Features Syndicate, Inc. Courtesy of International Museum of Cartoon Art

The Small Society
by BRICKMAN

THE SMALL SOCIETY hand-colored Sunday page by Morrie Brickman. © 7/28/68 Washington Star Syndicate, Inc. Courtesy of International Museum of Cartoon Art

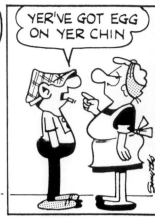

ANDY CAPP daily strip by Reg Smythe. © 8/4/64 Creators Syndicate, Inc.

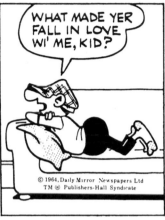
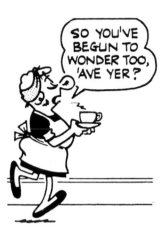

ANDY CAPP daily strip by Reg Smythe. © 9/21/64 Creators Syndicate, Inc.

ANDY CAPP daily strip by Reg Smythe © 8/14/69 Creators Syndicate, Inc.

ANDY CAPP daily strip by Reg Smythe © 9/18/69 Creators Syndicate, Inc.

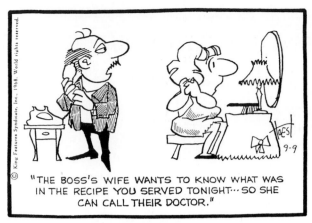

THE LOCKHORNS daily panel by Bill Hoest. © 9/9/68 King Features Syndicate, Inc.

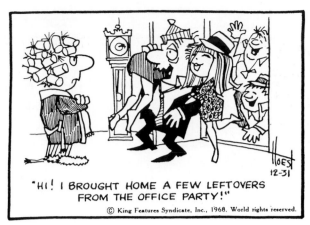

"HI! I BROUGHT HOME A FEW LEFTOVERS FROM THE OFFICE PARTY!"

THE LOCKHORNS daily panel by Bill Hoest. © 12/31/68 King Features Syndicate, Inc.

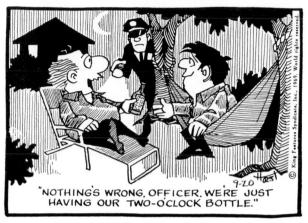

"NOTHING'S WRONG, OFFICER. WE'RE JUST HAVING OUR TWO-O'CLOCK BOTTLE."

THE LOCKHORNS daily panel by Bill Hoest. © 9/20/69 King Features Syndicate, Inc.

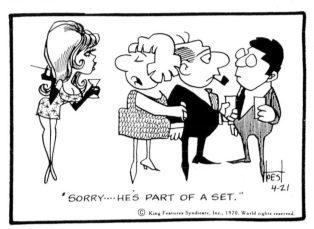

"SORRY… HE'S PART OF A SET."

THE LOCKHORNS daily panel by Bill Hoest. © 4/21/70 King Features Syndicate, Inc.

DOMESTIC DYSFUNCTION

The battle of the sexes was waged with renewed vigor in two 1960s comic features. Reg Smythe's *Andy Capp* (previous page), who made his British debut in 1957 and was imported to America in 1963, became a hero to readers around the world for his antisocial behavior. Leroy and Loretta Lockhorn, who first appeared on September 9, 1968 (upper left), in Bill Hoest's daily panel, *The Lockhorns*, were a throwback to the storm and strife of Maggie and Jiggs in their prime. These features must have provided some comic relief to readers who might have experienced increasing marital tension during the early years of the feminist movement.

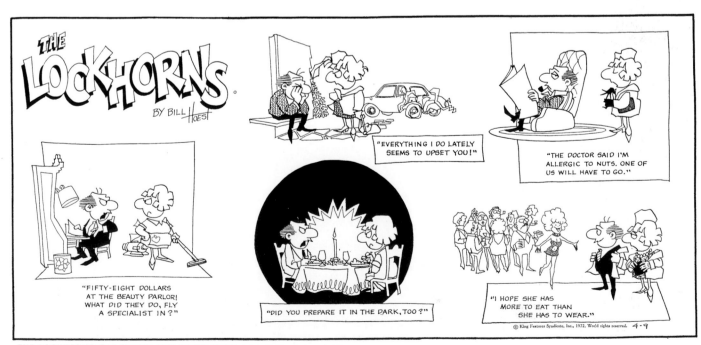

THE LOCKHORNS first Sunday page by Bill Hoest. © 4/9/72 King Features Syndicate, Inc.

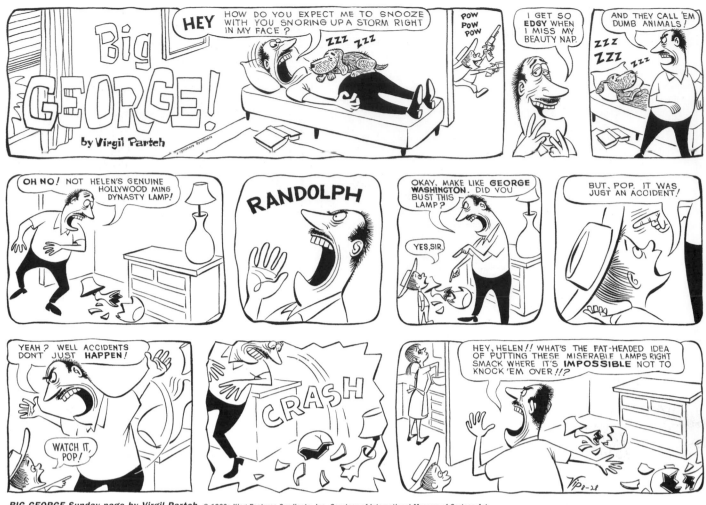

BIG GEORGE Sunday page by Virgil Partch. © 1960s King Features Syndicate, Inc. Courtesy of International Museum of Cartoon Art

"IT **SCARES** ME. MARILYN MONROE'S BODY AND MINE HAVE THE EXACT SAME CHEMICAL CONTENT!"

PONYTAIL daily panel by Lee Holley. © 11/17/60 King Features Syndicate, Inc.

FAMILY FARE Many of the second-tier humor strips of the decade were domestic comedies produced by former magazine gag cartoonists. *Big George* (1960), the harried husband in Virgil Partch's offbeat feature, was a city-bred office worker struggling with life in the suburbs (above). *Ponytail* (1960) by Lee Holley, a former assistant to Hank Ketcham on *Dennis the Menace*, starred a perky teenager (left). Next page (top to bottom): Harry Haenigsen's *Penny* (1943), a stylishly designed family strip, was ghosted by Bill Hoest in the late 1960s. *Professor Phumble* (1960), by Bill Yates, involved an absent-minded inventor who, when not tinkering in his basement, would hit the golf links; Dick Cavalli's *Morty Meekle* (1955) morphed into the durable kid strip *Winthrop* in 1966; Bob Weber's *Moose* (1965) was an American Andy Capp who avoided gainful employment and mooched off his neighbors.

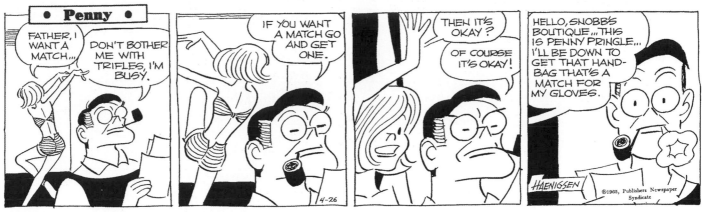

PENNY daily strip by Harry Haenigsen. © 4/26/65 King Features Syndicate, Inc. Courtesy of Bill Janocha

PROFESSOR PHUMBLE daily strip by Bill Yates. © 7/21/60 King Features Syndicate, Inc.

MORTY MEEKLE daily strip by Dick Cavalli. © 3/9/60 NEA, Inc.

MOOSE daily strip by Bob Weber. © 2/28/72 King Features Syndicate, Inc.

TIGER'S NEIGHBORHOOD—Special illustration by Bud Blake. © 1976 King Features Syndicate, Inc. Courtesy of Richard Marschall

BUD BLAKE Among the most admired cartoonists in the comics business, Bud Blake is frequently praised by his peers for the deceptively simple elegance of his linework and the understated honesty of his writing. The children in *Tiger*, which has maintained a solid list of clients for more than three decades, are not precocious mini-adults. They talk and act like real kids. As a testament to Blake's dedication to his craft, *Tiger* was voted Best Comic Strip of the Year by the National Cartoonists Society in 2000 (it was also honored twice in the 1970s), thirty-five years after its debut.

TIGER daily strip by Bud Blake. © 8/25/65 King Features Syndicate, Inc.

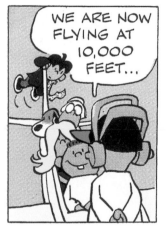

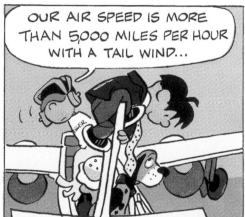

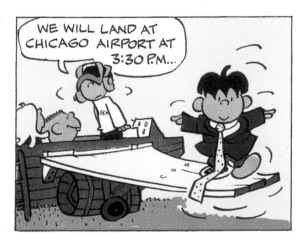

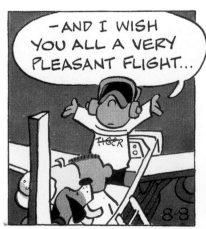

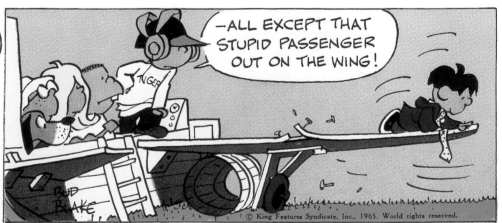

TIGER Sunday page by Bud Blake. © 8/8/65 King Features Syndicate, Inc. Courtesy of Richard Marschall

bil keane

FAMILY AFFAIR—Self-caricature by Bil Keane

A NATIVE OF PHILADELPHIA, Bil Keane claimed that when he was a boy, his father knocked the "L" out of him for drawing on the wall. The characters in his successful humor panel, *The Family Circus*, are based on himself, his wife Thel, and his five children, Gayle, Neal, Glen, Chris, and Jeff.

"I dream about them (*The Family Circus* characters) as real kids," Keane claimed. "I've had dreams where they are intermingled with our own children. I can have Jeffy and Dolly and Billy running around with Neal and Gayle and Chris."

Keane, who never had any formal art training, learned the craft by imitating his favorite cartoonists, George Price (a cartoonist for *The New Yorker*), Al Capp (*Li'l Abner*), and George Lichtenstein (*Grin and Bear It*). After three years in the army, he joined the art staff of the *Philadelphia Bulletin*, and in 1954 started the feature *Channel Chuckles* to capitalize on the growing popularity of television. He also sold gag cartoons to the *Saturday Evening Post* and other major magazines.

"Most of the stuff I was selling had to do with family and little children," Keane remembered, "so I decided to try another feature dealing with those subjects." The round panel was originally called *The Family Circle* when it debuted on February 29, 1960, but Keane had to change the name six

months later because there was a magazine with the same title. "Taking advantage of the leap year date," said Keane in 1968, "I have determined that the characters are growing older at the rate of one year in every four." This policy was soon abandoned and the children's ages were fixed at seven (Billy), five (Dolly), three (Jeffy), and one and a half years (PJ).

Keane discovered that a low-key approach worked best. "As I developed a warm feeling for the characters," he explained, "I would take a chance on something that wasn't really funny but was a commentary on today's society or life with a child or memories." Keane stated, "I would rather have a reader feel a warm, knowing glow—even a heart tug or shed a nostalgic tear—than roar with laughter."

The Family Circus Sunday pages often featured a large, detailed drawing. The kids would be shown commenting on a single subject in a multiballoon format or having elaborate fantasies that were revealed in a single dream balloon. Keane drew aerial views of the neighborhood and traced Billy's wanderings with a dotted line. This idea has been recycled many times and is a favorite with readers. Other popular recurring themes are the "not me" gremlin, appearances by Granddad's ghost, and the summer vacation sequences.

Keane designed *The Family Circus* to be easy to read and understand. "There's a general tendency among people who want to be funny to exaggerate," he explained. "I do just the opposite. I tone down every idea I get. I also keep my drawing style simple, using only the lines that are necessary."

Bud Warner began assisting Keane on *The Family Circus* in 1964. Warner would "clean up" Keane's pencil drawings, ink the panels, and do the coloring for the Sunday page. He retired in the mid-1990s, after contributing to the feature more than thirty years.

The Family Circus has always scored high in readership polls and passed the 1,000-paper mark in circulation in the 1980s. It was voted Best Syndicated Panel by the membership of the National Cartoonists Society four times (1967, 1971, 1973, and 1974) and Keane won the Reuben Award in 1982. In addition to more than forty book collections, three animated television specials were based on the feature.

Now that Keane's children are adults, he relies on his grandchildren for inspiration. Jeff Keane collaborates with his father on the feature, so *The Family Circus* is guaranteed to continue for another generation.

THE FAMILY CIRCUS daily panel by Bil Keane. © 1961

"I've only had time to read two pages."

THE FAMILY CIRCUS daily panel by Bil Keane. © 7/17/62

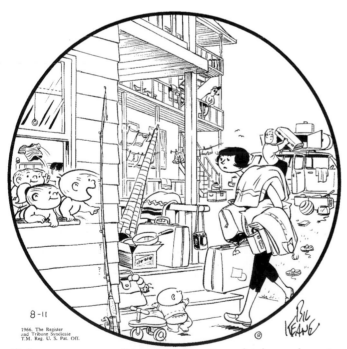

"Mommy, can you find our swimsuits and take us down to
the beach?"

THE FAMILY CIRCUS daily panel by Bil Keane. © 8/11/66

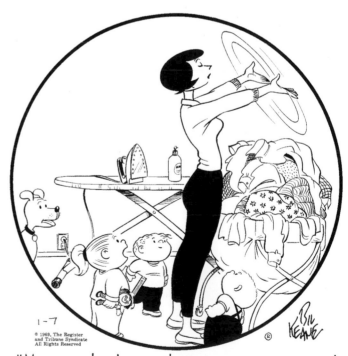

"Mommy, why do you always wave your arms and
say 'abracadabra' before you start to iron?"

THE FAMILY CIRCUS daily panel by Bil Keane. © 1/7/69

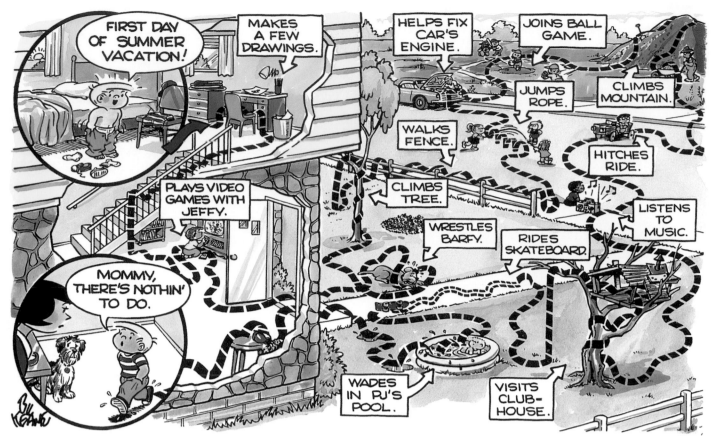

THE FAMILY CIRCUS hand-colored Sunday page by Bil Keane. © 6/11/89

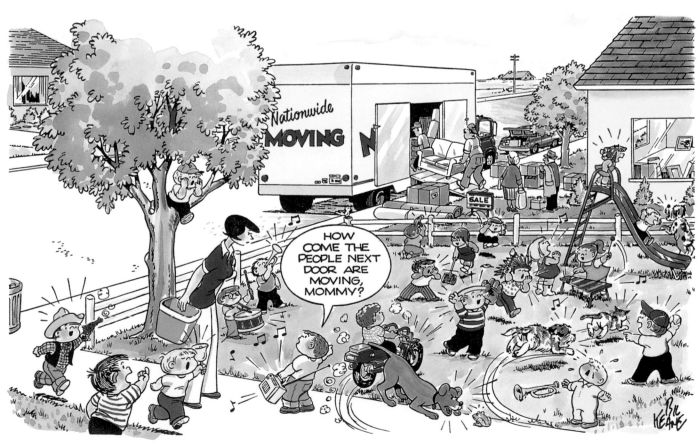

THE FAMILY CIRCUS hand-colored Sunday page by Bil Keane. © 5/16/82

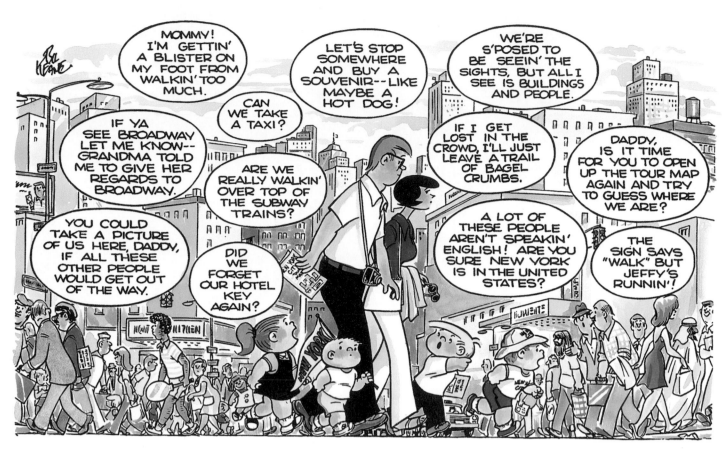

THE FAMILY CIRCUS hand-colored Sunday page by Bil Keane. © 8/14/77

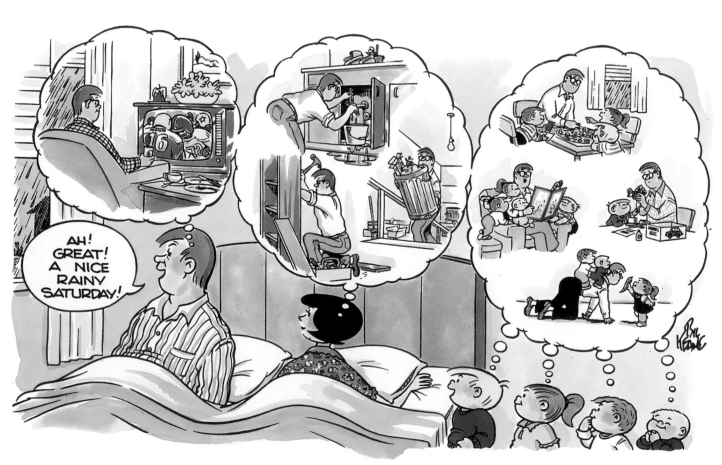

THE FAMILY CIRCUS hand-colored Sunday page by Bil Keane. © 10/21/79

"Hooray! We're here! Let's make a fire,
Daddy, and put up the tent!"

THE FAMILY CIRCUS *daily panel by Bil Keane.* © 8/1/70

"This air smells funny -- I guess it doesn't have
enough PLUTION in it."

THE FAMILY CIRCUS *daily panel by Bil Keane.* © 8/24/70

"This is the bestest time of day. Dinners
are cookin', kids are bathed and
daddys come home."

THE FAMILY CIRCUS *daily panel by Bil Keane.* © 10/15/85

"Grandma says we don't hear back
from Granddad 'cause he's havin'
too much fun with those angels."

THE FAMILY CIRCUS *daily panel by Jeff and Bil Keane.* © 7/19/2001

WEE PALS daily strip by Morrie Turner. © 1995 Creators Syndicate, Inc.

WEE PALS daily strip by Morrie Turner. © 8/13/80 Creators Syndicate, Inc.

INTEGRATION Morrie Turner, the first black cartoonist to sell a comic strip to a major syndicate, has been actively promoting racial tolerance and education for more than forty years. The cast of his 1965 creation, *Wee Pals*, was from a variety of backgrounds and provided graphic proof of Turner's belief in "Rainbow Power." "I decided that just by exposing readers to the sight of Negroes and whites playing together in harmony," Turner wrote, "rather than pointing up aggravations, a useful,

if subliminal, purpose would be served, and ultimately would have as great effect for good as all the freedom marchers in Mississippi." Among the African-American cartoonists who followed Turner's trailblazing path were Brumsic Brandon, Jr., who sold the mildly militant kid strip *Luther* in 1968, and Ted Shearer, who began drawing the evocative, Harlem-based *Quincy* in 1970.

LUTHER daily strip by Brumsic Brandon, Jr. © 4/24/81 Los Angeles Times Syndicate. Courtesy of International Museum of Cartoon Art

QUINCY debut strip by Ted Shearer. © 7/13/70 King Features Syndicate, Inc.

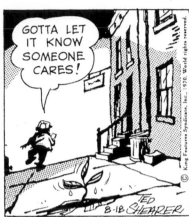

QUINCY daily strip by Ted Shearer. © 8/18/70 King Features Syndicate, Inc.

QUINCY daily strip by Ted Shearer. © 4/7/71 King Features Syndicate, Inc.

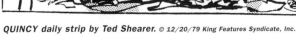
QUINCY daily strip by Ted Shearer. © 12/20/79 King Features Syndicate, Inc.

the seventies

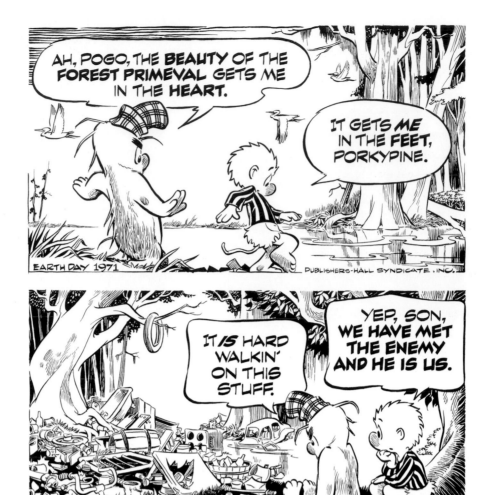

ECOLOGY—POGO Earth Day strip by Walt Kelly. © 1971 Used by permission © Okefenokee Glee & Perloo, Inc.
Courtesy of the Pogo Collection, The Ohio State University Cartoon Research Library

TOM WOLFE OFFICIALLY CHRISTENED IT "THE ME DECADE " IN THE AUGUST 23, 1976, ISSUE OF *NEW YORK* MAGA-ZINE. A GENERATION OF SELF-INDULGENT BABY BOOMERS WAS COMING OF AGE. THEY EXPERIMENTED WITH NEW APPROACHES TO SELF-IMPROVEMENT (EST, GESTALT, PRIMAL SCREAM), PHYSICAL FITNESS (JOGGING, DIETING, HEALTH CLUBS), SEX (SINGLES BARS, PORNO MOVIES, BIRTH CONTROL), AND RELIGION (HARE KRISHNA, MOONIES, CULTS). THEY DONNED HOT PANTS, LEISURE SUITS, AND PLATFORM SHOES. THEY DANCED TO DISCO AND STOOD IN LINE TO SEE *STAR WARS*. THEY BOUGHT PET ROCKS, MOOD RINGS, AND LAVA LAMPS.

Beneath the superficial parade of fads and fashions, major changes were taking place during the 1970s. The Watergate scandal further alienated an electorate disillusioned by the war in Vietnam. Crime, divorce, drug abuse, and teenage pregnancy frayed the social fabric. The women's movement made significant gains, and by the end of the decade more than half of adult females had jobs. Native Americans, blacks, senior citizens, and homosexuals fought for equal rights. Weakened by oil shortages and a slumping auto industry, the U.S. economy went into a downward spiral, and by 1979 inflation was at an alarming 13.3 percent. The first Earth Day on April 22, 1970, marked the dawn of a new global awareness.

The comics business was also in transition. In 1976 *Time* magazine reported, "Rising prices and chronic shortages of newsprint have driven editors to drop marginally popular panels and shrink survivors to the size of chewing-gum wrappers." But *Time* also offered hope: "*Doonesbury* seems likely to be the strip of the '70s, if any strips survive," concluded the article.

Garry Trudeau, the creator of *Doonesbury*, was the first baby boomer to succeed with a nationally syndicated comic strip. His crudely drawn college cartoon, *Bull Tales*, which clearly showed the influence of Jules Feiffer, debuted in the *Yale Daily News* on September 30, 1968. At the time, James Andrews and John McMeel were launching a new syndicate and were searching for young talent. They saw potential in Trudeau's lampoon of college life and talked him into signing a contract. *Doonesbury*, which was loosely adapted from *Bull Tales*, was released to

twenty-eight newspapers by Universal Press Syndicate on October 26, 1970. Trudeau was twenty-two years old.

By 1976 *Doonesbury* was appearing in 449 newspapers and had earned its creator the Pulitzer Prize. President Gerald Ford summed up the strip's impact when he remarked: "There are only three major vehicles to keep us informed as to what is going on in Washington—the electronic media, the print media, and *Doonesbury*, and not necessarily in that order."

The original cast—Michael J. Doonesbury, Zonker Harris, Mark Slackmeyer, B.D., Boopsie, and Joanie Caucus—were joined by an ever-expanding troupe of supporting players that included such characters as Phred, a Viet Cong terrorist, and Duke, a thinly veiled takeoff on Gonzo journalist Hunter S. Thompson. Trudeau viewed American life through the half-lidded eyes of these pen-and-ink personalities and delivered his observations with deadpan accuracy and biting satire.

Al Capp and Walt Kelly had paved the way for political comment on the funnies pages, but Trudeau took it a step further. He had his semifictional characters refer to public figures by name, without the protective layer of caricature and pseudonym that Capp and Kelly had employed. In 1973, when Trudeau showed Mark Slackmeyer announcing on his radio show that Watergate conspirator and former U.S. Attorney General John Mitchell was "Guilty, guilty, guilty!!" dozens of newspapers refused to print the strip. Trudeau continued to be censored on a regular basis for such offenses as introducing a gay character, showing an unmarried couple in bed, and calling the president's son a "pothead."

The upstart cartoonist earned reluctant praise from his peers. "Anybody who can draw bad pictures of the White House four times in a row and succeed knows something I don't know," grumbled Al Capp. Although nominated numerous times, Trudeau did not win the Reuben Award from the National Cartoonists Society until 1995.

On May 25, 1971, Trudeau was a guest on *To Tell the Truth*. Three out of four panelists failed to guess his identity. Preferring anonymity, he would make only one more television appearance in the next thirty years. An intensely private person, Trudeau eventually refused to do interviews of any kind. "I don't like celebrification," he explained. "Everything I have to share I share in the strip."

Trudeau also broke an age-old industry tradition when he announced in 1982 that he was taking a twenty-month leave of absence beginning on January 2, 1983. Syndicated cartoonists had always been reluctant to take vacations, fearing the loss of their coveted space on the comics pages. During his time off, Trudeau produced *The Doonesbury Musical*, in which his characters escaped from their "time warp" and finally graduated from college.

STUDENT MOVEMENT—Early DOONESBURY cast (left to right: Mark, Mike, and B.D.).

When he returned to work in 1984, Trudeau defended the historic hiatus in a speech to the Associated Press Managing Editors convention by saying, "Daily comic strips continue to be regarded as a kind of public utility; they are viewed as providing a routine service, a dependable day-in, day-out source of light entertainment. This attitude goes a long way toward explaining some of the widespread resentment in the industry when I took a leave of absence."

Doonesbury not only recovered virtually all of its 723 clients, Trudeau actually gained papers after his "sabbatical." In the late 1980s, many cartoonists followed his lead and began taking well-deserved time off.

Trudeau continued to speak out for his principles. In 1984 he told newspaper editors they had to run *Doonesbury* at 44 picas in width (7 $^5/_{16}$ inches), instead of a new industry standard of 38.6 picas (6 $^7/_{16}$ inches), or not run it at all. "It is self-defeating—and not a little ironic—that in an era when newspapers face their gravest threat from television and other visual media," stated Trudeau, "they have continued to reduce the comics page, the one area of genuine pictorial interest in their papers (and one of proven popularity)."

The editors were threatened by this affront to their authority and howled in protest, but only a handful canceled the strip. Although all cartoonists were affected by the shrinking size of comics, not many of Trudeau's professional peers supported his courageous stand. Approximately one-quarter

of the newspapers elected to print the 44-pica *Doonesbury* on the editorial page rather than upset the symmetry of their comics pages.

In 1990, after seventeen years of public silence, Trudeau granted an interview to *Newsweek* magazine. In the article, Jonathan Alter wrote that the creator of *Doonesbury* was "as much journalist as artist—an investigative cartoonist. Zeitgeist megaphone, flight attendant for his generation. . . ." *Doonesbury* was unlike any comic strip that had come before it, and reporters often struggled to describe exactly what it was that made Trudeau unique.

Trudeau preferred to call himself a "satirist." In 1995, in the introduction to his silver-anniversary anthology, he wrote, "Twenty-five years into it, I'm still trying to get it right. The strip remains a work in progress, an imperfect chronicle of human imperfection." A youth movement followed Trudeau's trailblazing path in the 1970s. These newcomers, all born in the postwar years, brought fresh insights to the comics pages. The funnies would never be the same.

In 1976 Cathy Guisewite was a vice president at an advertising agency in Detroit and coming off a "disaster" in her love life. She discovered that doodling helped relieve some of her anxieties. "I started seeing myself with a sense of humor," she remembered. "It became a big release for me to draw pictures of myself and my friends." Guisewite's mother convinced her to send a batch of her cartoons to Universal Press. "The syndicate that *Doonesbury* built" had been looking for a feature that reflected the experiences of a modern working woman. They offered the twenty-six-year-old cartoonist a contract and, on November 22, 1976, the *Cathy* comic strip debuted.

In Guisewite's autobiographical creation, her namesake shared the cartoonist's intimate fears and dreams with millions of readers. The supporting players in the feature—Cathy's doting parents, her on-again, off-again boyfriend, Irving, her exploitive boss, Mr. Pinkley, and her feminist coworker, Andrea—were inspired by Guisewite's friends and family. The humor in the strip focused on what she called the "four basic guilt groups—food, love, mother, and career."

Cathy became the poster girl for a generation of single women who juggled the demands of a career with the hope of eventually settling down and starting a family. "Helping women to laugh at themselves when they fall a bit short of the new liberated woman is what this strip is all about," claimed Guisewite in a 1977 interview. *Cathy* was their voice on the comics pages.

Jeff MacNelly was the youngest political cartoonist to win the Pulitzer Prize when he received the coveted honor in 1972 at the age of twenty-five. He was awarded two more Pulitzers (1978, 1985) as well as the National Cartoonists Society's Reuben in 1978 for editorial cartooning. In 1979 he won the Reuben for his comic strip, *Shoe*.

When MacNelly created *Shoe* in 1977 he became the first of the "double dippers"—cartoonists who produced both a daily comic strip and a weekly batch of editorial cartoons. In a remarkably short period of time, *Shoe* became a fixture on the funnies pages, and in 1989 its circulation passed the 1,000-paper mark.

The bird-brained stars of MacNelly's creation were the tough-talking editor in chief of the *Treetops Tattler Tribune*, J. Martin Shoemaker, and his disheveled reporter, Perfessor Cosmo Fishhawk. The cast also included Skylar, the Perfessor's nerdy nephew; Roz, the proprietress of the local greasy spoon; and Loon, a high-flying delivery boy.

MacNelly saved most of the topical humor for his political cartoons, but he couldn't help sneaking comments into his strip. Senator Battson D. Belfry, a corrupt Southern politician,

David, We're PREGNANT!

became a regular vehicle for jabs at government fat cats. Most of the gags in *Shoe*, however, revolved around eating, drinking, smoking, and the accumulation of clutter.

MacNelly's droll wit and graphic genius garnered almost universal praise from his fellow cartoonists and newspaper columnists. In the introduction to *The Very First Shoe Book*, published in 1978, Art Buchwald wrote: "MacNelly, with one stroke of his brush, has seared our conscience, and has grabbed us by the throat and made us sit up in our chairs, and admit that it is we, not he, who are marching to a different drummer."

In the early 1970s Lynn Johnston was a divorced mother pursuing a career as a freelance artist, designing posters, billboards, TV graphics, and medical illustrations. She had tried sending a batch of cartoons to *Ms.* magazine, but they had been rejected. When she was pregnant with her first child, she had created some drawings for her obstetrician while sitting in his waiting room. By the time she gave birth, she had finished eighty cartoons, which her doctor hung in the examining room to entertain his other patients. A few years later Dr. Murray Enkin convinced Johnston to do a book collection of her cartoons, and in 1974 *David We're Pregnant!* was published. With the success of this book, she published two more collections, *Hi Mom!, Hi Dad!* (about newborns) and *Do They Ever Grow Up?* (about toddlers).

In the summer of 1977, Jim Andrews from Universal Press Syndicate was looking for a cartoonist to do a strip about family life from a woman's perspective and saw one of Johnston's books. He asked her to submit twenty samples for a syndicated comic strip. A few months later she got a letter from U.P.S. comics editor Lee Salem with a critique of the strip and a twenty-year contract. He urged the thirty-year-old cartoonist to fly to Kansas City from her home in Manitoba right away. Racked with self-doubt about making such a long-term commitment, Johnston signed anyway. She got sick to her stomach immediately after.

For Better or For Worse debuted on September 9, 1979. The strip, which starred Elly Patterson, her husband, John, her two children, Michael and Elizabeth, and Farley the dog, was a chronicle of Johnston's own family life. A third child, April, was born in 1991. Similar to the characters in *Gasoline Alley*, the Pattersons aged at a relatively normal rate.

The feminine point of view of *For Better or For Worse* made it stand out from other family strips. "There are so many men in the business who are good at the comedy part," explained Johnston in a 1994 interview. "But the subtle, gentle, nuance part, you don't see that much."

Sensitive topics, such as teenage drinking, child abuse, and homosexuality, were dealt with honestly in the strip, earning Johnston supporters and detractors. The 1995 sequence in

which Farley died after saving April from drowning was one of the most moving episodes in the history of modern newspaper comics.

Johnston was the first woman to win the Reuben Award when she was honored as the "outstanding cartoonist of the year" in 1985. *For Better or For Worse* consistently topped readership polls throughout the 1980s and 1990s and built a circulation list of over 2,000 papers.

"I GOT MINE"—HAGAR illustration by Dik Browne. © King Features Syndicate, Inc.

Not all of the successful new features of the 1970s were produced by baby boomers. Dik Browne, who had illustrated *Hi and Lois* since 1954, was fifty-five years old when he created *Hagar the Horrible* in 1973. Browne was having trouble with his eyesight and worried about the financial future of his family. Sitting in his cluttered laundry-room studio, he remembered some old Norse legends his Swedish aunt had told him when he was a child. His hand sketched out a horned Viking helmet sitting on top of a big round nose. The rest of the figure seemed to draw itself. The cartoon barbarian's portly frame was draped with a rumpled bearskin, his shield was hacked and worn, and the crowning touch was a snarled beard encircling his bewildered face. The answer to the cartoonist's dilemma was staring him in the face.

Browne named his new comic-strip hero "Hagar the Horrible" and provided him with a strong-willed wife, Helga, a neat, studious son, Hamlet, a protofeminist daughter, Honi, and a loyal dog, Snert. He drew up some samples and took them to King Features Syndicate. It signed him up and quickly sold the strip to 200 newspapers. After its debut on February 4, 1973, *Hagar the Horrible* became

FAT CAT—GARFIELD illustration by Jim Davis. © Paws, Inc. Used by permission of Universal Press Syndicate. All rights reserved. Courtesy of Editor and Publisher

the fastest-growing feature in comics history, passing the 1,000-paper mark in five years.

In the 1985 anthology collection *The Best of Hagar the Horrible*, Dik Browne described the philosophy behind his remarkable creation: "A great historian once said that history is like a bloody flaming river cutting its way through the centuries. But on the banks families are doing the ordinary things—raising kids, paying bills, making love, shooting craps, whatever.... That's sorta the way I feel about Hagar the Horrible. He is a Viking and God knows he is a barbarian, but he is also a family man, a loving husband, and a devoted father."

One of the most successful comic strips of the modern era was created by another veteran in the 1970s. Jim Davis had worked as an assistant to Tom Ryan on *Tumbleweeds* for nine years before he launched *Garfield* in 1978. Cats had always been popular in the comics, but the success of

Davis's feature set off a feline frenzy that would reach its peak in the 1980s.

The lasagna-eating fat cat was not an overnight sensation. In 1980 *Garfield* was appearing in only 180 newspapers when Davis's marketing genius finally began to pay off. He came up with a clever horizontal shape (now known as the "*Garfield* format") for his first paperback collection, designed a special display rack, and went on a twenty-city book tour. At the beginning of the tour *Garfield*'s circulation was growing at the rate of seven newspapers per month. Two months later the strip was being picked up at the rate of one a day. *Garfield At Large* hit number one on the *New York Times* best-seller list, and by 1982 seven *Garfield* titles appeared on the best-seller list simultaneously. By 1988 the strip was appearing in over 2,000 newspapers and more than 3,000 licensed products had been designed and approved by Davis's multimillion-dollar cottage industry, Paws Incorporated. One hundred million *Garfield* books were eventually sold.

The 1970s was a particularly fertile period for new humor strips of all types. Although the copycat mentality still prevailed at the syndicates, it was no longer a reliable road to success. Editors were looking for fresh voices and unique perspectives to compete with the established features.

Russ Myers wrote and designed greeting cards at Hallmark for ten years before co-creating *Broom-Hilda* with Elliot Caplin in 1970. The strip starred a cigar-chomping, sex-starved, 1,500-year-old witch who traveled freely through time and space. Broom-Hilda and her two sidekicks, Gaylord the buzzard and Irwin the troll, lived in an enchanted forest that was graphically reminiscent of Krazy Kat's Coconino County. Myers's bold style and surreal imagination won over readers, and *Broom-Hilda* was appearing in 300 newspapers by the end of the decade.

Tom Wilson was also an artist in the sentiment industry when he created Ziggy in 1966. His employer, American Greetings, published a best-selling book collection of cartoons starring the round-headed nebbish in 1968, and the *Ziggy* syndicated panel was launched by Universal Press in 1971. Wilson consciously designed a character with minimal identity—

HIPPIES AND BUMS—BENJY daily strip by Jim Berry and Bill Yates. © 1973 NEA Inc.

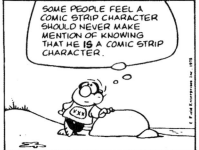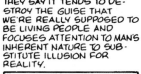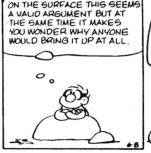

SELF-REFLECTION—CONCHY Sunday page by James Childress. © 6/8/75 Field Enterprises Inc. Courtesy of Thomas Inge

Ziggy had no discernible class, race, or character—so that he would be appealing to all readers. "Ziggy is a lot of things we don't talk about," explained Wilson in a 1973 interview. "There's a kind of loneliness about him none of us can ever shake, even in a room full of friends." The formula worked, as Ziggy's placid features appeared on millions of greeting cards, coffee mugs, and calendars, as well as in over 400 newspapers.

The "Everyman" theme was popular during the decade. *Frank and Ernest*, the Mutt and Jeff–like duo in Bob Thaves's 1972 single-panel strip creation, changed identities daily to fit the gag but were often depicted as tramps sitting on a park bench. *Benjy*, the star of a short-lived feature produced by Jim Berry and Bill Yates between 1973 and 1975, was a bum who was frequently mistaken for a hippie. *Herman*, the middle-aged slouch in Jim Unger's 1974 panel, took abuse from everyone with whom he came in contact.

In 1977 Mort Walker and Jerry Dumas were approached by the N.E.A. syndicate with an offer to revive their offbeat 1960s creation, *Sam's Strip*. The cartoonists asked King Features for permission, and King decided it wanted to do a strip utilizing the same characters but in a different setting. Sam and his assistant became Sam and Silo, a sheriff and his deputy from the town of Upper Duckwater (pop. 437). Shortly after its debut on April 18, 1977, Dumas took over the sole artistic duties on *Sam and Silo*.

A handful of established creators also launched second features during the decade. Mell Lazarus (*Miss Peach*) started *Momma*, a doodle about a doting mom, on October 26, 1970. Brant Parker (*The Wizard of Id*) helped Don Wilder (writer) and Bill Rechin (artist) develop a French Foreign Legion farce, *Crock*, in 1975. Bill Hoest (*The Lockhorns*) added *Agatha Crumm*, about a seventy-seven-year-old, penny-pinching tycoon, in 1977.

Many new humor features reflected contemporary lifestyles in an effort to be relevant to readers. *Funky Winkerbean* (1972), by twenty-five-year-old Tom Batiuk, was set in a high school, and *Drabble* (1979), by twenty-two-year-old Kevin Fagan, took place on a college campus. *Mixed Singles* (1972), by Mel Casson and Bill Brown, dealt with the dating scene, and *Splitsville* (1978), by Frank Baginski and Reynolds Dodson, looked at the lighter side of divorce. The central character in *Tank McNamara* (1974), by Jeff Miller and Bill Hinds, was a former gridiron great trying to make it as a television sportscaster. *Motley's Crew* (1976), by Tom Forman and Ben Templeton, starred two blue-collar workers from the "Silent Majority."

It often took extraordinary perseverance to break into the comics business. In 1970 James Childress took out a full-page advertisement in *Editor and Publisher* announcing the debut of a new comic strip entitled *Conchy*. His home address and phone number appeared at the bottom of the page for the benefit of editors. "We will admit that signing newspapers before establishing syndicate sponsorship may be a method of the unorthodoxed," wrote Childress in the ad. "But there are times that if any measure of success is to be realized, stepping from the norm is essential. This is the story of *Conchy*."

The saga started in October 1960 when a young G.I. submitted an idea for a caveman strip to the major syndicates. It didn't sell. After being discharged a year later, Childress tried again with a strip about a hobo, but, once again, the syndicates weren't interested. In 1962 he created a strip about a beachcomber his wife named after a conch shell. "With *Conchy* I got stubborn," Childress remembered. "I saw in this strip a bright future and each time it was rejected I'd improve on it and resubmit it." After seven years of futility he finally decided to market his cherished creation directly to newspaper editors without syndicate representation.

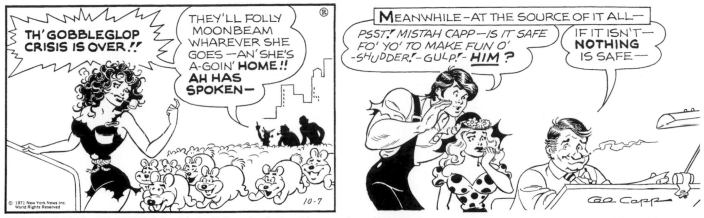

THE END IS NEAR—LI'L ABNER daily strip by Al Capp (caricatured in second panel). © 10/7/71 Capp Enterprises, Inc. Courtesy of International Museum of Cartoon Art

By 1973 *Conchy* was appearing in thirteen newspapers, and Childress had a book deal with Grosset and Dunlap. After *Conchy on the Half-Shell* was published, Childress finally got the break he had been waiting for. In 1974 Field Enterprises Syndicate took over the distribution of *Conchy* and claimed that it had 157 daily and Sunday clients lined up. After sales of the strip stalled, Field suggested to Childress that he abandon the philosophical bent of his creation and try a more conventional gag-a-day approach. In May 1976, disagreeing with his syndicate over the direction the strip was taking, Childress asked to be released from his contract and his wish was granted. A year later, in deep financial and marital trouble, Childress committed suicide.

The decade also saw the demise of two long-running classics. After Walt Kelly passed away in 1973, his widow, Selby Kelly, tried valiantly to continue *Pogo*. When the strip was finally canceled in 1975, the blame was laid directly on the reduced size that it was printed in the newspapers. Selby Kelly, who had worked as an animator at many of the major Hollywood studios, felt that it was no longer possible to do justice to her husband's creation in such cramped quarters.

Al Capp was also struggling with his allotted space. "I have enlarged my lettering so that a reader can simply NOT overlook it," Capp complained in 1975. "I long for the days when I was able to draw twice as much, write twice as much,

and give newspapers what I was able to give them in the days of the Shmoo." In 1977 Capp turned to an assistant in his Boston studio and casually remarked, "You can stop cutting the paper. I'm not going to draw any more." Capp had tried out a few artists as potential successors, but in the end, he knew that no one else could continue his creation. The last episode of *Li'l Abner* appeared on November 13, 1977. Two years later Capp was dead.

Only a handful of illustrative features survived. John Cullen Murphy (*Big Ben Bolt*) took over as the artist on Hal Foster's *Prince Valiant* in 1970. Dick Moores won the Reuben Award for his work on *Gasoline Alley* in 1974. After a number of attempts to revive *Little Orphan Annie*, Leonard Starr introduced a redesigned version with the shortened title *Annie* in 1979. Chester Gould, who had produced *Dick Tracy* for forty-seven years, retired in 1977 and handed over the chores to Rick Fletcher (artist) and Max Collins (writer). Losing papers and readers, Milt Caniff managed to keep *Steve Canyon* going until his death in 1988.

Story-strip casualties continued to mount. The last episode of *Terry and the Pirates* by George Wunder appeared on February 25, 1973. The demise of *Smilin' Jack*, *Johnny Hazard*, *On Stage*, and *Dateline Danger* followed. Although many of the soap-opera strips, such as *Mary Worth*, *Rex Morgan M.D.*, and *Apartment 3-G* still appeared, the future for new adventure strips looked bleak.

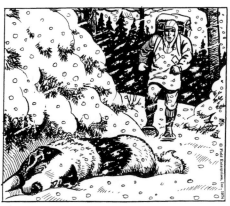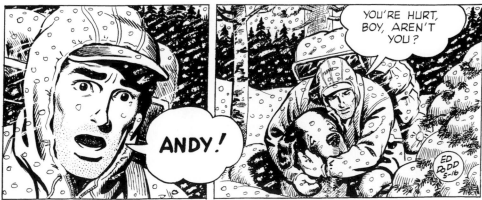

THE GREAT OUTDOORS—MARK TRAIL by Ed Dodd. (Dodd created his long-running adventure strip in 1946 and retired in 1978.) © 5/16/74 King Features Syndicate, Inc.
Courtesy of International Museum of Cartoon Art

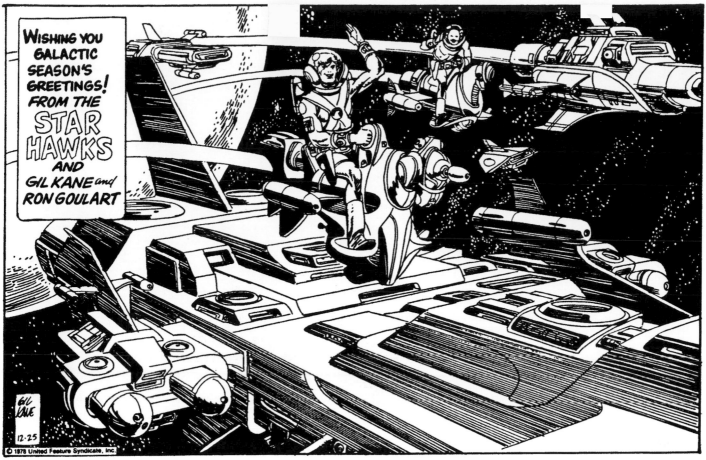

SCI-FI REVIVAL—STAR HAWKS by Gil Kane and Ron Goulart. © 12/25/78 United Feature Syndicate, Inc.

The success of George Lucas's *Star Wars* film in 1977 launched a mini-revival of science-fiction features. *Star Wars* (1979) and *Star Trek* (1980) comic strips soon followed, and *Buck Rogers in the 25th Century* (1979) was brought back to life after a live-action movie was produced. One original new outer-space creation, *Star Hawks* (1977), by Gil Kane (artist) and Ron Goulart (writer), was offered in an innovative two-tiered daily strip format.

Costumed superheroes also made a comeback in the late 1970s. Marvel jumped on the bandwagon with comic-strip adaptations of *The Amazing Spider-Man* (1977), *Conan the Barbarian* (1977), and *The Incredible Hulk* (1979). DC joined in with *The World's Greatest Superheroes* (1978), which teamed up Batman, Superman, Wonder Woman, and Flash.

The comics gained new respectability during the decade. In 1974 the Museum of Cartoon Art, the first institution in the world devoted to the collection, preservation, and exhibition of cartoon art, opened to the public. It was the realization of a dream for the founder, Mort Walker.

More than a decade before that historic occasion, Mort Walker and Dik Browne were attending a cartoonists outing in Jamaica. Relaxing after a round of golf, they slipped into a philosophical mood. "Why aren't cartoons considered art?" wondered Browne. "We don't have a museum," answered Walker. In that moment, an idea was hatched that would take years of perseverance to turn into reality.

A committee was formed, including Milt Caniff, Walt Kelly, Rube Goldberg, and Hal Foster as well as Walker and Browne, to investigate the establishment of a permanent museum devoted to cartoon art. They met with corporations, foundations, and government agencies and considered sites in Washington, D.C., Manhattan, Syracuse, and New Haven. Walker secured a promise from the Hearst Corporation for funding. A proposed budget was put together, a board of

UNDER CONSTRUCTION—A sketch by MAD cartoonist Sergio Aragonés, made while visiting the Museum of Cartoon Art in 1978

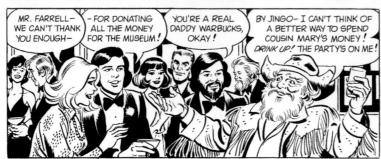

CARTOON MUSEUM—KERRY DRAKE Sunday page by Al Andriola. (The conclusion of a story based on the 1977 opening of the Museum of Cartoon Art in Ward's Castle. A caricature of the author, in a tuxedo, appears in the lower left panel.) © 11/19/78 Field Enterprises, Inc.

directors was formed, and a promotional brochure was printed. But the project never seemed to get off the ground.

In 1973 Walker heard that an old mansion, around the corner from his home in Greenwich, Connecticut, was for rent. The building was ideally suited for a museum and was located in an affluent suburb of New York City where many professional cartoonists lived. Walker knew that this was the opportunity for which he had been waiting. He put up some of his own money, signed a lease, and hired a staff. His personal collection of cartoons became part of the first exhibition. When the Museum of Cartoon Art opened on August 11, 1974, the event was national news.

In the first year of operation more than $200,000 was raised and 25,000 original cartoons were donated. In 1975 the museum displayed *A Retrospective of Walt Kelly and Pogo* and *The Hal Foster Exhibit*, and fourteen cartoon pioneers were elected to the museum's Hall of Fame by a distinguished panel of writers and scholars.

By 1976 the museum had outgrown its original home. John Mead, the owner of the mansion, was concerned that the thousands of visitors were putting too much wear and tear on his family estate and declined to renew the lease. After a year of searching, another location was found just a few miles away. The Ward Castle, in Rye Brook, New York, was the first residence in the world built entirely of reinforced concrete. Completed in 1875, the castle had been a private home until the early 1970s, when it was vacated due to maintenance problems. The task of renovating the building and converting it into a museum presented a daunting challenge. A crew of struggling artists, college dropouts, friends, and volunteers pulled off the impossible. Within months after the takeover of the castle, a gala opening reception was held on November 12, 1977.

Walker often wondered if it had been worth all the time and money he had put into the effort. Standing in the lobby of the museum one Sunday afternoon, he saw an elderly woman coming out of one of the galleries. "I feel like I've just spent an hour with some old friends," she said. The museum's founder was reassured that the positive public response more than justified the sacrifices.

Before the Museum of Cartoon Art opened, original cartoons were often thrown away, lost, or destroyed by artists, syndicates, publishers, and studios. The finest examples of the art form were traded at comic conventions, among a small group of collectors, for a few hundred dollars each.

The museum led the way in elevating the appreciation of cartoon art. Ohio State University established the Cartoon Research Library in 1977 and held the first Festival of Cartoon Art in 1983. The Cartoon Art Museum opened in San Francisco in 1987. By the 1990s cartoon museums could be found in France, Belgium, England, Switzerland, Bulgaria, Poland, Germany, Sweden, and Japan. Prestigious auction houses sold original cartoons to wealthy clients for prices that reached as high as a quarter of a million dollars. Cartoonists now had more respect for their own work.

"I don't think of comics as just entertainment," wrote Bill Watterson, creator of *Calvin and Hobbes*, in 1995. "To attract and keep an audience, art must entertain, but the significance of any art lies in its ability to express truths—to reveal and help us understand our world. Comic strips, in their own humble way, are capable of doing this."

Many of Watterson's contemporaries were equally enlightened about the importance of cartoon art. After all, their creations were now hanging in museums.

garry trudeau

TIME **MAGAZINE WROTE** of Garry Trudeau in 1976, "an indifferent draftsman, the artist is usually just good enough to strike an attitude or sink a platitude. But at his best, Trudeau manages to be a Hogarth in a hurry, a satirist who brings political comment back to the comics pages."

This assessment was typical of the pre-sabbatical *Doonesbury* era (1970 to 1982). Trudeau's static graphics were widely criticized while his biting social satire was universally praised. A typical strip from the early years would feature three nearly identical panels of a character watching television, followed by a subtle reaction in the final panel. The repetitious pictures tended to amplify the narrative, setting up a visually understated but powerful conclusion.

When Trudeau broke into national syndication, his experience was limited to the cartoons he had done for the *Yale Daily News*. The learning curve was evident in the early years of *Doonesbury*, as Trudeau went through a period of on-the-job training.

In November 1976 Trudeau drew a weeklong series in which Joanie Caucus and Rick Redfern, both unmarried, spent the night together. More than thirty newspapers dropped the controversial final strip in which the couple were shown in bed. More important, the brilliantly orchestrated "zoom," from Joanie's bedroom to Rick's, was completely wordless. Trudeau had come a long way from the stiff, posed look of his Jules Feiffer–influenced college cartoons.

During his twenty-month sabbatical, from January 1983 to September 1984, Trudeau made a conscious decision to overhaul the look of the strip. A talented graphic designer, Trudeau had served as his own art director on many special projects, including posters, book covers, and calendars. In the mid-1980s he applied these skills to a series of visually innovative *Doonesbury* episodes featuring J.J.'s performance art, Duke's flashbacks, "The Return to Reagan's Brain," and Boopsie's harmonic convergence.

In 1990 *Newsweek* described how Trudeau penciled the strip at his studio in New York and faxed it to his inker in Kansas City. Don Carlton began working as Trudeau's assistant in September 1971. "The first weeks he sent me (he penciled very tightly and still does) were inked and lettered by me," remembered Carlton in 1993. The two collaborated closely as the graphic look of the strip matured. This arrangement had changed very little in two decades.

A year after the *Newsweek* article appeared, *Entertainment Weekly* described Carlton as Trudeau's "ghost artist." After a call from Universal Press Syndicate, *EW* ran a retraction admitting that it had misrepresented Carlton's role. The conservative *Wall Street Journal*, looking for an excuse to attack the liberal-leaning Trudeau, ran an editorial on November 21, 1991, comparing him to Milli Vanilli, the duo who had been exposed for using other musicians to sing on their Grammy Award–winning album. Trudeau's syndicate threatened legal action, and on December 18, 1991, the *Journal* reluctantly admitted that "if our 'Garry Vanilli' headline and reference to Cartoon Syncing suggested that we consider Mr. Trudeau a complete fraud, we somewhat overstated the case."

This episode revealed the persistent ignorance among the general public about the demands of producing a daily comic feature. The majority of top-selling cartoonists have assistants. Garry Trudeau works closer to his deadline (often less than two weeks) than any other artist. After scripting his dailies on Wednesday and Thursday each week, the final strips are produced in a flurry of faxes between Trudeau and Carlton on Friday. This collaboration is essential to maintaining the topical content of *Doonesbury* and meeting the deadlines of its subscribers.

Doonesbury earned a reputation for being poorly drawn during its formative years. By the mid-1980s Trudeau's creation was among the most graphically adventurous strips on the comics (and editorial) pages. It has continued to provide a consistently high level of satire and entertainment for more than thirty years.

DOONESBURY *daily strip penciled by Garry Trudeau.* © 9/27/2002

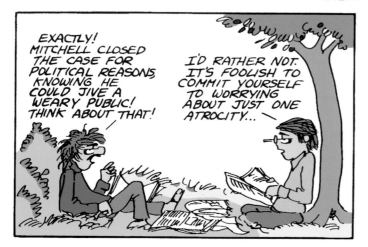

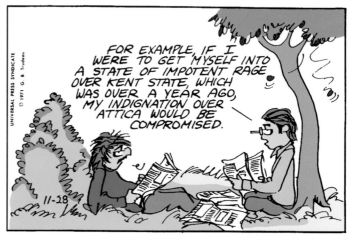

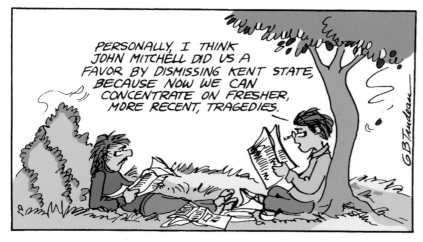

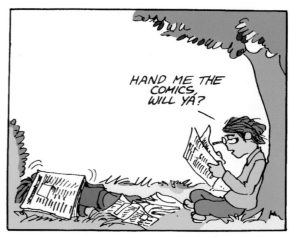

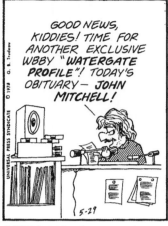
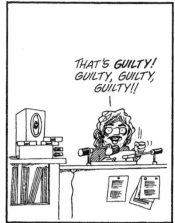
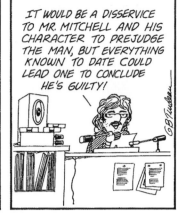

DOONESBURY daily strip by Garry Trudeau. © 5/29/73

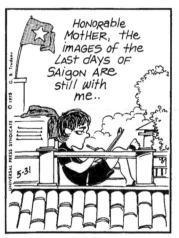
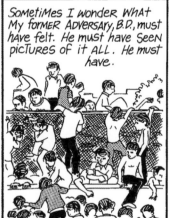
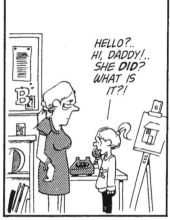

DOONESBURY daily strip by Garry Trudeau. © 12/13/73

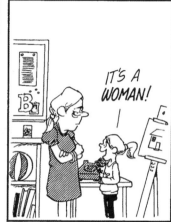
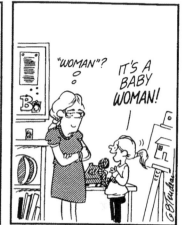

DOONESBURY daily strip by Garry Trudeau. © 5/31/75

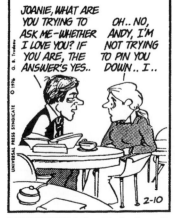
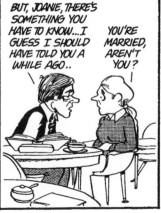
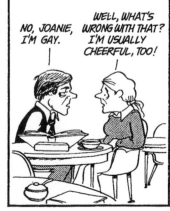
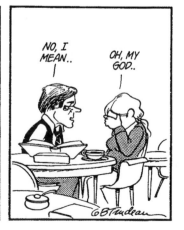

DOONESBURY daily strip by Garry Trudeau. © 2/10/76

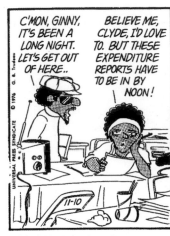

DOONESBURY daily-strip sequence by Garry Trudeau. © 11/10–11/13/76

DOONESBURY Sunday page by Garry Trudeau (the last episode before Trudeau went on sabbatical). © 1/2/83

DOONESBURY daily strip by Garry Trudeau. © 9/11/86

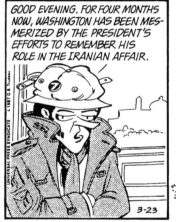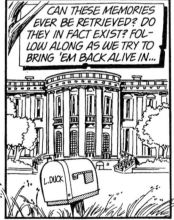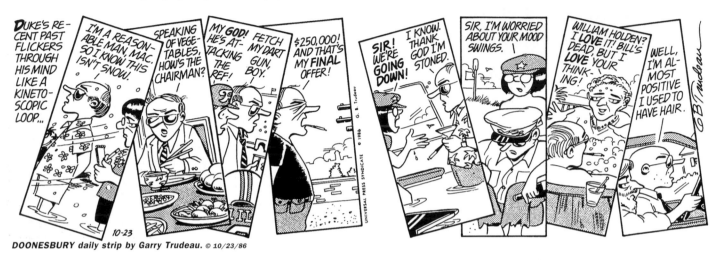

DOONESBURY daily strip by Garry Trudeau. © 10/23/86

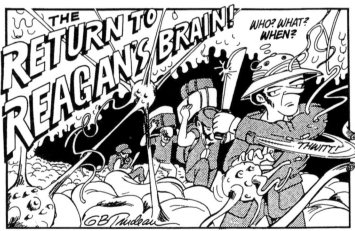

DOONESBURY daily strip by Garry Trudeau. © 3/23/87

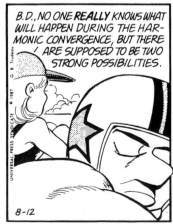

DOONESBURY daily strip by Garry Trudeau. © 8/12/87

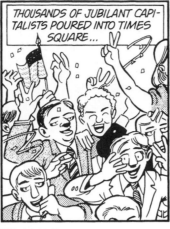
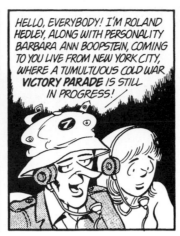
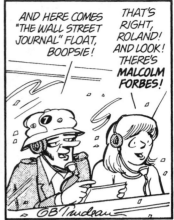

DOONESBURY daily strip by Garry Trudeau. © 6/14/88

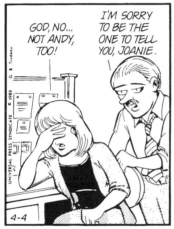
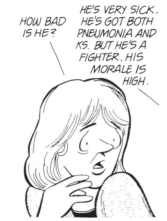
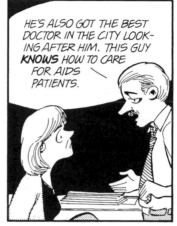
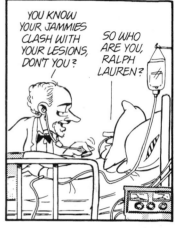

DOONESBURY daily strip by Garry Trudeau. © 4/4/89

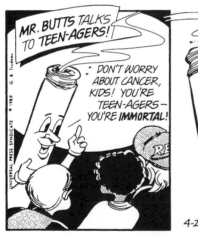
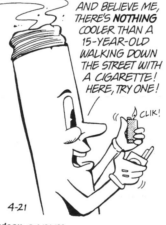
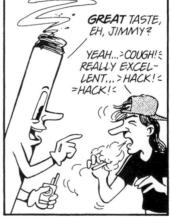
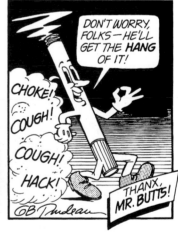

DOONESBURY daily strip by Garry Trudeau. © 4/21/89

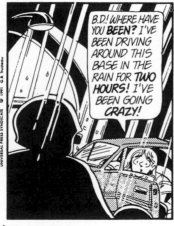
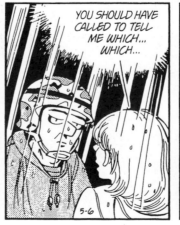

DOONESBURY daily strip by Garry Trudeau. © 5/6/91

HEY, READERS! REMEMBER OUR **1991 ORGANIZATIONAL CHART**, WHICH SORTED OUT OUR CAST OF CHARACTERS FOR CONFUSED READERS? WELL, FIVE YEARS LATER, SOME OF YOU REPORT YOU'RE **STILL** CONFUSED!

AS PROFESSIONAL COMMUNICATORS, WE FEEL BAD ABOUT THAT, SO WE'VE CREATED A GREATLY SIMPLIFIED **CAST PORTRAIT AND KEY!** IDENTIFYING THE CHARACTERS HAS NEVER BEEN EASIER! **ENJOY!**

CAST KEY

Progenitor of BUTTS (26), ex-ad man **MIKE** (6), son of the **WIDOW D.** (15) and brother of Dr. Whoopie rep **SAL** (14), is freshly divorced from artist **J.J.** (16) (lover of **ZEKE** (17) and daughter of legal eagle **JOANIE** (1), who is married to reporter **RICK** (10), and has moved with daughter **ALEX** (7) to Seattle, where he's fallen in love with GenX coder **KIM** (5) while working for technocrat **BERNIE** (34), a former roommate (at a college presided over by **KING** (28) and chaplained by **SCOT** (18)), as is state trooper **B.D.** (8) (friend of fellow vet **RAY** (19) and former adversary of **PHRED** (25)); his superstarlet wife **BOOPSIE** (9), who is repped by **SID** (29) and whose daughter **SAM** (2) is nannied by retired tannist **ZONKER** (4) (honorific nephew of **DUKE** (12), who with son **EARL** (11) has left love-slave **HONEY** (13) to settle in Las Vegas); and gay radio jock **MARK** (3) (son of financier **PHIL** (30), a friend of oil tycoon **JIM** (35)), who is a colleague of correspondent **ROLAND** (20), interviewer of homeless couple **ALICE** (24) and **ELMONT** (23), and a fan of **JIMMY** (22), whose benefit record for **GINNY** (32), wife to cookie czar **CLYDE** (31), failed to help her defeat **LACEY** (21) in her bid for Congress now led by **NEWT** (27) in opposition to **BILL** (33).

5-26

DOONESBURY Sunday page by Garry Trudeau. © 5/26/96

DOONESBURY daily strip by Garry Trudeau. © 9/9/93

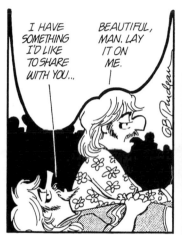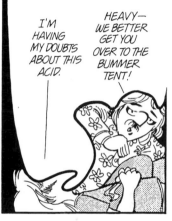

DOONESBURY daily strip by Garry Trudeau. © 8/18/94

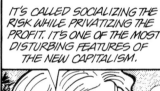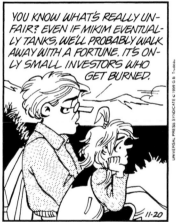

DOONESBURY daily strip by Garry Trudeau. © 11/20/99

DOONESBURY daily strip by Garry Trudeau. © 3/23/2000

cathy guisewite

CATHY REPRESENTS the foremost example of what comics historian Ron Goulart calls the "Grandma Moses School of Comic Strips." The success of Cathy Guisewite's creation inspired a wave of contemporary features that derived their humor from autobiographical experience and were rendered with minimal graphic flair.

honesty of Guisewite's voice. There is no question of authorship. She does all the writing and drawing herself and inks the final strips directly onto bristol board without penciling, to create a look of spontaneity.

Cathy still wishes she hadn't used her own name for the title. "I feel comfortable with the character; she's my creation,"

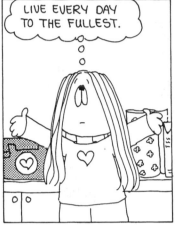
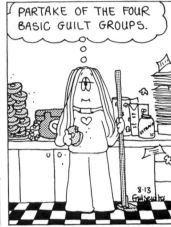

CATHY daily strip by Cathy Guisewite. © 8/13/82

Guisewite admitted, "I quit taking art class when I was seven years old because I was planning a career as a cowboy and felt it would be a waste of time to learn how to draw." She has been insecure about her abilities since *Cathy* debuted in 1976.

"Except for the basic things, like trying to connect the heads to the bodies, I've never consciously changed the way the characters looked, but have always just drawn them the only way I could," wrote Guisewite in her fifteenth-anniversary collection.

After she signed her contract with Universal Press Syndicate, Guisewite frantically tried to improve her drawing skills and told no one, other than her immediate family, that she was working on a comic strip. She studied how Charles Schulz communicated emotions with a few simple lines, and Mort Walker's *Backstage at the Strips* became her bible.

"The first day *Cathy* ran in the paper, I hid in my office in the advertising agency where I worked as a writer, praying that no one would read the comics that day," she recounted in her twentieth-anniversary collection.

Guisewite majored in English at the University of Michigan, was a copywriter at Campbell-Ewald advertising in Detroit, and had considerable experience in other types of creative writing. She frequently describes "writing" the strip rather than drawing it, and that is clearly her strength.

The artistic style of *Cathy*, which Universal Press once described as "primitively energetic," helped establish the

Guisewite explains. "She's not *me*, but she is *of* me—a large part of me." Many of her personal feelings are expressed through the character, but all of the experiences chronicled in the strip are not necessarily autobiographical. When Cathy used a computer dating service in one sequence, for example, Guisewite did extensive research but did not try out the service herself. Readers have always been convinced that everything that goes on in the strip actually happened to its creator, and Guisewite gave up dissuading them years ago.

"My syndicate says the worst thing that could happen to me would be if I fell in love and became content," said the cartoonist in an early interview. During the 1990s Guisewite won the Reuben Award, adopted a baby girl, and got married. Universal Press is no longer concerned. Cathy, the comic-strip character, is still single, frustrated, and unfulfilled. Fortunately for Cathy Guisewite, life doesn't always imitate art.

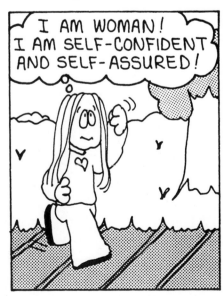

CATHY by Cathy Guisewite

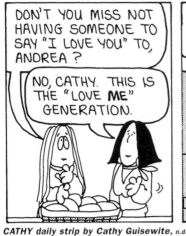

CATHY daily strip by Cathy Guisewite, n.d.

CATHY daily strip by Cathy Guisewite. © 9/7/78

CATHY daily strip by Cathy Guisewite, n.d.

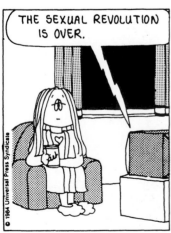

CATHY daily strip by Cathy Guisewite. © 4/30/84

CATHY Sunday page by Cathy Guisewite. © 11/8/87

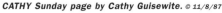

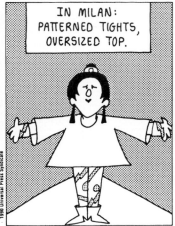
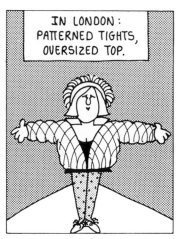
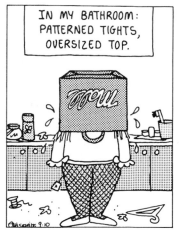

CATHY daily strip by Cathy Guisewite. © 9/10/90

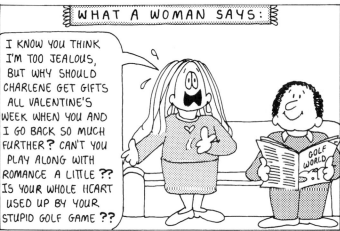
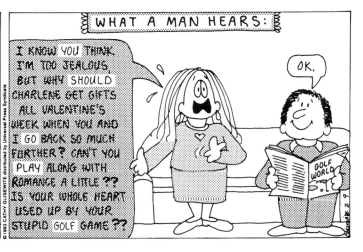

CATHY daily strip by Cathy Guisewite. © 2/9/93

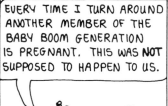

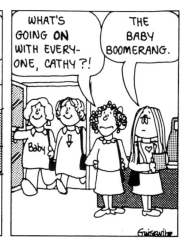

CATHY daily strip by Cathy Guisewite, n.d.

CATHY daily strip by Cathy Guisewite. © 11/6/95

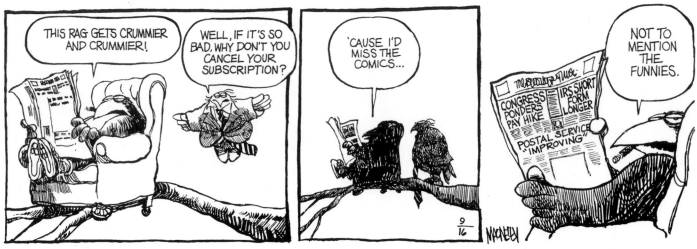

SHOE *daily strip by Jeff MacNelly.* © 9/16/77

SELF-CARICATURE *by Jeff MacNelly*

JEFF MACNELLY P. Martin Shoemaker, the star of Jeff MacNelly's 1977 comic strip creation, *Shoe*, was named after Jim Shumaker, a cigar-smoking journalism professor at the University of North Carolina who was also MacNelly's former editor at the *Chapel Hill Weekly*. The Walt Kelly influence was evident in the first few years of the feature, as MacNelly drew his birds and trees with fluid brush strokes and detailed crosshatching. The style of *Shoe* eventually became more simplified, and in the 1990s MacNelly began using computers to aid with the production of the strip. Amazingly prolific, he also launched a cartoon panel, *Pluggers*, in 1993, illustrated Dave Barry's weekly humor column, and continued to turn out political cartoons until his death in 2000. *Shoe* is carried on today by the team of Gary Brookins and Chris Cassatt.

SHOE *daily strip by Jeff MacNelly.* © 10/22/77

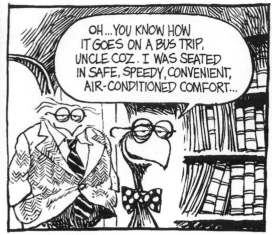
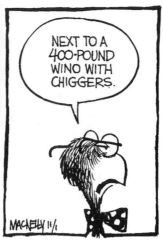

SHOE daily strip by Jeff MacNelly. © 11/1/77

SHOE daily strip by Jeff MacNelly. © 1/11/78

SHOE daily strip by Jeff MacNelly. © 4/26/78

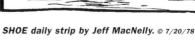
SHOE daily strip by Jeff MacNelly. © 7/20/78

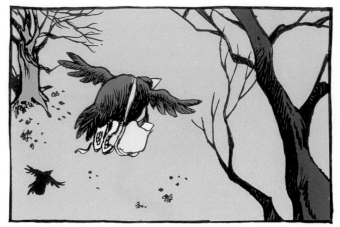

SHOE Sunday page by Jeff MacNelly. © 11/27/77

SHOE Sunday page by Jeff MacNelly. © 8/27/78

lynn johnston

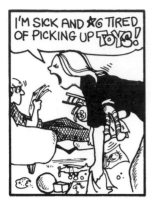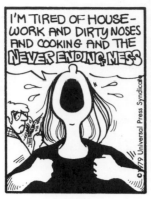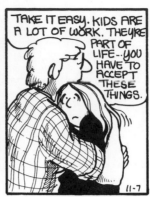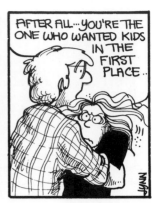

FOR BETTER OR FOR WORSE daily strip by Lynn Johnston. © 11/7/79

FOR BETTER OR FOR WORSE is the quintessential modern family strip. Lynn Johnston has portrayed domestic life from a distinctly feminine point of view in her autobiographical creation for more than two decades. The stars of the feature, Elly and John Patterson and their children, Michael, Elizabeth, and April, as well as a large supporting cast, have confronted the challenges of interpersonal relationships with courage and compassion. Millions of readers feel like members of this extended family by following the unfolding drama in daily installments as the characters age gracefully.

Johnston attended the Vancouver School of Art and worked in illustration, animation, and graphic design before launching her comic strip in 1979. Although her art has matured, Johnston's talent was evident from the start. *For Better or For Worse* was rendered in a semirealistic style with elegant, fluid linework and balanced compositions. Johnston was adept at conveying subtle emotions, as well as the more animated antics of her characters. The backgrounds were filled with convincing details, and her interiors captured the cozy intimacy of the Patterson home.

At first Johnston fretted over the demands of producing punch lines on a daily basis. She eventually took a different approach. "I segued into the little vignettes that have moralistic and motherly values, like little parables," Johnston explained. "I might not be able to have a joke every day, but I could have a thought every day."

The stories in *For Better or For Worse* are fictional, but as Johnston admits, the strip "is a fiction where I can undo wrongs that have been inflicted on me or others." Johnston added a new member to the cast in 1991 when, at age forty-five, she longed for another child. The Patterson's new baby, April, brought fresh energy to the strip as Johnston nurtured her with motherly devotion.

"What sets Lynn's strip apart from the others," claimed Elizabeth Anderson, Johnston's former editor at Universal Press Syndicate, "is that her characters and readers are not spared midlife crises, financial hardships, or confrontations with prejudice, child abuse, and death."

In 1995 Johnston made a daring move. She killed off one of her major characters. The four-week sequence was reminiscent of the death of Raven Sherman in Milton Caniff's *Terry and the Pirates*. Farley, the Patterson's fourteen-year-old sheepdog, suffered a heart attack after saving April from drowning. Many readers were upset, while others expressed their condolences in heartfelt letters. One man sent Johnston a granite tombstone carved with the inscription, "Farley, Our Hero 1981–1995." Farley's son, Edgar, who had also played a role in April's rescue, took over as the top dog in the Patterson family.

Lynn Johnston is the most successful female cartoonist in the history of comics. In addition to being the first woman to win the Reuben Award, in 1985, she was also the first to serve as president of the National Cartoonists Society, in 1988, and the first to be inducted in the International Museum of Cartoon Art's Hall of Fame, in 1997. *For Better or For Worse* consistently wins readership polls and appears in more than 2,000 newspapers.

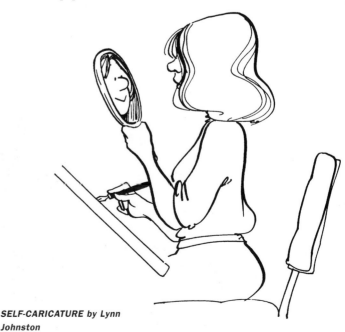

SELF-CARICATURE by Lynn Johnston

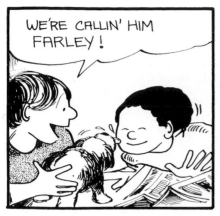
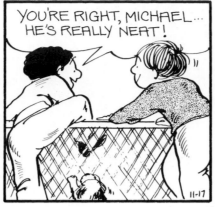
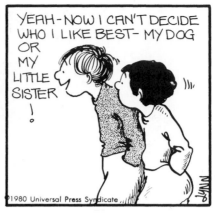

FOR BETTER OR FOR WORSE daily strip by Lynn Johnston. © 11/17/80

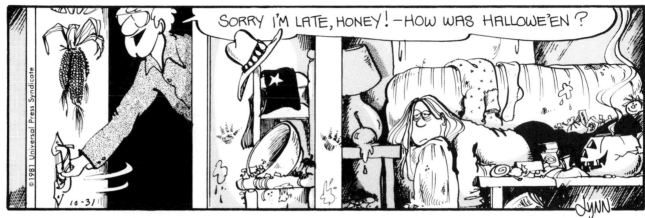

FOR BETTER OR FOR WORSE daily strip by Lynn Johnston. © 10/31/81

FOR BETTER OR FOR WORSE daily strip by Lynn Johnston. © 6/23/89

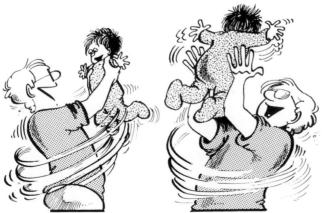

FOR BETTER OR FOR WORSE daily strip by Lynn Johnston. © 10/5/91

FOR BETTER OR FOR WORSE daily strip by Lynn Johnston. © 2/22/90

FOR BETTER OR FOR WORSE daily strip by Lynn Johnston. © 3/6/92

FOR BETTER OR FOR WORSE daily strip by Lynn Johnston. © 3/18/95

FOR BETTER OR FOR WORSE daily strip by Lynn Johnston. © 6/12/99

FOR BETTER OR FOR WORSE Sunday page (the birth of April) by Lynn Johnston. © 3/31/91

FOR BETTER OR FOR WORSE daily-strip sequence (the death of Farley) by Lynn Johnston. © 4/11–4/21/95 (4/12, 4/16, 4/19 not included)

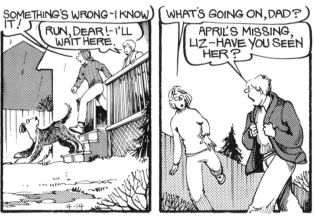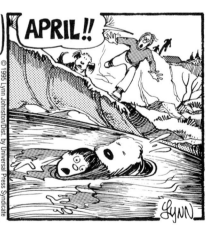

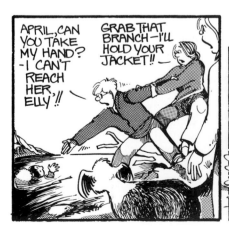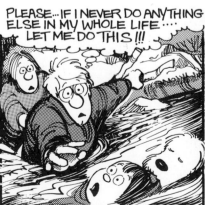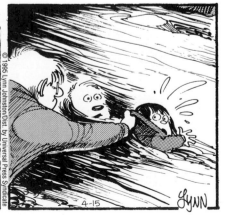

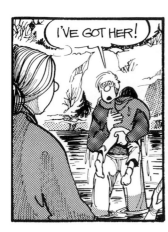

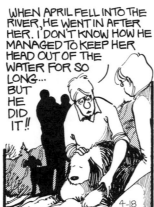

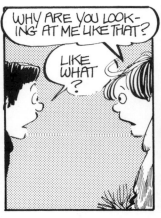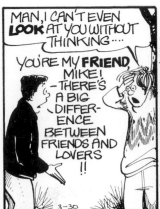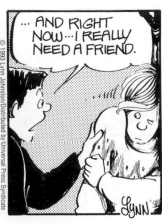

FOR BETTER OR FOR WORSE daily strip by Lynn Johnston. © 3/30/93

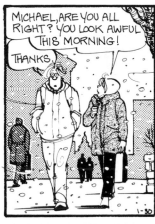

FOR BETTER OR FOR WORSE daily strip by Lynn Johnston. © 1/30/97

FOR BETTER OR FOR WORSE daily strip by Lynn Johnston. © 7/11/98

FOR BETTER OR FOR WORSE daily strip by Lynn Johnston. © 3/4/99

For Better or For Worse
By Lynn Johnston

MMMMM

FOR ME, JOHN ... THIS TIME OF YEAR IS PURE HEAVEN!

THE SMELL, THE COLORS, THE MARKETS, THE COOL, FRESH WINDS.

OF ALL THE SEASONS—I THINK I LIKE THIS THE BEST.

10-19

WE'VE SEEN A LOT OF AUTUMNS TOGETHER, HAVEN'T WE, EL.

MORE THAN 20!

I GUESS YOU COULD SAY WE'RE IN THE "AUTUMN OF OUR LIVES!"

THAT'S A NICE ANALOGY, JOHN – COMPARING A LONG-LASTING RELATIONSHIP TO THIS TIME OF YEAR.

YEAH...

FOR ONE THING, THERE'S FEWER BUGS.

©1997 Lynn Johnston Productions Inc./ Dist. by United Feature Syndicate

FOR BETTER OR FOR WORSE Sunday page by Lynn Johnston. © 10/19/97

HAGAR THE HORRIBLE daily strip by Dik Browne. © 2/16/73
All Hagar the Horrible comic strips © King Features Syndicate, Inc. Courtesy of Browne Creative, Inc.

DIK BROWNE Affectionately known by his peers in the profession as the "cartoonists' cartoonist," Dik Browne was universally loved by his family, friends, and fans as a gentle, wise, and generous soul. After gaining experience in the 1940s and 1950s as a magazine and advertising illustrator, Browne broke into the comics field when he teamed up with Mort Walker on *Hi and Lois* in 1954. Almost twenty years later he launched his own creation, *Hagar the Horrible*, which skyrocketed in sales to become one of the top features in the business within a few short years. Browne drew *Hagar* in a rough-hewn manner, quite different from the clean style he had perfected on *Hi and Lois.* "Your lines should not be too slick," the talented draftsman advised. "They should look like a human being drew them." Browne won the Reuben Award for *Hi and Lois* in 1962 and again for *Hagar* in 1973.

SELF-CARICATURE by Dik Browne

HAGAR THE HORRIBLE daily strip by Dik Browne. © 1/6/81

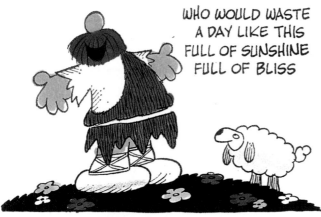

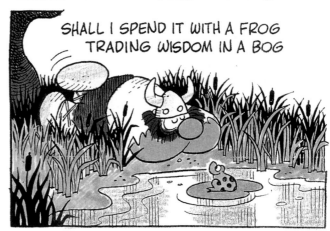

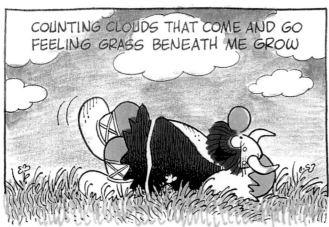

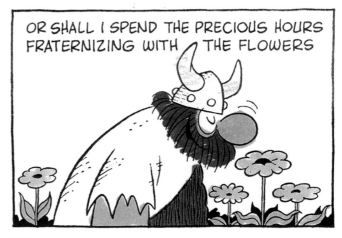

HAGAR THE HORRIBLE *Sunday page by Dik Browne. © 7/15/73*

HAGAR THE HORRIBLE daily strip by Dik Browne. © 11/29/73

HAGAR THE HORRIBLE daily strip by Dik Browne. © 2/5/75

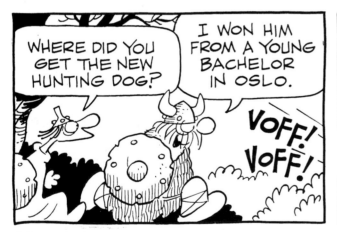

HAGAR THE HORRIBLE daily strip by Dik Browne. © 10/15/75

HAGAR THE HORRIBLE daily strip by Dik Browne. © 12/29/75

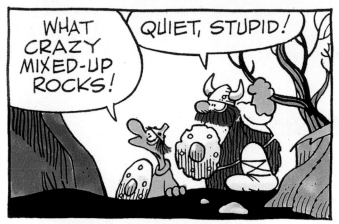

HAGAR THE HORRIBLE Sunday page by Dik Browne. © 6/2/74

HAGAR THE HORRIBLE daily strip by Dik Browne. © 12/12/73

HAGAR THE HORRIBLE daily strip by Dik Browne. © 6/6/74

HAGAR THE HORRIBLE daily strip by Dik Browne. © 9/23/82

HAGAR THE HORRIBLE daily strip by Dik Browne. © 3/6/84

HAGAR THE HORRIBLE Sunday page by Dik Browne. © 12/26/82

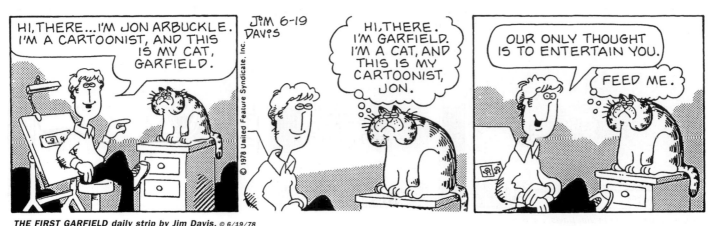

THE FIRST GARFIELD daily strip by Jim Davis. © 6/19/78

JIM DAVIS *Garfield,* the second most successful comic strip of all time after *Peanuts,* appeals to both cat-lovers and cat-haters. "People relate to him because he is them," explained creator Jim Davis. "After all, he's really a human in a cat suit." Garfield's owner, Jon Arbuckle, was introduced as a cartoonist when the strip debuted on June 19, 1978 (above). The limited supporting cast included Odie, a witless pooch, Nermal, a cutesy kitty, Arlene, his love interest, and Pooky, a stuffed teddy bear, but there was never any question who the real star of the strip was. Davis designed the feature to be reader-friendly, with heavy outlines and a minimum of dialogue, and concentrated on basic themes, like eating and sleeping. A number of talented artists, including Brett Koth, Gary Barker, Valette Green, Lori Barker, Larry Fentz, and Eric Reaves, have assisted with the production of the strip over the years, although Davis continues to be involved in generating scenarios for his famous fat cat.

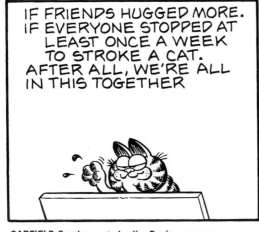

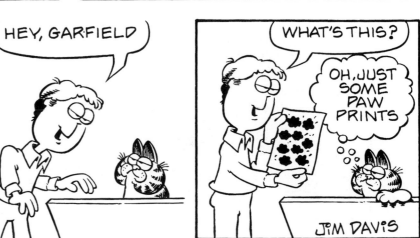

GARFIELD Sunday page by Jim Davis. © 3/18/79

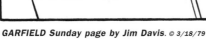

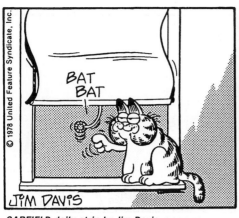

GARFIELD daily strip by Jim Davis. © 9/18/78

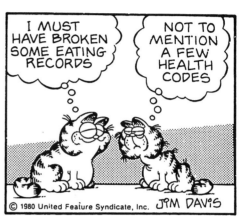

GARFIELD daily strip by Jim Davis. © 11/13/80

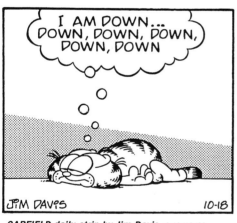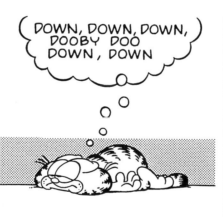

GARFIELD daily strip by Jim Davis. © 10/18/83

GARFIELD daily strip by Jim Davis. © 12/27/85

GARFIELD daily strip by Jim Davis. © 9/21/87

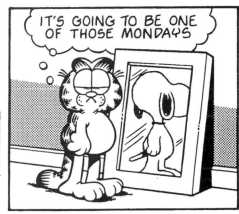

GARFIELD daily strip by Jim Davis. © 11/14/88

GARFIELD daily strip by Jim Davis. © 4/27/89

GARFIELD daily strip by Jim Davis. © 5/30/89

GARFIELD Sunday page by Jim Davis. © 4/30/95

GARFIELD Sunday page by Jim Davis. © 9/10/95

BROOM-HILDA *daily strip by Russ Myers, n.d.*

RUSSELL MYERS Broom-Hilda was once described by her creator, Russell Myers, as "a dirty old man in a dress." The eternally horny witch has been searching for a mate since her breakup with Attila the Hun in the fifth century and entertaining newspaper readers for more than thirty years. Myers, who once claimed Johnny Hart and Brant Parker's *The*

Wizard of Id as a major inspiration, introduced a distinctively energetic art style, blending surreal scenery with classic, big-nosed characters. Broom-Hilda and her two companions, Gaylord the buzzard and Irwin the troll, exist in a world that could only be conjured up by the fertile imagination and free-flowing pen of this gifted cartoonist.

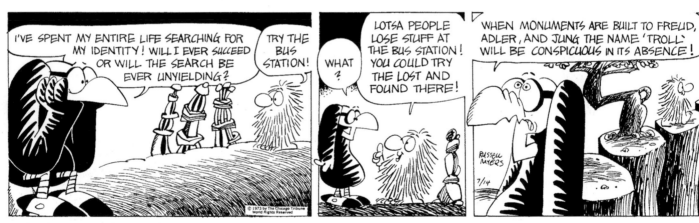

BROOM-HILDA *daily strip by Russ Myers.* © 7/14/73

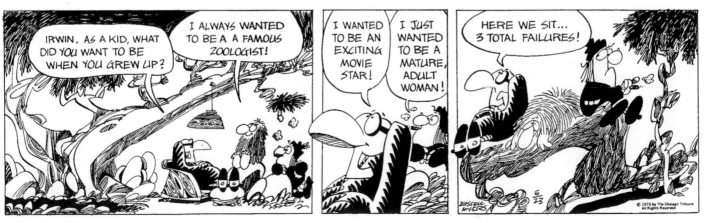

BROOM-HILDA *daily strip by Russ Myers.* © 6/23/75

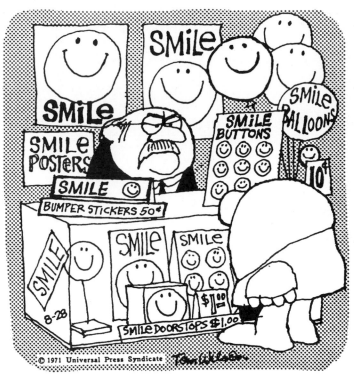

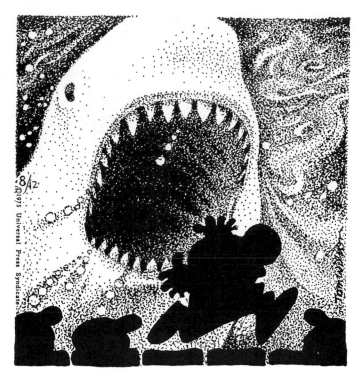

ZIGGY daily panel by Tom Wilson. © 8/12/75

TOM WILSON Ziggy, the quintessential loser, has been a big winner in the merchandising business. Hundreds of items, from dolls and games to ashtrays and soup bowls, have been decorated with the character's placid features, earning millions for his creator. Cartoonist Tom Wilson dreamed up the lovable character, with the big head and the generous heart, when he was a card designer for American Greetings in the late 1960s. The syndicated panel debuted in 1971 and appears in more than 600 newspapers. "Ziggy must be part of me because he feels as if he's been with me all my life," states Wilson. "It feels like I acknowledged him rather than invented him."

ZIGGY daily panel by Tom Wilson, n.d.

ZIGGY daily panel by Tom Wilson, n.d.

"Watch out...the plate's hot."

HERMAN daily panel by Jim Unger. © 10/10/75 NEA, Inc. Courtesy of International
Museum of Cartoon Art

" HE'S PRACTICING HIS SLAM DUNK !"

HEATHCLIFF daily panel by George Gately. © 1980 Creators Syndicate, Inc.
Courtesy of International Museum of Cartoon Art

LAUGHTER RULES Gag-a-day comics continued to dominate the industry in the 1970s, as the story-strip genre faded. Among the dozens of new humor creations that debuted were wacky single panels (*Herman*, *Heathcliff*, and *Frank and Ernest*), strips by established pros (*Sam and Silo*, *Half Hitch*, *Momma*, *Crock*, and *Catfish*), comics by young cartoonists (*Funky Winkerbean* and *Drabble*), and offerings that focused on changing lifestyles and social trends (*Mixed Singles*, *Splitsville*, and *Motley's Crew*). More than half of the features shown on these pages are still syndicated today.

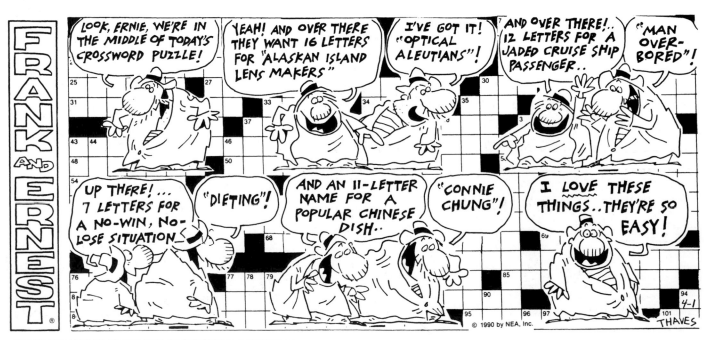

FRANK AND ERNEST Sunday page by Bob Thaves. © 4/1/90 NEA, Inc.

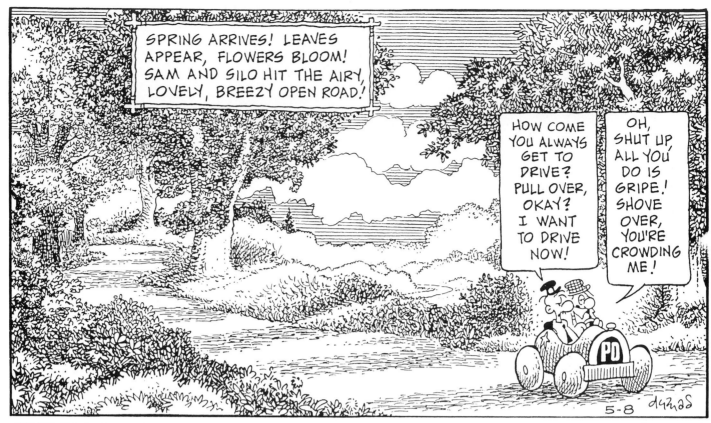

SAM AND SILO Sunday page by Mort Walker and Jerry Dumas. © 5/8/1970s King Features Syndicate, Inc.

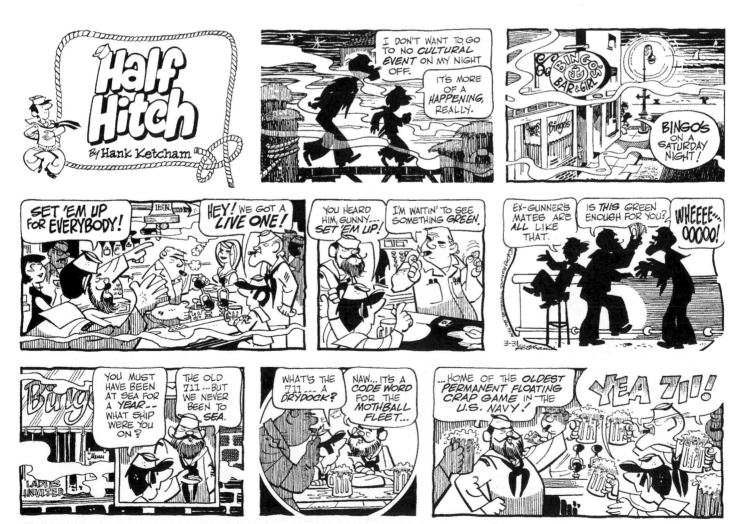

HALF HITCH Sunday page by Hank Ketcham, Bob Saylor (writer), and Dick Hodgins, Jr. (artist). © 3/3/74 King Features Syndicate, Inc.

FUNKY WINKERBEAN daily strip by Tom Batiuk. © 6/12/72 North America Syndicate, Inc

MIXED SINGLES daily strip by Mel Casson and Bill Brown. © 7/16/73 United Feature Syndicate, Inc. Courtesy of Richard Marschall

SPLITSVILLE daily strip by Frank Baginski and Reynolds Dodson. © 12/18/78 Los Angeles Times Syndicate, Inc.

DRABBLE daily strip by Kevin Fagan. © 3/27/79 United Feature Syndicate, Inc.

MOMMA daily strip by Mell Lazarus. © 3/15/71 Creators Syndicate, Inc. Courtesy of International Museum of Cartoon Art

CROCK daily strip by Don Wilder and Bill Rechin. © 11/15/75 North America Syndicate, Inc.

CATFISH daily strip by Rog Bollen. © 4/22/76 Tribune Media Services, Inc. All rights reserved. Reprinted with permission

MOTLEY'S CREW daily strip by Ben Templeton and Tom Forman. © 11/17/77 Tribune Media Services, Inc. All rights reserved. Reprinted with permission

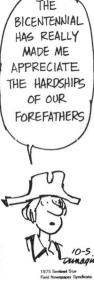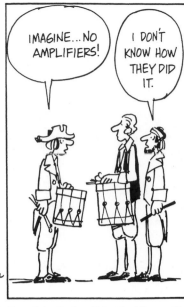

DUNAGIN'S PEOPLE Sunday page by Ralph Dunagin. © 10/5/75 Tribune Media Services, Inc. All rights reserved. Reprinted with permission. Courtesy of International Museum of Cartoon Art

CURRENT EVENTS

Topical humor was the primary focus of many new features introduced during the decade. *Dunagin's People* (1970) by Ralph Dunagin followed in the tradition of *Berry's World* and *the small society*, providing timely observations about the latest developments. *Tank McNamara* (1974) by Jeff Miller (writer) and Bill Hinds (artist) featured a retired football jock trying to make it as a sports broadcaster. *Travels with Farley* by Phil Frank, which was self-syndicated beginning in 1975 and picked up by Chronicle Features in 1978, starred a wandering backpacker in search of America.

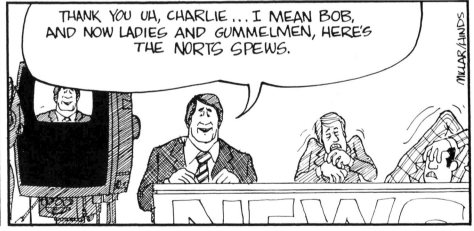

TANK MCNAMARA daily strip by Jeff Millar and Bill Hinds. © 1974 Millar/Hinds. Used by permission of Universal Press Syndicate, Inc. All rights reserved

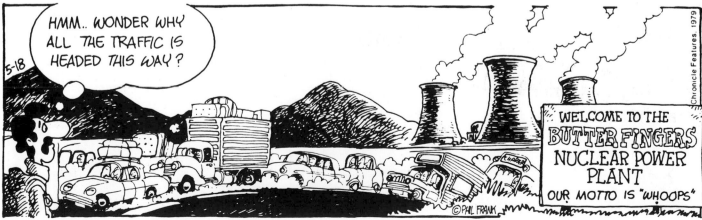

TRAVELS WITH FARLEY daily strip by Phil Frank. © 5/18/79 Chronicle Features Syndicate, Inc.

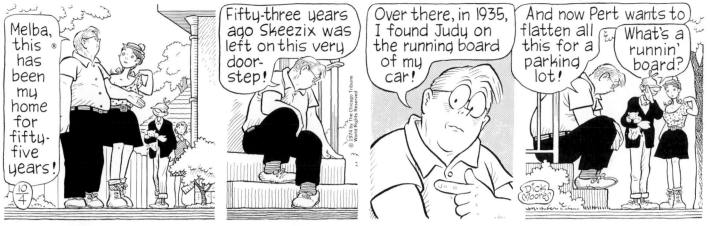

GASOLINE ALLEY daily strip by Dick Moores. © 10/4/74 Tribune Media Services, Inc. Courtesy of David Applegate

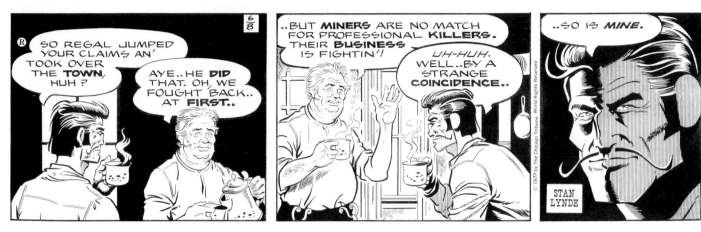

RICK O'SHAY daily strip by Stan Lynde. © 6/8/77 Tribune Media Services, Inc. Courtesy of David Applegate

TO BE CONTINUED . . .

A few story strips survived the gag-a-day onslaught. During the 1960s *Gasoline Alley* was taken over by Frank King's former assistant, Dick Moores, who won the Reuben Award in 1974 for his outstanding efforts. *Rick O'Shay*, which debuted in 1958 as a humorous western, evolved into a realistically rendered story strip in 1964. Its creator, Stan Lynde, left the feature in 1977 after a dispute with his syndicate, and it was continued by other artists until 1981. The newspaper adaptation of *The Amazing Spider-Man*, which was written by Stan Lee and illustrated initially by John Romita, made its debut in 1977 and was one of the few successful adventure-strip launches of the decade.

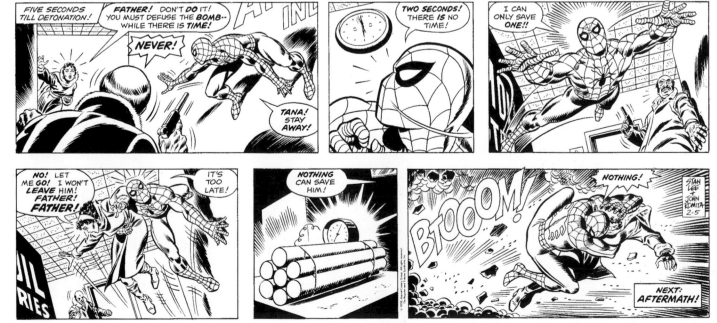

THE AMAZING SPIDER-MAN Sunday page by Stan Lee and John Romita. © 2/5/78 King Features Syndicate, Inc.

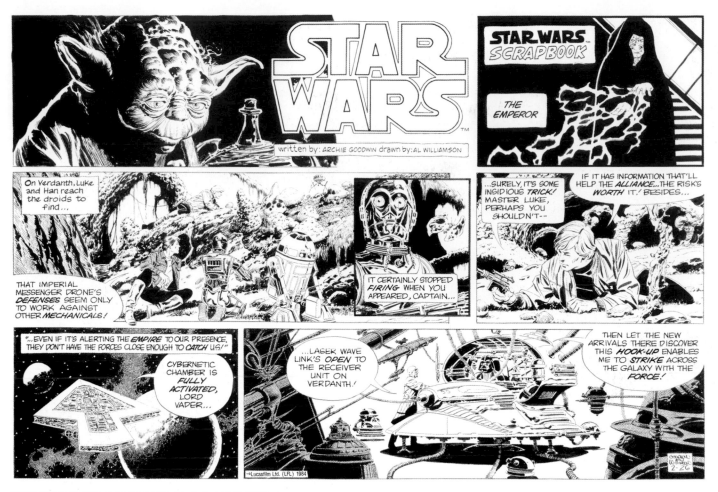

STAR WARS Sunday page by Archie Goodwin and Al Williamson. © 2/26/84 Lucasfilm LTD. Courtesy of the Frye Art Museum, Seattle. Photo credit: Susan Dirk/Under the Light

THE ART OF ILLUSTRATION

The classic spy strip *Secret Agent X-9* was written by Dashiell Hammett and illustrated by Alex Raymond when it debuted in 1934. The daily-only feature was continued by a long string of artists until Al Williamson, a devotee of Alex Raymond and a former assistant to John Prentice, took over the renamed *Secret Agent Corrigan* in 1967. After he quit *Corrigan* in 1980,

Williamson illustrated the short-lived *Star Wars* adaptation. Leonard Starr terminated his long-running feature, *On Stage*, in 1979 to produce the new *Annie* strip, which was reintroduced after the success of the Broadway stage adaptation of Harold Gray's classic creation. John Cullen Murphy, who began assisting Hal Foster on *Prince Valiant* in 1970, assumed control entirely after Foster's retirement in 1979.

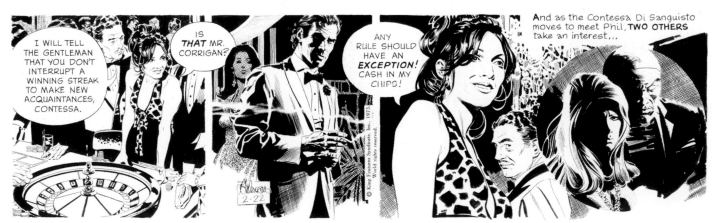

SECRET AGENT CORRIGAN daily strip by Al Williamson. © 2/22/73 King Features Syndicate, Inc. Courtesy of the Frye Art Museum, Seattle. Photo credit: Susan Dirk/Under the Light

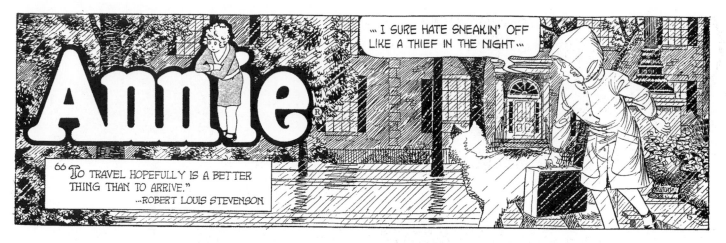

...I SURE HATE SNEAKIN' OFF LIKE A THIEF IN THE NIGHT...

66 "TO TRAVEL HOPEFULLY IS A BETTER THING THAN TO ARRIVE."
...ROBERT LOUIS STEVENSON

...TAKING OFF LIKE THIS MAKES ME FEEL LIKE A REAL **INGRATE** TOO, AFTER TH' SWELL WAY SENATOR STAN TREATED US, BUT...

...WE CAN'T HAVE 'EM STARTIN' RUMORS THAT SENATOR STAN IS "DADDY" WARBUCKS' **HIRED HAND** BECAUSE **I** WAS LIVING IN HIS HOUSE...

..."COURSE, IF "DADDY" WERE HERE HE'D HAVE THOSE CROOKS AND LIARS PINNED T' THE WALL BEFORE THEY COULD **BLINK**...

...BUT... HE'S **NOT** HERE...

© 1980 by Chicago Tribune-N.Y. News Synd. Inc.
All Rights Reserved

...SO WE'LL JUST HAVE T' DO THE BEST WE CAN 'TIL WE SEE HIM AGAIN!

LOOK, SANDY— "INTERSTATE MOVERS"...

...I'LL BET IF WE STOWED AWAY WHILE TH' DRIVERS ARE GRABBIN' A BITE, WE COULD WIND UP A REALLY LONG WAY FROM HERE!

ARF!

SHH! QUIET, SANDY! SOMEONE'S COMIN'! IT COULD BE THE **DRIVERS!** YEP! THERE GOES THE MOTOR! WE'RE **MOVIN'**!

GEE~ THAT FURNITURE LOOKS PRETTY **EXPENSIVE**...BET SOME FAMILY'LL BE GLAD T' HAVE THEIR THINGS AROUND THEM AGAIN IN THEIR NICE NEW HOME...

...ALL SNUG 'N' SECURE 'N' COZY 'N'...
MNZZ

THE MOVERS' TRUCK ROLLS ON AND ON THROUGH THE NIGHT, AND PRESENTLY...

LEFT TURN HERE, HUNK...

GOTCHA...

SURE THIS IS THE ADDRESS? IT DON'T **LOOK** LIKE MUCH!

IT SURE DON'T! ...AND WHERE'S THE OWNERS? THEY WAS SUPPOSED T' **MEET** US HERE!

ANNIE Sunday page by Leonard Starr. © 6/8/80 Tribune Media Services, Inc. Courtesy of International Museum of Cartoon Art

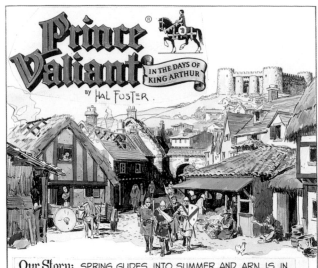

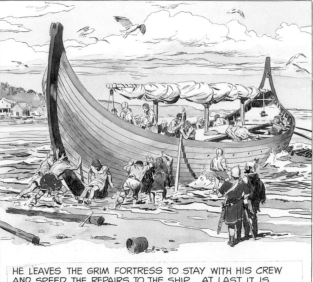

Our Story: SPRING GLIDES INTO SUMMER AND ARN IS IN DESPAIR. THE COUNTLESS DELAYS TO HIS HOMEWARD JOURNEY, THE UNCERTAINTY OF HIS RECEPTION THERE, AND THE PAIN OF HIS BROKEN ARM ADD TO HIS MISERY.

HE LEAVES THE GRIM FORTRESS TO STAY WITH HIS CREW AND SPEED THE REPAIRS TO THE SHIP. AT LAST IT IS SEAWORTHY AND IS LAUNCHED FOR THE LONG JOURNEY NORTH.

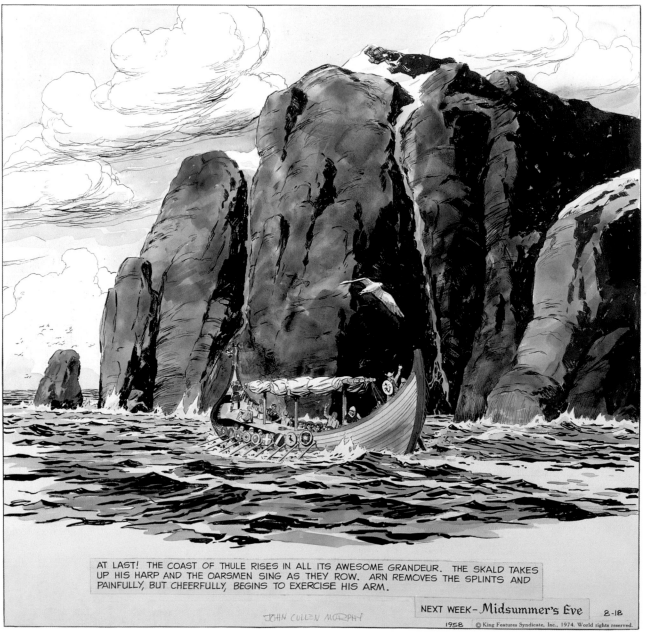

AT LAST! THE COAST OF THULE RISES IN ALL ITS AWESOME GRANDEUR. THE SKALD TAKES UP HIS HARP AND THE OARSMEN SING AS THEY ROW. ARN REMOVES THE SPLINTS AND PAINFULLY, BUT CHEERFULLY, BEGINS TO EXERCISE HIS ARM.

NEXT WEEK— Midsummer's Eve 8-18

1958 © King Features Syndicate, Inc., 1974. World rights reserved.

PRINCE VALIANT Sunday page by Hal Foster and John Cullen Murphy. © 8/18/74 King Features Syndicate, Inc. Courtesy of International Museum of Cartoon Art

the
eighties

ARE WE HAVING FUN YET?—Griffy and Zippy by Bill Griffith. © 1990 Bill Griffith. Courtesy Cartoonist PROfiles.

T HE REAGAN YEARS WERE GOOD FOR BUSINESS. AMERICA ENJOYED ITS LONGEST PEACETIME ECONOMIC EXPANSION TO DATE BETWEEN 1982 AND 1988. SEVENTEEN MILLION NEW JOBS WERE CREATED, INFLATION DROPPED TO SINGLE DIGITS, AND THE GROSS NATIONAL PRODUCT SHOWED THE LARGEST INCREASE IN THIRTY-THREE YEARS.

The baby boomers had grown into yuppies, and these young urban professionals had discovered a new thrill–investing in the stock market. The prevailing mood of the era was summed up by the master of high-risk arbitrage, Ivan Boesky, when he brazenly justified his profit motives by claiming, "Greed is all right. . . . You can be greedy and still feel good about yourself."

The moneymaking spree ended on "Black Monday," October 19, 1987, when the stock market lost 22 percent of its value. An estimated $870 billion in equity vanished, double the loss of the 1929 crash that marked the start of the Great Depression. The economy eventually stabilized in the early 1990s, but the party was over.

The accelerated pace of progress during the decade created changes in all areas of American life. Consumers were

confronted by a dizzying array of technological gadgets and entertainment options. Fax machines, cellular telephones, microwave ovens, and compact discs became commonplace, seemingly overnight. More than 60 percent of homes had cable television by 1989, and eleven million videocassette recorders were sold during the decade. In 1981 I.B.M. sold 25,000 units of its first personal computer. Three years later there were three million I.B.M. PCs in American offices and homes. Video games, big-budget movies, and televised sports all competed for the public's increasingly divided attention.

Newspaper comics, which were still produced the old-fashioned way—by hand—somehow managed to thrive in this intensely competitive environment. A fresh crop of new talent, an audience receptive to irreverent humor, and a boom in character licensing were among the

many factors that led to a modern renaissance in the funnies business.

Three of the top comics creators of the 1980s had careers as precipitous as the stock market. Gary Larson, Berke Breathed, and Bill Watterson rose quickly to the top of their profession, reached creative peaks by the end of the decade, and eventually succumbed to "burnout" in the 1990s. Unable to meet the daily demands of syndication and unwilling to compromise the quality of their work, all three retired from the business in 1995.

In the late 1970s Gary Larson was working at a music store in Seattle. He hated his job and decided to take a few days off to think about what he wanted to do with his life. While sitting in his kitchen, he started doodling on a sheet of paper and drew six cartoons. The next day he took them to a local magazine, *Pacific Search*, and the editor bought the batch for $90. Larson immediately quit his job and started selling cartoons. His first regular single-panel creation, *Natures's Way*, appeared in a small weekly paper, the *Sumner News Review*. Larson was paid $3 a drawing. In 1979 a friend showed *Nature's Way* to the editor of the *Seattle Times*, which began running Larson's panel in its Saturday edition.

During his summer vacation in 1979, Larson drove to San Francisco to seek his fortune as a cartoonist. He showed his portfolio to Stan Arnold at the *San Francisco Chronicle*, who liked Larson's work and asked if he could hold on to the samples for a few days. When Larson returned home, he found a letter from the *Seattle Times* notifying him that *Nature's Way* was going to be canceled. The next day he got a call from Stan Arnold telling him that Chronicle Features, the syndicate affiliated with the *San Francisco Chronicle*, wanted to distribute his panel and rename it *The Far Side*. Larson agreed, signed a contract with Chronicle Features, and *The Far Side* debuted on January 1, 1980.

Two years later, Andrews and McMeel, the publishing division of Universal Press Syndicate, released a book collection of Larson's panels and it became a best-seller. In 1984, when his contract expired with Chronicle Features, Larson signed with Universal.

The Far Side was one of the most successful syndicated cartoons of the 1980s and inspired a wave of "way out" panels and strips. Among the best of these were *The Quigmans* (1984) by Buddy Hickerson, *Caldwell* (1985) by John Caldwell, *Bizarro* (1985) by Dan Piraro, and *Mr. Boffo* (1986) by Joe Martin. When asked about the sudden proliferation of offbeat creations, one syndicate editor explained, "There is a general cynicism in the public and a tendency to question traditional values. This is particularly true of the new generation of baby boomers and yuppies. They look for comics that reflect a disenchantment with the conventional."

Larson's dark humor, which often featured bizarre role reversals between humans and animals, explored previously taboo subjects such as cannibalism, suicide, and extinction. By 1987 more than six million book collections of *The Far Side* had been sold, and an exhibition of Larson's cartoons, organized by the California Academy of Sciences, traveled to the Smithsonian in Washington, D.C. Larson won the Reuben Award in 1990 and 1994 and retired after the last panel of *The Far Side* appeared, on January 1, 1995, to pursue an interest in music.

Berke Breathed, who claimed he was never interested in comics as a youth, created a strip entitled *Academia Waltz* while majoring in photojournalism at the University of Texas in 1978 and 1979. During that time, Breathed turned out an estimated 658 episodes of *Academia Waltz*, which were published in two book collections. One store on the Austin campus sold 10,000 copies. Encouraged by his local success, he sent some samples to the national syndicates but got no takers. A year later, the Washington Post Writers Group called Breathed to see if he wanted to create a syndicated feature.

Bloom County debuted on December 8, 1980. Initially set in a boardinghouse run by Ma Bloom in "the center of the deepest, darkest, middlest America," Breathed's strip was drawn in a crude style without the use of speech balloons. The similarities to *Doonesbury* were evident in the beginning. "Obviously

SYNDICATED SERVITUDE—BLOOM COUNTY *daily strip by Berke Breathed (written during Garry Trudeau's sabbatical).* © 8/17/83 Rosebud Productions, Inc.

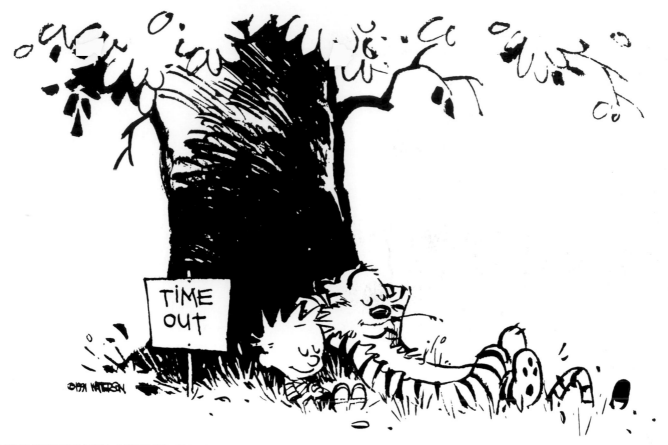

A WELL-DESERVED REST—CALVIN AND HOBBES illustration by Bill Watterson. © 1991 Watterson. Used by permission of Universal Press Syndicate. All rights reserved. Courtesy of Editor and Publisher

I've been influenced by Garry Trudeau," Breathed admitted. "But people seem to overlook the fact that, really, in concept and in style of humor, you could trace my roots back to more irreverent forms of humor, even back to Dr. Seuss."

When Trudeau went on sabbatical in 1983, many editors picked up *Bloom County* as a replacement, although the strip lost very few of its 550 clients when *Doonesbury* returned in 1984. Breathed used this opportunity to take his strip in bold new directions. The original human cast—Cutter John, a paraplegic Vietnam vet; Steve Dallas, a self-centered lawyer; Lola Granola, a former flower child; Milo Bloom, reporter for the *Bloom Beacon*; Mike Binkley, with his closet full of insecurities; and Oliver Wendall Jones, a computer hacker—was eventually eclipsed by Opus the penguin and Bill the Cat. Breathed's art style blossomed as his satire became more adventurous. *Bloom County* was now a comic strip that defied comparison.

Loose Tales, the first *Bloom County* book collection, was on the *New York Times* best-seller list for thirty-two weeks in 1983. Breathed won the Pulitzer Prize in 1987 and, at its peak, the strip appeared in more than 1,000 newspapers.

By 1989 Breathed was tapped out. "A good comic strip is no more eternal than a ripe melon," he explained. "The ugly truth is that, in most cases, comics age less gracefully than their creators. *Bloom County* is retiring before the stretch marks show."

Between 1990 and 1995 Breathed produced a Sunday-only feature, entitled *Outland*. This follow-up creation, although showcasing some inspired fantasy and appearances by many of the original *Bloom County* gang, never captured a large audience. After retiring from the comics business for good, Breathed released a series of children's books and produced a pair of animated specials starring Opus and Bill.

In 1980 Bill Watterson graduated from Kenyon College in Ohio, hoping to follow in the footsteps of another Kenyon alumnus, Jim Borgman, who was then working as the editorial cartoonist for the *Cincinnati Enquirer*. Watterson landed a job with the *Cincinnati Post* as its political cartoonist but was fired six months later.

After trying unsuccessfully to get a position at another paper, Watterson realized that he didn't have the zeal it took to be a political cartoonist. He then started submitting ideas for comic strips. His first proposal was an outer-space parody. He drew up several weeks of strips and mailed them to five syndicates simultaneously. It was rejected at all five. Over the next few years he continued to come up with ideas he thought the syndicates would buy and tried a number of topical "'80s-oriented" strips, with no success.

Finally, United Feature Syndicate suggested that he take two characters from one of his submissions and build a strip around them. Calvin was the little brother of the main character in the original proposal, and Hobbes was Calvin's stuffed tiger. United Feature gave Watterson a development contract to work on this idea, but in the end the syndicate rejected it.

STAYING ON SCHEDULE—Opening panel from "Daily Strip" story by Bill Griffith. © 1988 Bill Griffith

One U.F.S. employee suggested to Watterson that he incorporate another established character, Robotman, into his strip. Robotman was the star of a toy product line in England, and the syndicate thought he had great merchandising potential in America. Watterson declined the offer, and United eventually hired another cartoonist, Jim Meddick, to draw the *Robotman* comic strip, which debuted in 1984. The Robotman merchandising program never took off, but the comic strip survived.

After being rejected by United, Watterson started shopping *Calvin and Hobbes* around to the other syndicates, and after five years of perseverance, he finally sold his idea to Universal Press Syndicate. *Calvin and Hobbes* debuted on November 18, 1985.

In an interview at the time Watterson cautiously remarked, "Of course, launching a comic strip does not guarantee me a lifetime of steady income. Universal Press is gambling on the strip, and if it bombs, I'll be back to robbing the elderly of their welfare checks before the year is out."

Watterson's creation, which borrowed a bit of smart-aleck wisdom from *Skippy*, a dose of fantasy from *Barnaby*, and a touch of graphic flair from *Pogo*, was both traditional and innovative. The central concept of the strip—that Hobbes, a stuffed tiger, was real to Calvin but to no one else—became more than just a gimmick in Watterson's

gifted hands. It was the launching pad into a brilliantly conceived world of childhood imagination.

Watterson set his own standards of artistic integrity by refusing to merchandise his feature in any form other than books and, later, by demanding that his Sunday page run in a half-page format that could not be reduced or rearranged to fit any other configurations.

Calvin and Hobbes appeared in over 1,800 newspapers at its peak, and book collections of the strip continued to shatter sales records well into the 1990s. Watterson won the Reuben Award twice, in 1986 and 1988. He retired from the profession in 1995, citing fatigue and frustration with the demands and limitations of the comics business.

The accomplishments of these three creators inspired other cartoonists with unconventional ideas to take a plunge into national syndication. The saga of how Bill Griffith's *Zippy the Pinhead* made its way from underground comix to the mainstream press was one of the more remarkable success stories of the era. "It was a ten-year process that was completely unplanned by me," claimed Griffith. "And in each case, the way it happened was, I was asked in."

Zippy the Pinhead was first conceived in 1970 and made his debut in the underground comic book *Real Pulp* a year later. Griffith's non sequitur–spouting, polka-dot-suited, existential

PHYSICIST TURNED CARTOONIST—Self-caricature by Bud Grace

clown evolved over the next few years in the pages of a variety of alternative comics and magazines. In 1976 Griffith started doing a weekly *Zippy* comic strip for the *Berkeley Barb* and eventually self-syndicated his feature to about forty clients.

In 1985 Griffith was invited by Will Hearst III and his editor, Dave Burgin, to do a daily strip for the *San Francisco Examiner*. After a difficult year of adjusting to the demands of producing a daily version of *Zippy*, Griffith was offered a contract by King Features Syndicate. Fearful of making the commitment, Griffith drew up a list of about twenty demands that he hoped would be unacceptable. To his surprise, Alan Priaulx, an executive at King, agreed to all of them. Griffith found out later that Priaulx was about to quit his job and wanted to leave a "ticking time bomb" behind when he left.

Within a few months after its release in 1986, the daily *Zippy* strip was running in many of the nation's largest papers, including the *Washington Post*, *Baltimore Sun*, *L.A. Times*, and *Dallas Times-Herald*. "Seeing *Zippy* in the mainstream press," commented Griffith, "is like seeing some gaudily painted

motorboat weaving in and out of these slow-moving yachts and sailboats."

Griffith admitted that he felt like the "house weirdo of King Features" but was told by one syndicate employee that "they really enjoy the fact that, although King has always been accused of being the most conservative, stuck-in-the-mud syndicate, the fact that they have *Zippy* gives them a little kick." Griffith claimed that "there is a parallel with the way King Features supported me and stayed with me and the way they treated George Herriman. The original Hearst indulged in what amounted to personal taste. He was kind of a patron, and maybe Will Hearst is a little bit of that to me."

Another King Features discovery of the 1980s was Bud Grace, who graduated from Florida State University in 1971 with a Ph.D. in physics. After two years as a professor at the University of Georgia, he returned to teach at his alma mater. Grace began doodling in his spare time and developed an interest in cartooning. His first published work was a strip called *Nuclear Funnies* for the university paper.

In 1980 Grace had a "midlife crisis" and changed careers for good. He sold freelance cartoons successfully to national magazines for the next six years until, with a new baby on the way, he decided he needed more financial security. He worked up an idea for a strip and sent it to Bill Yates, the comics editor of King Features. Yates took it home and handed the strips to his wife, Skippy, before retiring to bed. Skippy woke Bill up at two o'clock in the morning and said she thought the strip was hilarious. Yates invited Grace to come to New York City and told him that, although he liked the characters, his writing needed some work. After some changes were made, *Ernie* was released on February 1, 1988.

In the first sequence, Ernie Floyd, the star of the strip, worked as the assistant manager of a "Mr. Squid" fast-food franchise. Ernie's uncle, Sid Fernwilter, a founding member and eternal treasurer of the Piranha Club, supported himself by conning people out of their money. Other characters in the strip included the homely Doris Husselmeyer, landlady Effie

WHAT READERS WANT—SHOE daily strip by Jeff MacNelly. © 3/14/85 Tribune Media Services, Inc. All rights reserved. Reprinted with permission

Munyon, doctor Enos Pork, the crooked Wurlitzer Brothers, and the lecherous Arnold Arnoldski. Grace described the humor in *Ernie* as "a comedy of low manners."

In 1994 Grace won the award for Best Humor Strip from the National Cartoonists Society and gradually built a respectable list of clients. In 1998 the name of the strip was changed to *The Piranha Club.*

Newsweek magazine, in a 1980 cover story on "The Art of Politics," observed, "There have never been so many good cartoonists—or more incompetence, folly and hypocrisy for them to lampoon." Many of the political cartoonists profiled in the article, including Mike Peters, Doug Marlette, and Tony Auth, would eventually follow Jeff MacNelly's lead and explore the greener pastures of comic-strip syndication.

Artists with an established reputation had an advantage when a syndicate looked at a submission. David Hendin, a former United Feature executive, explained, "They are not going to send you a comic strip that sucks wind. They may send you one that doesn't work, for one reason or another, but they're not going to send you something drawn on tissue paper that's the wrong size, that's drawn in magic marker and bleeding all over the place with a little note that says, 'I need somebody to edit these.'"

Experience didn't guarantee success, however. Bill Schorr, a political cartoonist for the Tribune Syndicate, created *Conrad,* a strip starring a cigar-chomping frog, in 1982. It only survived for two years. Wayne Stayskal's *Balderdash* (1983) had an even shorter run. Two Pulitzer Prize winners had better results. Doug Marlette's *Kudzu* (1981) and Mike Peters's *Mother Goose and Grimm* (1984) had large client lists by the end of the decade. All of these features were originally signed by Tribune, a syndicate that specialized in double-dipper strips.

In contrast to the meteoric rise of *The Far Side, Bloom County,* and *Calvin and Hobbes,* a number of new creations built momentum gradually throughout the decade. Among these solid family-oriented features were: *Marvin* (1982) by Tom Armstrong, *Sally Forth* (1982) by Greg Howard, *Rose Is*

Rose (1984) by Pat Brady, *Luann* (1985) by Greg Evans, *Fox Trot* (1988) by Bill Amend, *Curtis* (1988) by Ray Billingsley, *One Big Happy* (1989) by Rick Detorie, and *Jumpstart* (1989) by Robb Armstrong. All of these strips went through a period of evolution, built respectable lists of clients, and achieved their full potential in the 1990s.

On September 21, 1981, *Jim Henson's Muppets,* drawn by Guy and Brad Gilchrist, debuted in 550 newspapers and soon reached a peak of 660 subscribers. It was the most successful start-up of all time, but a pattern familiar to many spin-off strips soon set in. The talented young cartoonists struggled to adapt the live-action puppet stars to the two-dimensional comic-strip medium. Although disappointed editors began canceling the feature, the Gilchrists managed to maintain a list of 300 papers until moving on to other challenges in 1986.

A number of period creations showcased caricatures of famous personalities. *John Darling* (1979), by Tom Armstrong and Tom Batiuk, starred a television talk-show host. *Rock Channel* (1984), by the Gilchrist brothers and Greg Walker, was inspired by MTV. *Betty Boop and Felix* (1984), by the Walker Brothers, placed the two vintage animation stars in a modern Hollywood setting. *Benchley* (1984), by Mort Drucker and Jerry Dumas, revolved around the day-to-day activities of the Reagan White House. None of these strips survived the decade.

Ernie Bushmiller, the creator of *Nancy,* died of a heart attack on August 15, 1982. The strip was taken over by Mark Lasky, a staff cartoonist for United Feature, who emulated the original Bushmiller style. On July 31, 1983, Lasky succumbed to cancer at

MISS PIGGY AND KERMIT by Guy and Brad Gilchrist. © 1981 Henson Associates, Inc.

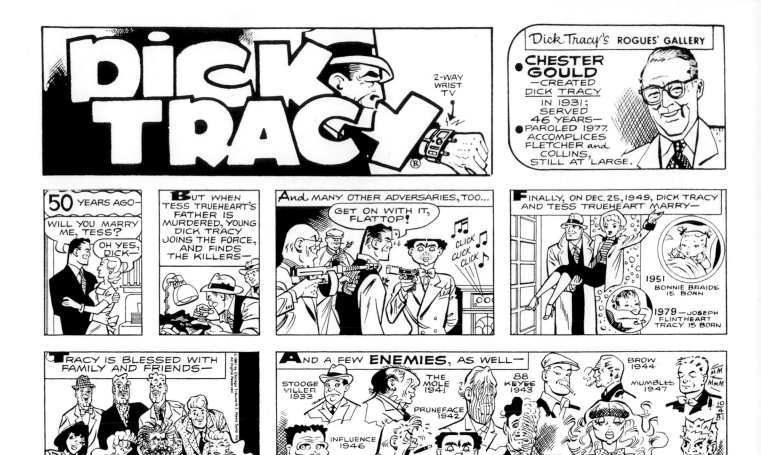

MILESTONE—DICK TRACY 50TH ANNIVERSARY Sunday page by Chester Gould, Rick Fletcher, and Max Collins. © 10/4/81 Tribune Media Services, Inc. All rights reserved. Reprinted with permission

the age of twenty-nine. Jerry Scott, who had been producing *Gumdrop* since 1981, was selected as Lasky's successor.

Scott, who admitted that he had hated *Nancy* when he was growing up, agreed to continue Bushmiller's creation on the condition that he could update the feature. Although criticized by traditionalists, Scott introduced a new, improved Nancy and built the list of subscribers to 500 newspapers by 1988.

A number of other legendary creators also died during the decade. Hal Foster (1982), Chester Gould (1985), Dick Moores (1986), and Milton Caniff (1988) had all been active in the comics business for over fifty years when they passed away. Bill Hoest (1988) and Dik Browne (1989) were among the most successful cartoonists in the business when they

died. In all but one case (Caniff's *Steve Canyon* ended upon his death), their features were left in able hands.

Although adventure strips had all but disappeared by the 1980s, readers of the remaining continuity strips were intensely loyal to their favorites. When two Lexington, Kentucky, newspapers, the *Herald* and the *Leader*, merged in 1983, *Apartment 3-G* was dropped. "There was tremendous public reaction," reported the editor. "We got at least five times as many calls and letters protesting the loss of *3-G* than for any of the other comics we dropped." It was promptly put back in the paper. A similar response occurred in Rochester when the *Times-Union* canceled *Rex Morgan*. The paper received 237 letters demanding its return.

BUNNY'S FUNNIES—Bunny Hoest and John Reiner continued Bill Hoest's comic creations after his death in 1988. Left to right: The Lockhorns, Agatha Crumm, Laugh Parade, Howard Huge, Bumper Snickers, and What a Guy. © King Features Syndicate, Inc. and Hoest Enterprises, Inc.

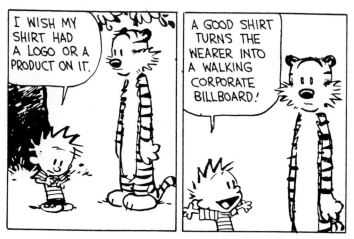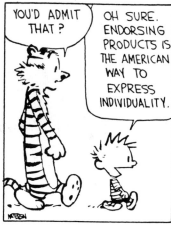

SELLING OUT—CALVIN AND HOBBES *daily strip by Bill Watterson.*

In 1985 *Rex Morgan* was in 350 papers, *Judge Parker* ran in 250, and *Apartment 3-G* had 200 clients. Dr. Nicholas Dallis, the writer of all three features, believed his strips continued to be relevant because they "address the problems that are occurring today." During the decade, Dr. Dallis tackled cocaine addiction, fetal alcohol syndrome, and spousal abuse.

Forbes magazine estimated, in a 1989 survey, that the combined annual income generated by the major syndicates from newspapers, excluding licensing revenue, was about $100 million, and that comic strips accounted for 70 percent of that amount. According to their research, when licensing revenue was added, United Media earned $140 million annually, King Features $120 million, Tribune Media $40 million, Universal Press $40 million, and Creators $8 million.

The *Forbes* article concluded, "The big syndicates, in any case, had been declining for decades—victims of stagnating newspaper readership, fewer dailies and more homegrown feature material. The syndicates responded by mining the gold in beloved characters like Snoopy, Garfield and Popeye, who are adapted and repackaged for animated TV shows, movies and books, and licensed to manufacturers of just about everything."

Charles Schulz and Jim Davis were listed in *Forbes* as among the highest-paid entertainers in the 1980s. The magazine estimated that Schulz earned $55 million in 1986 and 1987 combined, and Davis was not far behind with a two-year total of $31 million. Davis, who preferred not to discuss his salary, claimed, "Those figures are inflated. I don't make the kind of money *Forbes* suggested, although I'm not complaining. *Forbes* must have been confusing sales of *Garfield* products with my actual royalty, which is far less than they estimated."

According to *The Licensing Letter*, between 1978 and 1982 annual retail revenues from all licensed products rose from $6.5 billion to $20.6 billion, and comic properties accounted for approximately 20 percent of this business. In 1982 *People* magazine estimated that there were 1,500 Garfield products on the market that had earned between $14 million and $20 million. Davis's phenomenal success also made him a target of criticism.

In 1989 Bill Watterson gave a speech at Ohio State University, entitled "The Cheapening of Comics." Watterson lamented that "with the kind of money in licensing nowadays, it's not surprising many cartoonists are as eager as the syndicates for easy millions, and are willing to sacrifice the heart and soul of their strip to get it."

In Watterson's feature, Hobbes was a product of Calvin's imagination. He didn't want a toy designer determining how his tiger would look and act. It was his belief that merchandise would alter the delicate chemistry of his creation.

Most cartoonists didn't agree with Watterson. Some thought their syndicates were not doing enough to generate business. "Universal is a brilliant syndicate," said Cathy Guisewite in 1989, "but there are licensing companies out there that are more expert at it." The majority of cartoonists earned very little additional income beyond the fees paid by the newspapers for their strips.

The artists wanted more control of their merchandising programs, and this brought up the ownership issue. In the 1980s and 1990s a number of cartoonists fought for and successfully obtained the copyrights to their features, as well as increased licensing control and a more favorable split of the income. Bil Keane (*Family Circus*), Lynn Johnston (*For Better or For Worse*), Tom Wilson (*Ziggy*), and Cathy Guisewite (*Cathy*) were among the artists who renegotiated their contracts.

Corporate mergers also dramatically altered the funnies business. In March 1986 the second-most-profitable syndicate, King Features, under the leadership of Joe D'Angelo, absorbed the seventh-largest, Cowles (formerly known as the Register and Tribune Syndicate). The following February, King purchased News America Syndicate, the third-largest comics distributor, from Rupert Murdoch for a reported $23 million. King, which incorporated the renamed North America Syndicate into its group of companies, now controlled 225 syndicated features, including nine strips and panels with over 1,000 clients.

Jay Kennedy, a former cartoon editor and consultant to *Esquire, People, National Lampoon,* and *Lear's* magazines, took over as comics editor at King Features in 1989. Kennedy, who

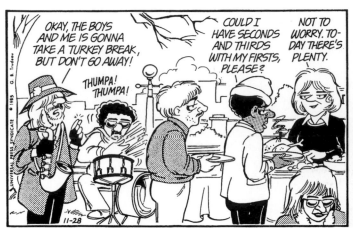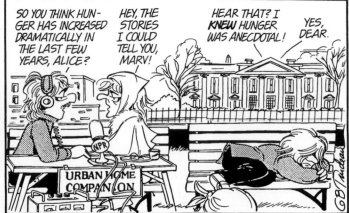

COMIC RELIEF—DOONESBURY *daily strip (from the first Thanksgiving Day Hunger Project) by Garry Trudeau.* © *11/28/85 G.B. Trudeau. Used by permission of* Universal Press Syndicate

had represented a number of "alternative" comics artists, promised to complement King's mainstream features with edgier creations. One of the first ideas the young editor developed was *The New Breed*, a syndicated panel that presented, on a rotating basis, the work of about thirty emerging talents, a dozen of whom became regular contributors. Kennedy would have a major hand in bringing fresh ideas to the syndicate in the 1990s.

Richard Newcombe, the former C.E.O. of News America Syndicate, responded to the King/N.A.S. merger by founding Creators Syndicate in 1987. To attract established talent, Newcombe promised cartoonists and writers full legal ownership of their creations, shorter contracts, and a larger percentage of the income generated by their features. On February 21, 1987, he announced the signing of superstar advice columnist Ann Landers. Johnny Hart (*B.C.* and *The Wizard of Id*) and Mell Lazarus (*Miss Peach* and *Momma*) were among the first cartoonists to join the new syndicate.

Lazarus, who was on the syndicate relations committee of the National Cartoonists Society before taking over as president in 1989, was a strong advocate for creator ownership. "There are still guys who sign standard syndication agreements," Lazarus stated. "But the next five to eight years are

going to see syndicate ownership of features as an occasional thing. More people will be owning their own work."

The 1980s weren't all about business. A number of highly publicized charity events during the decade provided concerned individuals with an opportunity to show that they were interested in more than just personal gain. In 1985 the Live Aid concert was broadcast to a global audience of 1.8 billion people and raised more than $50 million for famine relief in Africa. A year later, 6 million people linked up in Hands Across America, focusing attention on the domestic problem of homelessness.

In the summer of 1985 Milton Caniff, Charles Schulz, and Garry Trudeau sent letters to 250 syndicated cartoonists inviting them to dedicate their features to the topic of world hunger on November 28, 1985. Initially worried about the response, Trudeau was surprised to discover, when he opened his newspaper on Thanksgiving Day, that "175 artists, inspired by the potential impact of a concerted effort among their ranks, did something they had never attempted before—they worked together."

For that one day, America's cartoonists had raised awareness about a crisis of global proportions. The next day it was back to business as usual—helping the world to laugh at itself.

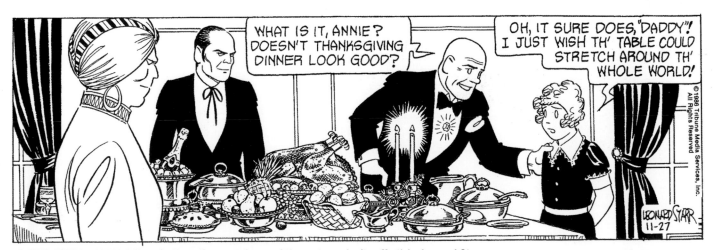

HELPING HANDS—ANNIE *daily strip (from the second year of the cartoon charity effort) by Leonard Starr.* © *11/27/86 Tribune Media Services, Inc. All rights reserved.* Reprinted with permission. Courtesy of International Museum of Cartoon Art

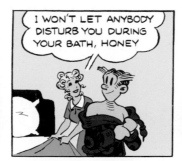
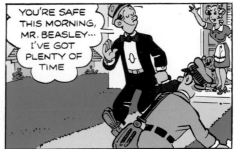

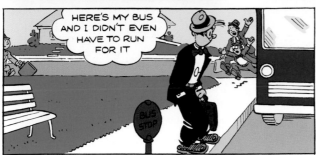

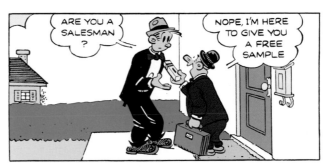

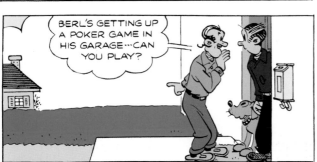
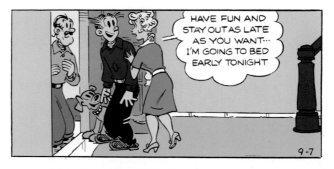

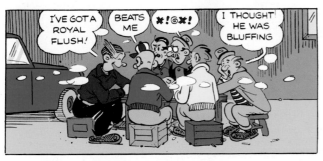

ANNIVERSARY PRESENT—*Dagwood finally gets a day off, after a half-century of creating hilarity, in this BLONDIE Sunday page by Dean Young and Jim Raymond.* © 9/7/80 King Features Syndicate, Inc.

gary larson

IN 1990 KEN TUCKER of *Entertainment Weekly* rated the top daily comics in the nation's newspapers. He gave *The Far Side* an "A" and offered the following words of praise: "Gary Larson has brought laugh-out-loud humor back to the funny pages with one-panel drawings that combine surrealism with an amateur's interest in science to create a comic tone that's at once eccentric and aggressive." Less than five years later, on January 1, 1995, *The Far Side* ended.

In his final book, *Last Chapter and Worse*, published in 1996, Larson promised, "The Call of the Vial (of ink) still speaks to me, and the thought of creating more mischief—somewhere, sometime—rumbles in the reptilian complex of my brain." His post-retirement output has been limited to thirteen panels of *The Far Side* (to fill out the last book collection), a sequel to his first animated special, *Tales from the Far Side II*, and one illustrated "children's" book, *There's A Hair in My Dirt! A Worm's Story.* A deluxe, two-volume, slipcased collection of every single *Far Side* cartoon (4,081 to be exact), with a comprehensive introduction by Gary Larson, was published by Andrews McMeel in the fall of 2003.

Terms such as "bizarre," "absurd," "demented," and "weird" were frequently used to describe Larson's creation. He found humor in all forms of organic life, and among his favorite subjects were cows, dogs, chickens, insects, amoebas, and cavemen.

In the early 1980s Larson's ghoulish scribblings attracted a cult following. As his cartoons became more sophisticated, the audience grew, and by the 1990s *The Far Side* was appearing in more than 1,800 newspapers and book collections of the popular panel were selling in the millions. The general mood of Larson's world was one of impending doom. Disaster, death, and even extinction were always lurking in the shadows. This playfully apocalyptic vision tapped a deeply cynical vein in the youth of America.

Readers often wonder where cartoonists get their ideas. Gary Larson was asked this question even more frequently than his professional peers. "Every time I hear it," he said, "I'm struck by this mental image where I see myself rummaging through my grandparents' attic and coming across some old, musty trunk. Inside I find this equally old and elegant-looking book. I take it in my hands, blow away the dust, and embossed on the front cover in large, gold script is the title, *Five Thousand and One Weird Cartoon Ideas.*"

In truth, Larson developed some of his best material by doodling in his sketchbook. "The act of drawing is a continuous learning process for me," he admitted, "and I greatly envy a number of cartoonists who have truly mastered their 'instrument.' I haven't—but I'm working on it." A talented draftsman, Larson mastered the subtle nuances of timing, delivery, and visual humor in his cartoons. *The Far Side* was one of the most consistently funny features in the newspapers during its relatively brief fifteen-year run.

Gary Larson was only forty-five years old when he retired. His loyal fans cling to the hope that some day this brilliant cartoonist may return to his drawing board and pick up where he left off. The world needs a tour guide to *The Far Side.*

THE FAR SIDE® By GARY LARSON

The real reason dinosaurs became extinct

HIGH ON HUMOR The success of *The Far Side* inspired a proliferation of offbeat creations in the 1980s. Among the notable single-panel debuts were *Bizarro* (1985) by Dan Piraro, *The Neighborhood* (1981) by Jerry Van Amerongen, *Caldwell* (1985) by John Caldwell, *The New Breed* (1989) by various artists, *The Quigmans* (1984) by Buddy Hickerson, and *Mr. Boffo* (1986) by Joe Martin. These, and other far-out features that started in the following decade, helped to fill the void on the funnies pages when Gary Larson retired in 1995.

How the brain works.

THE NEIGHBORHOOD *Sunday page by Jerry Van Amerongen.* © King Features Syndicate, Inc.

Bobby Tanner proves to be the weak link.

THE NEIGHBORHOOD *Sunday page by Jerry Van Amerongen.* © 5/4/86 King Features Syndicate, Inc.

CALDWELL Sunday page by John Caldwell. © 1/4/87 King Features Syndicate, Inc.

THE NEW BREED daily panel by Oliver (Revilo) Christianson. © 1/5/90

by Revilo. Distributed by King Features Syndicate, Inc.

THE QUIGMANS daily panel by Buddy Hickerson. © Tribune Media

Services, Inc. All rights reserved. Reprinted with permission

MR. BOFFO daily strip by Joe Martin © Joe Martin. Used by permission of Universal Press Syndicate. All rights reserved

berke breathed

BLOOM COUNTY daily strip by Berke Breathed, n.d. All Bloom County and Outland strips © Rosebud Productions, Inc. Courtesy of Washington Post Writers Group

IN 1987, AFTER Berke Breathed won the Pulitzer Prize for *Bloom County*, Pat Oliphant delivered an impassioned speech to the Association of American Editorial Cartoonists. "The work makes no pretense of being an editorial cartoon," protested Oliphant. "It's on the funny pages. It does, however, make the pretense of passing off shrill potty jokes, crotch jokes, and grade-school sight gags as social commentary. The Pulitzer Board was wrong, dead wrong, to overrule the nominating committee in selecting this year's winner."

Breathed, in response to this attack, pointed out that the official requirements for submitting work to the Pulitzer Prize committee did not specify that they had to be political cartoons. He described Oliphant's outburst as "the most magnificent display of sour grapes ever to be recorded within the known universe."

The thirtysomething cartoonist continued to court controversy in his rowdy feature. Li'l Ollie Funt, an obvious spoof of Oliphant's Punk the penguin, shouted "Reagan Sucks!" during a brief cameo appearance. The drug-addled Bill the Cat had a love affair with ex-U.N. ambassador Jeane Kirkpatrick. Opus discovered to his dismay that his mother was being used to test Mary Kay Cosmetics. Steve Dallas appeared nude in *Dog World* magazine. Breathed also took shots at liposuction, home-shopping networks, and heavy-metal bands. Donald Trump, Madonna, Carl Sagan, Prince William, Tammy Faye Baker, and Lee Ioacocca were among the media personalities skewered in *Bloom County.*

OPUS THE PENGUIN by Berke Breathed

Breathed's most costly faux pas was when he attempted to respond humorously to feminist critics who had accused him of sexism. In the last panel of an *Outland* Sunday page, Opus and Bill were shown gazing down into their underwear, looking for the one thing that brought the most meaning to their lives. Breathed lost about $14,000 in income when half a dozen papers canceled the strip permanently after this episode ran.

As Breathed's art matured during the mid-1980s, *Bloom County* relied more on visual humor than on traditional gags. Strips often ended with a dumbstruck expression and a surprising twist of dialogue. Breathed became increasingly frustrated with the small size his daily strips were printed and by the late 1980s was devoting most of his creative energy to the Sunday page.

Opus, a refugee from the Falkland Islands, was the cartoonist's most cherished creation. Breathed once confessed a desire to be as innocent, naive, and unworldly as his favorite bow-tied waterfowl. To him, Opus was an ideal to which to aspire.

In 1989 Breathed stated, "I have grown stubbornly affectionate toward my characters, and I have little desire to see Opus, Bill the Cat, and others disappear from my life." But he had made his decision. "After ten years of squeezing Bloom Countians into smudgy, postage stamp–sized stories, I thought it might be more comfortable for all concerned if we took a powder from the daily pages."

Breathed continued *Outland*, a Sunday-only spin-off of *Bloom County*, until 1995, then gave up cartooning for good. When asked to assess his contributions, the pen-and-ink prankster answered in typical fashion, "I want to be remembered for taking a ninety-two percent cut in my income for the sake of my cartoons. I figure attaining immortality as an artist is a long shot. But I'm a shoo-in as a martyr."

BLOOM COUNTY *daily strip by Berke Breathed.* © 5/25/81

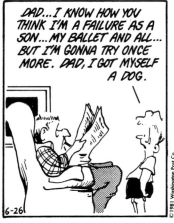
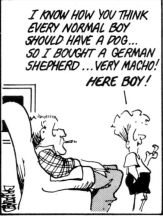
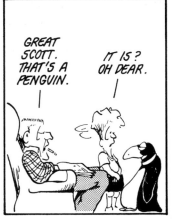
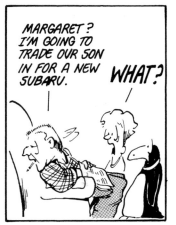

BLOOM COUNTY *daily strip (first appearance by Opus) by Berke Breathed.* © 6/26/81

BLOOM COUNTY *daily strip by Berke Breathed.* © 11/9/81

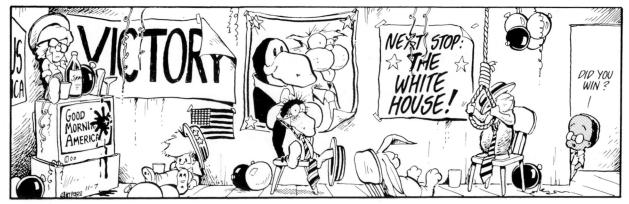

BLOOM COUNTY *daily strip by Berke Breathed.* © 11/7/84

BLOOM COUNTY daily strip by Berke Breathed. ©8/12/85

BLOOM COUNTY daily strip by Berke Breathed. © 5/5/86

BLOOM COUNTY daily strip by Berke Breathed. © 1/30/87

BLOOM COUNTY daily strip by Berke Breathed. © 5/23/87

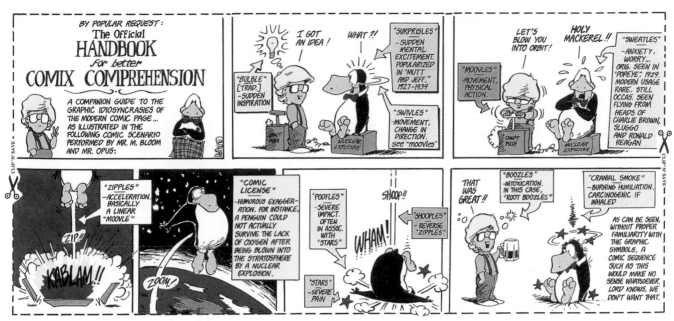

BLOOM COUNTY Sunday page by Berke Breathed, n.d.

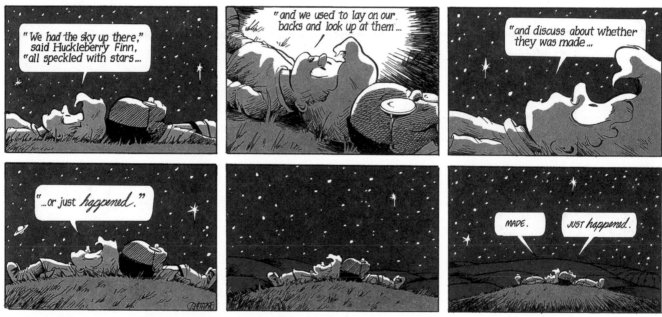

BLOOM COUNTY Sunday page by Berke Breathed, n.d.

BLOOM COUNTY Sunday page by Berke Breathed, n.d.

BLOOM COUNTY daily strip by Berke Breathed. © 9/26/87

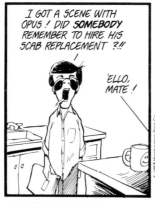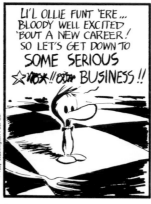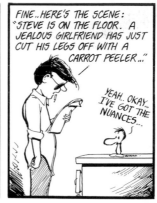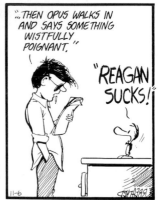

BLOOM COUNTY daily strip by Berke Breathed. © 11/6/87

BLOOM COUNTY daily strip by Berke Breathed. © 12/28/88

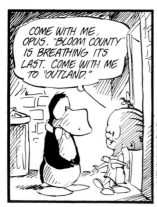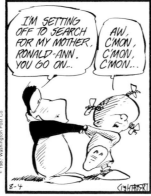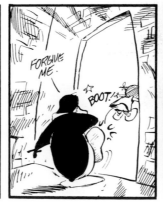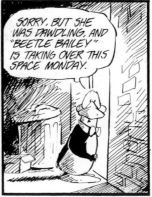

BLOOM COUNTY daily strip by Berke Breathed. © 8/4/89

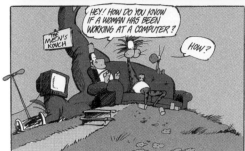
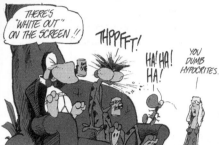
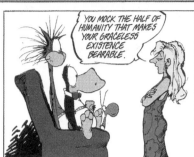

OUTLAND The infamous Sunday page by Berke Breathed. © 1993

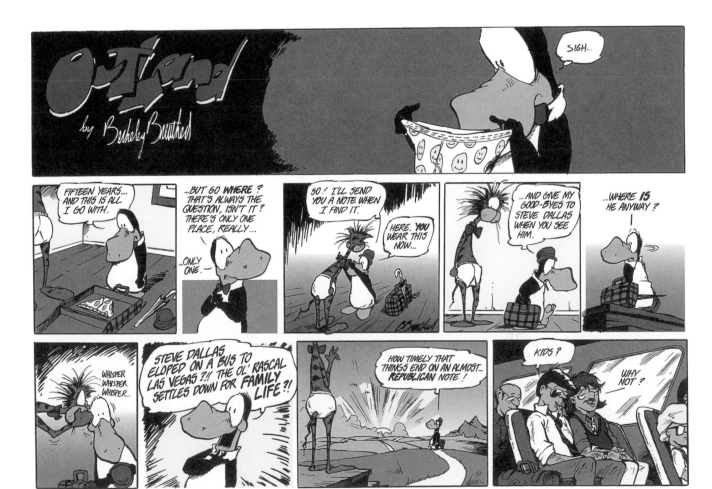

OUTLAND Sunday page by Berke Breathed. © 1995

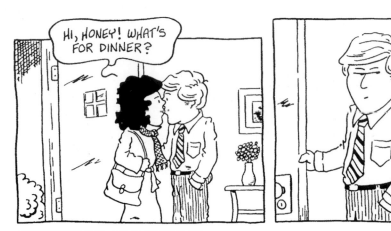

SALLY FORTH daily strip by Greg Howard. © 2/9/82 King Features Syndicate, Inc.

GREG HOWARD *Sally Forth*, a strip that appealed primarily to working women, was created by Greg Howard, a former attorney, in 1982. Howard recognized that his strength was writing and admitted that his drawing was "crude" in the beginning (above) and eventually improved to "mediocre" (below). In 1991, when he hired a replacement artist, Craig MacIntosh, to redesign *Sally Forth*, more than a thousand loyal fans called King Features Syndicate to protest the changes. Apparently, readers had become accustomed to Howard's awkward art. MacIntosh quickly developed a more acceptable blend between the old and new styles, and the circulation of the popular domestic feature grew to more than 600 newspapers.

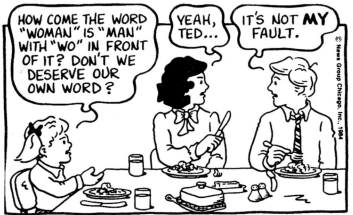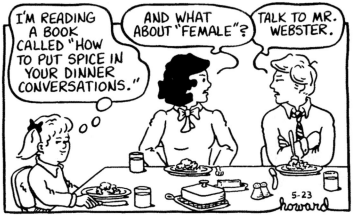

SALLY FORTH daily strip by Greg Howard. © 5/23/84 King Features Syndicate, Inc.

SALLY FORTH daily strip by Greg Howard and Craig MacIntosh. © 10/31/92 King Features Syndicate, Inc.

LUANN daily strip by Greg Evans. © 1988 United Feature Syndicate, Inc.

LUANN daily strip by Greg Evans. © 3/19/85 United Feature Syndicate, Inc.

GREG EVANS

An updated version of the classic teenager strip, Greg Evans's 1985 creation, *Luann*, focused on the contemporary world of video games and shopping malls as well as the eternal themes of homework and dating. In addition to thirteen-year-old Luann DeGroot, the cast included Brad, her seventeen-year-old brother; Aaron, the boy of her dreams; Bernice, her best friend; Delta, her fashion consultant; and her understanding Mom and Dad. In 1991 Evans made comics history by introducing a story line in which Luann had her first menstrual period (bottom). The sequence was presented with humor and sensitivity, and the response from readers was overwhelmingly positive.

LUANN daily strip by Greg Evans. © 5/10/91 United Feature Syndicate, Inc.

MOTHER GOOSE & GRIMM daily strip by Mike Peters. © 3/18/85 Tribune Media Services, Inc. All rights reserved. Reprinted with permission

MIKE PETERS Often introduced as the "Peter Pan of Cartooning," the eternally youthful Mike Peters won the Reuben Award in 1991 for his achievements in both the comics field and political cartooning. Peters launched *Mother Goose and Grimm* on October 1, 1984, three years after receiving the Pulitzer Prize for his editorial work at the *Dayton Daily News*. The clever comic strip was initially a spoof of fairy tales and popular culture, but its canine star, Grimmy, eventually stole the spotlight. Peters's pooch is a dog's dog, who chases cars, pees on fire hydrants, and drinks out of toilet bowls. The strip is drawn in a bold, visual style, and the humor is wildly entertaining and laden with puns. In the 1990s Grimmy was the star of an animated television series as well as a modestly successful line of licensed products.

SELF-CARICATURE by Mike Peters

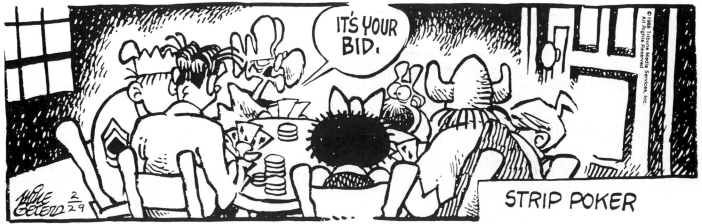

MOTHER GOOSE & GRIMM daily strip by Mike Peters. © 2/29/88 Tribune Media Services, Inc. All rights reserved. Reprinted with permission

MOTHER GOOSE & GRIMM Sunday page by Mike Peters. © 1992 Tribune Media Services, Inc. All rights reserved. Reprinted with permission

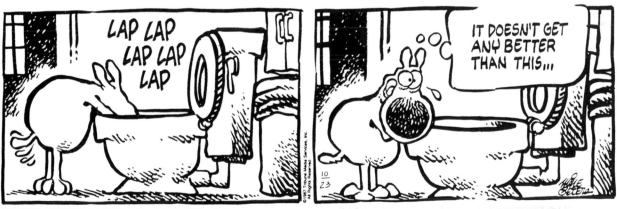

MOTHER GOOSE & GRIMM daily strip by Mike Peters. © 10/23/87 Tribune Media Services, Inc. All rights reserved. Reprinted with permission

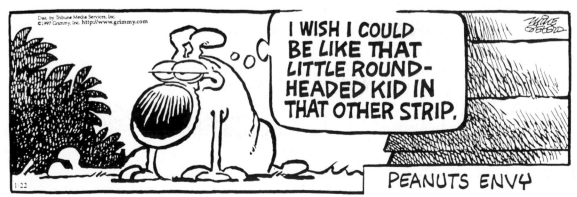

MOTHER GOOSE & GRIMM daily strip by Mike Peters. © 1/22/97 Tribune Media Services, Inc. All rights reserved. Reprinted with permission

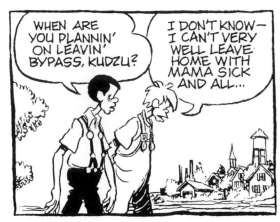

KUDZU daily strip by Doug Marlette. © 6/15/81 Tribune Media Services, Inc. All rights reserved. Reprinted with permission

DOUBLE DIPPERS

The success of Jeff MacNelly's *Shoe* encouraged other political cartoonists to try their hand at comic-strip syndication in the 1980s. Among the artists who took on double duty were Pulitzer Prize winner Doug Marlette, who launched the Southern-flavored *Kudzu* in 1981; Brian Basset, who created the stay-at-home dad *Adam* in 1984; and Bill Schorr, who tried a comic strip starring a frog, *Conrad*, in 1982 but had more success with bears in *The Grizzwells*, which began in 1987.

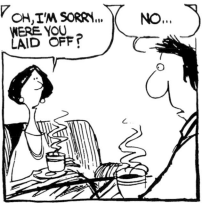

ADAM daily strip by Brian Basset. © 9/26/84 Brian Bassett. Used by permission of Universal Press Syndicate. All rights reserved

THE GRIZZWELLS daily strip by Bill Schorr. © 7/4/88 NEA Inc. Courtesy of International Museum of Cartoon Art

FRESH PERSPECTIVES

Two solid new creations of the 1980s (next page) were based on contemporary lifestyles. Bill Holbrook's *On The Fastrack* (1984) was set in the high-tech corporate world, and Rick Detorie's *One Big Happy* (1989) featured a multi-generation, extended family.

ON THE FASTRACK Sunday page by Bill Holbrook. © 1984 by King Features Syndicate, Inc. Courtesy of Richard Marschall.

ONE BIG HAPPY Sunday page by Rick Detorie, n.d. © Creators Syndicate, Inc.

PAT BRADY For the first seven years after Pat Brady's *Rose is Rose* debuted in 1984, the strip's juvenile star, Pasquale Gumbo, spoke in a phonetic baby talk the cartoonist dubbed "Pasqualian" (above). Concerned that the gimmick was getting tedious for his readers, on August 9, 1991, Brady decided to have Pasquale suddenly start speaking coherently (below). The *Rose is Rose* cast also included Rose and Jimbo Gumbo, Peekaboo the cat, cousin Clem, and neighbor Mimi. Brady did not shy away from sentiment in his warm, loving family strip and often suggested a strong physical attraction between Rose and Jimbo. He also explored his characters' daydreams in ambitiously designed episodes that featured innovative use of perspective, background, and color. Rose's transformation into Vicki the Biker has become one the most popular of these graphic fantasies. Brady was nominated four times for the Reuben Award in the 1990s and finally won in 2004.

SELF-CARICATURE by Pat Brady

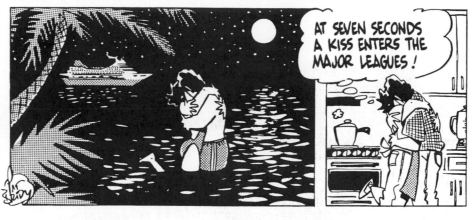

ROSE IS ROSE daily strip by Pat Brady. © 6/10/96

ROSE IS ROSE daily strip by Pat Brady. © 7/4/96

ROSE IS ROSE daily strip by Pat Brady. © 9/6/96

ROSE IS ROSE daily strip by Pat Brady. © 6/9/97

ROSE IS ROSE *daily strip by Pat Brady.* © 8/3/98

ROSE IS ROSE *daily strip by Pat Brady.* © 9/1/98

ROSE IS ROSE *daily strip by Pat Brady.* © 4/20/99

ROSE IS ROSE *daily strip by Pat Brady.* © 10/11/99

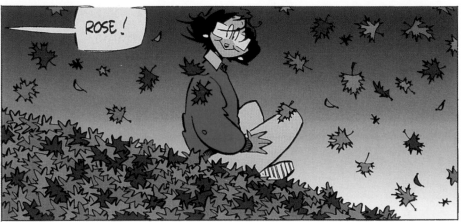
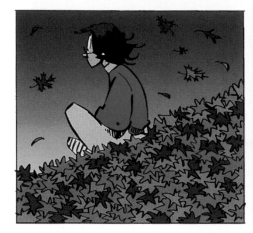
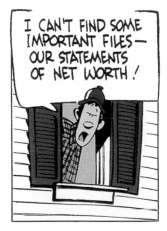
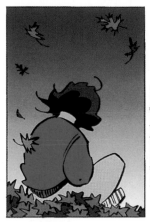
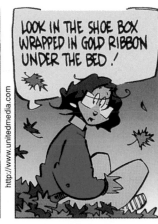

ROSE IS ROSE Sunday page by Pat Brady. © 9/22/96

BETTY BOOP AND FELIX

IT'S NICE TO BE ABLE TO SLEEP 'TIL TEN

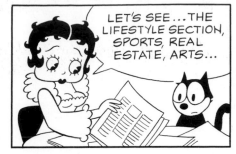

I LOVE THE SUNDAY MORNING RITUAL... READING THE SUNDAY PAPER WHILE I EAT MY SUNDAY BRUNCH

UGGH, THIS THING WEIGHS A TON!

LET'S SEE...THE LIFESTYLE SECTION, SPORTS, REAL ESTATE, ARTS...

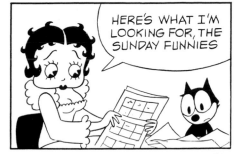
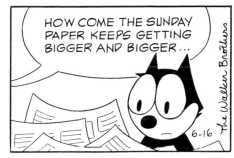
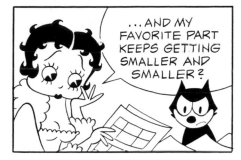

HERE'S WHAT I'M LOOKING FOR, THE SUNDAY FUNNIES

HOW COME THE SUNDAY PAPER KEEPS GETTING BIGGER AND BIGGER...

...AND MY FAVORITE PART KEEPS GETTING SMALLER AND SMALLER?

BETTY BOOP AND FELIX Sunday page by the Walker Brothers. © 6/16/85 King Features Syndicate, Inc.

"A NINE-LETTER WORD FOR 'STUBBORN'?" HEADSTRONG? UNREASONABLE? DOGGED...? INTRACTABLE...??

PIG-HEADED!!

IT'S A LITTLE-KNOWN FACT THAT CROSSWORD PUZZLES CAN BE HAZARDOUS TO YOUR HEALTH!

THE MUPPETS daily strip by Guy and Brad Gilchrist. © 5/8/84 King Features Syndicate, Inc.

McCALL AND PIGGINS VISIT THE HOME FOR RETIRED COMIC STRIP CHARACTERS...

WE BRING GREETINGS FROM SNOOPY, GARFIELD, HAGAR, DOONESBURY...

NEVER HEARD OF THEM!

WHO DAT?

Copyright 1987 Creators Syndicate, Inc.

McCALL OF THE WILD daily strip by Jerry Dumas and Mel Crawford © 1987 Creators Syndicate, Inc.

BENCHLEY Sunday page by Jerry Dumas and Mort Drucker. © 1986 Cowles Syndicate, Inc.

FAMILIAR FACES A mini-wave of comics starring personalities from entertainment and politics swept through the funnies business in the 1980s. *Betty Boop and Felix* (1984) by the Walker Brothers revived two classic characters from the golden age of cartoon animation. *The Muppets* (1981) by Guy and Brad Gilchrist brought Kermit and Miss Piggy and the rest of Jim Henson's television puppets to the comics pages. *Rock Channel* (1984) by the Gilchrists and Greg Walker capitalized on the rising popularity of MTV. *Benchley* (1984) by Mort Drucker and Jerry Dumas provided a vehicle for poking fun at political figures. *McCall of the Wild* (1987), a team effort by Jerry Dumas and illustrator Mel Crawford, featured visits with fairy-tale creatures and old comic-strip characters.

ROCK CHANNEL Sunday page by the Gilchrists and Greg Walker. © 3/17/85 Cowles Syndicate, Inc.

bill watterson

PROFESSIONAL CARTOONISTS recognized the brilliance of Bill Watterson's *Calvin and Hobbes* soon after it debuted on November 19, 1985. In the foreword to the first book collection, Garry Trudeau wrote: "Watterson is the reporter who has gotten it right; childhood as it actually *is*, with its constantly shifting frames of reference." Watterson won the Reuben Award from the National Cartoonists Society in 1986, after only a year in syndication, and again in 1988.

The stars of the strip were a hyperactive six-year-old and a stuffed tiger who came alive in the boy's imagination. They were named after John Calvin and Thomas Hobbes, two philosophers Watterson studied while majoring in political science in college. Calvin was surrounded by a small circle of supporting players, which included his bewildered Mom and Dad, Susie the girl next door, Rosalyn the babysitter, Miss Wormwood the teacher, and Moe the bully. But his constant companion was Hobbes. The duo delighted in reckless wagon and sled rides, playing pranks on Susie, and inventing the ever-changing rules to "Calvinball." Their relationship alternated between intense competition and cooperative camaraderie. In one early sequence, during which Hobbes was temporarily lost, Calvin's close emotional attachment to his pretend friend was touchingly revealed.

Calvin also took off on solo flights of fantasy, escaping from the real world of parental discipline and tedious schoolwork. He traveled through the galaxy as Spaceman Spiff and hacked his way through jungles as Safari Al. He vanquished authority as Stupendous Man or battled petty crime as Tracer Bullet, private detective. He defied the laws of physics with his "transmogrifier" and "duplicator" inventions.

Dialogue was an important element of the strip. Calvin's running commentary railed against the injustices of childhood and voiced his views on the way things should be. The boy had no qualms about expressing selfish indignation, undisguised greed, or downright mean-spiritedness. He was devilish but lovable.

Watterson was a versatile draftsman and designer who could seemingly render anything that Calvin would dream up. Anatomically correct dinosaurs, bug-eyed aliens, and oozing gunk flowed from his pen. He expertly captured the shifting perspectives of Calvin's aerial adventures. He depicted the changing seasons with the balanced hues of his Sunday pages. His characters moved with grace and energy.

He also expanded the visual vocabulary of the art form. Cartoonists had previously used the comics medium to communicate the internal thoughts and emotions of their characters, but Watterson developed this technique into an established graphic language. Readers of *Calvin and Hobbes* became accustomed to interpreting images that shifted back and forth between the "real" world and Calvin's daydreams. This visualization method is now used commonly in the comics, and certain artists, most notably Pat Brady (*Rose is Rose*) and Jim Borgman (*Zits*), have refined it even further.

Watterson's ambitious agenda eventually took its toll. He went on two sabbaticals, in 1992 and 1994, during which newspapers offered *Calvin and Hobbes* reruns. He talked openly about battles with Universal Press Syndicate over his refusal to merchandise the characters. In a rare public appearance at Ohio State University, he criticized editors for shrinking the size of the comics and his fellow cartoonists for selling out for licensing dollars. Watterson's frustrations also became evident in the strip as Calvin frequently went off into tirades about the shallowness of consumer culture.

In 1995 Watterson ended *Calvin and Hobbes*. "Professionally, I had accomplished far more than I'd ever set out to do and there were no more mountains I wanted to climb," he remembered five years later. "I had given the strip all my time and energy for a decade (and was happy to do so), but now I was that much older and I wanted to work at a more thoughtful pace, out of the limelight, and without the pressures and restrictions of newspapers."

Bill Watterson pushed the limits of his abilities to explore the potential of the art form. In a relatively brief period of time, he dramatically demonstrated how a comic strip could challenge the imagination and tickle the funny bone. The void he left behind has yet to be filled.

SELF-CARICATURE by Bill Watterson

CALVIN AND HOBBES *daily strip by Bill Watterson.* © 7/4/86

CALVIN AND HOBBES *daily strip by Bill Watterson.* © 3/28/87

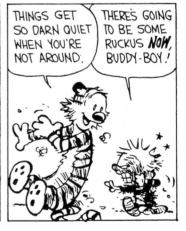

CALVIN AND HOBBES *daily strip by Bill Watterson.* © 9/8/n.d.

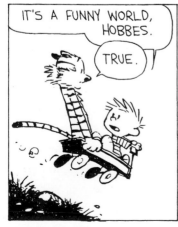
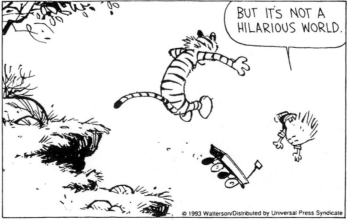
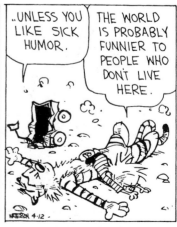

CALVIN AND HOBBES *daily strip by Bill Watterson.* © 4/12/93

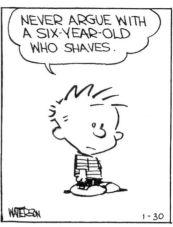

CALVIN AND HOBBES daily strip by Bill Watterson. © 1/30/86

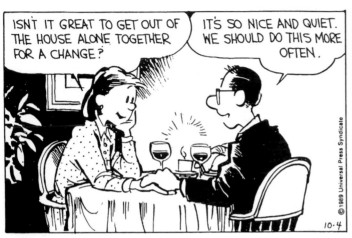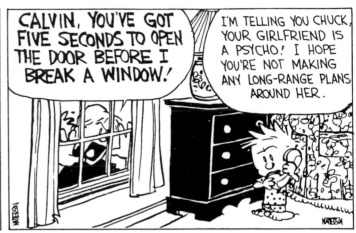

CALVIN AND HOBBES daily strip by Bill Watterson. © 10/4/89

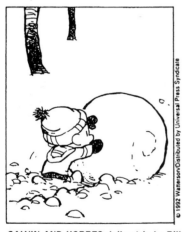

CALVIN AND HOBBES daily strip by Bill Watterson. © 2/4/92

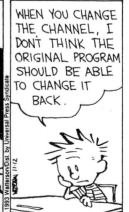

CALVIN AND HOBBES daily strip by Bill Watterson. © 11/12/93

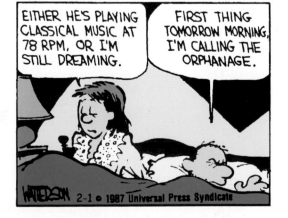

CALVIN AND HOBBES Sunday page by Bill Watterson. © 1987

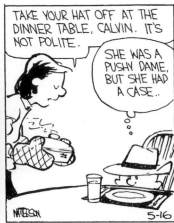

CALVIN AND HOBBES *daily strip by Bill Watterson.* © 5/16/87

CALVIN AND HOBBES *daily strip by Bill Watterson.* © 11/13/88

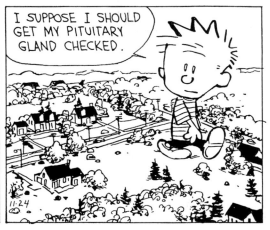

CALVIN AND HOBBES *daily strip by Bill Watterson.* © 11/24/89

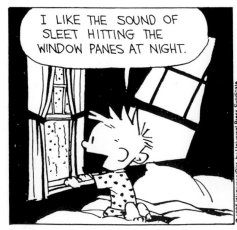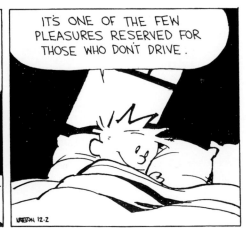

CALVIN AND HOBBES *daily strip by Bill Watterson.* © 12/2/95

CALVIN AND HOBBES Sunday page by Bill Watterson. © 7/5/87

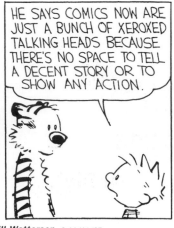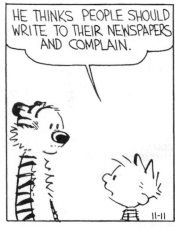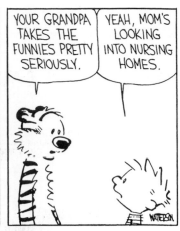

GRANDPA SAYS THE COMICS WERE A LOT BETTER YEARS AGO WHEN NEWSPAPERS PRINTED THEM BIGGER.

HE SAYS COMICS NOW ARE JUST A BUNCH OF XEROXED TALKING HEADS BECAUSE THERE'S NO SPACE TO TELL A DECENT STORY OR TO SHOW ANY ACTION.

HE THINKS PEOPLE SHOULD WRITE TO THEIR NEWSPAPERS AND COMPLAIN.

YOUR GRANDPA TAKES THE FUNNIES PRETTY SERIOUSLY.

YEAH, MOM'S LOOKING INTO NURSING HOMES.

CALVIN AND HOBBES daily strip by Bill Watterson. © 11/11/87

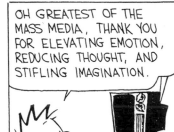

OH GREATEST OF THE MASS MEDIA, THANK YOU FOR ELEVATING EMOTION, REDUCING THOUGHT, AND STIFLING IMAGINATION.

THANK YOU FOR THE ARTIFICIALITY OF QUICK SOLUTIONS AND FOR THE INSIDIOUS MANIPULATION OF HUMAN DESIRES FOR COMMERCIAL PURPOSES.

THIS BOWL OF LUKEWARM TAPIOCA REPRESENTS MY BRAIN. I OFFER IT IN HUMBLE SACRIFICE. BESTOW THY FLICKERING LIGHT FOREVER.

CALVIN AND HOBBES daily strip by Bill Watterson. © 8/7/92

OH LOOK, YET ANOTHER CHRISTMAS TV SPECIAL!

HOW TOUCHING TO HAVE THE MEANING OF CHRISTMAS BROUGHT TO US BY COLA, FAST FOOD, AND BEER CONGLOMERATES.

WHO'D HAVE EVER GUESSED PRODUCT CONSUMPTION, POPULAR ENTERTAINMENT, AND SPIRITUALITY WOULD MIX SO HARMONIOUSLY. IT'S A BEAUTIFUL WORLD, ALL RIGHT.

DAD DOESN'T HANDLE THE SEASON'S STRESS VERY GRACEFULLY.

CALVIN AND HOBBES daily strip by Bill Watterson. © 12/14/92

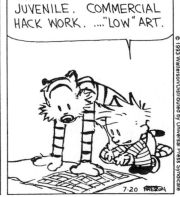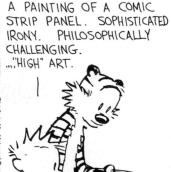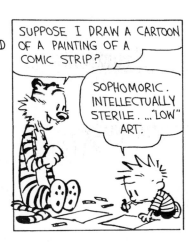

A PAINTING. MOVING. SPIRITUALLY ENRICHING. SUBLIME. ..."HIGH" ART!

THE COMIC STRIP. VAPID. JUVENILE. COMMERCIAL HACK WORK. ..."LOW" ART.

A PAINTING OF A COMIC STRIP PANEL. SOPHISTICATED IRONY. PHILOSOPHICALLY CHALLENGING. ..."HIGH" ART.

SUPPOSE I DRAW A CARTOON OF A PAINTING OF A COMIC STRIP?

SOPHOMORIC. INTELLECTUALLY STERILE. ..."LOW" ART.

CALVIN AND HOBBES daily strip by Bill Watterson. © 7/20/93

CALVIN AND HOBBES Sunday page by Bill Watterson. © 2/9/92

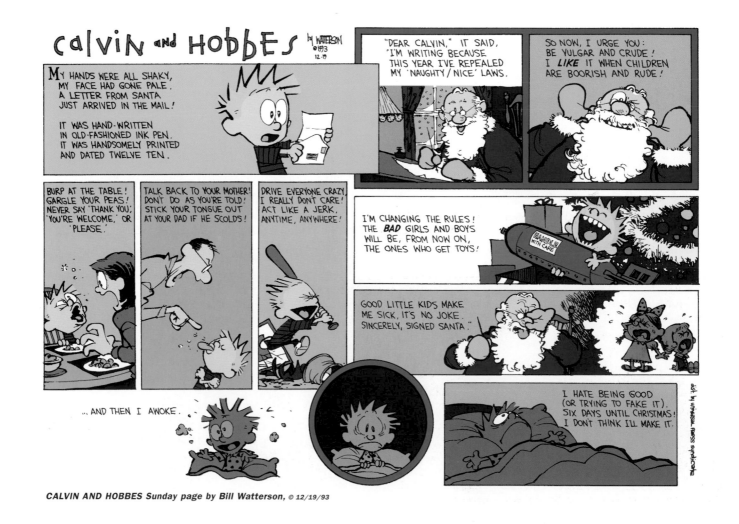

CALVIN AND HOBBES Sunday page by Bill Watterson, © 12/19/93

BILL GRIFFITH The only cartoonist from the alternative comix scene to cross over into mainstream syndication, Bill Griffith has carved out a unique niche for his unconventional creation, *Zippy*, on the nation's comics pages. The daily strip, which has been distributed by King Features since 1986, stars Zippy the Pinhead, a compulsive consumer of pop culture, and Griffy, a cranky social critic. "What Griffy and Zippy represent," explains Griffith, "is the dialogue between those two parts of myself, the critic and the fool." The autobiographical nature of the strip was fully explored in an ambitious continuity, entitled "The Pin Within," which ran from

December 30, 1991, to February 8, 1992. In this six-week sequence Griffy traveled back and forth in time, from Griffith's Brooklyn birthplace to other significant moments in the cartoonist's life, to reconcile his troubled relationship with his father, who died in 1972. A selection of episodes from this story are reproduced on the following pages. The *Zippy* Sunday strip, which was launched in 1990, provided Griffith with an opportunity to experiment with color, special effects, different artistic styles, and, as in the daily version, self-referential humor.

ZIPPY daily strip by Bill Griffith. © 6/30/86. Courtesy of Bill Janocha.

All Zippy strips © Bill Griffith. Distributed by King Features Syndicate, Inc.

ZIPPY daily strip by Bill Griffith. © 5/19/95

ZIPPY first Sunday strip by Bill Griffith. © 1990

ZIPPY Sunday strip by Bill Griffith. © 11/3/91

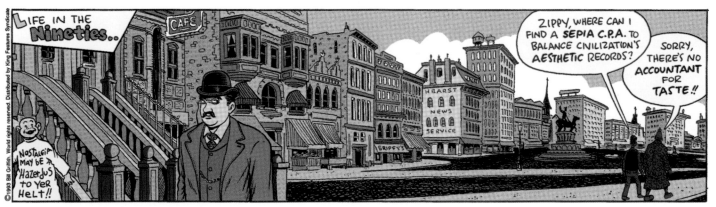

ZIPPY Sunday strip by Bill Griffith. © 4/11/93

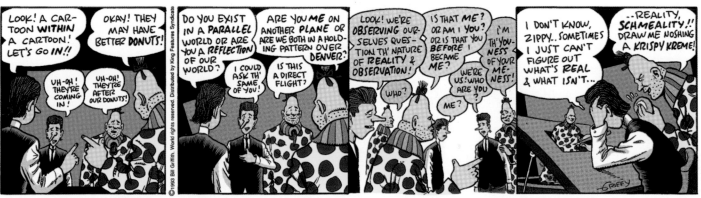

ZIPPY Sunday strip by Bill Griffith. © 9/5/93

"BAD CHEMISTRY"

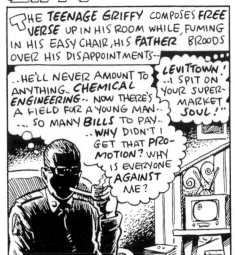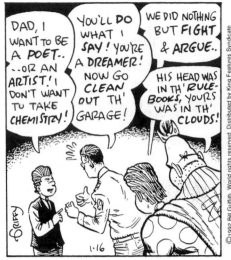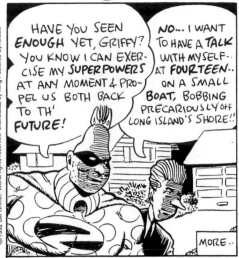

ZIPPY daily strip by Bill Griffith (selections from "The Pin Within" sequence on these two pages). © 1/16/92

"SIXTIES SOMETHING"

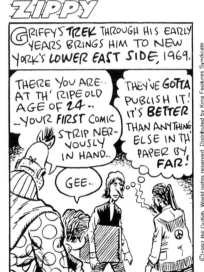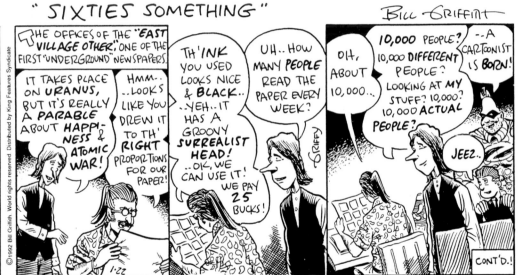

ZIPPY daily strip by Bill Griffith. © 1/22/92

"PEACE"

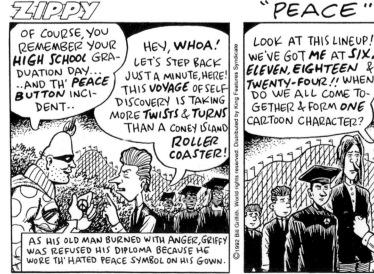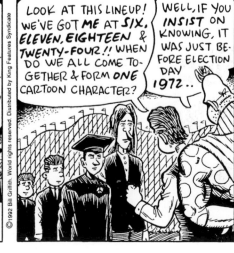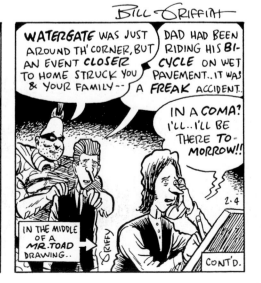

ZIPPY daily strip by Bill Griffith. © 2/4/92

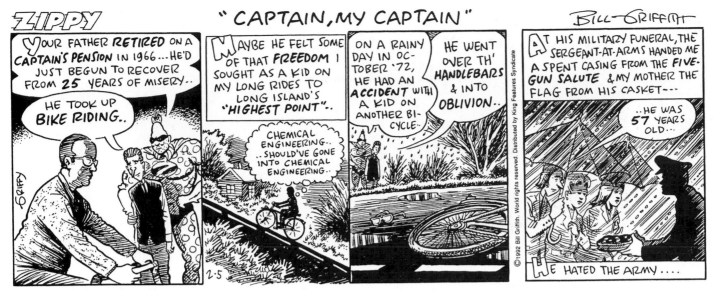

ZIPPY daily strip by Bill Griffith. © 2/5/92

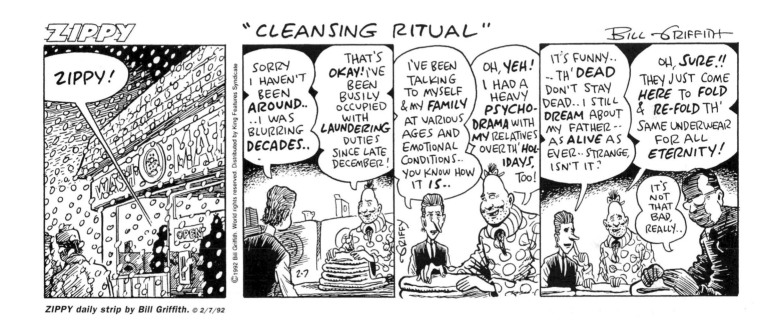

ZIPPY daily strip by Bill Griffith. © 2/7/92

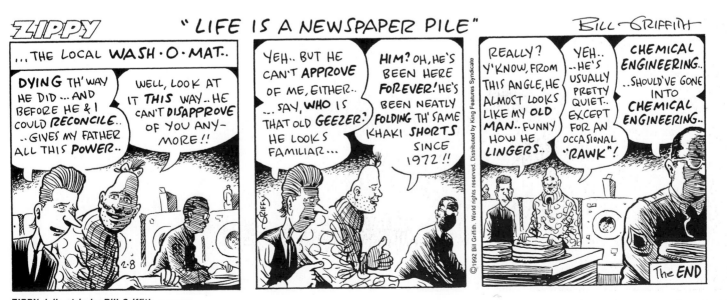

ZIPPY daily strip by Bill Griffith. © 2/8/92

ERNIE daily strip by Bud Grace. © 1988

BUD GRACE

Influenced by underground cartoonists Robert Crumb and Kim Deitch, Bud Grace developed a drawing style that provided the perfect vehicle for the lowbrow humor in his 1988 comic creation, *Ernie*. Grace researched the strip's offbeat subject matter with his scientifically trained powers of observation, and many of the quirky cast members were inspired by either real-life acquaintances or people Grace encountered in his travels. The cartoonist also made frequent guest appearances in the strip to kvetch about his home life or disagreements with his editor. His repeated forays into taste-lessness led to numerous cancellations, although *Ernie* continued to build a sizable list of clients and is popular in Scandinavia, where political correctness is not as much of a concern as it is in America. In 1999 the name of the feature was changed to *The Piranha Club*. "I think they were trying to slip it by editors as a brand new strip," mused Grace. "I even considered changing my name as well. From now on I'm Bill Watterson."

ERNIE daily strip by Bud Grace. © 9/2/88

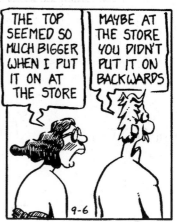

ERNIE daily strip by Bud Grace. © 9/6/88

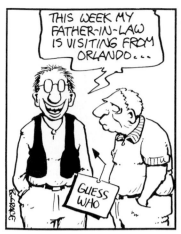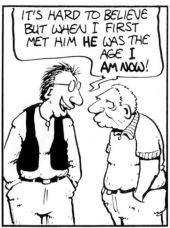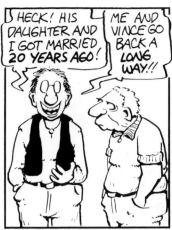

ERNIE *daily strip by Bud Grace.* © 3/29/99

ERNIE *daily strip by Bud Grace.* © 7/13/99

ERNIE *daily strip by Bud Grace.* © 4/19/2000

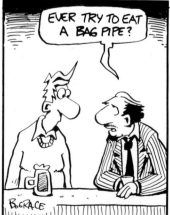

ERNIE *daily strip by Bud Grace.* © 6/15/2001

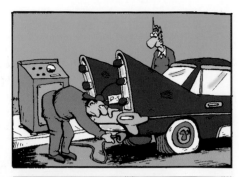
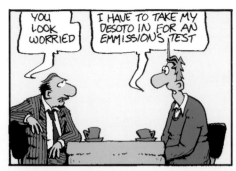

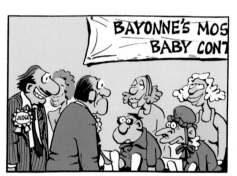

ERNIE Sunday page by Bud Grace. © 12/8/96

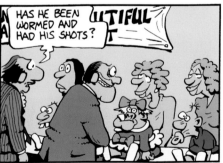
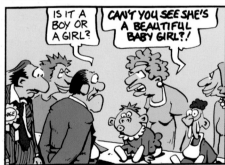
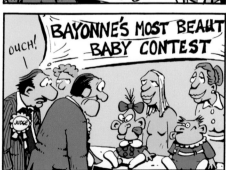

THE PIRANHA CLUB Sunday page by Bud Grace. © 5/7/2000

ROBOTMAN *daily strip by Jim Meddick.* © 2/15/86 NEA, Inc.

JIM MEDDICK

In 1985 Robotman was a successful licensing property in England when United Feature Syndicate hired Jim Meddick to develop a comic strip based on the character. As the merchandising program for Robotman failed to take off in the United States, Meddick was given more freedom with the newspaper feature. In the beginning, the character was an alien who was adopted by the Milde family. Eventually Robotman moved into an apartment of his own and Meddick experimented with parodies and bizarre plot twists. In 1993 a nerdy inventor, Monty Montahue, was added to the cast, and eight years later the strip was renamed *Monty* and Robotman bid a final farewell. The end result of this gradual evolution is a quirky comic strip, which frequently scores high in readers' polls, that is a direct reflection of Meddick's unique comedic vision.

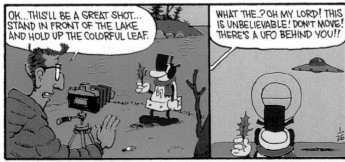
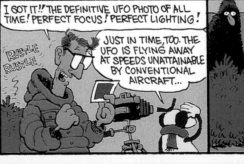
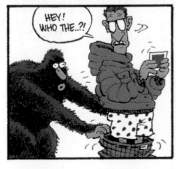
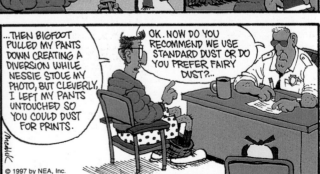

ROBOTMAN AND MONTY *Sunday page by Jim Meddick.* © 1/26/97 NEA, Inc.

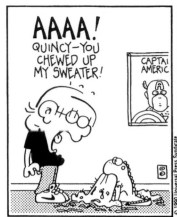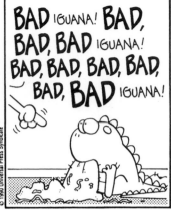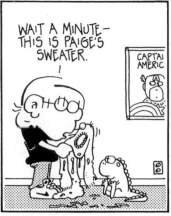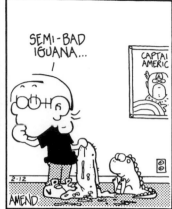

FOX TROT *daily strip by Bill Amend.* © 2/12/90

Andy Jason Paige Roger Peter

FOX TROT *cast by Bill Amend.* © 1998 Courtesy of Cartoonist PROfiles

BILL AMEND *Fox Trot,* which debuted in 1988, shortly after *The Simpsons* first appeared on television, starred a modern family with a similarly acerbic edge. "I think the strong part of the strip," creator Amend stated in 1988, "was that it has a very contemporary setting—it contains a lot of the trappings of our times." Story lines revolved around current television programs (*Star Trek*), music stars (Bruce Springsteen), and consumer electronics (video games and computers).

Amend's style, described by R. C. Harvey as having an "abstract cubistic quality," was initially limited to a static fixed perspective but improved with the introduction of more varied "camera angles." The strength of the strip was the writing, presented from the perspective of the Fox kids. Peter's rock-and-roll aspirations, Paige's romantic fantasies, and Jason's budding cartoon career struck a chord with youthful readers.

FOX TROT *daily strip by Bill Amend.* © 2/19/91

FOX TROT daily strip by Bill Amend. © 7/17/91

FOX TROT daily strip by Bill Amend. © 8/10/91

FOX TROT daily strip by Bill Amend. © 6/9/92

FOX TROT daily strip by Bill Amend. © 9/7/93

FOX TROT *daily strip by Bill Amend.* © 4/5/94

FOX TROT *daily strip by Bill Amend.* © 10/9/95

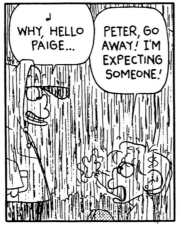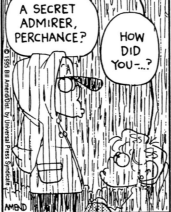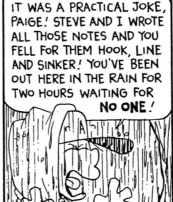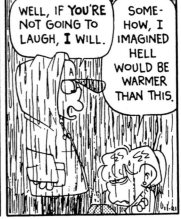

FOX TROT *daily strip by Bill Amend.* © 11/21/95

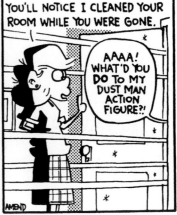

FOX TROT *daily strip by Bill Amend.* © 8/13/97

FoxTrot
BILL AMEND

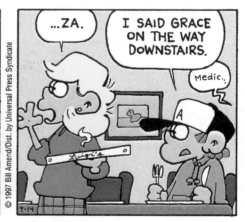

FOX TROT Sunday page by Bill Amend. © 9/14/97

NANCY daily strip by Jerry Scott. © 9/17/85 United Feature Syndicate, Inc.

CARRYING ON A number of long-running features were taken over by new artists in the 1980s. Jerry Scott introduced a redesigned *Nancy* in 1983 and continued Ernie Bushmiller's creation until 1995. Stan Drake, who had been illustrating the soap-opera strip *The Heart of Juliet Jones* since 1953, was hired as the artist for *Blondie* in 1985. Bobby London, the creator of the underground comic strip *Dirty Duck*, began producing *Popeye* in 1986. Six years later, after doing a controversial story line in which a priest mistakenly thinks Olive Oyl is in a "family way" and Popeye wants her to have an abortion, King Features Syndicate declined to renew London's contract.

BLONDIE daily strip by Dean Young and Stan Drake. © 4/2/86 King Features Syndicate, Inc.

POPEYE daily strip by Bobby London. © 2/19/87 King Features Syndicate, Inc. Courtesy of International Museum of Cartoon Art

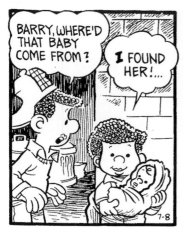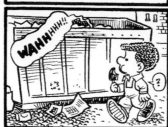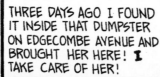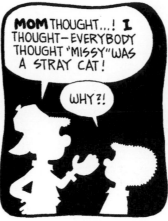

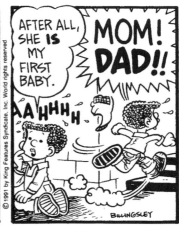

RAY BILLINGSLEY The setting of *Curtis* was a realistic inner city based on creator Ray Billingsley's own hometown Harlem neighborhood. Eleven-year-old Curtis and his eight-year-old brother, Barry, faced the challenges of city life with resourcefulness and optimism, as the examples from Billingsley's acclaimed 1991 crack-baby episode, shown here, demonstrate. The cartoonist has also been praised for his sequences on African folklore and the dangers of gangs, drugs, and smoking. On a more lighthearted note, Curtis is a devoted rap-music fan and interacts humorously with his idiosyncratic schoolmates Chutney, Michelle, Sheila, Verbena, Derrick, and Gunk as well as his teacher, Mrs. Nelson, Gunther the barber, and his parents, Greg and Diana. *Curtis* has been distributed by King Features Syndicate since 1988.

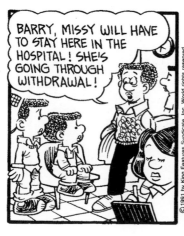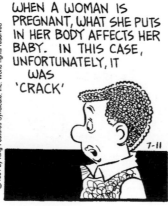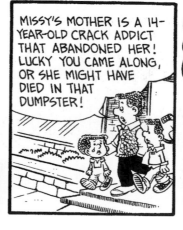

MARVIN Sunday page by Tom Armstrong. © 8/16/92 King Features Syndicate, Inc.

TOM ARMSTRONG *Marvin* was created by Tom Armstrong in 1982. Drawn in a clean, well-defined style, this popular modern kid strip starred the one-year-old toddler, his doting parents, Jeff and Jenny, the family dog, Bitsy, and his protofeminist cousin, Megan. Marvin's fantasies inspired many graphically innovative episodes, as in the Sunday funnies dream above. Armstrong also collaborated on *John Darling*, a feature starring a television talk show host, with Tom Batiuk, beginning in 1979. When the strip ended in 1990, the creators decided to kill off their character in a shockingly violent conclusion (below).

JOHN DARLING daily strip by Tom Armstrong and Tom Batiuk. © 8/3/90 North America Syndicate, Inc.

the nineties

MARCY AND JOE from JUMP START by Robb Armstrong. © United Feature Syndicate, Inc.

HOMAGE TO A HERO—Mooch, Earl, and Snoopy illustration by Patrick McDonnell. © Patrick McDonnell. Reprinted with special permission of King Features Syndicate, Inc.

WILLIAM JEFFERSON CLINTON WAS THE FIRST AMERICAN PRESIDENT BORN AFTER WORLD WAR II. CLINTON'S TRIUMPHS AND FAILURES IN THE DECADE OF THE 1990S WERE EMBLEMATIC OF THE STRUGGLES MANY BABY BOOMERS WERE EXPERIENCING AS THEY APPROACHED MIDDLE AGE.

David Brooks, in his best-selling book about the decade, *Bobos in Paradise*, identified a new class of "bourgeois bohemians" who had reconciled the idealism of the 1960s with the pragmatism of the 1980s. "Bobos" had pioneered a new lifestyle that blended hippie ethics with the realities of personal affluence and political power.

Brooks argued that "the Clinton-Gore administration embodied the spirit of compromise that is at the heart of Bobo enterprise. In the first place, the Clintons were both 1960s antiwar protesters and 1980s futures traders. They came to the White House well stocked with bohemian ideals and bourgeois ambitions."

The leader of the free world played the saxophone and admitted to experimenting with marijuana during his college years. He was also a Rhodes scholar and a skilled orator. Clinton combined the common sense of the World War II generation with the social concerns of the baby boomers. The new hybrid was labeled "compassionate conservatism" or "practical idealism" as political persuasions became less polarized.

This same reconciliation process was also at work in the comics business during the 1990s. Three of the most successful new features of the decade—*Baby Blues*, *Mutts*, and *Zits*—blended traditional themes with fresh perspectives. Jerry Scott, Rick Kirkman, Patrick McDonnell, and Jim Borgman, the creators of these King Features–distributed comic strips, were all born during the postwar years. They helped to revive classic, family-oriented genres and brought quality draftsmanship back to the funnies pages.

IN THE BEGINNING . . . —BABY BLUES DAY 1 by Rick Kirkman and Jerry Scott. © 1990 Baby Blues Partnership. Reprinted with special permission of King Features Syndicate, Inc.

In the early 1970s Rick Kirkman and Jerry Scott worked together at an art agency in Phoenix, Arizona. During their lunch hour they often talked about a shared dream of creating a syndicated comic strip. They developed some ideas, including a strip called *Hide and Zeke*, about two miners in the Arizona desert, and *Copps and Robberts*, which starred a pair of inept policemen. Their boss, Audrey Keyes, liked the latter concept so much that she started a new syndicate, Southwestern Features, solely to distribute it. *Copps and Robberts* ran from 1978 to 1980 and appeared in about thirty papers at its peak.

During this time, Jerry Scott moved to California and started his own ad agency. He was introduced to cartoonist Foster Moore, the creator of the syndicated panel *Gumdrop*. When Moore retired in 1981, Scott took over *Gumdrop*, which was syndicated by United Feature. Two years later he also started producing the *Nancy* comic strip.

Rick Kirkman had stayed at the agency in Arizona and was now a successful art director. During this ten-year period the two had never given up their ambition of collaborating on a syndicated feature. In 1984 Kirkman had a baby daughter, which gave him the idea of doing a strip about a newborn. When Scott moved back to Phoenix in 1987, the two developed the concept and started sending samples of the strip, originally titled *Oh Baby*, to the syndicates. They got rejection letters back. One syndicate suggested trying the idea as a panel. Renamed *Baby Blues*, it was turned down because the same syndicate said panels were too hard to sell. Kirkman and Scott tried it as a strip again, and three syndicates showed interest. One wanted to see an older child in the family. Another wanted to see a continuing story line. There were still no offers.

Then one afternoon Anita Medeiros, comics editor of Creators Syndicate, called to tell the cartoonists that she loved the proposal and wanted to discuss a contract. *Baby Blues* began syndication in January 1990.

The strip starred a thirtysomething, college-educated couple, Wanda and Daryl MacPherson, and their newborn baby, Zoe. Kirkman and Scott's creation struck a chord with the millions of Americans who were just starting families after pursuing careers during the 1980s. Zoe aged slowly and was joined by baby brother Hamish in 1995 and sister Wren in 2002.

By 1994 *Baby Blues* was appearing in over 200 newspapers, when the contract with Creators Syndicate expired. Kirkman and Scott entertained offers from other syndicates and eventually signed with King Features. *Baby Blues* won the award for Best Humor Strip from the National Cartoonists Society in 1996, debuted as a weekly animated series on the Warner Brothers television network in 2000, and increased its circulation to over 800 papers.

After graduating from the School of Visual Arts in 1978, Patrick McDonnell thought briefly about doing a comic strip. A friend set up an appointment with Bobby Miller, comics editor at United Feature Syndicate, but the meeting was so discouraging that McDonnell decided to put his first ambition on hold and embark on a career in freelance cartoon illustration. He put together a portfolio and started showing his work around to second-rate publications, hoping they might give a newcomer a chance. After repeated rejections, he decided that if he was going to be turned down, it might as well be by the top magazines.

McDonnell's first big break came when Ruth Ansel, art director of the *New York Times Magazine*, hired him to illustrate

Russell Baker's "Sunday Observer" column, which he did every week for the next ten years, until the feature was retired. This job gave him the exposure and the experience to sell to all the top magazines, including *Forbes*, *Time*, *Life*, and *Self*. He also did regular features for *Parents Magazine*, *Sports Illustrated*, *Parade*, and *Reader's Digest*.

Although his illustration career temporarily kept McDonnell from pursuing his dream of creating a comic strip, he still managed to incorporate many comic-strip elements into his illustration work. He frequently used the same small cast of characters and played with multipanel layouts and speech balloons. He drew a regular strip, *Bad Baby*, which ran for ten years in *Parents Magazine* and was collected in a book published by Fawcett.

In the 1980s McDonnell also spent four years researching and writing, with his wife Karen O'Connell and Graham Gallery director Georgia Riley DeHavenon, a book devoted to one of his major influences. *Krazy Kat: The Comic Art of George Herriman*, published by Harry N. Abrams, Inc., in 1986, was a landmark work of comics scholarship.

In 1990 Carolyn and Arnold Roth invited McDonnell to join the National Cartoonists Society. "As soon as I went to my first N.C.S. event," he remembered, "it hit home that these were my type of people who were doing the thing I would love to do." In 1992 McDonnell won two awards from the N.C.S. for magazine illustration and greeting cards. This gave him the impetus to finally begin work on a comic strip.

MAGIC INK—MUTTS logo. © 1995 Patrick McDonnell. Reprinted with special permission of King Features Syndicate, Inc.

Jay Kennedy, the comics editor at King Features Syndicate, had been a classmate of McDonnell's at the School of Visual Arts during the 1970s. In 1990 the two had lunch together, and McDonnell showed Kennedy some idea sketches for a strip about a stray dog. For the next two years, McDonnell continued to be occupied with his illustration career but kept thinking about his comic-strip concept. Finally, in late 1992, he drew up four weeks of finished strips and two Sunday pages and mailed them to King Features, Universal Press, and Creators Syndicate. The feature was named *Zero Zero*, and it starred a dog and his mustached owner. It was also populated with frogs, rabbits, elephants, and a menagerie of other creatures that the dog (Zero Zero) encountered in his wanderings.

Universal Press Syndicate, which had a policy against "talking animal strips," passed on the proposal, but King decided to sign McDonnell up. During a yearlong development period, he honed his cast down to six characters in two family groups. In one house lived Ozzie and his dog, Earl (named after McDonnell's own dog). The other household consisted of Frank and Millie, their cat, Mooch, and their fish, Sid. The title *Mutts* was finally chosen from a dwindling list of names at the eleventh hour.

During the development period McDonnell also made a pilgrimage to visit Charles Schulz at his studio in California. His boyhood hero offered some sage advice on avoiding self-referential humor and concentrating on establishing believable characters. Schulz's praise and support eventually helped to sell *Mutts* to the *Los Angeles Times*, one of the first major papers to buy the strip before it debuted on September 5, 1994. When Bill Watterson retired at the end of 1995, McDonnell picked up many of the spaces vacated by *Calvin and Hobbes*. *Mutts* was appearing in close to 500 newspapers when McDonnell won the Reuben Award in 1999.

He had realized his dream. "What I really love about comics is that magic, that these little ink things are alive," McDonnell said. "That's what I love and hopefully that's what comes across."

In 1996 Jerry Scott was enjoying the success of *Baby Blues* but felt he needed a new challenge. A friend suggested that he try doing a strip with a teenager as the central character. It sounded like a good idea. The only problem was that all the characters Scott drew looked like Nancy and Sluggo, the stars of the strip he had drawn for twelve years. Scott mentioned this dilemma to his good friend Jim Borgman, the Pulitzer Prize–winning political cartoonist for the *Cincinnati Enquirer*. Borgman, who had a teenage son at home, offered to collaborate with Scott as the artist on the strip.

Zits, which Charles Schulz claimed was the worst name for a comic strip since *Peanuts*, debuted in July 1997. In six

TEEN ANGST—Jeremy from ZITS by Jerry Scott and Jim Borgman. © 1997 Zits Partnership. Reprinted with permission of King Features Syndicate, Inc.

months it had a list of 425 clients. The reputation of the two established creators was only part of the reason *Zits* took off so quickly.

"The artwork is the best I've seen in years," said Carl Crothers, editor of the *Winston-Salem Journal* in North Carolina. "The strip has movement that you don't get in a lot of comics. So many are so static."

Jeremy Duncan, the star of *Zits*, was a typical hormone-addled, insecure fifteen-year-old, who played in a rock band and fumbled through a relationship with his girlfriend, Sara Toomey. Although Jeremy was in constant conflict with his parents, Walt and Connie Duncan, there was a tender side to the family relationships. "Jerry and I never have to remind each other, 'Remember these folks like each other,'" claimed Borgman.

Zits was named the Best Comic Strip of the Year by the National Cartoonists Society in 1998 and 1999 and doubled its list of papers in less than four years. Scott and Borgman's creation managed to be cutting-edge and traditional at the same time. The strip was not dependent on clever gimmicks or a niche marketing concept. Scott's perceptive writing and Borgman's brilliant artwork provided a strong foundation upon which the successful collaboration was built.

The emergence of the internet as a global communications network in the 1990s had parallels to the rise of television in the 1950s. The new electronic medium presented both a challenge and an opportunity to the comics business. Syndicates, initially concerned about competing with their newspaper subscribers, eventually set up websites and marketed features directly to internet clients. Aspiring cartoonists showcased their work on the web and benefited from the increased exposure. Publishers, manufacturers, and creators earned additional income from on-line sales of books and licensed products. In spite of these digital-age developments, comic strips continued to generate most of their profits from newspaper fees.

Scott Adams was one cartoonist who used modern technology to build a modestly successful feature, *Dilbert*, into a mega-hit in the 1990s. Adams had an M.B.A. from the University of California at Berkeley and was earning about $70,000 a year as an applications engineer for Pacific Bell when he created *Dilbert* in 1989. The strip grew slowly, so he continued to produce it during his off-hours while working in the corporate world.

In 1993 Adams decided it might be useful to get some input from his readers, so he printed his e-mail address within the strip. The response he received revealed that the office-oriented episodes in *Dilbert* were the ones his fans were hanging up on the walls of their cubicles. He switched the emphasis of the feature almost entirely to business and technology, and it took off. Adams began receiving 300 to 800 e-mail messages a day from all over the world, and he used these ideas and suggestions in the strip. His fans also actively petitioned newspaper editors to buy *Dilbert*, which helped build the list of subscribers. Adams finally left PacBell when he was downsized on June 30, 1995.

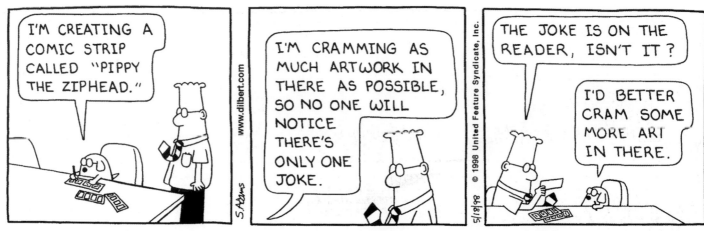

POTSHOT—DILBERT daily strip by Scott Adams (in retaliation for criticism by Bill Griffith). © 5/18/98 United Feature Syndicate, Inc.

The following year Adams attained superstar status. His comic strip passed the 1,000-client mark. The Dilbert Zone website was receiving an estimated 75,000 visitors a day. Adams was profiled in a *Newsweek* cover story. *The Dilbert Principle* stayed perched atop the *New York Times* best-seller list for months. *Dilbert* calendars, coffee mugs, ties, dolls, and mouse pads sold at a record pace. To top it off, Adams made more money that year giving speeches to corporations (at $7,500 an appearance) than he earned from the strip.

"I was a total failure in corporate America in terms of my career," Adams admitted in 1996. But he still wondered what might have happened had he not scored with *Dilbert*. "I truly think by now I would have been a fairly high-level manager and made more money than I do now," he speculated. "But I started doing cartooning just when I was most promotable, and the more I cartooned, the less promotable I became. I'll never know. It's a great mystery to me."

Adams won the Reuben Award in 1997, and a *Dilbert* animated television series debuted in 1999. *Dilbert* was the fifth strip, after *Peanuts*, *Garfield*, *For Better or For Worse*, and *Blondie*, to pass the 2,000-paper mark, in 2001.

As the new generation of cartoonists matured, they tackled more provocative issues. Among the sensitive subjects broached during the 1990s were crack babies (*Curtis*), menstruation (*Luann*), Alzheimer's disease (*Crankshaft*), and breast cancer (*Funky Winkerbean*). Some readers questioned whether the funnies were becoming too serious. Socially relevant story lines seemed more tragic than comic.

Lynn Johnston set off a storm of controversy in 1993 when Lawrence, a regular character in *For Better or For Worse*, admitted to his longtime friend, Michael Patterson, that he was gay. Johnston had sent letters of warning to all 1,400 newspapers that carried her strip before the four-week sequence was scheduled to appear. Although the subject was handled with sensitivity, a handful of editors and thousands of readers objected vehemently. When the dust settled, nineteen

papers had canceled *For Better or For Worse* permanently, and Johnston's phone rang off the hook for weeks.

A new term entered the national vocabulary in the 1990s: "political correctness." Americans became increasingly sensitive to the way certain groups were portrayed in the media. Initially the term was employed by conservatives to derisively label progressive causes. Eventually "politically correct" was used to describe socially acceptable references to gays, women, racial and ethnic minorities, and disabled persons. This uptight atmosphere made life difficult for many in the humor business.

"It's a new label," remarked Jeff MacNelly. "Every complaint we've ever had has been lumped into this huge monster. I'm politically incorrect. That's what I do for a living."

Mort Walker, who had deflected criticism for years about alleged sexism in *Beetle Bailey*, finally capitulated in 1997. General Halftrack, who had been ogling his curvaceous secretary, Miss Buxley, since she joined the cast in 1971, apologized for his behavior and attended a sensitivity training seminar. "I read my mail," said Walker. "I want to entertain my readers and when I find that certain subjects are not funny, I'm willing to change."

Beginning in 1989 Johnny Hart, a born-again Christian, began introducing overt religious commentary into his *B.C.* comic strip on certain holidays, such as Christmas and Easter. Many newspapers, including the *Washington Post* and *Los Angeles Times*, refused to run some of these episodes, claiming they were objectionable to their non-Christian readers. On Easter Sunday, 2001, the *B.C.* cartoon depicted a Jewish symbol, the Menorah, gradually transforming into a Christian symbol, the cross. The Anti-Defamation League, the American Jewish Committee, and other groups denounced the cartoon as a religious slur and many newspapers pulled the strip. Rick Newcombe, president of Creators Syndicate, Hart's distributor, issued a statement saying, "I interpreted it the same way as Johnny intended for it to be interpreted—that Christianity is rooted in Judaism."

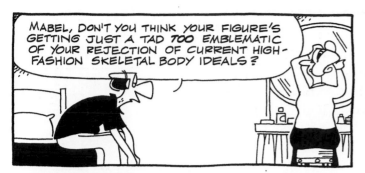
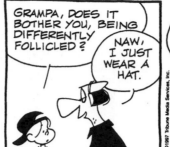
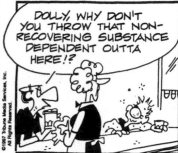

Cartoonists were finding it dangerous to poke fun at anyone. Berke Breathed, who was frequently censored for politically incorrect humor in *Bloom County* and *Outland*, claimed that if a woman did anything objectionable in his strip she became a "symbol for her gender," and if a black character did anything controversial he was regarded as a "minority icon."

"I am not free to portray minorities in the way they portray themselves. I have to be careful in dealing with drug issues and with minorities," Breathed stated. "The effect of political correctness is very powerful on the page."

Minority cartoonists also felt the heat. Aaron McGruder's comic strip, *The Boondocks*, which starred two black kids from inner-city Chicago who had just moved to the white suburbs, generated controversy from the day of its debut on April 19, 1999. Black readers complained that the strip perpetuated racial stereotypes. White readers felt they were being ridiculed. Others objected to the way McGruder portrayed an interracial married couple.

The twenty-five-year-old black cartoonist seemed unfazed by the criticism. "The focus of the strip is race," argued McGruder. "Just like the focus of *Dilbert* is cubicles."

Although *The Boondocks* was canceled by a handful of small-town newspapers, it had 195 clients within two months of its launch. Many editors rallied to McGruder's defense. Kristin Tillotson of the *Minneapolis Star-Tribune* wrote that readers who didn't appreciate the humor of the strip suffered from "irony deficiency." It was time for America to lighten up.

The centennial anniversary of the funnies was celebrated in 1995. The first color appearance of Richard F. Outcault's Yellow Kid in the *New York World* on May 5, 1895, was widely recognized as the birth of the art form. Many cartoonists did special tributes in their strips on the day of the milestone. A retrospective exhibition, "Featuring the Funnies: 100 Years of the Comic Strip," was held at the Library of Congress. The U.S. Postal Service released a series of twenty commemorative comic-strip stamps on October 1. Writers, columnists, and reporters across the nation featured stories on this major cultural event. Even the *New York Times*, one of the few newspapers in the country that does not publish comics, saluted the funnies.

COMICS CENTENNIAL—THATCH daily strip by Jeff Shesol. Many cartoonists created tributes on the day of the anniversary. © 5/5/95 Creators Syndicate, Inc.

The comics were basking in a warm glow of public acceptance. A study by Metropolitan Sunday Newspapers in 1993 reported that 113 million Americans read the comics regularly. In 1995 four strips were each appearing in more than 2,000 newspapers. The renamed International Museum of Cartoon Art opened a new, expanded facility in Boca Raton, Florida, in 1996. Other institutions devoted to the art form opened in San Francisco, Northampton, Massachusetts, and Washington, D.C. Membership in the National Cartoonists Society was at an all-time high. On April Fools' Day, 1997, forty-six syndicated artists swapped features in "The Great Comics Switcheroonie." Mike Peters ghosted *For Better or For Worse*, and Garfield and Jon moved in with Blondie and Dagwood in the crossover spoof.

A few prophets of gloom tried to spoil the fun. Bill Griffith, the creator of *Zippy the Pinhead*, wrote the following assessment in the *Boston Globe* on November 10, 1996: "The newspaper comic strip is 100 years old—and looks it. Shrunken. Pale. Shaky. One foot in the grave. Diagnosis: in desperate need of new blood. Instead, it gets *Dilbert*."

Anthony Lejeune, in a *National Review* article entitled "Eek! Sob! It's the Death of Comics," lamented, "Nobody fights over the breakfast table for a first glimpse of *Calvin and Hobbes* or hurries to the street corner for the latest episode of *Cathy*."

"Too many newspapers are running too many cartoons done by dead guys," claimed *Non Sequitur* cartoonist Wiley

Miller. "The guys who created *Blondie* and *Dick Tracy* have been dead for years and so are the strips." Miller urged editors to get rid of the "deadwood" and open up their pages to artists with cutting-edge creations.

The competitive nature of the comics business intensified in the 1990s as the number of papers dwindled and editors feared the wrath of loyal readers when they tried to cancel long-running features. Young cartoonists found it increasingly difficult to break in and resented the old standby strips that had been around since before they were born.

"Most new comics die," claimed David Seidman, a former comics editor of the *Los Angeles Times*. "After accounting for the big important strips, the average editor might have one or two spots to play around with for new strips." Most newspapers gave a strip six months to a year to establish a readership. Syndicates canceled the majority of features after a year if they didn't catch on. The odds of survival beyond that point were less than 40 percent.

When Bill Watterson, Gary Larson, and Berke Breathed retired in 1995, approximately 4,700 spaces opened up on the nation's comic pages. A handful of established features got an immediate boost in circulation. The rest of the talent found themselves scrambling for the remaining spots.

During the 1990s each of the major syndicates reported receiving more than 5,000 submissions from aspiring cartoonists every year. Many of these concepts tried to emulate the

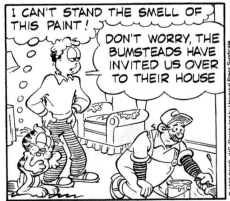

APRIL FOOLS—GARFIELD daily strip by Jim Davis. Cartoonists swap features for a day. © 4/1/97 Paws, Inc. Used by permission of Universal Press Syndicate. All rights reserved

BREAKING IN—NINA'S ADVENTURES weekly page by Nina Paley. © 2/13/92 Nina Paley

proven formula of an existing feature. In 1997 Lee Salem, comics editor of Universal Press Syndicate, remarked, "I just got one in my 'In' box that was called 'The Other Side.'"

Syndicate editors searched through these proposals for the next promising creation. Any envelope that crossed their desk could contain a unique idea whose time had come. Only a few blockbusters surface each decade.

"Comics are still one of the few Cinderella businesses," claimed King Features comics editor Jay Kennedy in 1996. "You don't need an agent and you don't need to know anyone—if you're good enough you can send it in and have a shot at seeing a dream come true."

The greatest success story in the history of comics came to an end in December 1999 when Charles Schulz announced that he was retiring after more than forty-nine years of producing the *Peanuts* comic strip. "Good Grief!"; "Aaugh!"; and "Nuts! No *Peanuts*" appeared as headlines in *Newsweek*, *People*, and the *New York Daily News*. "Aack! I can't stand it!!" shrieked the comic character Cathy, facing a future on the funnies pages without Charlie Brown and Lucy.

Schulz, who had been diagnosed with colon cancer after hospitalization on November 16, 1999, appeared emotionally drained in a *Today* show interview with Al Roker the following January. Although he had been contemplating retirement for many years, his health problems forced him

to make the decision prematurely. In his last daily strip, dated January 3, 2000, Schulz regretfully admitted to his readers, "Unfortunately, I am no longer able to maintain the schedule demanded by a daily comic strip, therefore I am announcing my retirement." The last *Peanuts* Sunday page was scheduled to appear on February 13, 2000.

Doonesbury creator Garry Trudeau wrote an elegant appreciation of Schulz's legacy in the *Washington Post* on December 19, 1999. "While the public at large regards *Peanuts* as a cherished part of our shared popular culture, cartoonists also see it as an irreplaceable source of purpose and pride, our gold standard for work that is both illuminating and aesthetically sublime. We can hardly imagine its absence."

United Media made plans to fill the void on the funnies pages with classic *Peanuts* strips from 1974. Only 140 of the strip's subscribers opted not to pay for the reruns. The licensing program continued. In fact, after the retirement announcement, interest in Schulz's creation increased.

A second shock wave hit on February 12, 2000, when Schulz died in his sleep less than three hours before the final *Peanuts* episode appeared in the Sunday newspapers. "The timing was prophetic and magical," said Lynn Johnston, a close friend of Schulz. "He made one last deadline. There's romance in that."

"Sparky," as his friends and fellow cartoonists called him, single-handedly conceived, drew, inked, and lettered over 17,500

PEANUTS PATIENT—JUMP START by Robb Armstrong. (Schulz was in the hospital.) © 1/5/2000 United Feature Syndicate, Inc.

individual *Peanuts* comic strips and Sunday pages. The feature appeared in 2,600 newspapers and consistently placed its creator on the *Forbes* magazine list of highest-paid entertainers.

Schulz's accomplishments cannot be measured solely by numbers, however. The *Peanuts* gang—Charlie Brown, Lucy, Linus, Schroeder, Pigpen, Sally, Marcie, Peppermint Patty, and Snoopy—were among the most recognized and beloved personalities on the planet. Schulz's strokes of genius—Linus's security blanket, Snoopy's flights of fantasy, Charlie Brown's travails on the baseball mound—became as much a part of American folklore as Tom Sawyer and Huck Finn's adventures.

"I have been asked many times if I ever dreamed that *Peanuts* would become so successful," wrote Schulz in the introduction to his fiftieth-anniversary anthology, *Peanuts: A Golden Celebration*. "Obviously I did not know that Snoopy

was going to go to the moon and I did not know that the term 'happiness is a warm puppy' would prompt hundreds of other such definitions and I did not know that the term 'security blanket' would become part of the American language; but I did have the hope that I would be able to contribute something to a profession that I have loved all my life."

Although his genius was universally recognized during his lifetime, Schulz did not regard what he produced as "Great Art." "Having a large audience does not, of course, prove that something is necessarily good," he modestly stated. "I subscribe to the theory that only a creation that speaks to succeeding generations can truly be labeled art."

Charles Schulz's impressive body of work, as well as the imaginative creations of his contemporaries in the comics field, will have their day of reckoning in the twenty-first century.

A SAD FAREWELL—Charlie Brown by Charles Schulz. © United Feature Syndicate, Inc.

DENNIS THE MENACE Sunday page by Ron Ferdinand. © 5/28/2000 North America Syndicate. Used by permission of Hank Ketcham Enterprises

COMIC LEGACIES A number of classic features, whose creators or successors died or left to pursue other opportunities in the 1980s and 1990s, were continued by former assistants, experienced pros, or family members. Ron Ferdinand began illustrating the *Dennis the Menace* Sunday page (above) in the early 1980s, and Marcus Hamilton took over the *Dennis* daily panel (right) in the mid-1990s. Hank Ketcham worked closely with both artists until his death in 2001. Jim Scancarelli took over *Gasoline Alley* (following page) after Dick Moores passed away in 1986. He won the Best Story-Strip Award from the National Cartoonists Society in 1989 for his distinguished work. Guy and Brad Gilchrist succeeded Jerry Scott on *Nancy* (following page) in 1995, restoring it to the original Bushmiller style, while exploring more contemporary themes.

"BOY, GRAMPA! NATURE'S SO MUCH *BIGGER* IN PERSON, THAN IT IS ON TV."

DENNIS THE MENACE daily panel by Marcus Hamilton. © 8/15/2001 North America Syndicate. Used by permission of Hank Ketcham Enterprises

GASOLINE ALLEY Sunday page by Jim Scancarelli (to mark the comics centennial). © 4/16/95 Tribune Media Services, Inc. All rights reserved. Used by permission

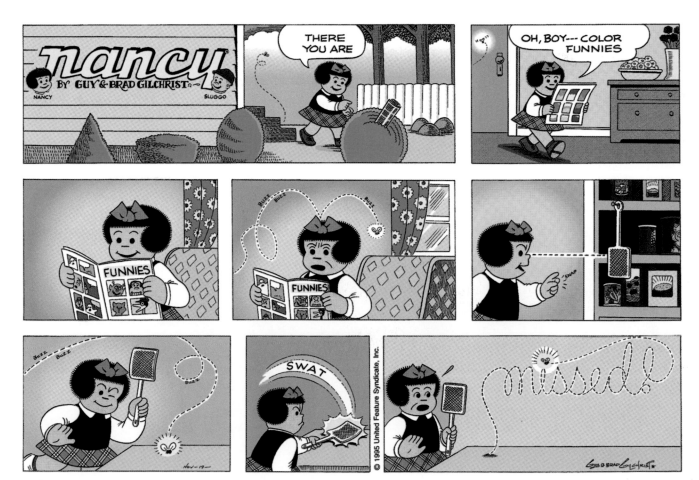

NANCY Sunday page by Guy & Brad Gilchrist. © 11/19/95 United Feature Syndicate, Inc.

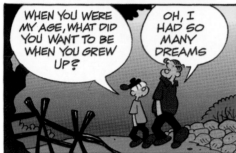
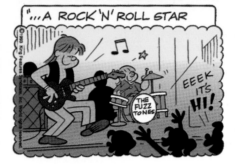
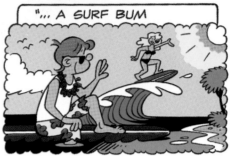
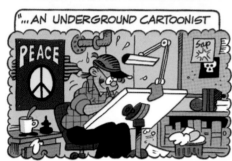
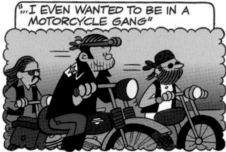
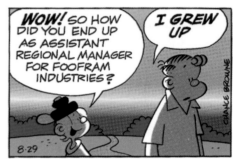

HI AND LOIS Sunday page by Brian and Greg Walker and Chance Browne. © 8/29/93 King Features Syndicate, Inc.

COMIC LEGACIES (CONTINUED)

When Dik Browne died on June 4, 1989, his two strips were left in able hands. The art production of *Hi and Lois*, which had been scripted by Mort Walker's sons, Brian and Greg, since the mid-1980s, was officially assumed by Chance Browne, who had been working with his father for many years. Frank Johnson, who had been inking *Hi and Lois* since the early 1970s, also continued. Dik's other son, Chris, who had been involved with *Hagar the Horrible* since its inception in 1973, took over the production of that strip with the help of Bud Jones (writing) and Dick Hodgins, Jr. (artwork).

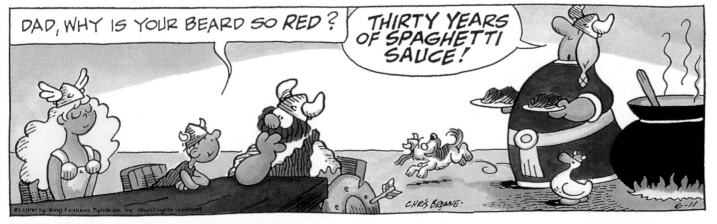

HAGAR THE HORRIBLE daily strip by Chris Browne. © 6/11/90 King Features Syndicate, Inc. Courtesy of Bill Janocha

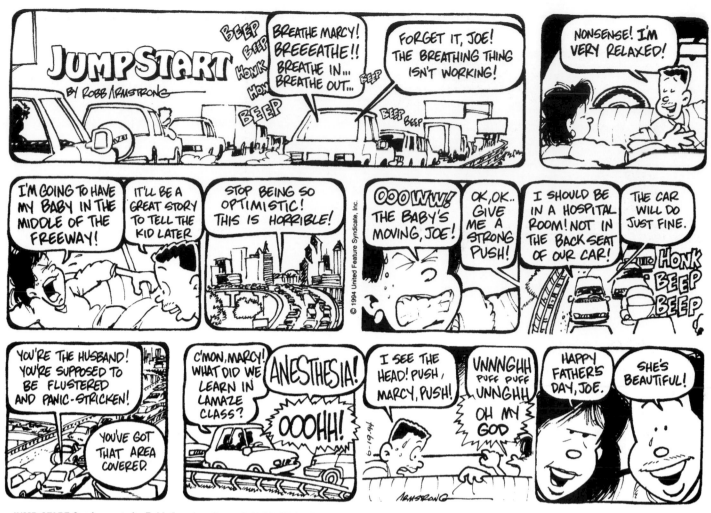

JUMP START Sunday page by Robb Armstrong. © 6/19/94 United Feature Syndicate, Inc.

ROBB ARMSTRONG When *Jump Start* began in 1989, the characters spoke in modern street slang. "I was trying to be blacker," admitted Armstrong, the African-American creator of the strip. "Then a black woman wrote me, and she was just irate. I said, 'You know, she's right—I don't use this slang.' I was feeding into all those stereotypes." Armstrong decided to develop a more mainstream family feature that "flies in the face of racial stereotypes." The loving relationship

between his two main characters, Joe, a policeman, and Marcy, a nurse, culminated in the dramatic 1994 episode, shown here, in which Marcy gives birth to a baby girl, Sunny, in the back of the family car. *Jump Start* was inspired by Armstrong's own happy home life with wife Sherry, daughter Tess, and son Rex, and millions of newspapers readers have responded to his positive outlook on contemporary marriage and parenthood.

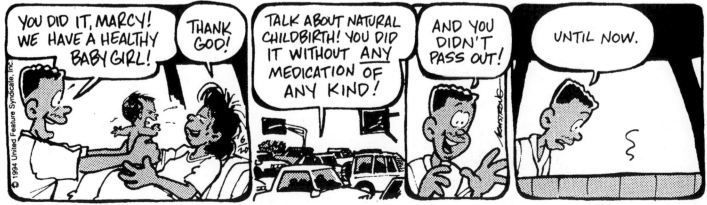

JUMP START daily strip by Robb Armstrong. © 6/20/94 United Feature Syndicate, Inc.

DILBERT daily strip by Scott Adams. © 4/17/89

All Dilbert strips © United Feature Syndicate, Inc.

SCOTT ADAMS The most successful comic strip of the last decade, Scott Adams's 1989 creation *Dilbert*, gained a large following among cubicle-dwelling office workers before expanding its appeal to a broader audience by the mid-1990s. The star of the strip is a hapless techno-nerd who lives with a cynical canine named Dogbert and is victimized by his pointy-haired boss and befuddled by his neurotic coworkers, Alice, Tina, Wally, Albert, and Asok. *Dilbert* was produced, until 1995, during Adams's off-hours from his job at a high-tech company that inspired the environment in the strip. His graphically minimal doodles manage to convey the bleak futility of Dilbert's pathetic existence. The character's appeal is similar to Charles Schulz's lovable loser, Charlie Brown. Readers identify with Dilbert because he puts up with the petty insults of the corporate world and comes back each day for more abuse.

SELF-CARICATURE by Scott Adams

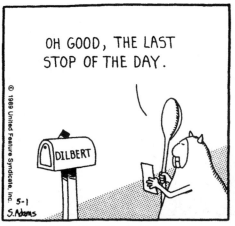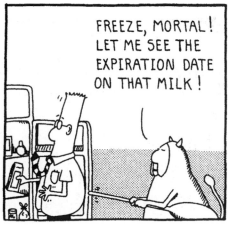

DILBERT daily strip by Scott Adams. © 5/1/89

DOGBERT, I'D LIKE TO HAVE A WORD WITH YOU.

THE NEIGHBOR SAYS YOU GLUED LITTLE SUCTION CUPS ON THEIR NEW KITTEN AND STUCK HIM ON THEIR WINDSHIELD.

© 1989 United Feature Syndicate, Inc.

WHAT'S THE PROBLEM, SOME KIND OF COPYRIGHT INFRINGEMENT?

WHAT'S YOUR SECOND GUESS?

DILBERT daily strip by Scott Adams. © 9/25/89

DID YOU HEAR THAT THE TINY EAST EUROPEAN COUNTRY OF ELBONIA HAS ABANDONED COMMUNISM?

WHOA! BIG CHANGES AHEAD.

ELBONIA: MONDAY

MUD FARM

© 1990 United Feature Syndicate, Inc.

ELBONIA: TUESDAY

MY TREE

MY PIG

MY MUD FARM

MY FEET

DILBERT daily strip by Scott Adams. © 4/2/90

MOTHER NATURE HAS DECIDED TO BE LENIENT WITH YOU HUMAN LITTERBUGS.

© 1990 United Feature Syndicate, Inc.

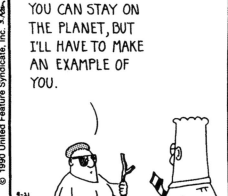
YOU CAN STAY ON THE PLANET, BUT I'LL HAVE TO MAKE AN EXAMPLE OF YOU.

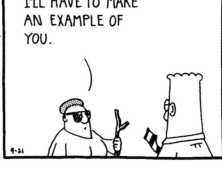
IT'S AN IDEA I GOT FROM A GARY LARSON CARTOON.

DILBERT daily strip by Scott Adams. © 9/21/90

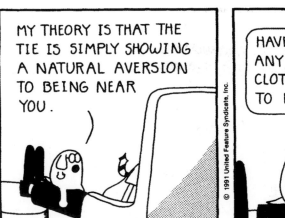
I'VE ALWAYS WONDERED WHY YOUR TIE CURLS UP LIKE THAT.

MY THEORY IS THAT THE TIE IS SIMPLY SHOWING A NATURAL AVERSION TO BEING NEAR YOU.

© 1991 United Feature Syndicate, Inc.

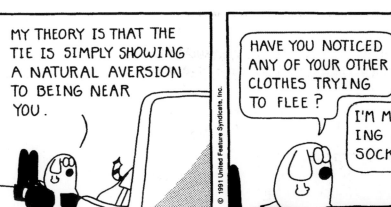
HAVE YOU NOTICED ANY OF YOUR OTHER CLOTHES TRYING TO FLEE?

I'M MISSING A SOCK...

DILBERT daily strip by Scott Adams. © 8/7/91

I PREPARE TO ENTER THE SENSORY DEPRIVATION CHAMBER.

I WILL EXPERIENCE NO MENTAL OR PHYSICAL STIMULATION FOR HOURS.

ALL THAT AND I GET PAID TOO.

DILBERT daily strip by Scott Adams. © 5/3/93

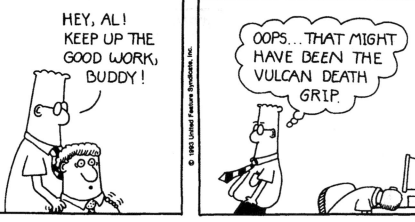

I'LL GIVE ALBERT A MALE BONDING SHOULDER MASSAGE TO SHOW I'M A TEAM PLAYER.

HEY, AL! KEEP UP THE GOOD WORK, BUDDY!

OOPS... THAT MIGHT HAVE BEEN THE VULCAN DEATH GRIP.

DILBERT daily strip by Scott Adams. © 8/21/93

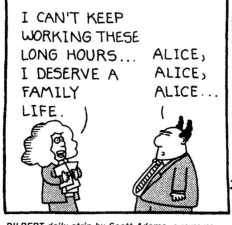
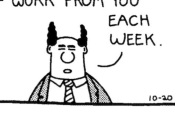

I CAN'T KEEP WORKING THESE LONG HOURS... I DESERVE A FAMILY LIFE.

ALICE, ALICE, ALICE...

THIS ISN'T THE "ME" GENERATION OF THE EIGHTIES. THIS IS THE "LIFELESS NINETIES." I EXPECT 178 HOURS OF WORK FROM YOU EACH WEEK.

THERE ARE ONLY... UH, 168 HOURS IN A WEEK.

I EXPECT YOUR FAMILY TO CHIP IN A FEW HOURS.

DILBERT daily strip by Scott Adams. © 10/20/93

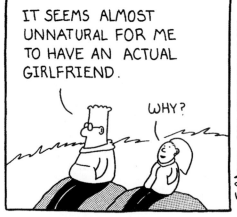

IT SEEMS ALMOST UNNATURAL FOR ME TO HAVE AN ACTUAL GIRLFRIEND.

WHY?

IT'S LIKE WHEN THE CAPTAIN ON "STAR TREK" FALLS IN LOVE, AND YOU KNOW THE WOMAN WILL DIE IN AN UNLIKELY ACCIDENT.

HEY! WE JUST SAW OUR FIRST SHOOTING STAR!

DILBERT daily strip by Scott Adams. © 7/25/94

DILBERT daily strip by Scott Adams. © 9/16/94

DILBERT daily strip by Scott Adams. © 9/28/94

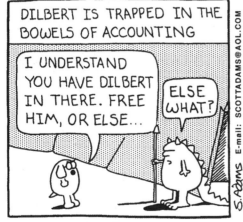

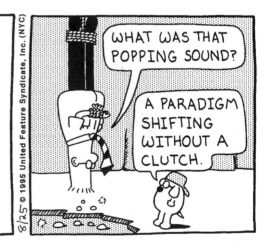

DILBERT daily strip by Scott Adams. © 8/25/95

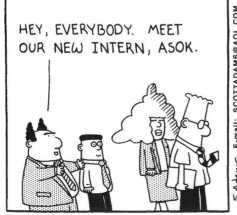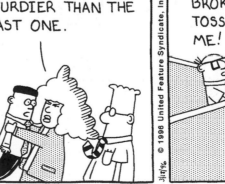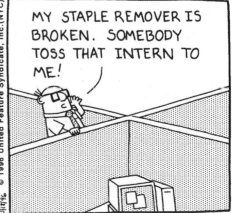

DILBERT daily strip by Scott Adams. © 3/18/96

THE **7** HABITS OF

HIGHLY DEFECTIVE PEOPLE

OW!

1. IGNORE ANY SIGNS OF DISCOMFORT IN OTHERS.

BUT HEY, I'VE BEEN DOING ALL OF THE TALKING.

2. USE HUMOR TO BELITTLE PEOPLE IN PUBLIC.

OUR NEWEST TEAM MEMBER HAS MOVIE STAR LOOKS. SPECIFICALLY, LASSIE.

3. TREAT ALL COMPLAINTS AS THE COMPLAINER'S FAULT.

YOU DON'T MOTIVATE ME.

MAYBE YOU SHOULD SEE A THERAPIST.

4. SHOW UP LATE AND RAISE CONTROVERSIAL ISSUES.

I THINK WE SHOULD LICENSE "BARNEY" AS OUR MASCOT.

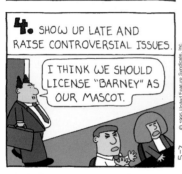

5. GIVE ADVICE ON THINGS YOU DON'T UNDERSTAND.

TRY WRITING SOME ASSEMBLY LINE CODE HERE.

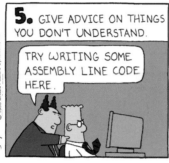

6. USE COMPLIMENTS TO SHOW YOUR PREJUDICES.

OOH, NICE CRISP PHOTO-COPY, ALICE. I DON'T THINK A MAN COULD HAVE DONE IT BETTER!

7. THINK THE COMICS ARE NOT ABOUT YOU

HEE HEE! LOOK AT THE HAIR ON THAT GUY!

DILBERT Sunday page by Scott Adams. © 5/7/95

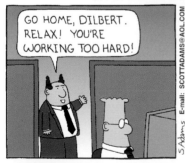

GO HOME, DILBERT. RELAX! YOU'RE WORKING TOO HARD!

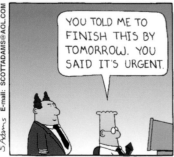

YOU TOLD ME TO FINISH THIS BY TOMORROW. YOU SAID IT'S URGENT.

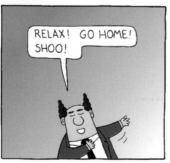

RELAX! GO HOME! SHOO!

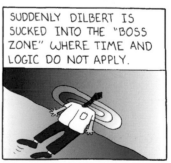

SUDDENLY DILBERT IS SUCKED INTO THE "BOSS ZONE" WHERE TIME AND LOGIC DO NOT APPLY.

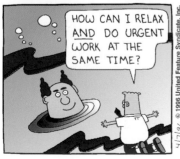

HOW CAN I RELAX AND DO URGENT WORK AT THE SAME TIME?

WORK SMARTER, NOT HARDER.

AAEEII!!

MERCIFULLY, THE ANGEL OF CYNICISM APPEARS.

SLAP SOMETHING TOGETHER IN THE MORNING. HE WON'T LOOK AT IT ANYWAY.

THE INSPIRATIONAL MORAL...

FREEDOM'S JUST ANOTHER WORD FOR NOT CARING ABOUT THE QUALITY OF YOUR WORK!

DILBERT Sunday page by Scott Adams. © 4/7/96

rick kirkman & jerry scott

SUCCESSFUL COLLABORATIONS are rare in the comics. Most features are produced by a single creator, often with the help of assistants. Even when gag writers and ghost artists are used, there is almost always one individual who guides the direction of a strip. During the last fifty years, very few features have begun as collaborations. Mort Walker and Dik Browne teamed up to produce *Hi and Lois* in 1954. Johnny Hart and Brant Parker, who created *The Wizard of Id* in 1964, were another successful partnership.

A more recent collaborative effort is Rick Kirkman and Jerry Scott's *Baby Blues*. When this family feature was launched in 1990, Scott, the writer, did not have children of his own. He depended on Kirkman, the artist, who had two young daughters at home, to provide inspiration for gags.

In a 1990 article in *Cartoonist PROfiles*, Scott described their working methods: "While I generate all of the actual gags, it's conversations with Rick about the strip that get the ideas started. After I give Rick the gags I've written (between seven and twelve a week), he goes through them and chooses the ones he feels are the strongest and makes suggestions on improving the rest. This is really where the fun starts for me because some of our best material has come out of these sessions. Tearing ideas apart and rearranging them into totally different gags not only improves the existing gags that we're working on, it also results in the creation of new material. Often the new stuff is more insightful or just plain sillier than what we started with. When we agree on seven cartoons for the week, Rick does roughs of each gag, and we do the same critique, with me making comments and suggestions on the art. We push each other toward constant improvement, and the result is a better product than either of us could produce alone."

The finished strips are then drawn on two-ply bristol board with black colored pencils. Kirkman's pencil line gives *Baby Blues* a relaxed, friendly look.

Despite the title, the focus of the strip is on parenting, not babies. In the beginning, Zoe, who was drawn smaller than most comic-strip infants, did not speak or "think" in balloons. As she grew (she was one year old after two years on the comics pages), Zoe began to babble like a baby, and before long she was talking like a toddler. Her parents, Wanda and Darryl, confronted many of the same child-rearing issues that contemporary parents face, including disposable diapers vs. cloth diapers, breast-feeding in public, unisex toys, potty-training, preschool, and husband-coached natural childbirth (when the second baby, Hamish, was born in 1995).

In 1996 the National Cartoonists Society presented the award for Best Comic Strip of the Year to Rick Kirkman for *Baby Blues*. Jerry Scott, the co-creator of the feature, was not given an equal share of the honor. This situation set off a heated debate within the organization. The existing bylaws of the N.C.S. restricted full membership to individuals who earned more than 50 percent of their income as cartoonists (defined as a "graphic storyteller"). Writers could only be associate members and were not eligible for awards. The rule was particularly hard to justify in the case of collaborators whose duties often overlapped. In 1998, when *Zits* was nominated for best comic strip, Scott, who was also the co-creator of that feature, was left off the ballot again. Scott's partner, Jim Borgman, protested, and the N.C.S. was finally forced to amend the rules to recognize collaborators equally.

Scott no longer depends on Kirkman as the main source of his gag material. "The strip was originally based on Rick's second daughter," he remembers. "But in 1993 Kim (Scott's wife) and I welcomed Abbey into our lives to love, educate, and help produce gags." A second child, Cady, was born on October 26, 2001. Scott now writes from firsthand experience.

BABY BLUES daily strip by Rick Kirkman and Jerry Scott, © 11/5/97

All Baby Blues strips © Baby Blues Partnership. Reprinted with special permission of King Features Syndicate, Inc.

BABY BLUES daily strip by Rick Kirkman and Jerry Scott. © 6/19/90

BABY BLUES daily strip by Rick Kirkman and Jerry Scott. © 10/6/90

BABY BLUES daily strip by Rick Kirkman and Jerry Scott. © 7/23/91

BABY BLUES daily strip by Rick Kirkman and Jerry Scott. © 12/27/96

BABY BLUES daily strip by Rick Kirkman and Jerry Scott. © 2/21/94

BABY BLUES daily strip by Rick Kirkman and Jerry Scott. © 9/21/94

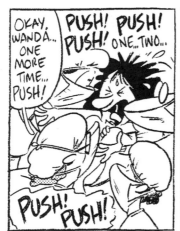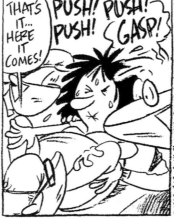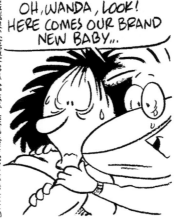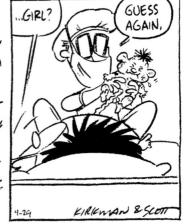

BABY BLUES daily strip by Rick Kirkman and Jerry Scott. © 4/29/95

BABY BLUES daily strip by Rick Kirkman and Jerry Scott. © 8/25/97

BABY BLUES Sunday page by Rick Kirkman and Jerry Scott. © 9/6/92

BABY BLUES Sunday page by Rick Kirkman and Jerry Scott. © 7/28/96

BABY BLUES Sunday page by Rick Kirkman and Jerry Scott. © 1/25/98

BABY BLUES daily strip by Rick Kirkman and Jerry Scott. © 3/27/2000

BABY BLUES daily strip by Rick Kirkman and Jerry Scott. © 4/14/2000

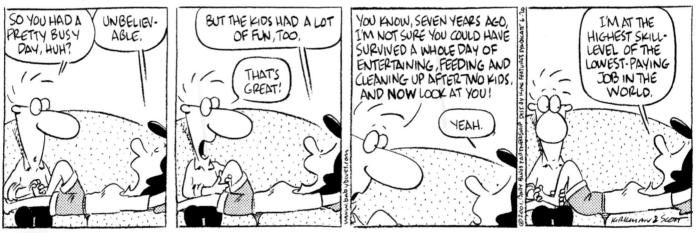

BABY BLUES daily strip by Rick Kirkman and Jerry Scott. © 6/20/2001

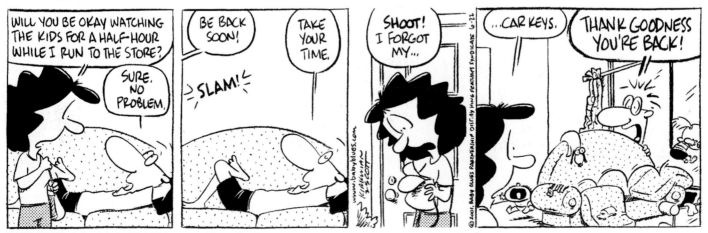

BABY BLUES daily strip by Rick Kirkman and Jerry Scott. © 6/22/2001

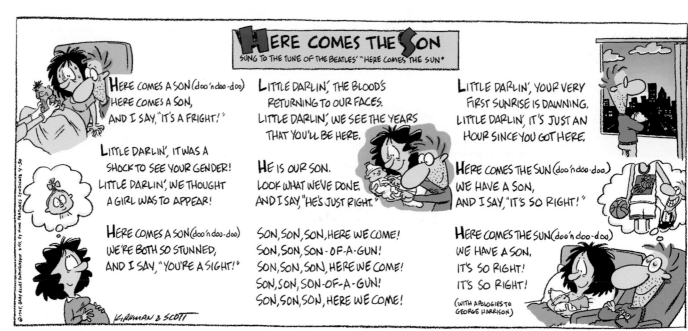

Here comes the Son
SUNG TO THE TUNE OF THE BEATLES' "HERE COMES THE SUN"

HERE COMES A SON (doo 'n doo-doo)
HERE COMES A SON,
AND I SAY, "IT'S A FRIGHT!"

LITTLE DARLIN', IT WAS A
SHOCK TO SEE YOUR GENDER!
LITTLE DARLIN', WE THOUGHT
A GIRL WAS TO APPEAR!

HERE COMES A SON (doo 'n doo-doo)
WE'RE BOTH SO STUNNED,
AND I SAY, "YOU'RE A SIGHT!"

LITTLE DARLIN', THE BLOOD'S
RETURNING TO OUR FACES.
LITTLE DARLIN', WE SEE THE YEARS
THAT YOU'LL BE HERE.

HE IS OUR SON.
LOOK WHAT WE'VE DONE.
AND I SAY, "HE'S JUST RIGHT."

SON, SON, SON, HERE WE COME!
SON, SON, SON - OF-A-GUN!
SON, SON, SON, HERE WE COME!
SON, SON, SON-OF-A-GUN!
SON, SON, SON, HERE WE COME!

LITTLE DARLIN', YOUR VERY
FIRST SUNRISE IS DAWNING.
LITTLE DARLIN', IT'S JUST AN
HOUR SINCE YOU GOT HERE.

HERE COMES THE SUN (doo 'n doo-doo)
WE HAVE A SON,
AND I SAY, "IT'S SO RIGHT!"

HERE COMES THE SUN (doo 'n doo-doo)
WE HAVE A SON.
IT'S SO RIGHT!
IT'S SO RIGHT!

(WITH APOLOGIES TO
GEORGE HARRISON)

KIRKMAN & SCOTT

BABY BLUES Sunday page by Rick Kirkman and Jerry Scott. © 4/30/95

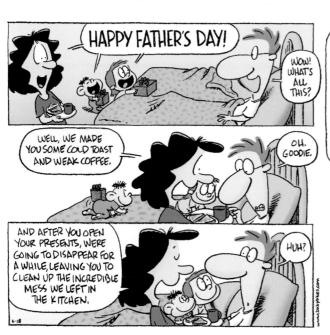

HAPPY FATHER'S DAY!

WOW! WHAT'S ALL THIS?

WELL, WE MADE YOU SOME COLD TOAST AND WEAK COFFEE.

OH, GOODIE.

AND AFTER YOU OPEN YOUR PRESENTS, WE'RE GOING TO DISAPPEAR FOR A WHILE, LEAVING YOU TO CLEAN UP THE INCREDIBLE MESS WE LEFT IN THE KITCHEN.

HUH?

THEN WE'RE GOING TO PIN A HUGE UGLY FLOWER ON YOUR SHIRT AND TAKE YOU OUT TO BRUNCH AT A BIG, IMPERSONAL HOTEL RESTAURANT WHERE THEY SERVE VATS OF RUNNY SCRAMBLED EGGS AND UNDERCOOKED BACON THAT TASTE LIKE THEY WERE PREPARED IN A PRISON KITCHEN, AND, OF COURSE, THEY'LL HAVE CHAMPAGNE BY THE PITCHER.

THIS IS BEGINNING TO SOUND A LOT LIKE WHAT WE DID FOR MOTHER'S DAY...

♪ TURNABOUT IS FAIR PLAY! ♪

GET DRESSED! LET'S GO!

YAY!

KIRKMAN & SCOTT

BABY BLUES Sunday page by Rick Kirkman and Jerry Scott. © 6/18/2000

Hammie and Me

WHEREVER I AM,
THERE'S ALWAYS HAM,
BUT WE ALL JUST CALL
HIM "HAMMIE."
WHATEVER I DO,
HE WANTS TO, TOO,
EVEN WHEN I TELL
HIM TO "SCRAMMIE!"

"WHERE ARE YOU GOING?
WHAT SHOULD WE DO?"
HE WANTS TO KNOW
ONE OR THE OTHER.
"LEAVE ME ALONE,"
I WEARILY GROAN,
IT AIN'T EASY
HAVING A BROTHER.

HE WANTS TO PLAY
TRUCKS OR CARS OR TRAINS
(IT IS CONSTANTLY
SOMETHING WITH WHEELS).
HE WON'T DRESS-UP
WITH ME ANYMORE
EVEN THOUGH HE LOOKS
GREAT IN HIGH HEELS.

ONE TIME GRAPE JUICE
GOT SPILLED ON THE COUCH,
WHEN MOM SAW IT
I KNEW SHE WOULD SNAP.
I HAD NO DOUBT
I'D GET A TIME-OUT,
BUT HEROICALLY,
HAM TOOK THE RAP.

SO WHEREVER I AM,
THERE'S ALWAYS HAM,
AND SOMETIMES I THINK
I MIGHT SMOTHER.
BUT ORNERY, STINKY
AND CLINGY ASIDE,
THERE'RE WORSE THINGS
THAN HAVING A BROTHER.

© 2001, BABY BLUES PARTNERSHIP DIST. BY KING FEATURES SYNDICATE

www.babyblues.com

BABY BLUES Sunday page by Rick Kirkman and Jerry Scott. © 2/18/2001

GRAPHIC OPINION The tradition of social and political humor on the funnies pages was continued in the 1990s by a number of talented artists. Wiley Miller's innovative 1992 creation, *Non Sequitur* (above and below), was designed to run in both the strip and panel format. Wiley's favorite targets were lawyers, businessmen, doctors, and entertainers. Jim Borgman, whose political cartoons had been distributed by King Features since 1980, launched a short-lived weekly strip in 1994 entitled *Wonk City* (next page, top), which tackled "inside the beltway satire." Barbara Brandon, daughter of *Luther* creator Brumsic Brandon, Jr., became the first black woman with a syndicated feature, when her weekly autobiographical strip, *Where I'm Coming From* (next page, bottom), debuted in 1991.

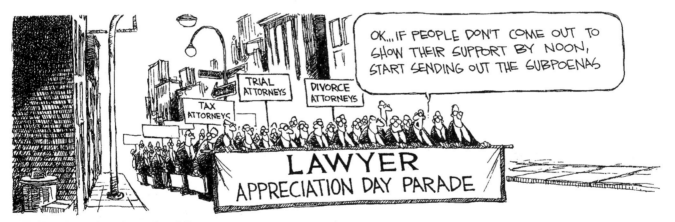

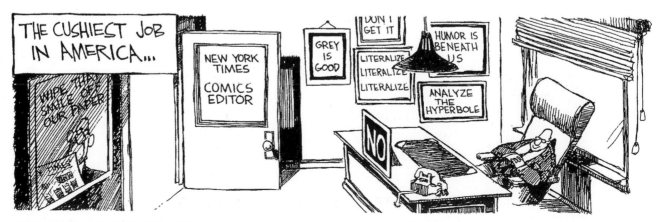

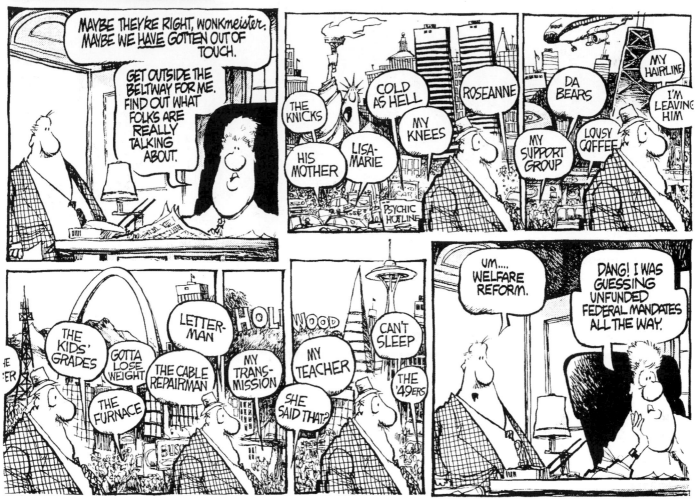

WONK CITY weekly page by Jim Borgman. © 1994 King Features Syndicate, Inc.

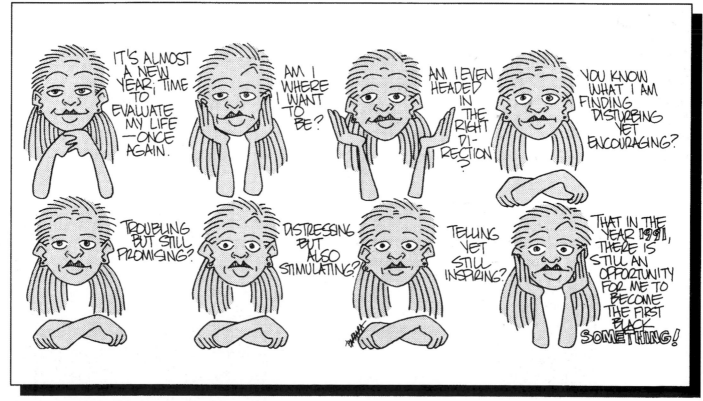

WHERE I'M COMING FROM weekly page by Barbara Brandon. © 1991 Barbara Brandon Croft. Used by permission of Universal Press Syndicate. All rights reserved

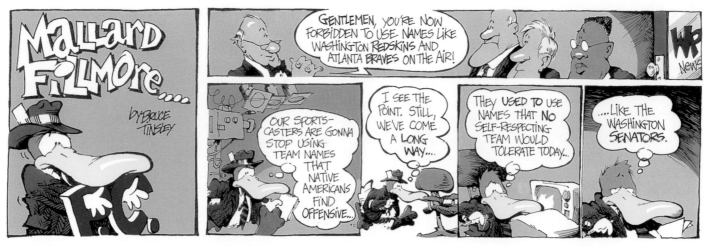

MALLARD FILLMORE Sunday page by Bruce Tinsley. © 1994 King Features Syndicate, Inc.

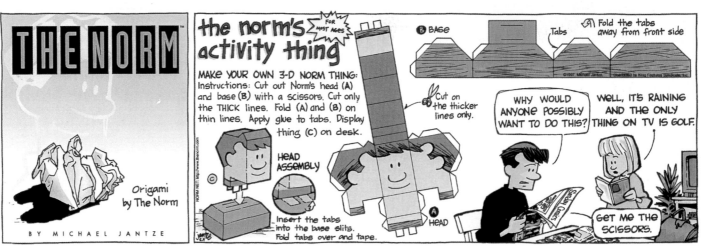

THE NORM Sunday page by Michael Jantze. © 1996 King Features Syndicate, Inc.

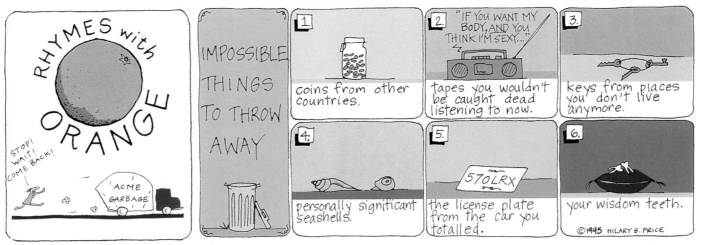

RHYMES WITH ORANGE Sunday page by Hillary Price. © 1995 King Features Syndicate, Inc.

STAYING POWER

A small group of new humor features, introduced in the first half of the decade, held on in the competitive comics market. *Mallard Fillmore* (1994) by Bruce Tinsley provided a conservative alternative to *Doonesbury* on many of the nation's editorial pages. Michael Jantze's *The Norm*, which began as a college strip in the 1980s, was developed at United Media in 1992, and finally sold to King Features in 1996, focused on "Life, Love, Work, and Technology." Hillary Price's *Rhymes With Orange* (1995) was a free-form, gag-based strip without recurring characters. *Pickles* (1991) by Brian Crane starred two senior citizens, Earl and Opal Pickles. Jim Toomey's undersea fantasy, *Sherman's Lagoon*, was launched by Creators Syndicate in 1991 and switched to King Features in 1998.

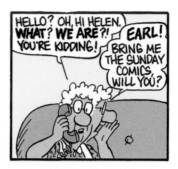
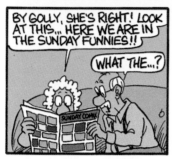
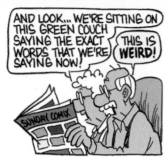
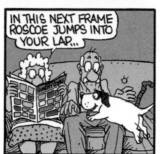

PICKLES Sunday page by Brian Crane. © 1991 Washington Post Writers Group

SHERMAN'S LAGOON Sunday page by Jim Toomey. © 1998 King Features Syndicate, Inc.

patrick mcdonnell

THE LAUNCHING OF MUTTS in 1994 was the culmination of a life-long ambition for Patrick McDonnell. "When I actually started doing the comic strip it was like a semireligious experience," he recalled. "I realized it was what I was meant to do."

The first episodes of *Mutts* were in a traditional gag-a-day format with occasional running themes. McDonnell soon began featuring two-week stories and found he enjoyed the challenge of extended continuity. He has done stories that have lasted for as long as four weeks. "I think one of the exciting things about comics is not just to tell jokes but to have stories that people can get involved in," he says.

McDonnell initially would do five weeks of strips in four weeks, and then take a week off. The pressure of meeting daily deadlines eventually forced him to change this routine. He now produces a week of strips at a time, often working seven days a week with infrequent breaks.

After outlining his stories at the beginning of each sequence, he continues to add and refine the material while he is drawing the individual strips. "I'm writing and drawing and doing concepts all at the same time," McDonnell explains. "Every day is a surprise." He does the inking and lettering last, as well as the coloring of the Sunday page, which is the final chore in completing each week of work.

Accustomed to using half-tones in his magazine cartoons, McDonnell experimented with "Duo-Shade," a commercial paper that revealed tonal patterns when a clear liquid chemical was applied. This gave the *Mutts* dailies a black-and-white-and-gray "painted" quality. He eventually abandoned this technique when he became concerned about exposure to the chemicals and discovered he preferred a cleaner black-and-white look.

Like most syndicated cartoonists, McDonnell works at home and has very few opportunities to bask in his newfound fame and fortune. "I'm not looking for celebrity," he claims. He receives regular feedback in the form of fan mail, but he produces his strip primarily to amuse himself. He hopes that his readers will enjoy it too, but realizes he has no control over the public's taste.

McDonnell often creates *Mutts* Sunday pages that pay homage to George Herriman's *Krazy Kat*, his primary source of inspiration. Subtle color palettes, delicate line work, and distinctive dialogue convey a mood that is more lyrical than laughable. McDonnell transforms his Sunday logo panels (which many newspapers don't use, for space reasons) into re-creations of famous masterpieces of art and cartooning. He has done graphic tributes to Degas, Dalí, Warhol, McCay, Crumb, and Kurtzman. Readers delight in trying to match the subject referenced in the title panel to the theme of that day's strip.

McDonnell has no specific policy against licensing, but because he devotes all of his energy toward producing *Mutts*, he has little time to think about other projects. He has approved a few items, including dolls of Earl and Mooch made in Japan, but has apprehensions about adapting his characters to animation. He does not relish the idea of battling with Hollywood producers for creative control.

His opinions about the current state of newspaper comics come from a highly personal perspective. "I'm doing the exact comic strip I want to do and it's getting printed and people are reading it and writing me letters saying they like it," he explains. His experiences convince him that "the potential of the art form is always there for it to be anything it wants to be. I wouldn't close the patent office yet. There are still people who love cartoons."

McDonnell is as much a fan of the art form as his readers. "I love comic strips—words and pictures, pen and ink, black and white," he explains. "I love the music in the line, the rhythm of a gag, the variation on a theme. I love repetition. I love repetition."

MUTTS daily strip by Patrick McDonnell. © 3/17/95

All Mutts strips © Patrick McDonnell. Reprinted with special permission of King Features Syndicate, Inc.

MUTTS daily strip by Patrick McDonnell. © 9/13/94

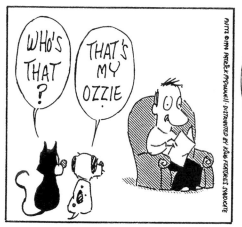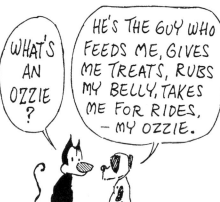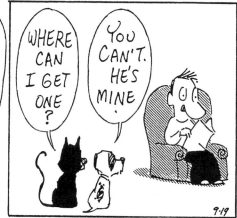

MUTTS daily strip by Patrick McDonnell. © 9/19/94

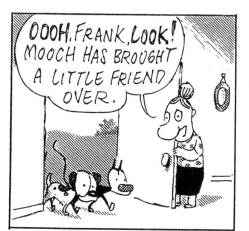

MUTTS daily strip by Patrick McDonnell. © 9/20/94

MUTTS daily strip by Patrick McDonnell. © 5/20/95

MUTTS daily strip by Patrick McDonnell. © 8/30/95

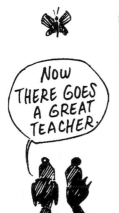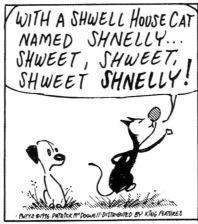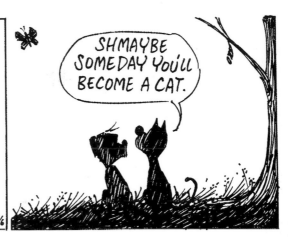

MUTTS daily strip by Patrick McDonnell. © 4/6/96

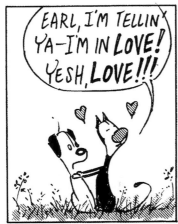

MUTTS daily strip by Patrick McDonnell. © 5/21/96

MUTTS daily strip by Patrick McDonnell. © 1/19/98

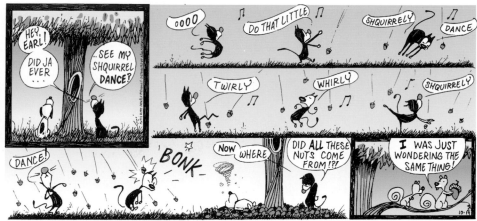

MUTTS Sunday page by Patrick McDonnell (logo panel after Edgar Degas). © 10/19/97

MUTTS Sunday page by Patrick McDonnell (logo panel after Bob Kane). © 10/26/97

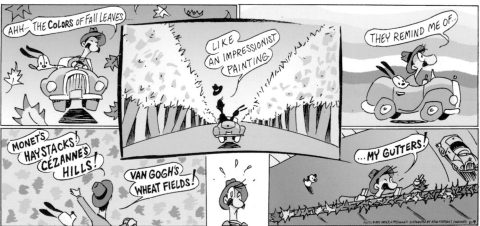

MUTTS Sunday page by Patrick McDonnell (logo panel after Maxfield Parrish). © 11/9/97

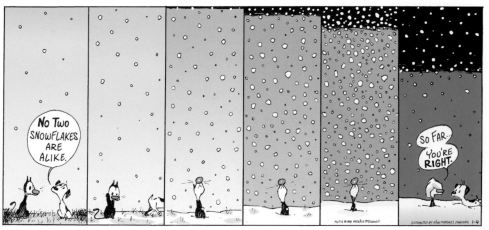

MUTTS Sunday page by Patrick McDonnell (logo panel after Hiroshige). © 1/4/98

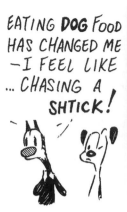
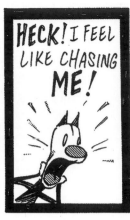
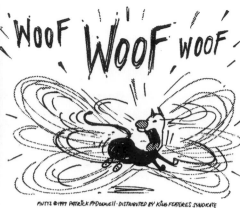
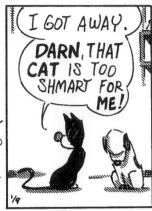

MUTTS daily strip by Patrick McDonnell. © 1/9/97

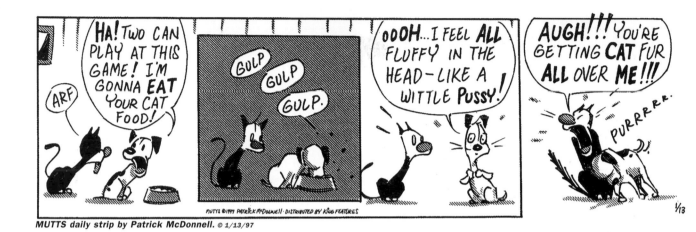

MUTTS daily strip by Patrick McDonnell. © 1/13/97

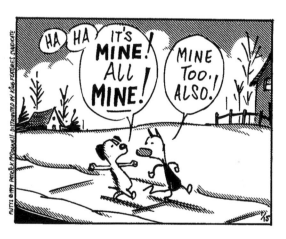

MUTTS daily strip by Patrick McDonnell. © 1/15/97

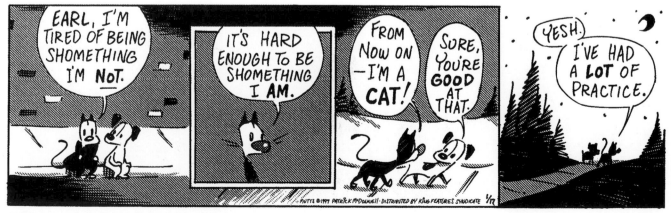

MUTTS daily strip by Patrick McDonnell. © 1/17/97

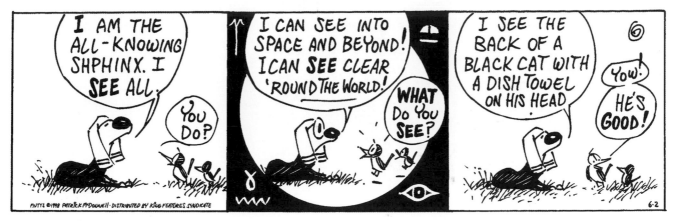

MUTTS daily strip by Patrick McDonnell. © 6/2/98

MUTTS daily strip by Patrick McDonnell. © 4/23/99

MUTTS daily strip by Patrick McDonnell. © 9/18/99

MUTTS daily strip by Patrick McDonnell. © 11/13/2000

MUTTS *Sunday page by Patrick McDonnell.* © 10/13/96

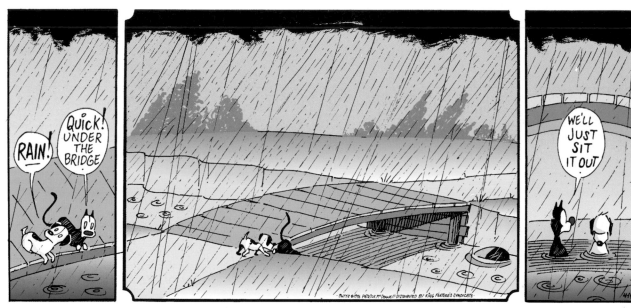

MUTTS *Sunday page by Patrick McDonnell.* © 4/14/96

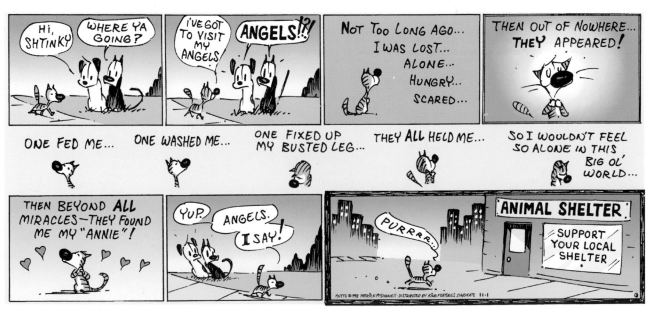

MUTTS *Sunday page by Patrick McDonnell.* © 11/1/98

FUNKY WINKERB...

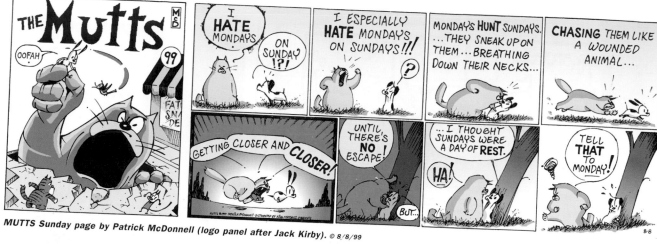

MUTTS Sunday page by Patrick McDonnell (logo panel after Jack Kirby). © 8/8/99

HI
WE

FUN...

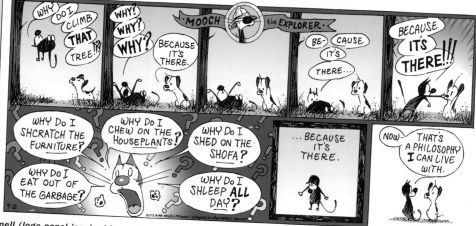

MUTTS Sunday page by Patrick McDonnell (logo panel inspired by a silent movie poster). © 9/12/99

THE "TR

number of
In addition
(drug abuse
as teenage
A 1986 ser

MUTTS Sunday page by Patrick McDonnell (logo panel inspired by an African cloth design). © 10/22/2000

CRANKSH...

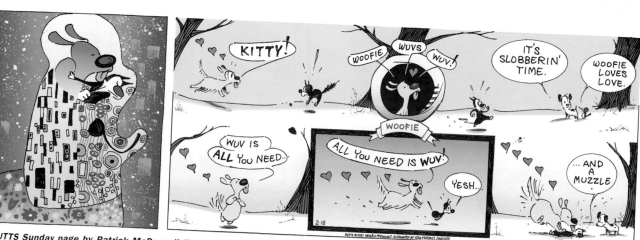

MUTTS Sunday page by Patrick McDonnell (logo panel after Gustav Klimt). © 2/18/2001

FRANK CHO One of the most original comic-strip creations of the 1990s was Frank Cho's *Liberty Meadows*. Cho, a young Korean-born cartoonist, was signed to a contract with Creators Syndicate in 1995 but wanted to finish college before launching his strip in 1997. A gifted draftsman and designer, Cho blended fluid penmanship with innovative layouts and clever self-referential humor. The *Liberty Meadows* Sunday pages provided showcases for his impressive graphic technique, which was influenced by great pen-and-ink artists of the past, such as Franklin Booth, Howard Pyle, and Joseph Clement Coll. Set in a wildlife preserve and animal shelter, the plots revolved around the romantic tension between Brandy, an animal psychologist, and Frank, a veterinarian. A favorite among loyal readers of *Liberty Meadows*, the buxom Brandy turned off some editors, limiting the strip's chances for success. Cho decided to terminate *Liberty Meadows* at the end of 2001, with a cliff-hanger about Brandy's wedding. This story reached its conclusion in a special publication sold only in comic-book shops in 2002. Cho plans to continue *Liberty Meadows* in a comic-book format and pursue projects in other fields of cartooning.

SELF-CARICATURE by Frank Cho

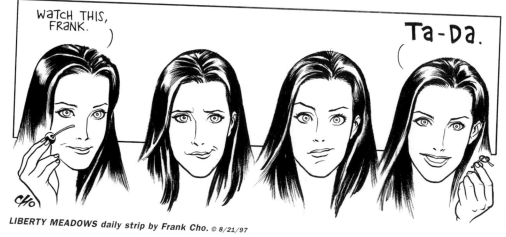

LIBERTY MEADOWS daily strip by Frank Cho. © 8/21/97

LIBERTY MEADOWS Sunday pages by Frank Cho. © 1997–1999

jerry scott & jim borgman

JERRY SCOTT'S SECOND co-creation is produced differently from his first. The ideas for *Baby Blues* are scripted on paper whereas the gags for *Zits* are drawn as rough sketches. Scott, who lives in California, talks with his partner, Jim Borgman, in Cincinnati almost every day on the phone to discuss ideas. He then draws up the gags and faxes them to Borgman, who refines the layouts by changing the expressions or adjusting the perspective. The drawings are often faxed back and forth until both artists are satisfied.

"It's a real, kind of, sloppy arrangement where we both do about three-fourths of the work," explained Scott in an interview. "Both Jerry and I originate and write strip ideas, and we both draw, compose, and design the strip," added Borgman.

The product of this unique collaboration is one of the most visually innovative comic strips to come along in years. Scott and Borgman experiment constantly with the artwork. Daily strips often consist of multilayered, overlapping images and panels-within-panels. The Sunday pages can be conventional six- or eight-panel sequences or wildly creative compositions with fractured borders, spectacular special effects, and vivid coloring. Borgman's graphic pyrotechnics are the perfect complement to Scott's carefully designed layouts.

Scott and Borgman also make liberal use of the visualization techniques Bill Watterson introduced in *Calvin and Hobbes*. The perceptions and fantasies of fifteen-year-old Jeremy Duncan, the star of *Zits*, are shared with the readers. Jeremy's reaction to his mother's new haircut (clownish) or his take on his father's limited computing skills (gorilla-like) are hilariously depicted rather than merely implied. The strip provides a refreshing contrast to the talking-head graphics that dominate contemporary comics pages.

Zits accurately captures the awkwardness of the teenage years. Although Borgman's son Dylan, who was born in 1983, provides inspiration, he is not the model for Jeremy. Scott develops most of the material by observation and reflection.

"My sisters both have teenagers and I also pick up ideas from newspapers," Scott explains. "A lot is from memory too."

The majority of gags revolve around Jeremy, who self-reflectively describes himself as "a high school freshman with, thank God, four good friends but other than that a seriously boring life in a seriously boring town made livable only by the knowledge that someday in the far-off future at least this will all be over and you'll turn sixteen and get a driver's license which you so richly deserve and then life will finally be good. Oh, and your parents are seriously ruining your life."

In addition to Jeremy and his parents, Walt and Connie Duncan, the cast has expanded since the strip's debut in July 1997. Hector Garcia is Jeremy's best "amigo" and plays in "Goat Cheese Pizza," one of the ever-changing names for a rock band that also includes Tim and Pierce. Sara Toomey is Jeremy's sometimes girlfriend, and among the other high school classmates are know-it-all Brittany, the inseparable RichandAmy, and Zuma, Redondo, and LaJolla, members of "The Posse." Jeremy's overachieving older brother, Chad, occasionally returns home from college.

Both cartoonists carry a heavy workload. Borgman continues to produce editorial cartoons for the *Cincinnati Enquirer* and King Features Syndicate. "The strip lets me get away from political thoughts, which refreshes that part of my brain," says Borgman. He is also less tempted to compromise his more serious work with unnecessary humor.

Scott works ten hours a day on *Zits* and *Baby Blues*. "I'm certainly busier than I've ever been in my life," he says. "But I'm having a lot of fun."

Zits was voted the Best Comic Strip of the Year in 1999 and 2000 and, in 2002, it passed the 1,000-newspaper mark in circulation and Jerry Scott won the Reuben Award. The unappealing name of the feature, originally suggested as a joke by Scott, hasn't hurt its success. *Zits* just keeps on growing and growing.

***ZITS* daily strip by Jerry Scott and Jim Borgman. © 1/26/98**

All Zits strips © Zits Partnership. Reprinted with special permissions of King Features Syndicate, Inc.

ZITS daily strip by Jerry Scott and Jim Borgman. © 7/8/97

ZITS daily strip by Jerry Scott and Jim Borgman. © 7/10/97

ZITS daily strip by Jerry Scott and Jim Borgman. © 7/18/97

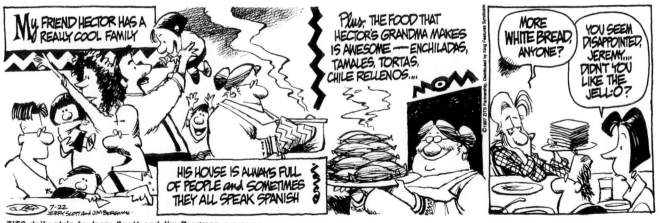

ZITS daily strip by Jerry Scott and Jim Borgman. © 7/22/97

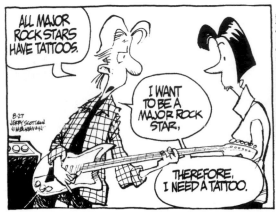

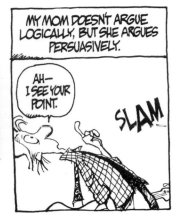

ZITS daily strip by Jerry Scott and Jim Borgman. © 8/27/97

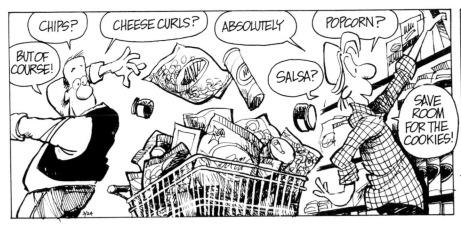
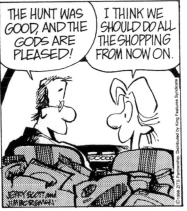

ZITS daily strip by Jerry Scott and Jim Borgman. © 3/24/98

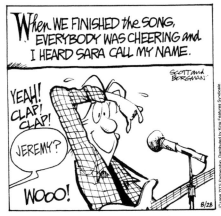
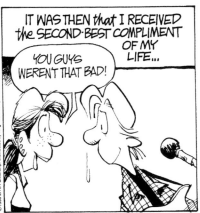

ZITS daily strip by Jerry Scott and Jim Borgman. © 8/28/98

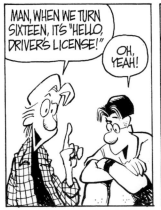
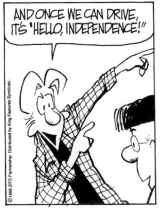
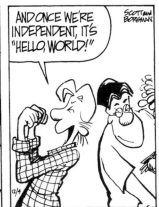

ZITS daily strip by Jerry Scott and Jim Borgman. © 12/4/98

ZITS Sunday page by Jerry Scott and Jim Borgman. © 4/26/98

ZITS Sunday page by Jerry Scott and Jim Borgman. © 6/28/98

ZITS Sunday page by Jerry Scott and Jim Borgman. © 10/26/98

ZITS daily strip by Jerry Scott and Jim Borgman. © 4/1/99

ZITS daily strip by Jerry Scott and Jim Borgman. © 4/19/99

ZITS daily strip by Jerry Scott and Jim Borgman. © 8/4/99

ZITS daily strip by Jerry Scott and Jim Borgman. © 10/22/99

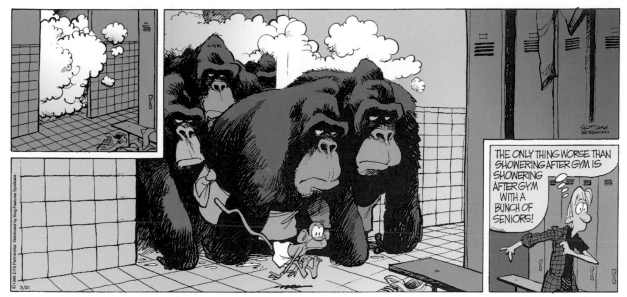

ZITS Sunday page by Jerry Scott and Jim Borgman. © 3/21/99

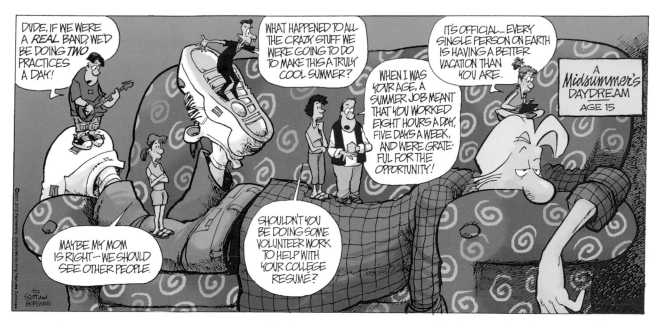

ZITS Sunday page by Jerry Scott and Jim Borgman. © 7/22/2001

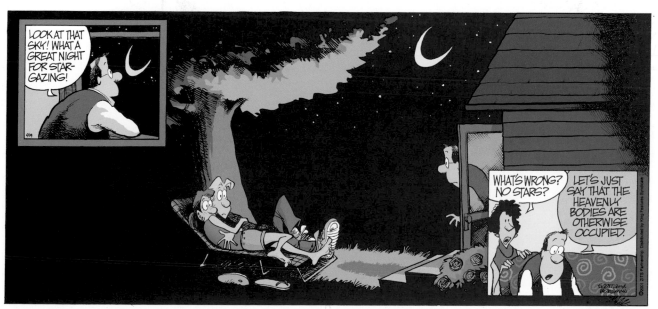

ZITS Sunday page by Jerry Scott and Jim Borgman. © 9/9/2001

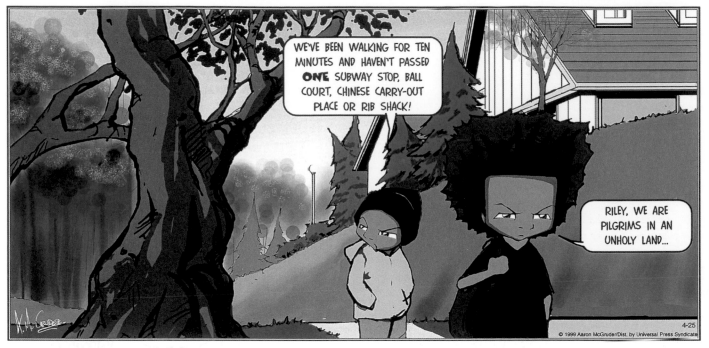

THE BOONDOCKS Sunday page by Aaron McGruder. © 4/25/99 Aaron McGruder. Used by permission of Universal Press Syndicate. All rights reserved

COMPETITION AND SURVIVAL

Breaking into the comics business has never been easy, but in recent years the opportunities for success have become even more limited. The five major syndicates release only about a dozen new features each year combined, and these must compete for the remaining slots not taken up by established strips and panels. There are fewer newspapers, devoting less space to the comics, which makes the prospects even more daunting. Only about 40 percent of new comics survive beyond the second year of syndication.

On the following pages is a selection of features that were introduced between 1990 and 2002. Some have managed to build up a respectable list of subscribers and could last well into the next decade and beyond. Others might not survive much past the publication of this book. All are promising creations by talented cartoonists who worked hard to develop their ideas just to be selected from the thousands of submissions received annually by the syndicates. Editors cannot predict what will catch on with readers, so they must remain open-minded to new offerings. The potential rewards for those who succeed are great. It is still a business in which the dreams of an aspiring artist can be transformed into fulfilling reality.

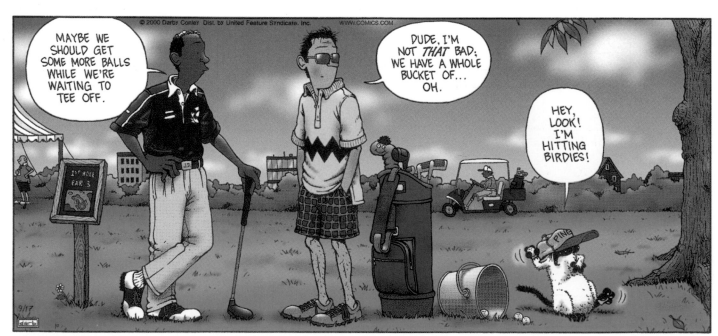

GET FUZZY Sunday page by Darby Conley. © 9/17/2000 Darby Conley. Distributed by United Feature Syndicate, Inc.

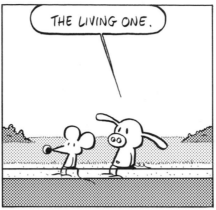
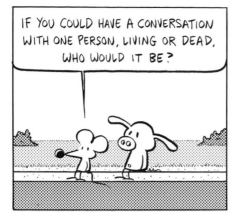
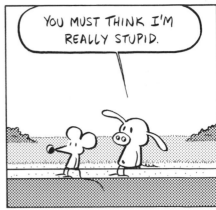

PEARLS BEFORE SWINE daily strip by Stephan Pastis. © 1/31/2002 Stephan Pastis. Distributed by United Feature Syndicate, Inc.

THE DUPLEX daily strip by Glenn McCoy. © 4/26/93 Glenn McCoy. Used by permission of Universal Press Syndicate. All rights reserved

SOUP TO NUTZ daily strip by Rick Stromoski. © 4/19/2005 by Rick Stromoski. Distributed by NEA, Inc

LOLA daily strip by Steve Dickenson and Todd Clark. © 4/19/99 Tribune Media Services, Inc. All rights reserved. Reprinted with permission

9 CHICKWEED LANE Sunday page by Brooke McEldowney. © 10/6/97 United Feature Syndicate, Inc.

OVER THE HEDGE Sunday page by Michael Fry and T. Lewis. © 9/17/95 United Feature Syndicate, Inc.

STONE SOUP Sunday page by Jan Eliot. © 1/28/95 Jan Eliot. Used by permission of Universal Press Syndicate. All rights reserved

AGNES Sunday page by Tony Cochran. © 12/26/99 Creators Syndicate, Inc.

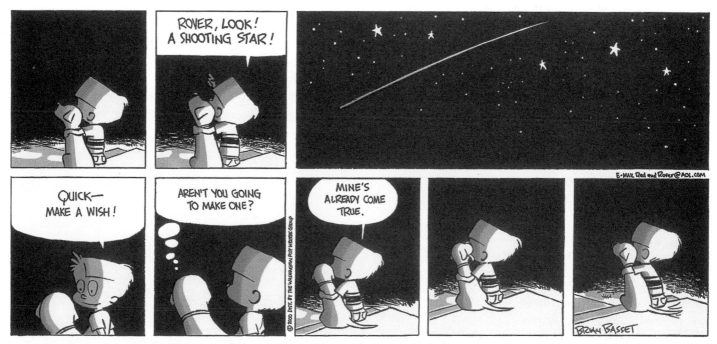

RED AND ROVER Sunday page by Brian Basset. © 2000 Brian Bassett. Distributed by the Washington Post Writers Group

 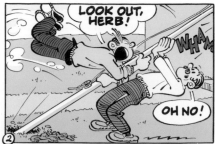

BLONDIE Sunday page by Dean Young and Denis Lebrun (a pre-Thanksgiving salute). © 10/28/2001 King Features Syndicate, Inc.

A TRIBUTE TO HEROES

In response to the September 11 terrorist attacks on America, National Cartoonists Society president Steve McGarry, at the suggestion of Patrick McDonnell, invited each of its members to create a special cartoon for Thanksgiving Day, November 22, 2001. More than 125 cartoonists participated in the event by providing graphic tributes to rescue workers, survivors, and those who lost their lives in the senseless acts of violence. The Network for Good website address was included in many of the strips and panels, which helped direct potential donors to relief organizations of their choice. The original artwork was also auctioned off on-line, raising close to $50,000 for the September 11th Fund. Once again, the nation's cartoonists had used the power of their pens to focus attention on an issue of serious concern to their readers.

"Don't worry, PJ, we'll rebuild!
It's the 'Merican way."

THE FAMILY CIRCUS daily panel by Jeff and Bil Keane. © 11/22/2001 King Features Syndicate, Inc.

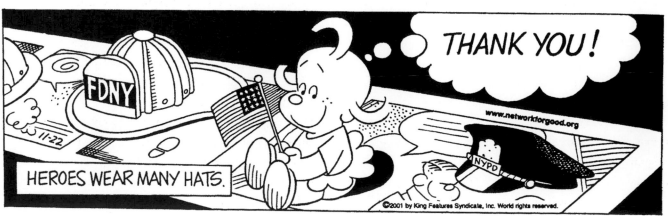

HI AND LOIS daily strip by Brian and Greg Walker and Chance Browne. © 11/22/2001 King Features Syndicate, Inc.

DOONESBURY Sunday page by Garry Trudeau. © 2/13/94 G.B. Trudeau. Used by permission of Universal Press Syndicate. All rights reserved

the twenty-first century

ARE NEWSPAPERS a dying medium? Is the future of the funnies in cyberspace? Will there be a new technology that will revolutionize graphic entertainment? These questions will be answered in the coming years.

Newspapers and syndicates now have websites on the internet where readers can create their own personal comics pages and view a selection of features that are updated each day. Although this a convenient way to get a daily dose of comics, the graphics don't look the same on a computer screen as they do in the newspapers. There is something pleasing and permanent about the clean, black-and-white lines of a daily comic strip and the bold, primary colors of a Sunday page when they are printed on paper.

Perhaps someday, in the not-too-distant future, an enterprising newspaper editor will experiment with enlarging the comics and printing them on higher-quality paper. Readers would welcome seeing their favorite features in a more luxurious format. The newspaper's circulation might take off. Competing papers would be forced to print their comics the same way. Publishers would discover, as Joseph Pulitzer and William Randolph Hearst did in 1896, that the funnies will sell newspapers when they are displayed prominently and promoted aggressively.

As long as there is money to be made in the comics business, cartoonists will continue to come up with new ideas. The possibilities are limitless. Every decade or so, a fresh creation leaps off the funnies pages and captures the public's attention. This will not change.

Cartoonists will adapt to new technologies. Cartoons can be drawn on anything from cave walls to digital tablets. The future of the art form is not limited by the fate of the print medium.

Humans have a basic need to communicate, and cartoons are one of the most effective means of self-expression. When words and pictures are blended together successfully, they can tell stories, state opinions, or convey feelings in a simple, direct way. A well-crafted cartoon may elicit a gasp of surprise, a howl of laughter, a sigh of recognition, or a mixture of emotions.

In the past half-century, thousands of cartoonists have created millions of images that have been enjoyed by billions of readers. In the history of human communication, this is but a brief flash of our creative potential. The words and pictures will continue to captivate us for as long as we have the desire to be entertained and enlightened.

ACKNOWLEDGMENTS

The author would like to thank the following individuals and organizations for their invaluable assistance in producing this book:

Artists: Jim Borgman, Pat Brady, Chance Browne, Frank Cho, Brian Crane, Rick Detorie, Jerry Dumas, Will Eisner, Ron Ferdinand, Guy Gilchrist, Bud Grace, Marcus Hamilton, Johnny Hart, Michael Jantze, Lynn Johnston, Bil and Jeff Keane, Gary Larson, Mell Lazarus, Patrick McDonnell, John Cullen Murphy, Nina Paley, Dan Piraro, Arnold Roth, Jim Scancarelli, Jerry Scott, Leonard Starr, Garry Trudeau, and Mort Walker.

Other individuals: Rafaella Allesandrio, David Applegate, David Astor, Helen W. Bertholet, Bill Blackbeard, Katie Burke, Mark Burstein, Jim Carlsson, Russ Cochran, Nikki Columbus, Bill Crouch, Scott Daley, Mark Evanier, Gill Fox, Jim Gauthier, Steve Geppi, Jack Gilbert, Ed Glisson, Carole Goodman, Ron Goulart, Bruce Hamilton, R. C. Harvey, Eric Himmel, Tom Horvitz, Jud Hurd, Bill Janocha, Harry Katz, Carolyn Kelly, Pete Kelly, Denis Kitchen, Judith Kliban, Howard Lowery, Ricardo Martinez, Richard Marschall, Matt Masterson, Toni Mendez, Richard Olson, Trina Robbins, Mike Seeley, Richard Slovak, David Stanford, Catherine Walker, Malcolm Whyte, Art Wood, and Craig Yoe.

Syndicates: King Features—Jim Cavett, Mark Johnson, Jay Kennedy, Karen Moy, and Claudia Smith. United Media—Amy Lago and Maura Peters. Universal Press—Lee Salem and Mary Suggett. Tribune Media Services—Jan Bunch and Lee Hall. Creators—Christina Lee, Rick Newcombe, Lori Sheehey, and Mary Ann Sugawara. Washington Post Writers Group—Bethany Cain and Suzanne Whelton. Copley News Service—Glenda Winders.

Organizations and institutions: American Color—Andy Olsen. Boston University—Sean Noel. Cartoon Art Museum—Jenny Robb Dietzen. Cartoon Research Library, Ohio State University—Lucy Shelton Caswell. FarWorks—Melissa Irons. Frye Art Museum—Richard West. Johnny Hart Studios—Perri Hart. Illustration House—Kim Deitz, Roger Reed, and Walt Reed. International Museum of Cartoon Art—Stephen Charla, Alexis Faro, and Jeanne Greever. Lynn Johnston Productions—Laura Pische. Hank Ketcham Enterprises—Dottie Roberson. Rosebud Productions—Jody Boyman. Storyopolis—Fonda Snyder.

ARTICLES

The following comics-related periodicals are currently being published regularly:

Comic Buyer's Guide. Published monthly by F + W Publications, Inc., 700 E. State St., Iola, WI 54990.

The Comics Journal. Published monthly by Fantagraphics Books, Inc., 7563 Lake City Way N.E., Seattle, WA 98115.

Editor & Publisher. Published monthly by BPI Communications, Inc. 770 Broadway, New York, NY 10003.

Hogan's Alley. Published semi-annually by Bull Moose Publishing Corp., P.O. Box 4784, Atlanta, GA 30362.

The following comics-related periodicals are no longer being published:

Cartoonist PROfiles. 146 issues were published quarterly between March 1969 and June 2005 by Cartoonist PROfiles Inc., 281 Bayberry Lane, Westport, CT 06430.

Inks. Twelve issues were published tri-annually between February 1994 and November 1997 by the Ohio State University Press, 1070 Carmack Road, Columbus, OH 43110.

Nemo. Thirty-two issues were published semi-annually between June 1983 and January 1992 by Fantagraphic Books, Inc. 7563 Lake City Way N.E., Seattle, WA 98115.

NOTES

The following articles and books were quoted directly or referred to for specific facts. The listings are by chapter and subject, in order of appearance.

INTRODUCTION

Sunday papers: Bevona, Donald E. "First Sunday Editions Had No Place in Home." *Editor & Publisher,* June 27, 1959.

Early syndicates: Emery, Michael, Edwin Emery, and Nancy L. Roberts. *The Press in America.* Boston: Allyn and Bacon, 2000, pp. 248–49.

Pulitzer and Hearst: Turner, Hy. "This Was Park Row!" *Editor & Publisher,* June 27, 1959.

Richard F. Outcault: Olson, Richard D. "Richard Fenton Outcault's Yellow Kid." *Inks: Cartoon and Comic Art Studies,* vol. 2, no. 3, November 1995.

The Yellow Kid: Blackbeard, Bill. *The Yellow Kid.* Northampton, Mass.: Kitchen Sink Press, 1995.

Daily comic strips: Harvey, R. C. "Bud Fisher and the Daily Comic Strip." *Inks: Cartoon and Comic Art Studies,* vol. 1, no. 1, February 1994.

First comics page: Blackbeard, Bill, and Dale Crain, eds. *The Comic Strip Century.* 2 vols. Englewood Cliffs, N.J.: O.G. Publishing Corp., 1995.

National syndication: Collings, James L. "Personalities and Piracy in Early Syndicate Days." *Editor & Publisher,* June 27, 1959.

King Features: Koenigsberg, M. *King News: An Autobiography.* Philadelphia and New York: F. A. Stokes Company, 1941.

Syndication and circulation: "The Funny Papers." *Fortune,* April 1933.

Syndication process: Interviews with syndicate comics editors in *Cartoonist PROfiles:* Sarah Gillespie (UFS) 3/86, 12/87, 9/89. David Hendin (UFS) 6/85, 6/93. Jay Kennedy (KFS) 9/89, 3/90, 9/91, 9/94. Lee Salem (UPS) 3/82, 12/88, 9/89, 6/95. David Seidman 3/89, 6/89, 9/89, 12/89, 6/90. Evelyn Smith (TMS) 9/89, 9/90. Bill Yates (KFS) 3/89.

Contemporary cartooning: Nordling, Lee. *Your Career in the Comics.* Kansas City: Andrews and McMeel, 1995.

Creative challenges: Thomas, Keith L. "Comic Relief." *Atlanta Constitution,* May 5, 1991.

Rivenburg, Roy. "Sunset Strips." *Los Angeles Times,* Dec. 31, 1995.

Comics decline: Marschall, Richard. *America's Great Comic-Strip Artists.* New York: Abbeville Press, 1989.

Blackbeard, Bill, and Dale Crain, eds. *The Comic Strip Century.* 2 vols. Englewood Cliffs, N.J.: O.G. Publishing Corp., 1995.

THE POSTWAR YEARS

World War II: Monchak, S. J. "Cartoonists Important Factor in Keeping Nation's Morale." *Editor & Publisher,* Sept. 12, 1942.

Caniff, Milton. "Comic Strips at War." *Vogue,* July 15, 1943.

Marschall, Rick. "The World War II Cartoonist Corps." *Nemo,* June 1985.

Vaughn, Don. "War-Toons." *The Retired Officer Magazine,* June 1998.

Newsprint: Hollis, Daniel W. *The Media in America.* Santa Barbara, Calif.: ABC-CLIO, 1995, pp. 192–94.

Size reduction: Goulart, Ron. *The Funnies: 100 Years of American Comic Strips.* Holbrook, Mass.: Adams Publishing, 1995, p. 229.

Ivey, Jim, and Allan Holtz. "Stripper's Guide Q&A." *Hogan's Alley,* no. 5, 1998, pp. 35–36.

George McManus: Sheridan, Martin. *Comics and Their Creators.* Boston: Hale, Cushman & Flint, 1942, p. 46.

Postwar circulation: Emery, Michael, Edwin Emery, and Nancy L. Roberts. *The Press in America.* Boston: Allyn and Bacon, 2000, p. 352.

Syndicate business: Staunton, Helen M. "Syndicates Enjoyed Good Year in 1946." *Editor & Publisher,* Dec. 28, 1946.

Milton Caniff: Staunton, Helen M. "Steve Canyon—Milton Caniff Unveils His New Strip." *Editor & Publisher,* Nov. 23, 1946.

Jenson, Chris. "Setting the Stage." *Steve Canyon Magazine,* no. 1, 1983.

Saba, Arn. "Milton Caniff—An Interview with One of the Masters of Comic Art." *The Comics Journal,* no. 108, May 1986.

Al Capp: Staunton, Helen M. "Capp Sues Syndicate on $14,000,000 Claim." *Editor & Publisher,* July 19, 1947.

"Li'l Abner's Mad Capp." *Newsweek,* Nov. 24, 1947.

McMaster, Jane. "Li'l Abner Sideline is Shmoopendous." *Editor & Publisher,* July 16, 1949.

"Die Monstersinger." *Time,* Nov. 6, 1950.

Capp, Al. "Why I Let Abner Marry." *Life,* March 31, 1952.

Ellison, Harlan, and Dave Schreiner. Introduction to *Li'l Abner Meets the Shmoo.* Northampton, Mass.: Kitchen Sink Press, 1992.

Chic Young: Alexander, Jack. "The Dagwood and Blondie Man." *Saturday Evening Post,* April 10, 1948.

Superman: Hill, Roger. "Comic Books and Comic Art." *Sotheby's.* Auction catalog, Sale 6588. June 18, 1994.

Will Eisner: Yronwode, Catherine. *The Art of Will Eisner*. Princeton, Wis.: Kitchen Sink Press, 1982.

Censorship: Rochelle, Ogden J. "Syndicates Tighten Up Taboos in Comic Strips." *Editor & Publisher*, Dec. 11, 1948.

Teenagers: Hine, Robert. *The Rise and Fall of the American Teenager*. New York: Avon Books, 1999, pp. 8–9.

Soap-opera strips: Andriola, Alfred. "The Story Strips." *Cartoonist PROfiles* #15, September 1972.

Crockett Johnson: Harvey, R. C. "Cushlamochree! Their Creators Abandoned Them!" *Comic Buyer's Guide* #1225, May 9, 1997.

Walt Kelly: "Our Archives of Culture: Enter the Comics and Pogo." *Newsweek*, June 21, 1954.

Maley, Don. "Walt Kelly Muses on his 20 Years of Playing Possum." *Editor & Publisher*, April 19, 1969.

Mastrangelo, Joseph. "Unforgettable Walt Kelly." *Reader's Digest*, July 1974.

Thompson, Steve. "Highlights of Pogo" from *A Retrospective Exhibit of Walt Kelly*. Ohio State University Libraries, 1988.

Watterson, Bill. "Some Thoughts on Pogo," adapted from a speech at Ohio State University. *The Comics Journal* #140, February 1991.

National Cartoonists Society: Becker, Stephen. *Comic Art in America*. New York: Simon and Schuster, 1959, pp. 285–87.

Harvey, R. C. "Tales of the Founding of the National Cartoonists Society." *Cartoonist PROfiles* #109, March 1996, and #110, June 1996.

THE FIFTIES

Television: "Comics and TV" editorial. *Editor & Publisher*, June 2, 1951.

McMaster, Jane. "51 to Test 'Other Media' Comics Trend." *Editor & Publisher*, Dec. 23, 1950.

Romance vs. adventure: Brandenburg, George A. "Soap Opera in Comics?" *Editor & Publisher*, April 22, 1950.

Top strips (1950 and 1962): "Die Monstersinger." *Time*, Nov. 6, 1950.

White, David Manning, and Robert H. Abel, eds. *The Funnies: An American Idiom*. New York: The Free Press of Glencoe/Macmillan, 1963.

Story strips vs. humor strips: Harvey, R. C. Caniff quote from unpublished biography.

Mort Walker: Walker, Mort. *The Best of Beetle Bailey*. Bedford, N.Y.: Comicana Books, 1984.

———. *Mort Walker's Private Scrapbook*. Kansas City: Andrews McMeel Publishing, 2000.

Charles Schulz: Johnson, Rheta Grimsley. *Good Grief: The Story of Charles Schulz*. New York: Pharos Books, 1989.

Schulz, Charles. *Peanuts: A Golden Celebration*. New York: HarperCollins Publishers, 1999.

Harvey, R. C. "The Age of Schulz." *Hogan's Alley* #8, 2000.

Hank Ketcham: Ketcham, Hank. *The Merchant of Dennis*. New York: Abbeville Press, 1990.

Herald Tribune Syndicate: Collings, James L. "Miss Peach Peachy Strip for Herald Trib." *Editor & Publisher*, Jan. 26, 1957.

"He Was Going to be a Cartoonist, By Gosh," profile of Johnny Hart. *Editor & Publisher*, Dec. 28, 1957.

"Roth's 'Almanac.'" *Editor & Publisher*, April 11, 1958.

"Jaffees 'Tall Tales' Good for Tall Laughs." *Editor & Publisher*, Sept. 6, 1958.

Capp comments: McMaster, Jane. "Editor, Capp Disagree on Opinions in Strips" and "Capp's Position on Strip Opinion Draws Dissent." *Editor & Publisher*, June 10 and 24, 1950.

Harold Gray: Smith, Bruce. *The History of Little Orphan Annie*. New York: Ballantine Books, 1982, p. 67.

Comics investigation: Scholz, Carter. "Seduction of the Ignorant." *The Comics Journal* #80, March 1983.

Capp-Fisher feud: Maeder, Jay. "Spitting on Pictures." *New York Daily News*, Sept. 18, 1998.

"Fisher's End." *Hogan's Alley* #8, 2000.

Raymond death: "Alex Raymond 'Kirby' Artist Dies in Crash." *Editor & Publisher*, Sept. 15, 1956.

Schumer, Arlen. "Alex Raymond's Last Ride." *Hogan's Alley* #3, 1996.

Jack Cole suicide: Goulart, Ron. "Betsy and Me and Jack Cole." *Hogan's Alley* #6, 1999.

Spiegelman, Art. "Forms Stretched to Their Limits." *The New Yorker*, April 19, 1999.

Hearst passing: Knoll, Erwin. "Chief had Direct Control of Syndicate Operation." *Editor & Publisher*, Aug. 18, 1951.

"The King is Dead." *Time*, Aug. 20, 1951.

THE SIXTIES

Newspaper business: "ANPA Statement on the Newspaper Business." *Editor & Publisher*, March 16, 1963.

Advertising: Erwin, Ray. "Editors Slash at Comics Sale to Advertising Agencies." *Editor & Publisher*, Feb. 13, 1960.

Licensing: Maley, Don. "Super Roads to Riches are Paved with Daily Comics." *Editor & Publisher*, Nov. 30, 1968.

Spin-off strips: "TV's 'Flintstones' Join Papers, Too." *Editor & Publisher*, Sept. 23, 1961.

Erwin, Ray. "'Bullwinkle' Moose Becomes Comic Strip." *Editor & Publisher*, Feb. 10, 1962.

"Ken Bald Will Draw 'Dr. Kildare.'" *Editor & Publisher*, June 30, 1962.

Erwin, Ray. "'Ben Casey' Joins Comic Pages Soon." *Editor & Publisher*, Oct. 6, 1962.

Top strips: "Essential Features in Salesman's Poll." *Editor & Publisher*, June 30, 1962.

Soap-opera strips: Erwin, Ray. "Physician Writes 'Rex Morgan, M.D.'" *Editor & Publisher*, Jan. 26, 1963.

Adventure strips: Erwin, Ray. "Don Sherwood Draws 'Dan Flagg' Marine." *Editor & Publisher*, March 9, 1963.

"The Green Berets Land on Comics Page." *Editor & Publisher*, Feb. 12, 1966.

"Pow! Bam! Zap! 'Batman' Returns." *Editor & Publisher*, March 5, 1966.

Violence: "Editors Displeased with Violent Strips." *Editor & Publisher*, June 22, 1968.

Maley, Don. "Violence in Comics Discussed by NCC." *Editor & Publisher*, Oct. 5, 1968.

Brothers, Dr. Joyce. "Violence in Comics." *Cartoonist PROfiles* #7, January 1969.

Social comment: Blank, Dennis. "Comics Aren't Funny Telling Off the World." *Editor & Publisher*, June 25, 1966.

"Comment in the Comics." *Time*, April 9, 1965.

Friedman, Rick. "Feiffer—Cartoonist with a Point of View." *Editor & Publisher*, June 10, 1961.

"Jim Berry Begins Gag Panel Comment." *Editor & Publisher*, Feb. 16, 1963.

"Berry's World." *Cartoonists PROfiles* #7, September 1970.

Erwin, Ray. "Inanimate Objects Converse in Panel." *Editor & Publisher*, April 6, 1963.

"Still Life by Jerry Robinson." *Cartoonist PROfiles* #13, March 1972.

"New Strip Satirizes 'the small society.'" *Editor & Publisher*, April 16, 1966.

New directions: "It's Characterization and Sophistication." *Editor & Publisher*, April 25, 1964.

Humor features: Erwin, Ray. "2 Cartoonists Create New 'Sam's Strip.'" *Editor & Publisher*, July 29, 1961.

"Eek and Meek are Mouse-Like Comics." *Editor & Publisher*, July 31, 1965.

"Of Mice and Howie Schneider." *Cartoonist PROfiles* #2, June 1969.

"Tom Ryan's Cartoon Old West Lampoon" (on *Tumbleweeds*). *Editor & Publisher*, Nov. 13, 1965.

"Wackiest Warriors Follow Chief Redeye." *Editor & Publisher*, June 3, 1967.

"Mort Walker Begins Third Comic Strip" (on *Boner's Ark*). *Editor & Publisher*, Jan. 20, 1968.

Maley, Don. "Beachcomber Strip Hit with Editors" (on *The Dropouts*). *Editor & Publisher*, Aug. 3, 1968.

"'The Dropouts' by Howard Post." *Cartoonist PROfiles* #9, March 1971.

"'Andy Capp' Comic Strip is Imported." *Editor & Publisher*, Aug. 24, 1963.

Dean, Paul. "Reggie Smythe Draws 'Andy Capp' for Belly Laughs and Profit." *Editor & Publisher*, Nov. 16, 1968.

Johnny Hart: "He Was Going to be a Cartoonist, By Gosh." *Editor & Publisher*, Dec. 28, 1957.

"Prehistoric Account of Current Success." *Editor & Publisher*, March 16, 1968.

"'B.C.' by Johnny Hart." *Cartoonist PROfiles* #9, March 1971; #26, June 1975; #48, December 1980; #49, March 1981; and #78, June 1988.

Marschall, Richard. "The Johnny Hart Interview." *Hogan's Alley* #2, 1995.

Bil Keane: "'Family Circle' Round & Round." *Editor & Publisher*, Feb. 27, 1960.

"'Family Circus' has New Baby." *Editor & Publisher*, Aug. 4, 1962.

"Cartoonist Studies to be Arizona Cactus." *Editor & Publisher*, Sept. 28, 1968.

"Report from Paradise Valley." *Cartoonist PROfiles* #5, March 1970.

The Family Circus Treasury. Kansas City: Sheed Andrews and McMeel, 1977.

Ropp, Thomas. "Bil Keane's Illustrated Circus. *Arizona Republic*, Sept. 4, 1983.

Bud Blake: "Bud Blake's 'Tiger' Leads Comic Kids." *Editor & Publisher*, Jan. 30, 1965.

"'Tiger' by Bud Blake." *Cartoonist PROfiles* #29, March 1976.

Family dysfunction: "New Cartoon Hero: 'The Born Loser.'" *Editor & Publisher*, March 20, 1965.

"'The Born Loser' featuring Brutus Thornapple." *Cartoonist PROfiles* #9, March 1971.

"Loafer and Family Generate Laughs" (on *Moose*). *Editor & Publisher*, June 12, 1965.

"'The Lockhorns' Unlock the Fun in Marital Woes." *Editor & Publisher*, May 31, 1969.

Racial integration: Jones, Steven Loring. "From 'Under Cork' to Overcoming: Black Images in the Comics." In *Ethnic Images in the Comics*, ed. Charles Hardy and Gail F. Storm. Philadelphia: The Balch Institute for Ethnic Studies, 1986.

"Comic Strip Plugs Racial Integration" (on *Wee Pals*). *Editor & Publisher*, Jan. 23, 1965.

Carter, Tom. "Cartoonist Morrie Turner." *Essence*, July 1974.

"Morrie Turner." *Cartoonist PROfiles* #6, June 1970.

"'Luther' by Brumsic Brandon, Jr." *Cartoonist PROfiles* #69, March 1986.

"'Quincy' Will Deliver Gags of Inner City." *Editor & Publisher*, June 13, 1970.

"'Quincy' by Ted Shearer." *Cartoonist PROfiles* #11, November 1971.

Maley, Don. "Cartoonist Finds Integrated Strip Poses New Art Problem" (on *Dateline Danger*). *Editor & Publisher*, Aug. 16, 1969.

"Adventure Strip and Column Feature Blacks" (on *Friday Foster*). *Editor & Publisher*, Dec. 6, 1969.

"Lieut. Flap's Friends Break Through Army Censorship." *Editor & Publisher*, Jan. 23, 1971.

Cartoon art: Couperie, Pierre, and Maurice Horn. *A History of the Comic Strip*. New York: Crown Publishers, 1968 (Caniff "Louvre quote" from preface, p. 3. SOCERLID quote, p. 219).

Maley, Don. "'Batman' Made Him a Dropout from J-School" (Jerry Robinson quote). *Editor & Publisher*, Nov. 9, 1968.

THE SEVENTIES

Garry Trudeau: Williamson, Lenora. "Fresh Air from the Campus in Trudeau's 'Doonesbury.'" *Editor & Publisher*, Jan. 16, 1971.

"'Doonesbury': Drawing and Quartering for Fun and Profit." *Time*, Feb. 9, 1976.

"Speech Before Associated Press Managing Editors." Nov. 27, 1984.

Alter, Jonathan. "Real Life with Garry Trudeau." *Newsweek*, Oct. 15, 1990.

Astor, David. "The Wall Street Journal vs. 'Doonesbury.'" *Editor & Publisher*, Dec. 28, 1991.

Carlton, Don. Letter to Bill Janocha. June 28, 1993.

Trudeau, G. B. *Flashbacks: Twenty-Five Years of Doonesbury*. Kansas City: Andrews and McMeel, 1995.

Cathy Guisewite: "'Cathy' by Cathy Guisewite." *Cartoonist PROfiles* #34, June 1977, and #101, March 1994.

Astor, David. "Guisewite Works Overtime on 'Cathy.'" *Editor & Publisher*, June 25, 1983.

Guisewite, Cathy. *Reflections*. Kansas City: Andrews and McMeel, 1991.

———. *Twentieth Anniversary Collection*. Kansas City: Andrews and McMeel, 1996.

Jeff MacNelly: "MacNelly: The Richmond News Leader." *Cartoonist PROfiles* #20, December 1973.

Buchwald, Art. "MacNelly as Seen by Another Artist." In *The Very First Shoe Book*. New York: Avon Books, 1978.

"Jeff MacNelly: An Interview with the Creator of 'Shoe.'" *Clockwatch Review*, 1985.

Daley, Steve. "Poison Pen and A Pink Desoto." *The Washingtonian*, November 1999.

Lynn Johnston: "Best Selling Author Creates Comic Strip." *Editor & Publisher*, Sept. 8, 1979.

Astor, David. "Finding Universality in One Family's Life." *Editor & Publisher*, July 14, 1984.

"'For Better or For Worse' by Lynn Johnston." *Cartoonist PROfiles* #71, September 1986, and #118, June 1998.

Heintjes, Tom. "The Lynn Johnston Interview." *Hogan's Alley* #1, 1994.

Johnston, Lynn. *Remembering Farley: A Tribute to the Life of Our Favorite Cartoon Dog*. Kansas City: Andrews and McMeel, 1996.

———. *The Lives Behind the Lines: 20 Years of For Better or For Worse*. Kansas City: Andrews McMeel Publishing, 1999.

"Comic Relief." *Chatelaine*, March 1997.

Dik Browne: Williamson, Lenora. "Dik Browne Presents 'Hagar the Horrible.'" *Editor & Publisher*, Jan. 20, 1973.

Marschall, Rick. "Browne the Magnificent: On Comics, Commentary and Contentment." *Nemo*, June 1983.

Walker, Brian. *The Best of Hagar the Horrible*. Bedford, N.Y.: Comicana Books, 1985.

Jim Davis: "Fat Cat is Hero of Comic Strip." *Editor & Publisher*, April 22, 1978.

"'Garfield' by Jim Davis." *Cartoonist PROfiles* #40, December 1978; #55, September 1982; #71, September 1986; and #118, June 1998.

Pauer, Frank. "From Gnorm the Gnat to 'Garfield.'" *WittyWorld*, Autumn 1988.

Davis, Jim. *20 Years and Still Kicking: Garfield's Twentieth Anniversary Collection*. New York: Ballantine Books, 1998.

Walker, Brian. "'Garfield' Turns 20." *Collectors Showcase*, May/June 1998.

Humor strips: "Broom-Hilda's Potion of Fun Dispels Gloom." *Editor & Publisher*, April 11, 1970.

"Consistency is Key for New Cartoon Hero" (on *Ziggy*). *Editor & Publisher*, May 5, 1973.

Williamson, Lenora. "Walker and Dumas Producing New Strip" (on *Sam & Silo*). *Editor & Publisher*, April 23, 1977.

James Childress: Maley, Don. "Undaunted Cartoonist Tries for Big Time." *Editor & Publisher*, Feb. 7, 1970.

Williamson, Lenora. "Staff Cartoonist's Strip Makes it to Paperback." *Editor & Publisher*, March 10, 1973.

"Self-Syndicated 'Conchy' Strip Goes National." Oct. 12, 1974.

Ivey, Jim. "Jim Childress . . . Self-Made Man." *Cartoonews* #13, 1976.

Ivey, Jim, and Allan Holtz. "Stripper's Guide—'Conchy.'" *Hogan's Alley* #5, 1998.

Passings: Williamson, Leonora. "Reduced Size of Comics Gets Blamed in 'Pogo' Demise. *Editor & Publisher*, June 21, 1975.

"Cartoonist Al Capp Writes a Letter to the Editor." *Editor & Publisher*, July 19, 1975.

"Dogpatch is Ready for Freddie: After 43 Years, Al Capp Decides to Hang Up His Pen." *Time*, Oct. 17, 1977.

Story-strip survivors: Williamson, Lenora. "'Gasoline Alley' Cartoonist Wins Reuben." *Editor & Publisher*, April 26, 1975.

"Orphan Annie Being Re-Born December." *Editor & Publisher*, Nov. 10, 1979.

"By-Line for 'Prince Valiant' to Change." *Editor & Publisher*, Dec. 8, 1979.

Sci-fi revival: "'Spider-Man' Debuts." *Editor & Publisher*, Nov. 6, 1976.

"'Star Hawks' Debut. *Editor & Publisher*, Aug. 13, 1977.

"'Buck Rogers' Being Re-Launched This Fall." *Editor & Publisher*, June 9, 1979.

Cartoon Museum: Walker, Mort. *Backstage at the Strips*. New York: Mason Charter, 1975.

Williamson, Lenora. "Comics Museum and Hall of Fame Will Open." *Editor & Publisher*, Aug. 10, 1974.

"Museum of Cartoon Art." *Cartoonist PROfiles* #23, September 1974; #30, June 1976; and #38, June 1978.

Museum of Cartoon Art Inklings #s 1–12, fall 1975 to summer 1978.

Cartoon art: Watterson, Bill. *The Calvin and Hobbes Tenth Anniversary Book*. Kansas City: Andrews and McMeel, 1995 (quote from p. 207).

THE EIGHTIES

Gary Larson: Astor, David. "Larson Explores 'The Far Side' of Life." *Editor & Publisher*, July 2, 1983.

Larson, Gary. *The PreHistory of The Far Side*. Kansas City: Andrews and McMeel, 1989.

———. *Last Chapter and Worse*. Kansas City: Andrews and McMeel, 1996.

Tucker, Ken. "Black and White . . . and Read All Over." *Entertainment Weekly*, Oct. 5, 1990.

Far-out humor: Astor, David. "Soaring Popularity for 'Way Out' Comics." *Editor & Publisher*, July 26, 1986.

"How Dan Piraro Came to Draw 'Bizarro.'" *Editor & Publisher*, Aug. 9, 1986.

Berke Breathed: Astor, David. "Off the Wall Strip Blooms in Popularity." *Editor & Publisher*, June 18, 1983.

"'Bloom County' by Berke Breathed." *Cartoonist PROfiles* #76, December 1987.

Oliphant, Pat. AAEC speech, reprinted in *The Comics Journal* #119, January 1988.

Breathed, Berke. AAEC response speech, reprinted in *The Comics Journal* #124, August 1988.

Jannot, Mark. "Can Berke Breathed Be Taken Seriously?" *The Comics Journal* #125, October 1988.

"Berke Breathed Ends 'Bloom County.'" *The Comics Journal* #130, July 1989.

Levy, Daniel S. "A Hooligan Who Wields a Pen." *Time*, Dec. 25, 1989.

Bill Watterson: "'Calvin and Hobbes' by Bill Watterson." *Cartoonist PROfiles* #68, December 1985.

Christie, Andrew. "Bill Watterson" interview. *Honk!* #2, 1986.

Marschall, Richard. "Oh You Kid: A Strip of Leviathan Quality." *The Comics Journal* #127, March 1989.

West, Richard Samuel. "Interview: Bill Watterson." *The Comics Journal* #127, March 1989.

Watterson, Bill. *The Calvin and Hobbes Tenth Anniversary Book*. Kansas City: Andrews and McMeel, 1995.

———. *Calvin and Hobbes Sunday Pages 1985–1995*. Kansas City: Andrews McMeel Publishing, 2001.

Bill Griffith: Groth, Gary. "Bill Griffith Interview." *The Comics Journal* #157, March 1993.

Harvey, R. C. "Zippy and Griffy." *Cartoonist PROfiles* #101, March 1994.

Bud Grace: Drevets, Tricia. "Bud Grace: Physicist Turned Cartoonist." *Editor & Publisher*, April 9, 1988.

"'Ernie' by Bud Grace." *Cartoonist PROfiles* #80, December 1988.

Double dippers: "The Finer Art of Politics." *Newsweek*, Oct. 13, 1980.

Williamson, Lenora. "Editorial Cartoonist Introduces Comic Strip" (on *Kudzu*). *Editor & Publisher*, May 16, 1981.

Astor, David. "Double-Duty Cartoonists." *Editor & Publisher*, Oct. 29, 1983.

Huisking, Charlie. "The Peter Pan of Cartooning." *Sarasota Herald-Tribune*, Oct. 15, 1989.

Humor features: "'Marvin' by Tom Armstrong." *Cartoonist PROfiles* #55, September 1982, and #75, September 1987.

"'Sally Forth' by Greg Howard." *Cartoonist PROfiles* #55, September 1982, and #94, June 1992.

"'Rose is Rose' by Pat Brady." *Cartoonist PROfiles* #63, September 1984.

"'Luann' by Greg Evans." *Cartoonist PROfiles* #65, March 1985, #103, September 1994, and #115, September 1997.

"'Robotman' by Jim Meddick." *Cartoonist PROfiles* #65, March 1985.

Heintjes, Tom. "Toy Story: The Jim Meddick Interview." *Hogan's Alley* #9, 2001.

"'Fox Trot' by Bill Amend." *Cartoonist PROfiles* #84, December 1989.

Harvey, R. C. "Foxtrotting at Ten." *Cartoonist PROfiles* #119, September 1998.

"'Curtis' by Ray Billingsley." *Cartoonist PROfiles* #101, March 1994.

"'Jumpstart' by Robb Armstrong." *Cartoonist PROfiles* #88, December 1990.

Spin-off strips: Williamson, Lenora. "Miss Piggy to Meet Newspaper Readers." *Editor & Publisher*, Aug. 8, 1981.

Condon, Garret. "Drawing Upon the 'Muppets' Success." *Hartford Courant*, Jan. 23, 1983.

The new Nancy: "New 'Nancy' Cartoonist." *Editor & Publisher*, Sept. 17, 1983.

"'Nancy!' by Jerry Scott." *Cartoonist PROfiles* #69, March 1986.

Webb, Dewey. "What's It All About Nancy?" *New Times*, Nov. 30, 1988.

Story strips: Astor, David. "Editors: Comics Readership Holding Up." *Editor & Publisher*, June 11, 1983.

"Creator of Three Enduring Serial Strips." *Editor & Publisher*, June 29, 1985.

Licensing: Schmuckler, Eric. "Free 'Peanuts!' Free 'Beetle Bailey!'" *Forbes*, Oct. 30, 1989.

"The Forbes Top 40 Highest-Paid Entertainers." *Forbes*, September 1987.

Vespa, Mary. "'Garfield' Goes Hollywood." *People*, Nov. 1, 1982.

Astor, David. "Comics Characters Spawn Licensed Products Boom." *Editor & Publisher*, March 12, 1983.

Power, William. "Some People May Still Call Them Funnies, But Comics Have Become Serious Business." *Wall Street Journal*, Aug. 6, 1986.

Watterson, Bill. "The Cheapening of the Comics." Speech at OSU Festival of Cartoon Art, reprinted in *The Comics Journal* #137, September 1990.

Astor, David. "Watterson and Walker Differ on Comics." *Editor & Publisher*, Nov. 4, 1989.

Ownership: Cleaveland, Carol. "Comics Business Not All Funny." *Allentown Morning Call*, Dec. 28, 1989.

Astor, David. "Contracts are a Hot Topic of Discussion." *Editor & Publisher*, April 4, 1987.

"NFC to Discuss Ownership Rights Issue." *Editor & Publisher*, Aug. 29, 1987.

"Three Get New Pacts as Suit is Dropped." *Editor & Publisher*, Oct. 20, 1990.

Mergers: Astor, David. "King Buying Cowles Syndicate." *Editor & Publisher*, March 8, 1986.

"The Syndicate World Reacts to NAS Deal." *Editor & Publisher*, Jan. 10, 1987.

"King-News America Deal Finalized." *Editor & Publisher*, Feb. 14, 1987.

Syndicates: Alexander, Katina. "A Superhero for Cartoonists?" *New York Times*, June 14, 1987.

Astor, David. "Strong Opinions About a New Syndicate." *Editor & Publisher*, March 7, 1987.

"'B.C.' Comic Joining Ann Landers at CS." *Editor & Publisher*, March 21, 1987.

"Mell Lazarus Moves to Creators." *Editor & Publisher*, March 12, 1988.

"King Appoints New Comics Editor." *Editor & Publisher*, Feb. 18, 1989.

"New Comics Editor in Time of Transition." *Editor & Publisher*, July 15, 1989.

Comic relief: Orwen, Pat. "Cartoonists Take Up Pen to Aid Hungry." *Toronto Star*, July 29, 1985.

"More Than Just Comic Relief." *Time*, Dec. 9, 1985.

Comic Relief: Drawings from the Cartoonists Thanksgiving Day Hunger Project. New York: Henry Holt and Company, 1986.

THE NINETIES

Kirkman and Scott: "'Baby Blues' Comic Will Make Its Debut Next Month." *Editor & Publisher*, Dec. 16, 1989.

"Baby Blues." *Cartoonist PROfiles* #85, March 1990.

Beiswinger, George L. "'Baby Blues' Has a Successful Formula." *Editor & Publisher*, Dec. 1, 1990.

Kirkman, Rick, and Jerry Scott. *Baby Blues: Ten Years and Still in Diapers.* Kansas City: Andrews McMeel Publishing, 1999.

Patrick McDonnell: "'Mutts' by Patrick McDonnell." *Cartoonist PROfiles* #104, December 1994.

Walker, Brian. Interview with Patrick McDonnell. Nov. 5, 1996.

Folkman, David. "The Inspired 'Mutts.'" *Hogan's Alley* #7, 1999.

Scott and Borgman: Astor, David. "Why 'Zits' Zoomed Up the Sales Charts." *Editor & Publisher*, Feb. 28, 1998.

Stepp, Laura Sessions. "Drawn from Life." *Washington Post*, Dec. 1, 2000.

Carter, Kellye. "The Line." *Raising Teens*, 2000.

Scott Adams: "'Dilbert' by Scott Adams." *Cartoonist PROfiles* #84, December 1989, and #106, June 1995.

Dolan, Carrie. "People at Pacific Bell See One Another in the Funny Paper." *Wall Street Journal*, Sept. 6, 1994.

Meisler, Andy. "Yes, Dilbert's Dad Has A Cubicle of His Own." *New York Times*, Jan. 25, 1995.

Van Biema, David. "Layoffs for Laughs." *Time*, March 18, 1996.

Levy, Steven. "Working in Dilbert's World." *Newsweek*, Aug. 12, 1996.

Heintjes, Tom. "Interviewing with Dilbert's Boss." *Hogan's Alley* #3, 1996.

Serious issues: Myers, Greg. "'Funky Winkerbean' Deals With Teen Pregnancy." *Comic Buyer's Guide*, Nov. 14, 1986.

Kiernan, Laura A. "Comic Strip's Storyline on Gay Teen Stirs Controversy." *Boston Globe*, March 1993.

Astor, David. "Comic With Gay Character is Dropped by Some Papers." *Editor & Publisher*, April 3, 1993.

"More Papers Cancel Controversial Comic." *Editor & Publisher*, April 10, 1993.

Teegarden, Carol. "Are Gloom and Doom Invading the Comics?" *Free Press*, April 1995.

Political correctness: Astor, David. "A Session on 'Political Correctness.'" *Editor & Publisher*, June 20, 1992.

"Frank Language in Comics: OK or #*&+%!<@>#?" *Editor & Publisher*, Aug. 15, 1998.

Lang, Tony. "That's Not Funny! P.C. War Flared on the Comics Page." *Cincinnati Enquirer*, Oct. 31, 1993.

Mullen, Rodger. "Rank Humor: 'Beetle' Artist Changes Tactics With Time." *Fayetteville Observer-Times*, Jan. 19, 1997.

Fazio, Debbie. "'Beetle Bailey's' General Halftrack Ordered to Sensitivity Training." Tryon Communications, July 1997.

"'B.C.' Strips Pulled from L.A. Times." *The Comics Journal* #186, April 1996.

Van Biema, David. "Preach It Caveman!" *Time*, April 19, 1998.

Neven, Tom. "Lessons from the Hart." *Focus on the Family*, April 1999.

Chafets, Zev. "It's No Joke When Papers Cut Comics." *New York Daily News*, April 16, 2001.

"'B.C.' Pulled, Impugned, and Praised." *Editor & Publisher*, April 23, 2001.

Kiska, Tim. "Movin' Out to 'The Boondocks.'" *Detroit News*, April 17, 1999.

Hornblower, Margot. "Comics N the Hood." *Time*, July 5, 1999.

Croal, N'Gai. "What's the Color of Funny?" *Newsweek*, July 5, 1999.

Comics centennial: "A Century of the 'Funnies.'" *New York Times*, April 9, 1995 (editorial page).

Precker, Michael. "Comic Relief." *Dallas Morning News*, April 9, 1995.

Adler, Eric. "100 Years of Laughter." *Charlotte Observer*, May 5, 1995.

DeLeon, Clark. "A Century of Comics." *Philadelphia Inquirer*, April 30, 1995.

Hinckley, David. "Comic-Strip Stamp Draws on the Heart of American Culture." *New York Daily News*, May 5, 1995.

Astor, David. "Study Finds Comics Read by 113 Million." *Editor & Publisher*, Jan. 30, 1993.

"International Museum of Cartoon Art Opens." *The Comics Journal* #185, March 1996.

Frankenhoff, Brent. "Comics Creators Switch Strips for April 1." *Comic Buyer's Guide* #1225, May 9, 1997.

State of the art: Griffith, Bill. "Comics at 100 . . . Fading to Gray and Little to Smile About." *Boston Sunday Globe*, Nov. 10, 1996.

LeJeune, Anthony. "Eek! Sob! It's the Death of Comics!" *National Review*, Aug. 29, 1994.

Falk, William B. "Serious Business on the Funny Pages." *Newsday*, Feb. 10, 1997.

Kamp, David. "That Joke Isn't Funnies Anymore." *GQ*, April 2000.

Thomas, Jack. "Let's Face It: The Comics Aren't Funny." *Boston Globe*, Nov. 13, 2000.

Breaking in: Asimov, Eric. "Fledgling Cartoonists Pin Hopes on an Increasingly Unlikely Break." *New York Times*, 1991.

Astor, David. "Speakers Feel Comics Pages are Too Safe." *Editor & Publisher*, Oct. 19, 1991.

Peterson, Iver. "The Search for the Next 'Doonesbury.'" *New York Times*, Oct. 28, 1996.

Charles Schulz: Hinckley, David. "Nuts! No 'Peanuts.'" *New York Daily News*, Dec. 15, 1999.

Trudeau, Garry. "For 'Peanuts,' Americans Got a New Form of Comics." *Washington Post*, Dec. 19, 1999.

Poniewozik, James. "The Good and the Grief." *Time*, Dec. 27, 1999.

Begley, Sharon. "So Long, Snoopy & Co." *Newsweek*, Jan. 1, 2000.

Astor, David. "For United Media, Hapiness is a Warm Response to Reruns." *Editor & Publisher*, Jan. 10, 2000.

Boxer, Sarah. "Charles M. Schulz, 'Peanuts' Creator, Dies at 77." *New York Times*, Feb. 14, 2000.

Astor, David. "Sunday Will Never be the Same." *Editor & Publisher*, Feb. 21, 2000.

"Gentle Genius." *People*, Feb. 28, 2000.

Astor, David. "'Peanuts' Still Holding on to 2,460 Clients." *Editor & Publisher*, Oct. 30, 2000.

Schulz, Charles. *Peanuts: A Golden Celebration*. New York: HarperCollins Publishers, 1999.

The next generation: Astor, David. "The Cartoon Dilema." *Editor & Publisher*, May 8, 2000.

For further listings of articles on contemporary cartoonists, see: Harvey, R. C. "Complete 30-Year Index." *Cartoonist PROfiles* #123, September 1999.

BOOKS

GENERAL HISTORIES

Appel, John J. *Cartoons and Ethnicity*. Columbus: Ohio State University Libraries, 1992.

Becker, Stephen. *Comic Art in America*. New York: Simon and Schuster, 1959.

Berger, Arthur Asa. *The Comic-Stripped American*. Baltimore: Penguin Books, 1973.

Blackbeard, Bill. *The Yellow Kid*. Northampton, Mass.: Kitchen Sink Press, 1995.

Blackbeard, Bill, and Dale Crain, eds. *The Comic Strip Century*. 2 vols. Englewood Cliffs, N.J.: O.G. Publishing Corp., 1995.

Blackbeard, Bill, and Martin Williams, eds. *The Smithsonian Collection of Newspaper Comics*. Washington, D.C.: Smithsonian Institution Press and Harry N. Abrams, 1977.

Carlin, John, and Sheena Wagstaff. *The Comic Art Show: Cartoons and Painting in Popular Culture*. New York: Whitney Museum of American Art, 1983.

Carrier, David. *The Aesthetics of Comics*. University Park, Pa.: The Pennsylvania State University Press, 2000.

Caswell, Lucy. *See You in the Funny Papers*. Columbus: Ohio State University Libraries, 1995.

————. *Historic Virtuoso Cartoonists*. Columbus: Ohio State University Libraries, 2001.

Couperie, Pierre, and Maurice Horn. *A History of the Comic Strip*. New York. Crown Publishers, 1968.

Ellinport, Jeffrey M. *Collecting Original Comic Strip Art*. Norfolk, Va.: Antique Trader Books, 1999.

Emery, Michael, Edwin Emery, and Nancy L. Roberts. *The Press in America*. Boston: Allyn and Bacon, 2000.

Goulart, Ron. *The Encyclopedia of American Comics*. New York: Facts On File, Inc., 1990.

————. *The Funnies: 100 Years of American Comic Strips*. Holbrook, Mass.: Adams Publishing, 1995.

Hardy, Charles, and Gail F. Storm, eds. *Ethnic Images in the Comics*. Philadelphia: The Balch Institute for Ethnic Studies, 1986.

Harvey, Robert C. *The Art of the Funnies*. Jackson, Miss.: University Press of Mississippi, 1994.

————. *Children of the Yellow Kid*. Seattle: Frye Art Museum, 1998.

————. *A Gallery of Rogues: Cartoonists' Self-Caricatures*. Columbus: Ohio State University Cartoon Research Library, 1998.

Hollis, Daniel W. *The Media in America*. Santa Barbara, Calif.: ABC-CLIO, 1995.

Horn, Maurice, ed. *75 Years of the Comics*. Boston: Boston Book and Art, Publisher, 1971.

————. *Comics of the American West*. South Hackensack, N.J.: Stoeger Publishing, 1977.

————. *Women in the Comics*. New York: Chelsea House Publishers, 1977.

————. *Sex in the Comics*. New York: Chelsea House Publishers, 1985.

————. *100 Years of American Newspaper Comics*. New York: Gramercy Books, 1996.

————. *The World Encyclopedia of Cartoons*. Philadelphia: Chelsea House Publishers, 1999.

————. *The World Encyclopedia of Comics*. Philadelphia: Chelsea House Publishers, 1999.

Hurd, Jud. *To Cartooning: 60 Years of Magic*. Fairfield, Conn.: PROfiles Press, 1993.

Inge, M. Thomas. *Comics as Culture*. Jackson, Miss.: University Press of Mississippi, 1990.

————. *Great American Comics*. Columbus: Ohio State University Libraries and Smithsonian Institution, 1990.

————. *Anything Can Happen in a Comic Strip*. Columbus: Ohio State University Libraries, 1995.

Janocha, Bill, ed. *The National Cartoonists Society Album 1996*. New York: National Cartoonists Society, 1996.

Katz, Harry L., and Sara W. Duke. *Featuring the Funnies: One Hundred Years of the Comic Strip*. Washington, D.C.: Library of Congress, 1995.

King Features Syndicate. *Famous Artists & Writers of King Features Syndicate*. New York: King Features Syndicate, Inc., 1949.

Koenigsberg, M. *King News: An Autobiography*. Philadelphia and New York: F. A. Stokes Company, 1941.

Lent, John A. *Comic Books and Comic Strips in the United States: An International Bibliography*. Westport, Conn.: Greenwood Press, 1994.

Marschall, Richard. *The Sunday Funnies: 1896–1950*. New York: Chelsea House Publishers, 1978.

————. *What's So Funny: The Humor Comic Strip in America*. Salina, Kan.: The Salina Art Center, 1988.

————. *America's Great Comic-Strip Artists*. New York: Abbeville Press, 1989.

Nordling, Lee. *Your Career in the Comics*. Kansas City: Andrews and McMeel, 1995.

O'Sullivan, Judith. *The Great American Comic Strip*. Boston: Little, Brown and Company, 1990.

Phelps, Donald. *Reading the Funnies*. Seattle: Fantagraphics Books, 2001.

Robbins, Trina. *The Great Women Cartoonists*. New York: Watson-Guptill Publications, 2001.

Robinson, Jerry. *The Comics: An Illustrated History of Comic Strip Art*. New York: G. P. Putnam's Sons, 1974.

————. *Cartoon: A Celebration of American Comic Art*. Washington, D.C.: John F. Kennedy Center for the Performing Arts, 1975.

Sheridan, Martin. *Comics and Their Creators*. Boston: Hale, Cushman & Flint, 1942.

Strickler, Dave. *Syndicated Comic Strips and Artists 1924–1995: The Complete Index*. Cambria, Calif.: Comics Access, 1995.

Thorndike, Chuck. *The Business of Cartooning*. New York: The House of Little Books, 1939.

Turner, Hy B. *When Giants Ruled: The Story of Park Row, New York's Great Newspaper Street*. New York: Fordham University Press, 1999.

Van Hise, James. *Calvin and Hobbes, Garfield, Bloom County, Doonesbury and All That Funny Stuff*. Las Vegas: Pioneer Books, 1991.

Walker, Brian. *The Sunday Funnies: 100 Years of Comics in American Life*. Bridgeport, Conn.: The Barnum Museum, 1994.

Waugh, Coulton. *The Comics*. New York: Macmillan, 1947.

White, David Manning, and Robert H. Abel, eds. *The Funnies: An American Idiom*. New York: The Free Press of Glencoe/Macmillan, 1963.

Whyte, Malcolm. *Great Comic Cats*. San Francisco: Pomegranate, 2001.

Wood, Art. *Great Cartoonists and Their Art*. Gretna, La.: Pelican Publishing Company, 1987.

Yoe, Craig. *Weird But True Toon Factoids*. New York: Gramercy Books, 1999.

AUTOBIOGRAPHIES, BIOGRAPHIES, AND RETROSPECTIVE ANTHOLOGIES

Adams, Scott. *Seven Years of Highly Defective People*. Kansas City: Andrews McMeel Publishing, 1997.

Bang, Derrick. *50 Years of Happiness: A Tribute to Charles M. Schulz*. Peanuts Collectors Club, 1999.

Berger, Arthur Asa. *Li'l Abner: A Study in American Satire*. Jackson, Miss.: University Press of Mississippi, 1994.

Breathed, Berkeley. *One Last Little Peek, 1980–1995*. Boston: Little Brown and Company, 1995.

Burstein, Mark. *Much Ado: The Pogofenokee Trivia Book*. Forestville, Calif.: Eclipse Books, 1988.

Caplin, Elliott. *Al Capp Remembered*. Bowling Green, Ohio: Bowling Green State University Popular Press, 1994.

Capp, Al. *The Best of Li'l Abner*. New York: Holt, Rinehart and Winston, 1978.

———. *My Well Balanced Life on a Wooden Leg*. Santa Barbara, Calif.: John Daniel and Company, 1991.

Davis, Jim. *20 Years and Still Kicking: Garfield's Twentieth Anniversary Collection*. New York: Ballantine Books, 1998.

Feiffer, Jules. *Jules Feiffer's America*. New York: Alfred A. Knopf, 1982.

Grandinetti, Fred M. *Popeye: An Illustrated History of E.C. Segar's Character in Print, Radio, Television and Film Appearances, 1929–1993*. Jefferson, N.C.: McFarland & Company, 1994.

Guisewite, Cathy. *Reflections*. Kansas City: Andrews and McMeel, 1991.

———. *Twentieth Anniversary Collection*. Kansas City: Andrews and McMeel, 1996.

Harvey, Robert C. *Accidental Ambassador Gordo*. Jackson, Miss.: University Press of Mississippi, 2000.

Inge, Thomas M., ed. *Charles M. Schulz Conversations*. Jackson, Miss.: University Press of Mississippi, 2000.

Johnson, Rheta Grimsley. *Good Grief: The Story of Charles Schulz*. New York: Pharos Books, 1989.

Johnston, Lynn. *A Look Inside . . . For Better or For Worse: The 10th Anniversary Collection*. Kansas City: Andrews and McMeel, 1989.

———. *It's the Thought that Counts . . . For Better or For Worse Fifteenth Anniversary Collection*. Kansas City: Andrews and McMeel, 1994.

———. *Remembering Farley: A Tribute to the Life of Our Favorite Cartoon Dog*. Kansas City: Andrews and McMeel, 1996.

———. *The Lives Behind the Lines: 20 Years of For Better or For Worse*. Kansas City: Andrews and McMeel Publishing, 1999.

Kane, Brian M. *Hal Foster: Prince of Illustrators—Father of the Adventure Strip*. Lebanon, N.J.: Vanguard Productions, 2001.

Keane, Bil. *The Family Circus Treasury*. Kansas City: Sheed Andrews and McMeel, 1977.

Kelly, Selby, and Bill Crouch, Jr., eds. *The Best of Pogo*. New York: Simon and Schuster, 1982.

———. *Pogo Even Better*. New York: Simon and Schuster, 1984.

———. *Outrageously Pogo*. New York: Simon and Schuster, 1985.

———. *Pluperfect Pogo*. New York: Simon and Schuster, 1987.

———. *Phi Beta Pogo*. New York: Simon and Schuster, 1989.

Kelly, Selby, and Steve Thompson. *Pogo Files for Pogofiles*. Richfield, Minn.: Spring Hollow Books, 1992.

Kelly, Walt. *Ten Ever-Lovin' Blue-Eyed Years with Pogo*. New York: Simon and Schuster, 1959.

Ketcham, Hank. *The Merchant of Dennis*. New York: Abbeville Press, 1990.

———. *Dennis the Menace: His First 40 Years*. New York: Abbeville Press, 1991.

Kidd, Chip, ed. *The Art of Charles M. Schulz*. New York: Pantheon Books, 2001.

Kirkman, Rick, and Jerry Scott. *Baby Blues: Ten Years and Still in Diapers*. Kansas City: Andrews McMeel Publishing, 1999.

Larson, Gary. *The PreHistory of The Far Side*. Kansas City: Andrews and McMeel, 1989.

Lazarus, Mell. *The Momma Treasury*. Kansas City: Sheed Andrews and McMeel, 1978.

Maeder, Jay. *Dick Tracy: The Official Biography*. New York: Plume, 1990.

Marschall, Rick, and John Paul Adams. *Milt Caniff: Rembrandt of the Comic Strip*. Endicott, N.Y.: Flying Buttress Publications, 1981.

Roberts, Garyn G. *Dick Tracy and American Culture*. Jefferson, N.C.: McFarland & Company, 1993.

Sagendorf, Bud. *Popeye: The First Fifty Years*. New York: Workman Publishing, 1979.

Schulz, Charles. *Peanuts Jubilee*. New York: Holt, Rinehart and Winston, 1975.

———. *You Don't Look 35, Charlie Brown!* New York: Holt, Rinehart and Winston, 1985.

———. *Around the World in 45 Years*. Kansas City: Andrews and McMeel, 1994.

———. *Peanuts: A Golden Celebration*. New York: HarperCollins Publishers, 1999.

Smith, Bruce. *The History of Little Orphan Annie*. New York: Ballantine Books, 1982.

Theroux, Alexander. *The Enigma of Al Capp*. Seattle: Fantagraphics Books, 1999.

Trimboli, Giovanni. *Charles M. Schulz: 40 Years Life and Art*. New York: Pharos Books, 1990.

Trudeau, G. B. *Flashbacks: Twenty-Five Years of Doonesbury*. Kansas City: Andrews and McMeel, 1995.

Walker, Brian. *The Best of Hagar the Horrible*. Bedford, N.Y.: Comicana Books, 1985.

———. *The Best of Hi and Lois*. Bedford, N.Y.: Comicana Books, 1986.

———. *The Best of Ernie Bushmiller's Nancy*. Wilton, Conn.: Comicana Books, 1988.

———. *Barney Google and Snuffy Smith: 75 Years of an American Legend*. Wilton, Conn.: Comicana Books/Ohio State University Libraries, 1994.

Walker, Mort. *Backstage at the Strips*. New York: Mason Charter, 1975.

———. *The Best of Beetle Bailey*. Bedford, N.Y.: Comicana Books, 1984.

———. *Mort Walker's Private Scrapbook*. Kansas City: Andrews McMeel Publishing, 2000.

Watterson, Bill. *The Calvin and Hobbes Tenth Anniversary Book*. Kansas City: Andrews and McMeel, 1995.

———. *Calvin and Hobbes Sunday Pages 1985–1995*. Kansas City: Andrews McMeel Publishing, 2001.

Young, Dean, and Richard Marschall. *Blondie and Dagwood's America*. New York: Harper & Row, 1981.

Yronwode, Catherine. *The Art of Will Eisner*. Princeton, Wis.: Kitchen Sink Press, 1982.

REPRINTS

Thousands of book collections of newspaper comic strips and panels have been published since 1945 and are too numerous to list here. Andrews McMeel Publishing in Kansas City currently offers annual reprint collections of many of the major contemporary features, including *Baby Blues*, *Cathy*, *Dilbert*, *Doonesbury*, *For Better or For Worse*, *Foxtrot*, *Mutts*, and *Zits*. Fantagraphics Books of Seattle has published collections of *Dennis the Menace*, *Peanuts*, *Pogo*, *Prince Valiant*, and *Zippy*.

INDEX

THE BASIC ELEMENTS—Special MUTTS page by Patrick McDonnell created for the anniversary of The Comics Journal. © 1997 Patrick McDonnell